CARTOONING The LANDSCAPE

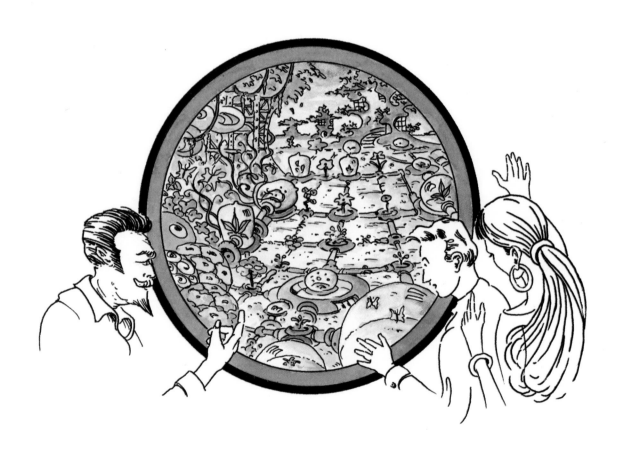

Chip Sullivan

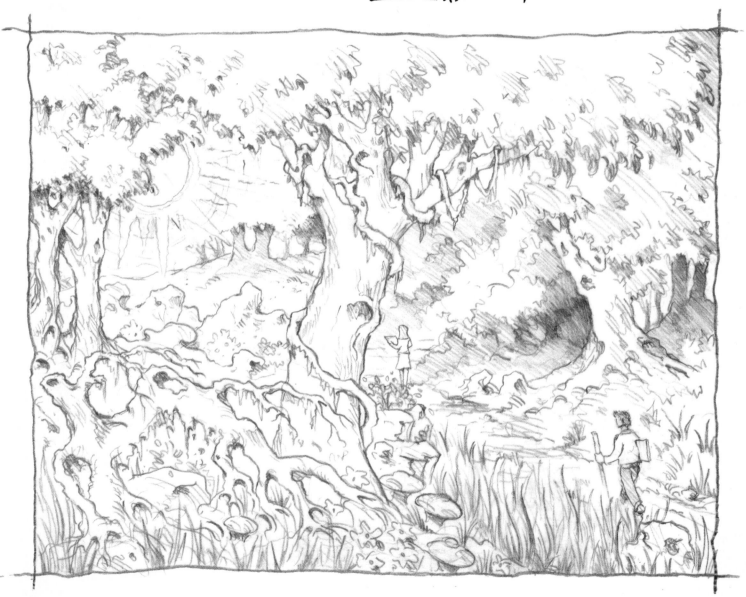

UNIVERSITY OF VIRGINIA PRESS

Charlottesville and London

University of Virginia Press

© 2016 by the Rector and Visitors of the University of Virginia

Printed in the United States of America on acid-free paper

First published 2016

ISBN 978-0-8139-3852-3 (cloth)

ISBN 978-0-8139-3920-9 (paper)

9 8 7 6 5 4 3 2 1

For Joe McBride,
guardian of the forest, plein air painter, sensei

CONTENTS

PREFACE

This book evolved from a series of comics I produced on creative thinking that ran in *Landscape Architecture* magazine from 2006 to 2011. The increasing popularity of the graphic novel and the recognition of the comic-book format as a legitimate educational tool helped inspire my approach to the content. The integration of word and image is a powerful technique for communicating the transformative powers of observation.

The narrative revolves around a sustained mentor-protégé relationship wherein weekly lessons on drawing, seeing, and consciousness fulfill the protagonist's long search for a wise teacher. The plot is inspired by actual events and real people who have influenced my search for the metaphysical meaning of the garden and my struggle to create and promote landscape architecture as an art form. Throughout my life I have been fortunate to have my family's support and encouragement to pursue an artistic career. When I was in the fourth grade my father suggested I learn to draw by copying the Sunday comics; accomplishing this took me several years. My mother bought me my first oil painting set and showed me how to paint still lifes. My grandfather always made sure I had plenty of drawing materials; when I went off to college, his last words to me were "Don't ever forget your art."

I've been extremely fortunate to have been guided by many wise mentors; this work is a small tribute to them all. An example of how an insightful comment by a teacher forever changed my life took place during my senior year at the University of Florida. Herrick Smith, then chair of the landscape architecture department, was hanging a poster for an exhibition of landscape paintings by a recent graduate of the program. I protested, saying, "Hey, that's not landscape architecture!" He immediately responded, "Yes, it is most definitely landscape architecture." This notion blew me away, and opened up a new perspective of what landscape architecture could be, helping to establish my belief that it is art.

Since childhood, comics have been my art school. This book is a testament to my love of the medium. I've employed a variety of representational methods—pencil, ink, watercolor—to correspond to the trajectory of the creative process and illustrative techniques presented in the text. All the art work is hand drawn, hand lettered, and painted with watercolor, according to traditional methods. As ideas come to me I jot them down in a small sketchbook that I carry with me at all times. I work out the page concepts on 8½" x 11" gold-

enrod paper, then enlarge and redraw them on 11″ x 17″ tracing paper. Next, I refine the details and block in the dialogue balloons. Once the page is composed, I use a light table to transfer the drawing with a 2B pencil onto 140 lb. Arches hot-pressed watercolor paper. After inking, I erase the pencil lines and watercolor the ink drawing. I then scan the completed paintings and use Adobe Photoshop to make corrections.

The work is organized as a collection of six thematic chapters embedded in an ongoing dialogue between student and teacher. Each chapter is envisioned as a separate issue containing individual segments relative to environmental awareness and creativity. The conceptual format of the work is established in Issue 1, wherein main characters and recurring features are introduced; the stage is set for the reader to discover with youthful exuberance the connections between built and natural systems in such engineering marvels as trains, topiaried trees, amusement parks, and underground fortresses. At the conclusion of each issue is a selection of "neat stuff": visualization and drawing exercises, do-it-yourself modeling projects, captivatingly fun facts, provocative quizzes, and imaginative ads, as one would find in a traditional comic book or child's activity magazine.

I hope this book can serve as a guide for those who are struggling to find their own creative visions and personal pathways to consciousness. Nature and the garden can be never-ending sources of inspiration. Let the Gaia spirit be your muse.

Our mentors and guides are always hidden in plain sight. We need just to open our eyes to see them.

ACKNOWLEDGMENTS

This project evolved over many years, with assistance and encouragement from a long list of individuals. I am grateful for the overwhelming support I received from everyone, and would particularly like to recognize the following people:

I would like to thank the University of Virginia Press and Boyd Zenner for her belief in the potential of my original proposal and for her support in getting the book into print. I am very grateful to managing editor Ellen Satrom for her masterful stewardship and to design and production managers Martha Farlow and Sylvia Mendoza.

I am indebted to the Department of Landscape Architecture and Environmental Planning at the University of California for allowing me the freedom to experiment with new and innovative methods of graphic communication in my studios. The support of the department's Beatrix Farrand Research Fund played an essential role in this project. The endorsement of the project by Professor Emeritus Randy Hester was particularly reassuring during the early stages of its development. Professor Joe McBride, fellow cartoon enthusiast and plein air painter, has always provided me with a limitless source of inspiration.

Sincere thanks to Bill Thompson, former editor of *Landscape Architecture* magazine, for giving me my first big break by publishing my comic *The Landscape Imagineer*. Bill established the "Creative Learning" feature as a forum for illustrative work.

Filmmaker Tom Hammock shared valuable insight in the initial development of the manuscript's theme and story arc. Student intern Maura Chen served as an invaluable research assistant, drawing on her artistic talents to help with pencil layouts and many other essential graphic details. Throughout the life of this project I have been fortunate to have had the help of many exceptional graduate student instructors and researchers, including Fiona Cundy, who developed the process that allowed me to paint my inked drawings directly onto watercolor paper; Joseph Ewan and Adrienne Wong, who filmed Big Daddy Roth's visit to our site planning studio; Mike Cook, who assisted in the production of page layouts; and Johanna Hoffman, whose in-depth research provided the framework for many of the comics. Rae Ishee played a key role in all aspects of the creation of this book; her artistic expertise and critical judgment were vital to all levels of production. Kevin Lenhart applied a masterful touch and some thorough polishing to the final edits.

Eddie Chau, landscape architecture program director at the University of California, Berkeley Extension, organized the first exhibition of drawings in the book at the Art and Design Gallery in San Francisco; the show was a key source of exposure and feedback. Artist and sculptor Joseph Slusky was a big supporter of the project throughout our many drawing jams and doodling sessions.

I never would have become the world's "original landscape cartoonist" without Marc Treib's direction and provocation; and I could not have finished this book without the guidance of Elizabeth Boults, who played an essential role in the development of its content, graphic design, and editing. She should share the title of author, but her modesty would not allow it.

Last, my deepest appreciation goes to my late mother, Kitty Sullivan, whose lifelong support and belief in me molded my creative career, and who, in her final days, helped refine and give creative life to the ideas presented in this text.

FISHES, ASKING WHAT WATER WAS,
WENT TO A WISE FISH.
HE TOLD THEM THAT IT WAS
ALL AROUND THEM,
YET THEY STILL THOUGHT
THEY WERE THIRSTY.

NASAfI
13th C. scholar

PROLOGUE

PRE-DAWN
CHACO CANYON
JUNE 15, 1980

CASA RINCONADA
THE GREAT KIVA
CHACO CANYON

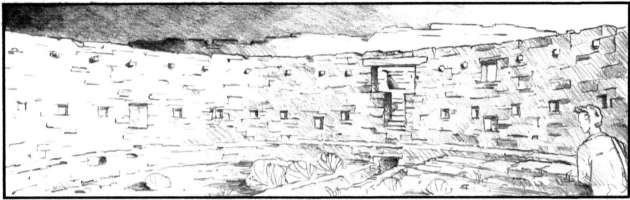

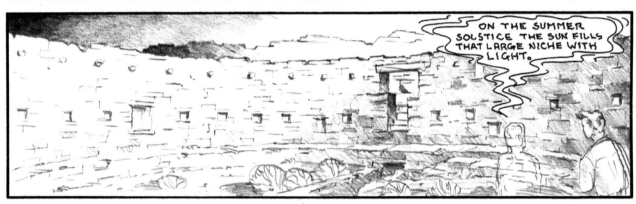

ON THE SUMMER SOLSTICE THE SUN FILLS THAT LARGE NICHE WITH LIGHT.

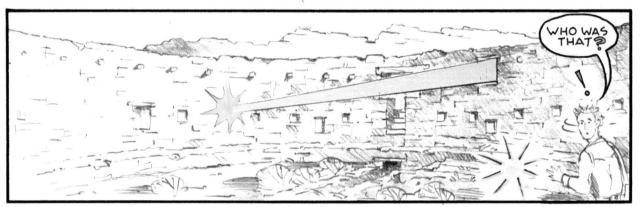

WHO WAS THAT?

WHEN A STUDENT IS READY A TEACHER APPEARS

MANY YEARS LATER

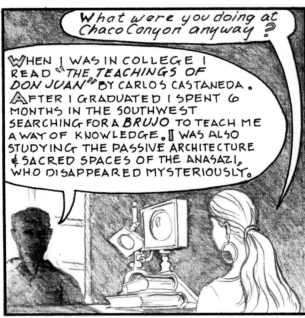

What were you doing at Chaco Canyon anyway?

WHEN I WAS IN COLLEGE I READ "THE TEACHINGS OF DON JUAN" BY CARLOS CASTANEDA. AFTER I GRADUATED I SPENT 6 MONTHS IN THE SOUTHWEST SEARCHING FOR A BRUJO TO TEACH ME A WAY OF KNOWLEDGE. I WAS ALSO STUDYING THE PASSIVE ARCHITECTURE & SACRED SPACES OF THE ANASAZI, WHO DISAPPEARED MYSTERIOUSLY.

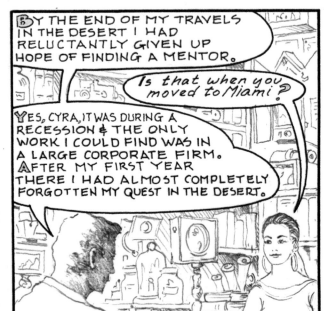

BY THE END OF MY TRAVELS IN THE DESERT I HAD RELUCTANTLY GIVEN UP HOPE OF FINDING A MENTOR.

Is that when you moved to Miami?

YES, CYRA, IT WAS DURING A RECESSION & THE ONLY WORK I COULD FIND WAS IN A LARGE CORPORATE FIRM. AFTER MY FIRST YEAR THERE I HAD ALMOST COMPLETELY FORGOTTEN MY QUEST IN THE DESERT.

BUT THEN ONE DAY AT A STAFF MEETING...

THE FIRM HAS NOW ESTABLISHED A SET OF GRAPHIC STANDARDS WHICH EVERYONE IN THE OFFICE WILL HAVE TO ADOPT. THERE WILL BE NO MORE INDIVIDUAL EXPRESSION OR DESIGN EXPERIMENTATION. WE NEED TO PROMOTE OUR CORPORATE IDENTITY. AFTER ALL... WE NO LONGER HAVE TO DRAW LIKE VAN GOGH—WE HAVE OUR MACHINES.

THIS REALLY PISSED ME OFF...SO I WENT OUT FOR A WALK TO COOL OFF. I STILL BELIEVED THAT LANDSCAPE ARCHITECTURE WAS AN ART FORM.

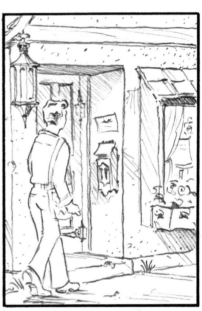

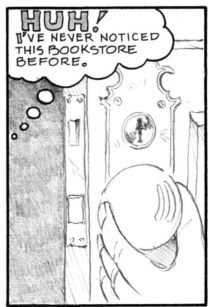

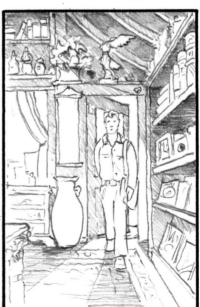

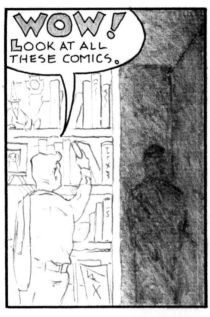

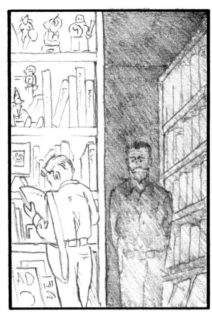

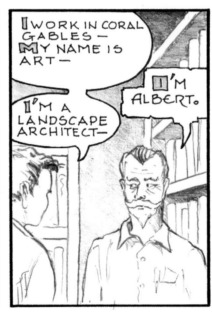

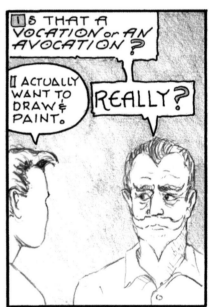

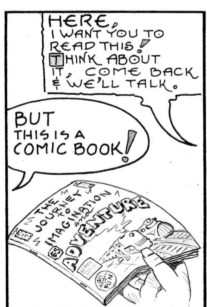

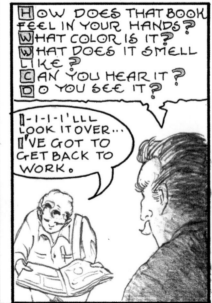

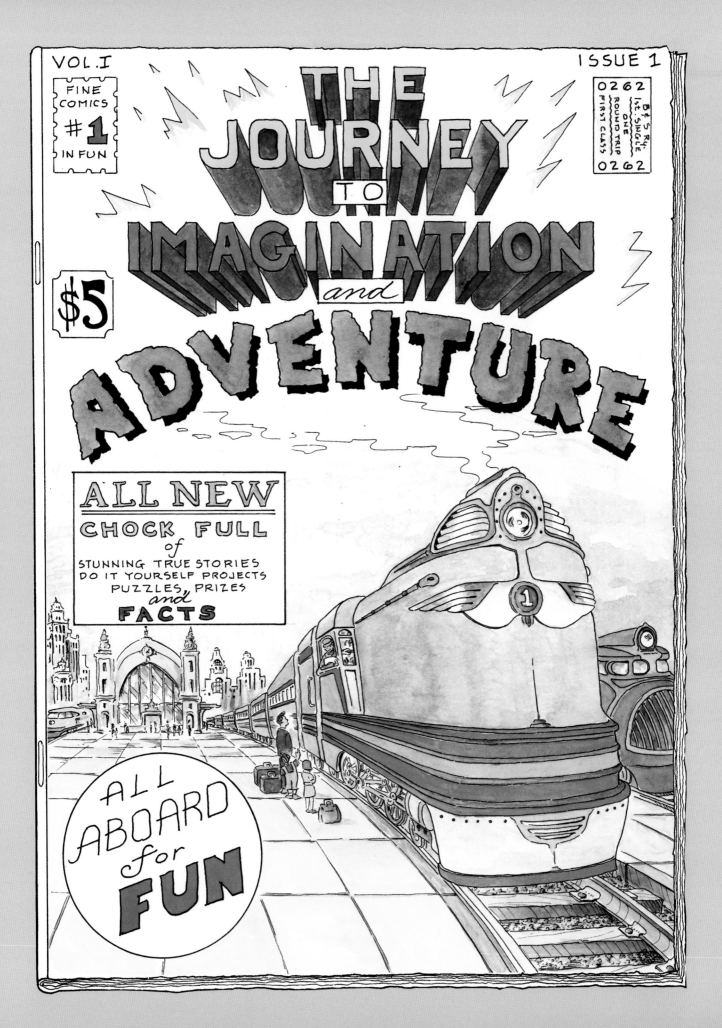

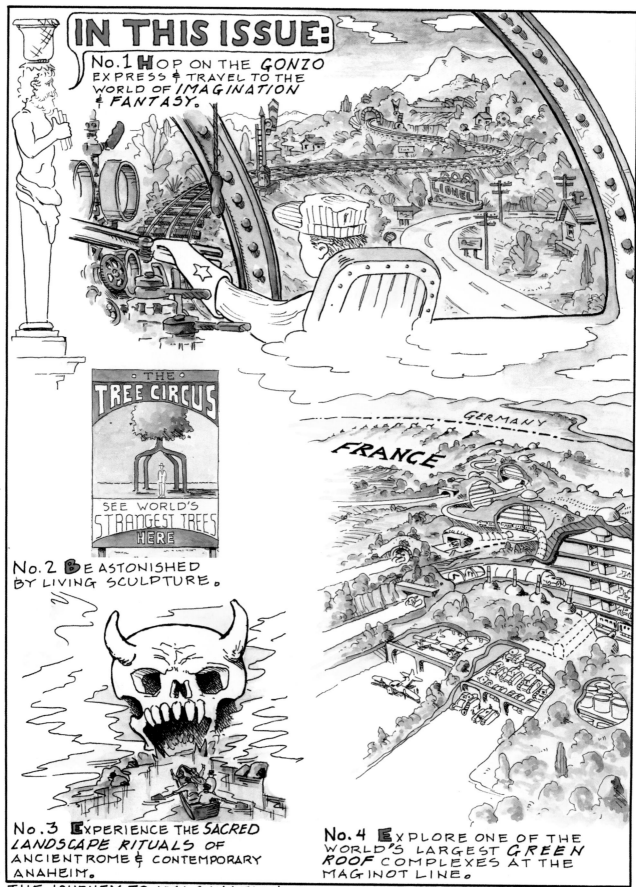

IN THIS ISSUE:

No. 1 HOP ON THE *GONZO* EXPRESS & TRAVEL TO THE WORLD OF *IMAGINATION* & *FANTASY*.

THE
TREE CIRCUS

SEE WORLD'S
STRANGEST TREES
HERE

No. 2 BE ASTONISHED BY LIVING SCULPTURE.

No. 3 EXPERIENCE THE *SACRED LANDSCAPE RITUALS* OF ANCIENT ROME & CONTEMPORARY ANAHEIM.

No. 4 EXPLORE ONE OF THE WORLD'S LARGEST *GREEN ROOF* COMPLEXES AT THE MAGINOT LINE.

THE JOURNEY TO IMAGINATION AND ADVENTURE, VOLUME I, ISSUE NUMBER 1. PUBLISHED BY THE UNIVERSITY OF VIRGINIA PRESS, CHARLOTTESVILLE, VIRGINIA, 22904/USA.

THE *FUTURE* LIES IN THE *PAST*

There is a fascinating connection between model railroads & landscape design. A survey conducted by the AIA in the late 1950s & early 1960s, when the field was even more dominated by men, discovered that children who played with Erector Sets became architects & those who played with model railroads became landscape architects.

A model railroad maintains a strong relationship to the *landscape*. The trains run along the ground plane & pass through fields, towns, cities, & over mountains, hills & rivers.

The toys we play with as children can have a *powerful effect on the professions we choose as adults.*

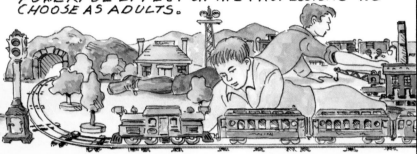

"We carry our childhood within us till the last moments of our lives."
HARLAN ELLISON

"The artist has to look at everything as though he saw it for the first time; he has to look at life as he did when he was a *child*..."
HENRI MATISSE

MY FIRST REALIZATION OF THE LANDSCAPE BEGAN WITH THE LIONEL TRAIN SET GIVEN TO ME AS A YOUNG CHILD BY MY GRANDFATHER. MY MOTHER TOOK ME ON MY FIRST TRAIN TRIP, WHERE I SAT AT THE WINDOW TRANSFIXED BY THE MOVING PANORAMA. LATER MY FATHER AND I BUILT THE FIRST OF MANY SCENIC LAYOUTS. MY CAREER AS A LANDSCAPE ARTIST BEGAN WITH THE IMAGINATION, VISUALIZATION, AND PLANNING OF THESE MINIATURE WORLDS...

The LANDSCAPE IMAGINEER
in
THE DREAM LAYOUT

No. 1

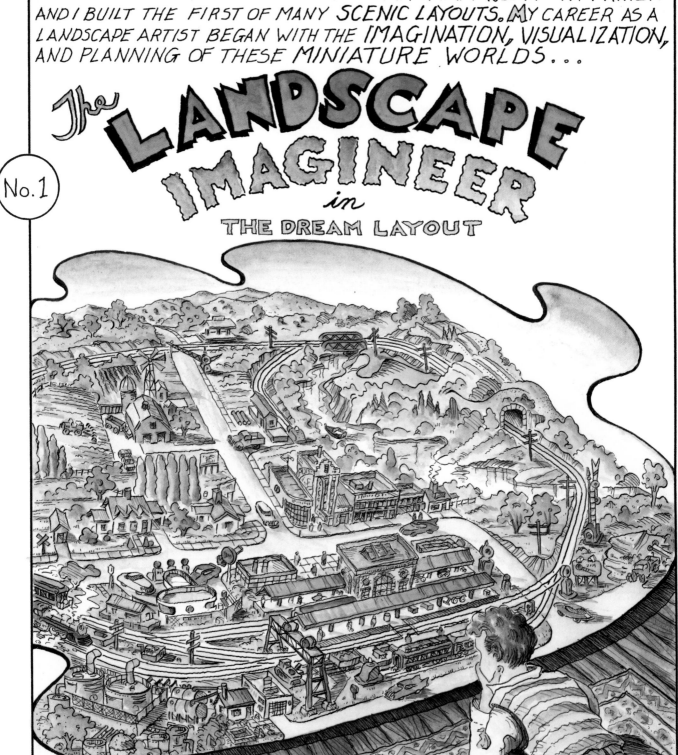

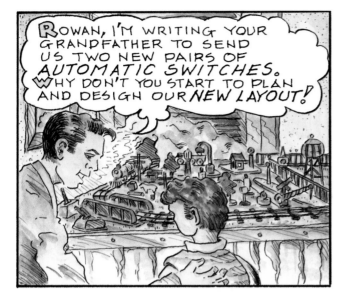

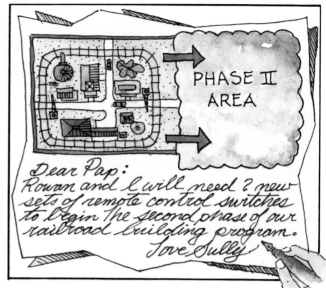

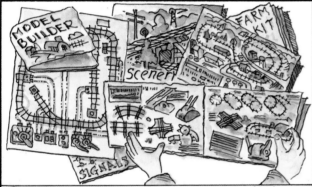

I BEGAN PORING OVER *LIONEL* CATALOGUES FILLED WITH MAGNIFICENT TRAIN SETS, REALISTIC OPERATING ACCESSORIES, DETAILED *LAYOUT PLANS* AND PAGES OF *SCENERY* DESIGN TIPS.

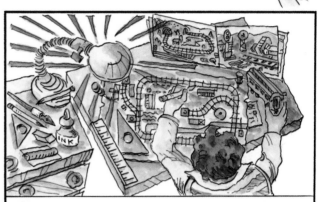

THE FIRST DRAWINGS THAT I REMEMBER SKETCHING WERE *LAYOUT* DESIGNS FOR OUR NEW R.R. I USED MY MIND'S EYE TO *VISUALIZE* HOW THEY WOULD LOOK.

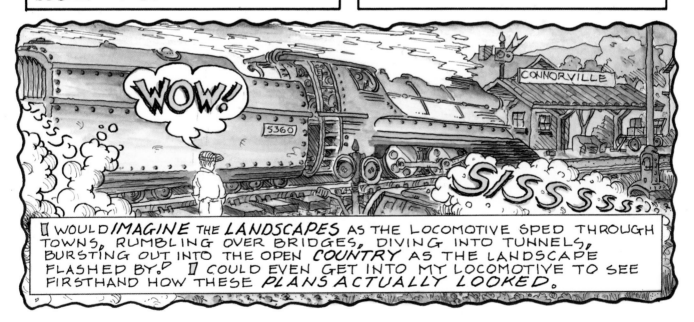

I WOULD *IMAGINE* THE *LANDSCAPES* AS THE LOCOMOTIVE SPED THROUGH TOWNS, RUMBLING OVER BRIDGES, DIVING INTO TUNNELS, BURSTING OUT INTO THE OPEN *COUNTRY* AS THE LANDSCAPE FLASHED BY. I COULD EVEN GET INTO MY LOCOMOTIVE TO SEE FIRSTHAND HOW THESE *PLANS ACTUALLY LOOKED.*

IT WAS QUITE A CLIMB TO GET INTO THE CAB...

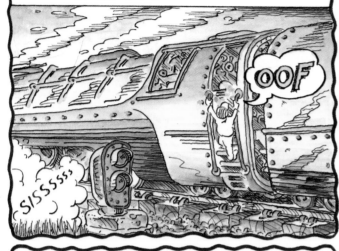

I WAS JUST TALL ENOUGH TO REACH THE THROTTLE, BUT I HAD A CLEAR VIEW OF THE TRACKS AND SCENERY FROM THE WINDOW...

RELEASING THE HAND BRAKE AND SETTING THE AIR BRAKES, I EASED BACK THE THROTTLE AND THE LOCOMOTIVE GENTLY PICKED UP STEAM...

THE ENGINE EASILY CLIMBED THE FIRST GRADE!

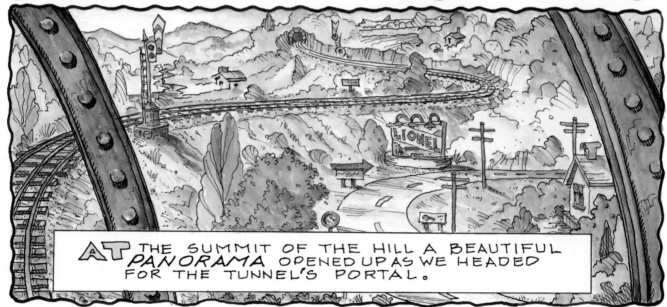

AT THE SUMMIT OF THE HILL A BEAUTIFUL PANORAMA OPENED UP AS WE HEADED FOR THE TUNNEL'S PORTAL.

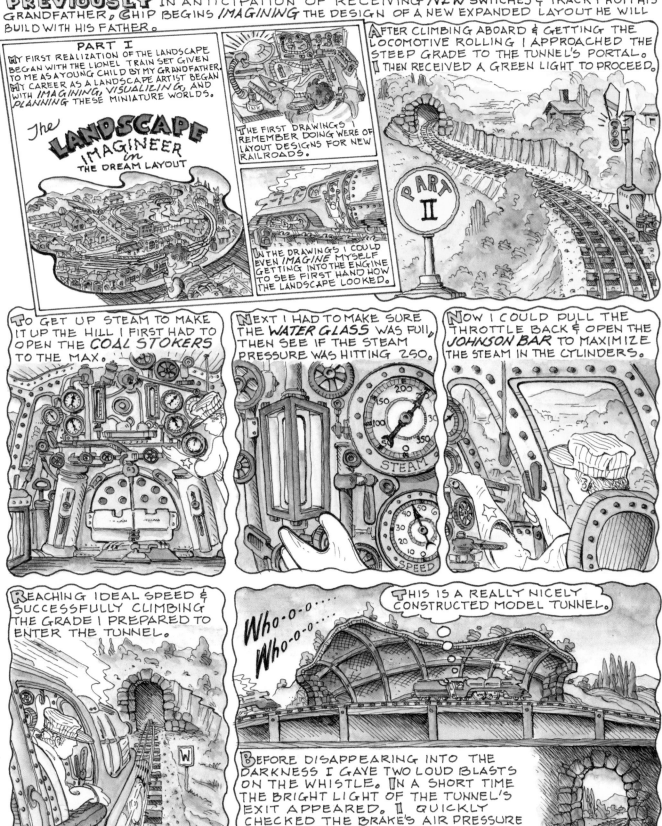

PREVIOUSLY IN ANTICIPATION OF RECEIVING *NEW* SWITCHES & TRACK FROM HIS GRANDFATHER, CHIP BEGINS *IMAGINING* THE DESIGN OF A NEW EXPANDED LAYOUT HE WILL BUILD WITH HIS FATHER.

PART I

MY FIRST REALIZATION OF THE LANDSCAPE BEGAN WITH THE LIONEL TRAIN SET GIVEN TO ME AS A YOUNG CHILD BY MY GRANDFATHER. MY CAREER AS A LANDSCAPE ARTIST BEGAN WITH *IMAGINING*, VISUALILING, AND *PLANNING* THESE MINIATURE WORLDS.

The **LANDSCAPE** IMAGINEER *in* THE DREAM LAYOUT

THE FIRST DRAWINGS I REMEMBER DOING WERE OF LAYOUT DESIGNS FOR NEW RAILROADS.

IN THE DRAWINGS I COULD EVEN *IMAGINE* MYSELF GETTING INTO THE ENGINE TO SEE FIRST HAND HOW THE LANDSCAPE LOOKED.

AFTER CLIMBING ABOARD & GETTING THE LOCOMOTIVE ROLLING I APPROACHED THE STEEP GRADE TO THE TUNNEL'S PORTAL. I THEN RECEIVED A GREEN LIGHT TO PROCEED.

PART II

TO GET UP STEAM TO MAKE IT UP THE HILL I FIRST HAD TO OPEN THE *COAL STOKERS* TO THE MAX.

NEXT I HAD TO MAKE SURE THE *WATER GLASS* WAS FULL, THEN SEE IF THE STEAM PRESSURE WAS HITTING 250.

NOW I COULD PULL THE THROTTLE BACK & OPEN THE *JOHNSON BAR* TO MAXIMIZE THE STEAM IN THE CYLINDERS.

REACHING IDEAL SPEED & SUCCESSFULLY CLIMBING THE GRADE I PREPARED TO ENTER THE TUNNEL.

Who-o-o.....
Who-o-o.....

THIS IS A REALLY NICELY CONSTRUCTED MODEL TUNNEL.

BEFORE DISAPPEARING INTO THE DARKNESS I GAVE TWO LOUD BLASTS ON THE WHISTLE. IN A SHORT TIME THE BRIGHT LIGHT OF THE TUNNEL'S EXIT APPEARED. I QUICKLY CHECKED THE BRAKE'S AIR PRESSURE IN ANTICIPATION OF THE APPROACHING DOWN HILL GRADE.

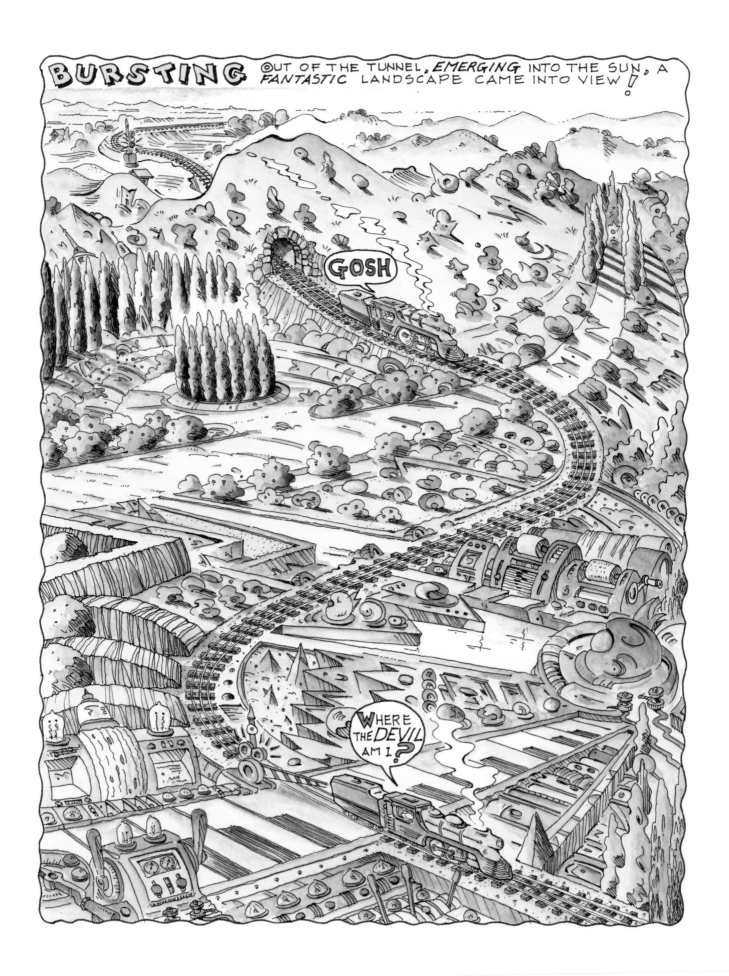

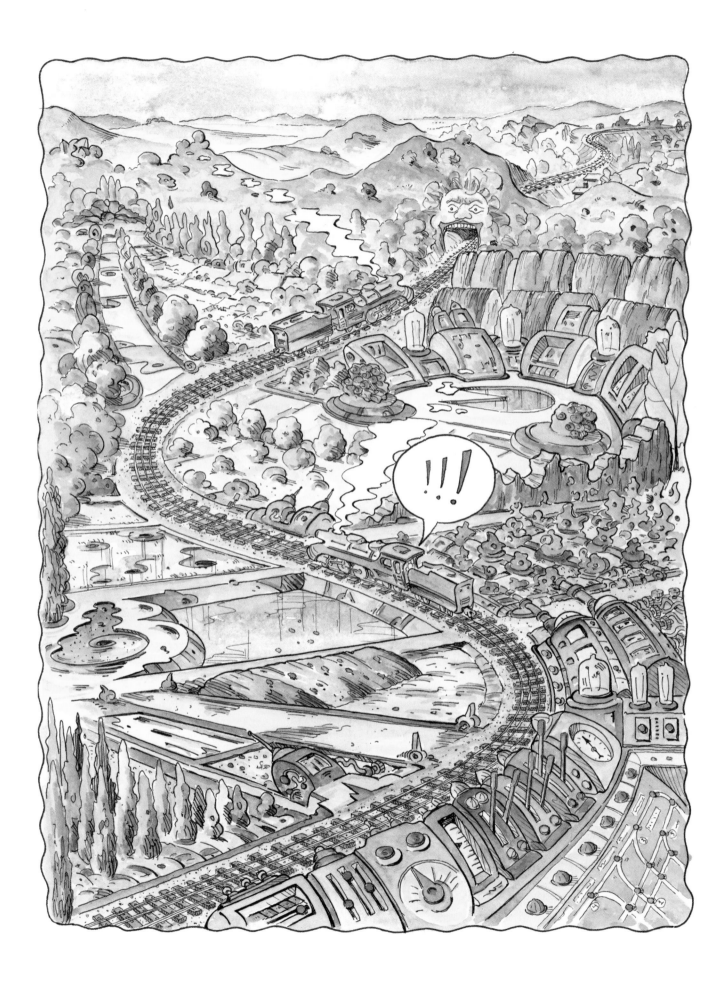

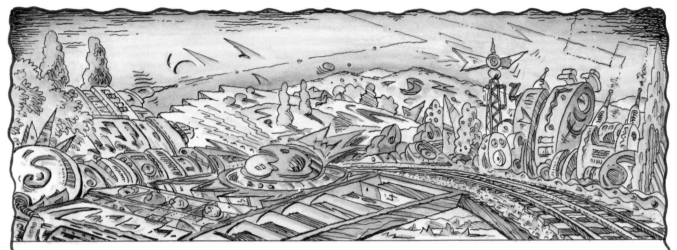

I'VE NEVER SEEN ANYTHING LIKE THIS BEFORE IN MY TRAIN CATALOGUES.

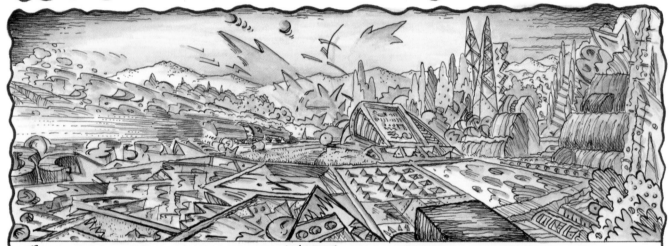

I OPENED THE THROTTLE AS *WIDE* AS IT WOULD GO, AND SPED THROUGH ACRES OF STARTLING GARDENS

JUST AS I STARTED TO BLOW THE *WHISTLE*... I HEARD...

HEY ROWAN!

LOOK AT THIS! THE BOX OF SWITCHES FROM PAP JUST *ARRIVED*. LET'S GET STARTED BUILDING THAT LAYOUT.

THE END

SCENIC RIDDLE

WHAT ARE THESE MYSTERIOUS INVISIBLE ANCIENT LINES CROSSING THE AUSTRALIAN LANDSCAPE?

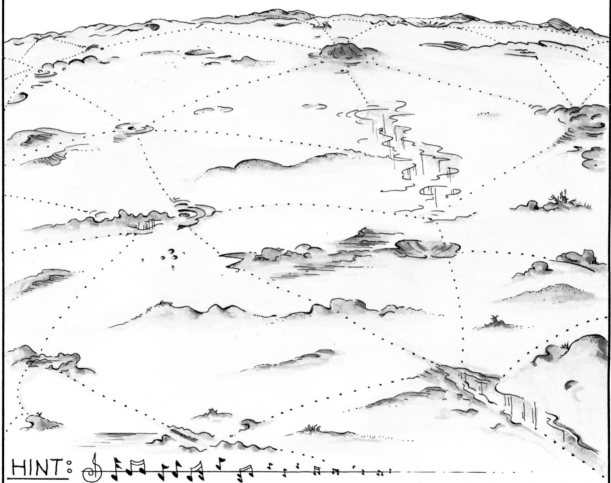

HINT:

ANSWER:

SONGLINES–AN ANCIENT G.P.S. NAVIGATIONAL SYSTEM.

SONGLINES ARE INVISIBLE PATHS THAT CROSS AUSTRALIA LINKING *SACRED SITES.* ABORIGINAL PEOPLE ARE ABLE TO NAVIGATE VAST LANDSCAPES THROUGH *SONGLINES,* WHICH DESCRIBE THE LOCATION OF *SPECIAL LANDMARKS.* BY SINGING SONGS IN THE *APPROPRIATE SEQUENCE* INDIGENOUS PEOPLE COULD FIND THEIR WAY ACROSS THE DESERT.

CREATE YOUR OWN SONGLINES:

USE YOUR CELL PHONE MUSIC APP TO CREATE YOUR VERY OWN SONGLINES WHEN YOU *JOURNEY THROUGH THE LANDSCAPE.*

OFFICE OF PUZZLES & RIDDLES

VISUAL QUIZ

COMPARISON PuzzLe
- TEST YOUR OBSERVATION SKILLS -
WHICH OF THE LANDSCAPES BELOW REVEALS
AN ARMY ATTACK ON THE MAGINOT LINE?

ANSWER: LOOK CLOSELY AT THE LANDSCAPE AT THE TOP OF THE PAGE & OBSERVE HOW THE ENEMY HAS BLOWN UP THE STRUCTURES ON THE RIDGE LEFT OF CENTER.

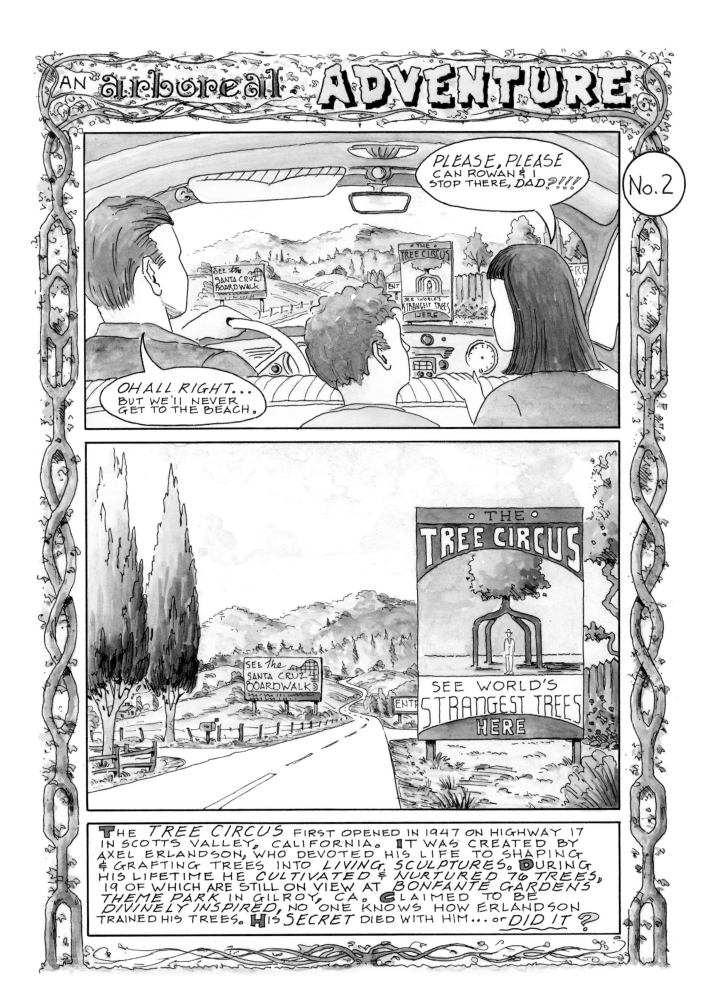

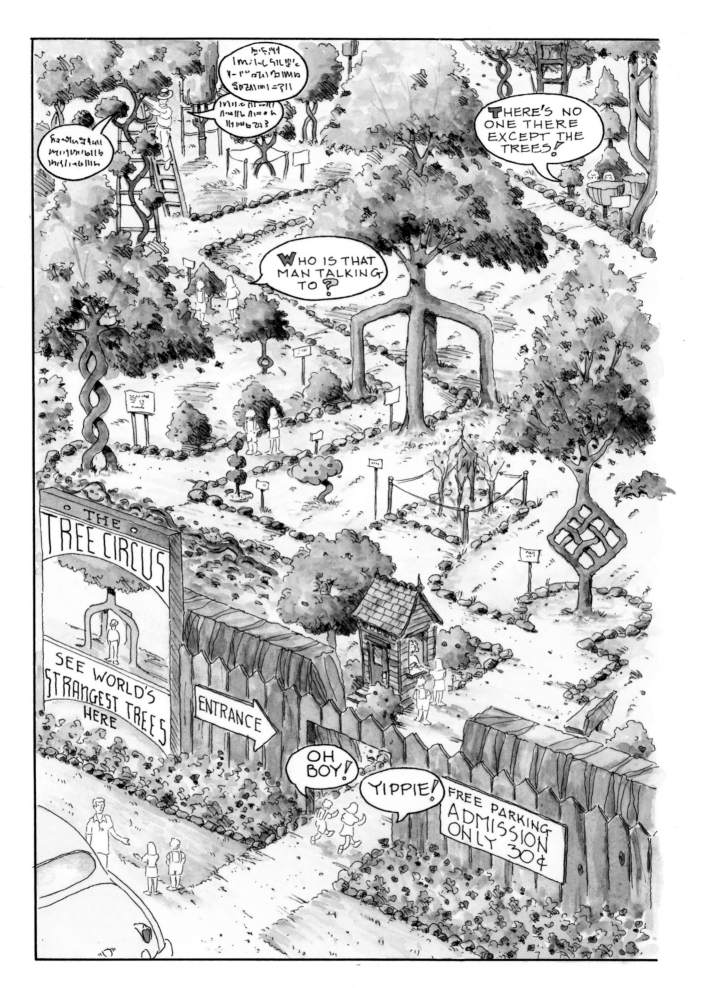

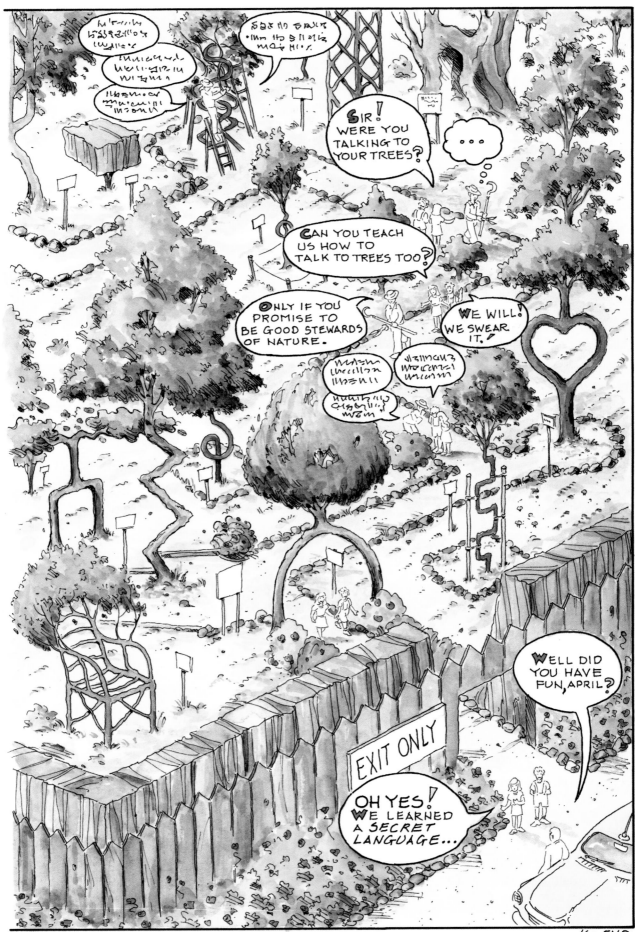

the END

CHIPLEY'S ~ ~ *Believe It or What?*

JACK KIRBY

KING OF COMICS

THE CAREER OF COMICS PIONEER JACK KIRBY EXTENDED OVER 52 YEARS. NO OTHER CARTOON ARTIST EVER PRODUCED AS MANY COMICS AS KIRBY. MOST OF HIS DRAWINGS WERE PRODUCED WITH A #2 DIXON TICONDEROGA PENCIL.

DIXON TICONDEROGA #2

"HE DREW EACH OF HIS 25,000 PUBLISHED PAGES OF ART BY STARTING AT THE UPPER-LEFT-HAND CORNER & CONTINUING UNTIL HE WAS FINISHED IN THE LOWER RIGHT.

HE DIDN'T SKETCH. HE DIDN'T LAY OUT LINES OF PERSPECTIVE. HE DIDN'T ERASE. AND SOMETIMES HE'D FIND HE'D DRAWN 23 PAGES THAT COMPLETELY DEPARTED FROM THE 23 PAGE STORY HE'D THOUGHT HE WAS DOING.

THIS WAS A MAN CONSUMED BY IMAGINATION."

GLEN DAVID GOLD
MASTERS of AMERICAN COMICS

AFTER JACK KIRBY PASSED AWAY, THE SMITHSONIAN INSTITUTION IN WASHINGTON, D.C., REQUESTED HIS DRAWING TABLE & TABORET, BUT THEY HAVE YET TO BE ENSHRINED IN AMERICA'S MUSEUM.

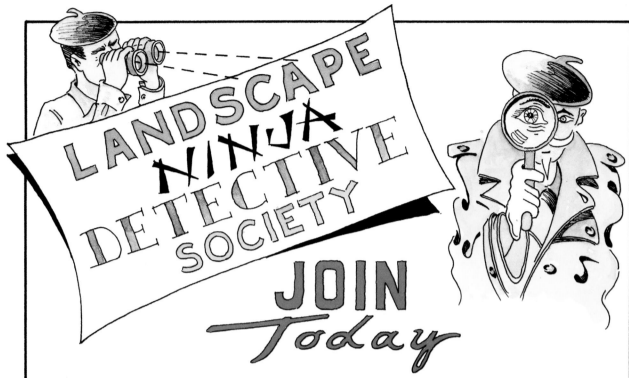

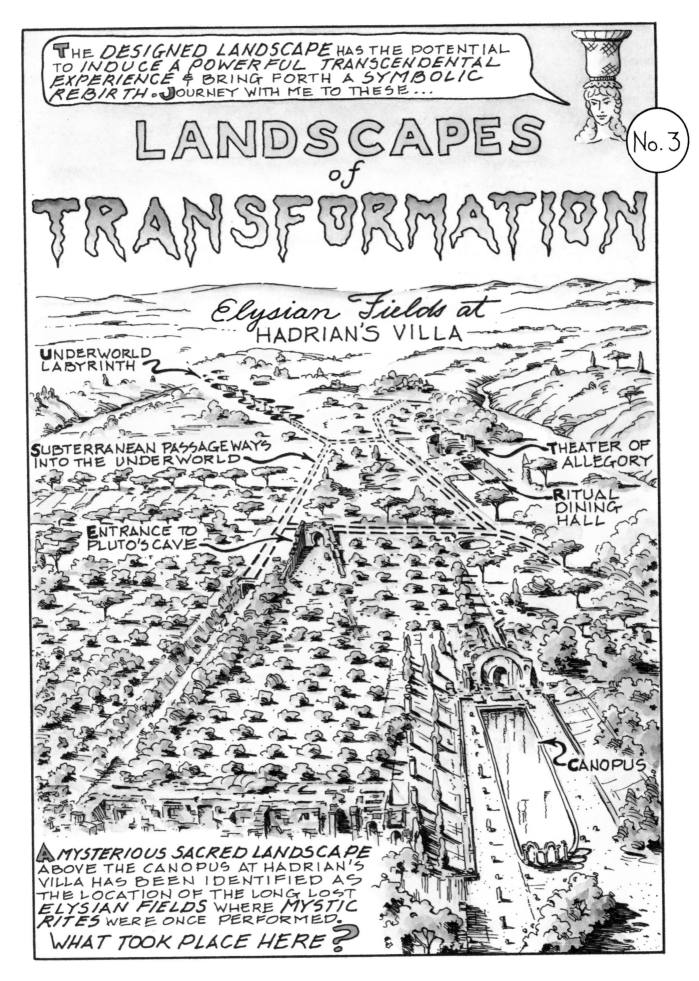

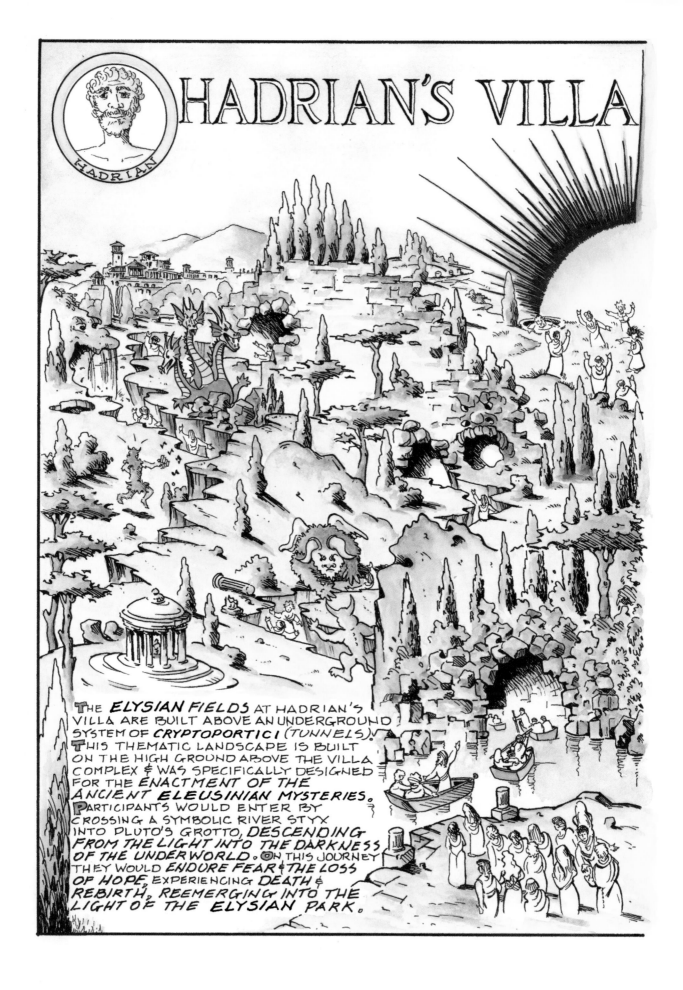

HADRIAN'S VILLA

THE *ELYSIAN FIELDS* AT HADRIAN'S VILLA ARE BUILT ABOVE AN UNDERGROUND SYSTEM OF *CRYPTOPORTICI* (TUNNELS). THIS THEMATIC LANDSCAPE IS BUILT ON THE HIGH GROUND ABOVE THE VILLA COMPLEX & WAS SPECIFICALLY DESIGNED FOR THE *ENACTMENT OF THE ANCIENT ELEUSINIAN MYSTERIES*. PARTICIPANTS WOULD ENTER BY CROSSING A SYMBOLIC RIVER STYX INTO PLUTO'S GROTTO, *DESCENDING FROM THE LIGHT INTO THE DARKNESS OF THE UNDERWORLD*. ON THIS JOURNEY THEY WOULD *ENDURE FEAR & THE LOSS OF HOPE*, EXPERIENCING *DEATH & REBIRTH*, REEMERGING INTO THE LIGHT OF THE *ELYSIAN PARK*.

Disneyland

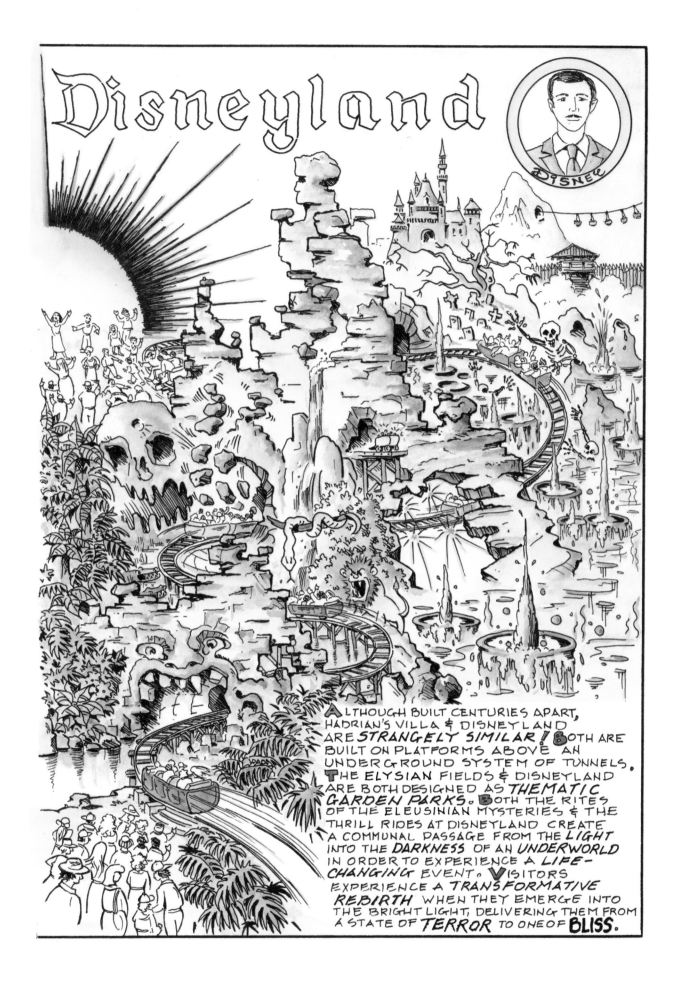

Although built centuries apart, Hadrian's Villa & Disneyland are *STRANGELY SIMILAR!* Both are built on platforms above an underground system of tunnels. The Elysian Fields & Disneyland are both designed as *THEMATIC GARDEN PARKS.* Both the rites of the Eleusinian Mysteries & the thrill rides at Disneyland create a communal passage from the *LIGHT* into the *DARKNESS* of an *UNDERWORLD* in order to experience a *LIFE-CHANGING* event. Visitors experience a *TRANSFORMATIVE REBIRTH* when they emerge into the bright light, delivering them from a state of *TERROR* to one of *BLISS.*

HADRIAN BUILT ANOTHER *UNIQUE LANDSCAPE* CALLED THE "*VALE of TEMPE*" ALONG THE EASTERN BORDER OF THE VILLA. LIKE THE *ELYSIAN FIELDS*, IT WAS ALSO A *THEMED EXPERIENCE* & THUS ALSO SIMILAR TO *DISNEY'S THEME PARKS*. THE "*VALE of TEMPE*" IS THE FIRST KNOWN *NARRATIVE LANDSCAPE*. IT IS A RECONSTRUCTION BASED ON THE CLASSIC GREEK "*VALE of TEMPE*" DEPICTED IN OVID'S MOVING ACCOUNT OF *APOLLO & DAPHNE*.

In Thessaly there is a shaded valley
called Tempe, with steep groves on every hill;
It is where the river Peneus breaks in foam
At Pindus' foot: and down the mountainside
The water courses, tossing its spray in clouds...

The roaring echoes of the ceaseless river
Pour from cliffside and cave...

the METAMORPHOSES, OVID

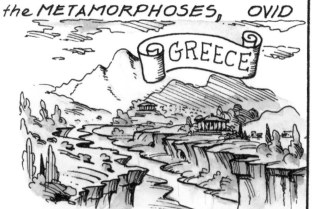

TO MAKE THE VALLEY RESEMBLE THE TEMPE, HADRIAN RECONSTRUCTED THE TUFA CANYON WALLS AS STEEP WOODED SLOPES WITH CAVES & OVERHANGING ROCKS — COMPLETE WITH A SCENIC WALK. THIS WILD DRAMATIC LANDSCAPE FORESHADOWED THE 18th cent. ENGLISH ROMANTIC GARDEN.

FIN

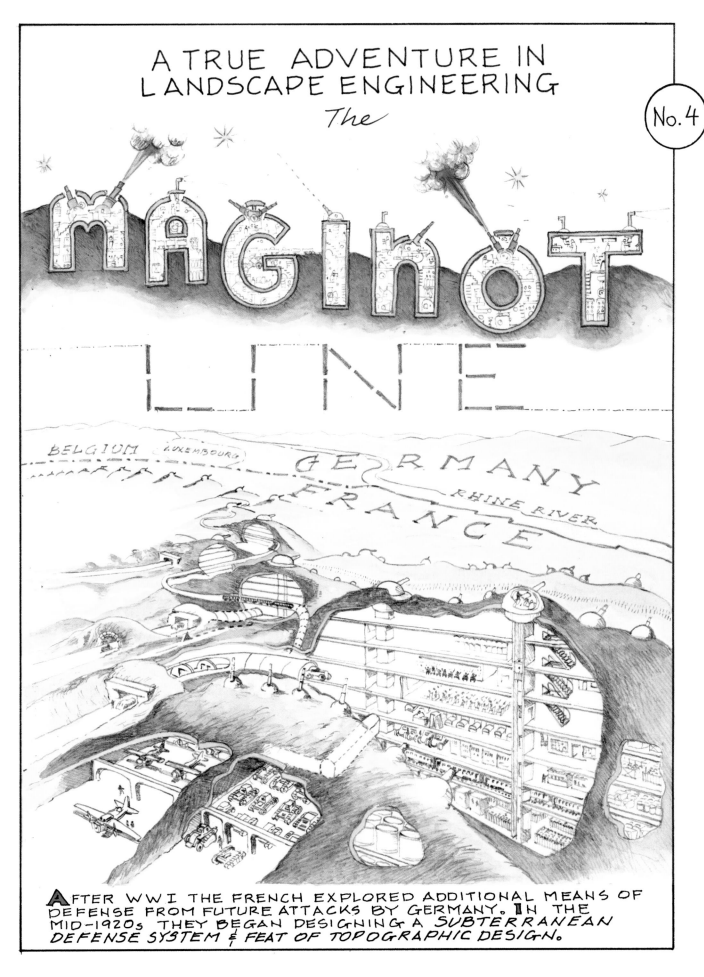

A TRUE ADVENTURE IN LANDSCAPE ENGINEERING

The

MAGINOT LINE

BELGIUM LUXEMBOURG GERMANY FRANCE RHINE RIVER

AFTER WWI THE FRENCH EXPLORED ADDITIONAL MEANS OF DEFENSE FROM FUTURE ATTACKS BY GERMANY. IN THE MID-1920s THEY BEGAN DESIGNING A *SUBTERRANEAN DEFENSE SYSTEM & FEAT OF TOPOGRAPHIC DESIGN.*

THE VAST UNDERGROUND NETWORK OF FORTRESSES THAT STRETCHED ALONG THE GERMAN BORDER WAS COMPRISED OF A SUCCESSION OF SUBTERRANEAN STRUCTURES SITED ACCORDING TO *NATURAL TERRAIN, VEGETATION & LINES OF SITE.* GUN TURRETS WERE HIDDEN BEHIND *EARTHEN BERMS* GRADED TO ABSORB THE IMPACT OF BOMBS.

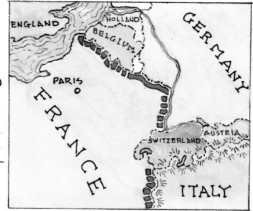

THE MAIN FORTS OR *OUVRAGES* SUPPORTED GARRISONS OF UP TO 1,200 MEN. THESE UNDERGROUND COMPLEXES INCLUDED BARRACKS, KITCHENS, HOSPITALS, COMMAND POSTS, COMMUNICATION CENTERS & ARMORED GUN TURRETS. THE WHOLE SYSTEM WAS CONNECTED BY A NARROW-GAUGE ELECTRIC RAILROAD. EACH SELF-SUSTAINING FORTRESS GENERATED ITS OWN POWER, HAD A SELF-CONTAINED WATER SUPPLY SYSTEM, & ENOUGH SUPPLIES FOR THE TROOPS TO LIVE UNDERGROUND FOR MANY MONTHS!

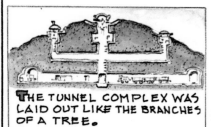

THE TUNNEL COMPLEX WAS LAID OUT LIKE THE BRANCHES OF A TREE.

ELECTRIC POWER GENERATION PLANT.

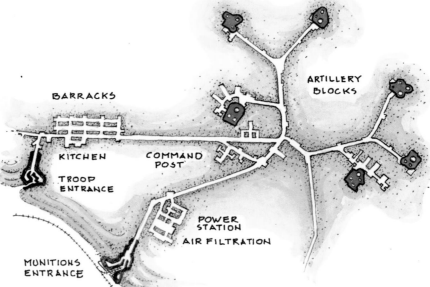

BARRACKS

ARTILLERY BLOCKS

KITCHEN

COMMAND POST

TROOP ENTRANCE

POWER STATION
AIR FILTRATION

MUNITIONS ENTRANCE

INSIDE AIR PRESSURE WAS INCREASED TO *KEEP OUT POISON GAS!* A MECHANICAL VENTILATION & FILTRATION SYSTEM SUPPLIED PURIFIED AIR, & COULD BE OPERATED BY HAND IN AN EMERGENCY.

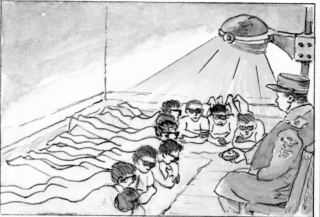

THE MAGINOT LINE EVEN HAD *TANNING ROOMS* WITH ARTIFICIAL SUNLIGHT TO COUNTER THE COMPLEX'S LACK OF NATURAL LIGHT.

OBSERVATION

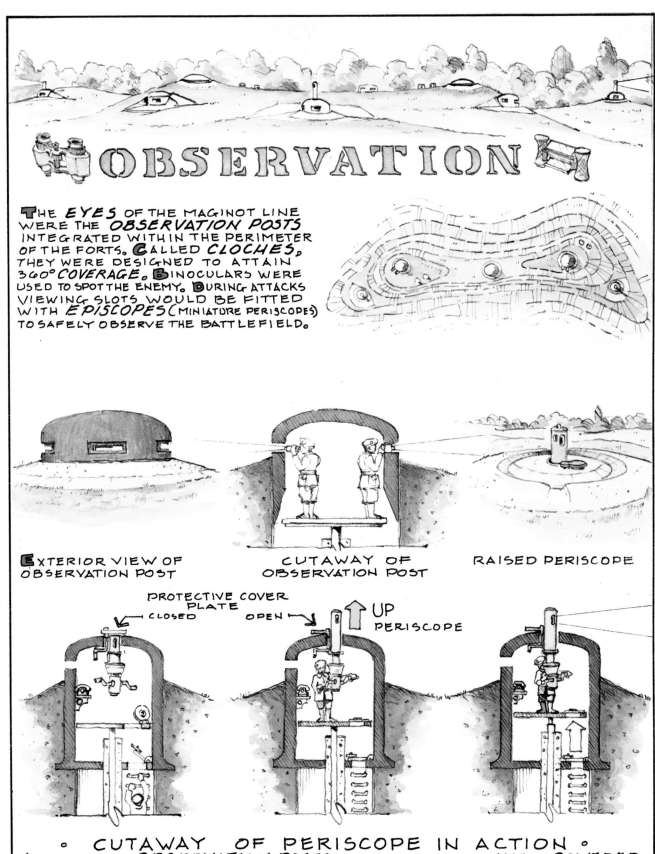

THE *EYES* OF THE MAGINOT LINE WERE THE *OBSERVATION POSTS* INTEGRATED WITHIN THE PERIMETER OF THE FORTS. CALLED *CLOCHES*, THEY WERE DESIGNED TO ATTAIN 360° COVERAGE. BINOCULARS WERE USED TO SPOT THE ENEMY. DURING ATTACKS VIEWING SLOTS WOULD BE FITTED WITH *EPISCOPES* (MINIATURE PERISCOPES) TO SAFELY OBSERVE THE BATTLEFIELD.

EXTERIOR VIEW OF OBSERVATION POST

CUTAWAY OF OBSERVATION POST

RAISED PERISCOPE

PROTECTIVE COVER PLATE

CLOSED OPEN

UP PERISCOPE

° CUTAWAY OF PERISCOPE IN ACTION °

AUXILIARY *OBSERVATION POSTS* WERE FITTED WITH *HIGH POWERED PERISCOPES* WHOSE PORTALS WERE PROTECTED BY MOVABLE IRON PLATES. THE FLOOR OF THE POST COULD BE RAISED OR LOWERED ACCORDING TO THE HEIGHT OF THE OBSERVER. THESE INNOVATIVE UNDERGROUND PERISCOPES PROVIDED PRECISE PANORAMIC VIEWS. THE SYSTEM WAS VERY MUCH LIKE A *TERRESTRIAL SUBMARINE*.

PANORAMIC PHOTO MURALS

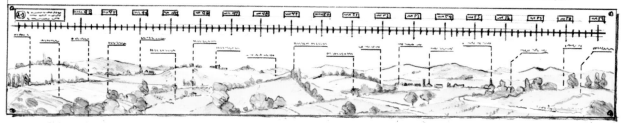

Panoramic landscape photographs were placed directly above the *EMBRASURES FOR QUICK REFERENCE* in case of an *ENEMY ATTACK.* However, it was found that if an observer continually stared for more than 4 hours, the *LANDSCAPE COULD INDUCE HALLUCINATIONS!* Therefore watches were limited to 3 hours.

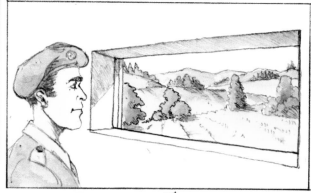 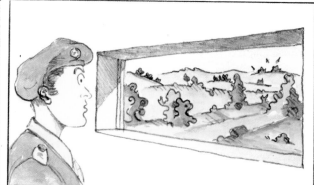

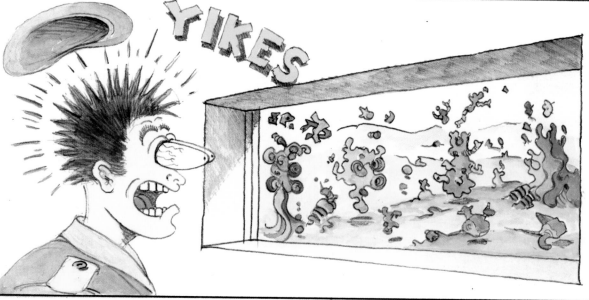

COMMUNICATION

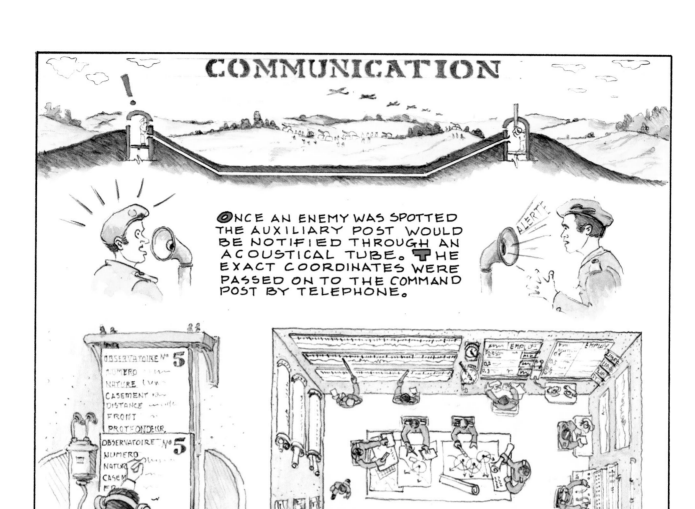

Once an enemy was spotted the auxiliary post would be notified through an acoustical tube. The exact coordinates were passed on to the command post by telephone.

The telephone operator would record the information on a blackboard. Commanders confirmed the bearing & elevation & reviewed topographic maps to determine a strategy & decide which gun blocks to fire.

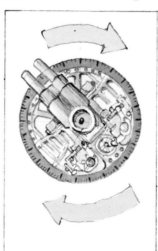

The coordinates were relayed to the gun turrets by a pointing mechanism which revolved around a dial labeled with MAJOR LANDMARKS. The turret operator would align the gun with the pointer, set the elevation & fire.

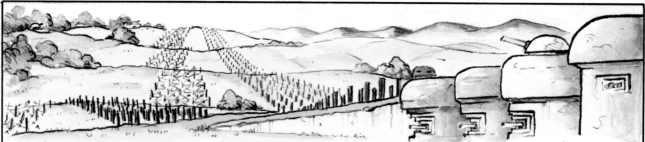

GARDEN PARTERRES OF STEEL & BARBED WIRE

EACH FORTRESS WAS PROTECTED BY WIDE ROWS OF TANK TRAPS & BARBED WIRE STRATEGICALLY SITED TO LEAD THE GERMAN ARMY INTO FRENCH FLANK FORTS & GUN IMPLACEMENTS.

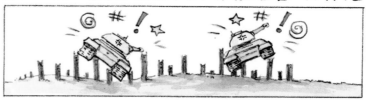

HA-HA WALLS for GERMAN TANKS

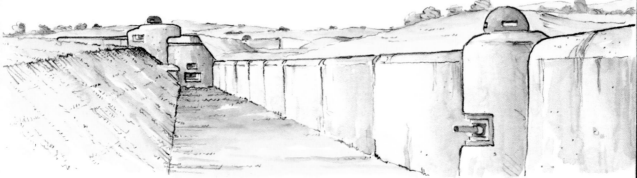

LANDFORM WAS MANIPULATED ON A GRAND SCALE TO INGENIOUSLY TRAP TANKS, WHICH WERE LED DOWN SLOPES, *ENSNARED*, & THEN *BLASTED BY FLANKING GUNS.*

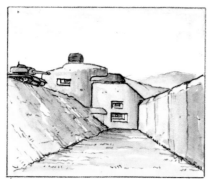 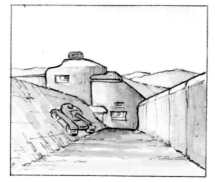 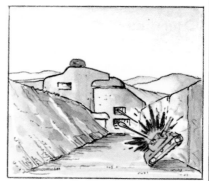

CONTRARY TO ITS REPUTATION, THE MAGINOT LINE WAS NOT A FAILURE. IT WAS *NEVER CONQUERED* BY THE GERMAN ARMY, WHO SKIRTED THE MAGINOT LINE & PUSHED INTO FRANCE FROM THE NORTH.

THE MAGINOT LINE IS CERTAINLY THE *LARGEST GREEN ROOF COMPLEX* IN THE HISTORY OF LANDSCAPE ARCHITECTURE. IN SCOPE IT IS BEYOND WHAT JULES VERNE OR ANY OF THE EARTH ARTISTS OF THE 1970s & '80s *COULD IMAGINE.* STILL EXISTING, THE MAGINOT LINE HAS ALMOST COMPLETELY MERGED INTO THE LANDSCAPE — A PROTOTYPE OF *EARTH ARCHITECTURE* WORTH STUDYING AS WE *CONTEMPLATE OUR GREEN FUTURE.*

THE END

THE *CLASSIC PENCIL* CAN PLAY AN ESSENTIAL ROLE IN THE *ARTIST'S REPERTOIRE.* SO WHY DON'T WE PARTAKE IN A FEW EXERCISES TO *REFINE & ENLIVEN* OUR PENCIL TECHNIQUE...

GRAB A PENCIL
and

LET'S SPREAD

SOME LEAD

" FAR FROM BEING TRIVIAL, THE PENCIL IS ONE OF THE MOST USEFUL TOOLS AT THE ARTIST'S COMMAND — A THING OF AMAZING POTENTIAL."

ARTHUR GUPTILL

- BASIC MATERIALS -

• THE PENCIL

GET YOURSELF AN EMPTY TOMATO SAUCE CAN TO STORE YOUR GROWING SUPPLY OF PENCILS.

• FABER-CASTELL BEGAN MASS PRODUCING PENCILS AS WE KNOW THEM TODAY IN THE 1660s. THEY QUICKLY WERE ADAPTED AS DRAWING INSTRUMENTS. *HERE ARE 4 BASIC PENCILS THAT CAN HANDLE JUST ABOUT ANY OF YOUR DRAWING NEEDS:*

DIXON TICONDEROGA #2

• A CLASSIC, ITS SOFT LEAD MAKES FOR A SATIN SMOOTH LINE & AN ALL-AROUND GENERAL USE PENCIL; A FAVORITE OF *CARTOONISTS.*

GENERAL'S 314 • DRAUGHTING

• THIS PENCIL'S LARGE SOFT BLACK LEAD MAKES IT PERFECT FOR DRAWING, SHADING & FINE DETAILS. ITS CREAMY EFFECTS MAKE IT DELIGHTFUL TO USE.

PALOMINO 602

• FIRST INTRODUCED BY EBERHARD FABER IN THE 1930s & BELOVED BY FAMOUS WRITERS, COMPOSERS & ARTISTS, THIS PENCIL HAS ACHIEVED *CULT STATUS.* MANY CONSIDER IT TO BE THE BEST IN THE WORLD.

GENERAL'S FLAT SKETCHING

• THESE RECTANGULAR CARPENTER'S PENCILS HAVE A SOFT, WIDE LEAD. THE FLAT SHAPE ALLOWS FOR A WIDE VARIETY OF LINE WEIGHTS. THE *CHISEL POINT* YIELDS VERY QUICK, EXPRESSIVE LINES.

• SHARPENING

KEEP IT SHARP!

• USING A SINGLE EDGE RAZOR BLADE OR AN X-ACTO KNIFE ① TAPER THE WOOD BACK 3/4 OF AN INCH ② TO EXPOSE 1/4 INCH OF THE LEAD ③. SLOWLY TRIM THE EXPOSED LEAD TO THE *SHAPE YOU DESIRE* ④.

• ERASERS

MAKE NO MISTAKES!

• PINK PEARL = EXCEPTIONAL ERASING QUALITIES. IT IS SOFT & PLIABLE WITH BEVELED ENDS FOR ACCURACY.

• GUM ERASER = A SOFT ALL-PURPOSE ERASER WHICH REMOVES GRAPHITE EASILY & DOES NOT DAMAGE THE PAPER.

• KNEADED RUBBER ERASER = GOOD FOR CLEANING LARGE AREAS, IT IS SMUDGE PROOF & EXCELLENT FOR BLENDING TONES & CREATING HIGHLIGHTS.

• PAPER

STRATHMORE SERIES 400 DRAWING PAPER WITH A MEDIUM SURFACE IS GOOD FOR *QUICK SKETCHES.* IT HAS A MEDIUM TOOTH & ERASES WELL.

• 2-PLY STRATHMORE BRISTOL BOARD IS EXCELLENT FOR DRAWING. THE VELLUM FINISH ALLOWS THE PENCIL TO *GLIDE ACROSS THE PAGE.* ITS SURFACE IS SUPERB FOR BLENDING & BUILDING UP TONE.

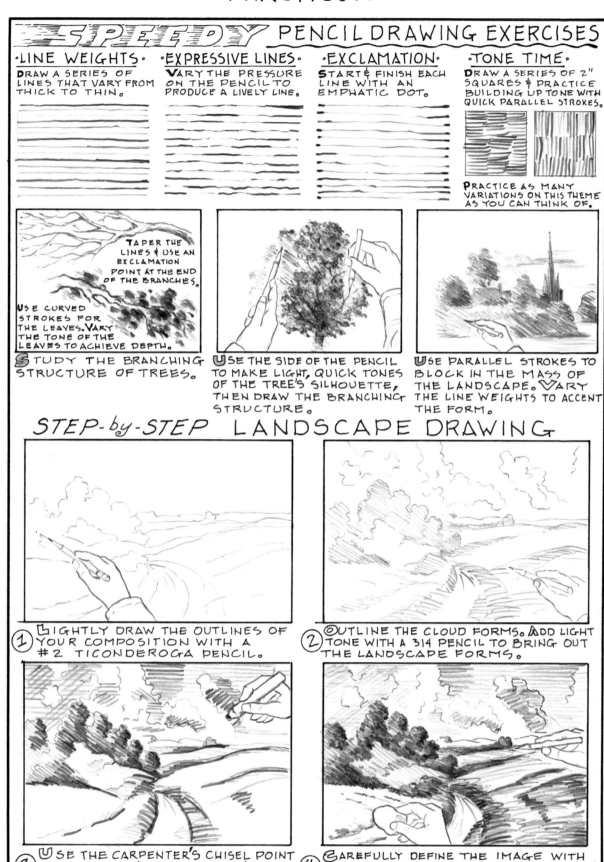

SPEEDY PENCIL DRAWING EXERCISES

·LINE WEIGHTS·
DRAW A SERIES OF LINES THAT VARY FROM THICK TO THIN.

·EXPRESSIVE LINES·
VARY THE PRESSURE ON THE PENCIL TO PRODUCE A LIVELY LINE.

·EXCLAMATION·
START & FINISH EACH LINE WITH AN EMPHATIC DOT.

·TONE TIME·
DRAW A SERIES OF 2" SQUARES & PRACTICE BUILDING UP TONE WITH QUICK PARALLEL STROKES.

PRACTICE AS MANY VARIATIONS ON THIS THEME AS YOU CAN THINK OF.

TAPER THE LINES & USE AN EXCLAMATION POINT AT THE END OF THE BRANCHES.

USE CURVED STROKES FOR THE LEAVES. VARY THE TONE OF THE LEAVES TO ACHIEVE DEPTH.

STUDY THE BRANCHING STRUCTURE OF TREES.

USE THE SIDE OF THE PENCIL TO MAKE LIGHT, QUICK TONES OF THE TREE'S SILHOUETTE, THEN DRAW THE BRANCHING STRUCTURE.

USE PARALLEL STROKES TO BLOCK IN THE MASS OF THE LANDSCAPE. VARY THE LINE WEIGHTS TO ACCENT THE FORM.

STEP-by-STEP LANDSCAPE DRAWING

① LIGHTLY DRAW THE OUTLINES OF YOUR COMPOSITION WITH A #2 TICONDEROGA PENCIL.

② OUTLINE THE CLOUD FORMS. ADD LIGHT TONE WITH A 314 PENCIL TO BRING OUT THE LANDSCAPE FORMS.

③ USE THE CARPENTER'S CHISEL POINT TO ADD EXPRESSIVE LINES & TO ACCENT SHAPES.

④ CAREFULLY DEFINE THE IMAGE WITH THE PALOMINO 602 TO DEFINE LIGHT & DARK AREAS. USE THE KNEADED ERASER TO ADD HIGHLIGHTS.

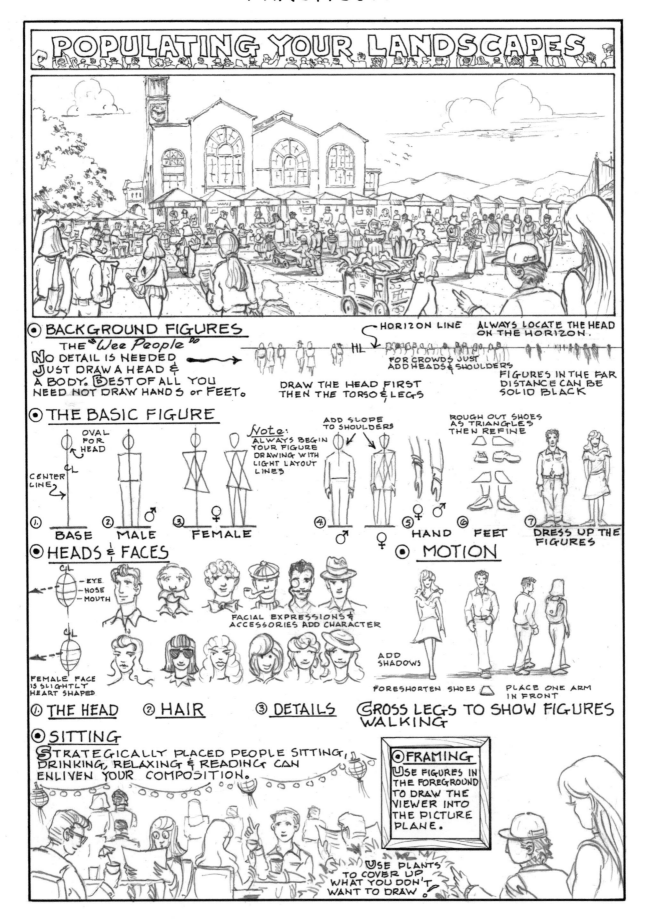

POPULATING YOUR LANDSCAPES

• BACKGROUND FIGURES

THE "Wee People"

NO DETAIL IS NEEDED
JUST DRAW A HEAD &
A BODY. **B**EST OF ALL YOU
NEED NOT DRAW HANDS or FEET.

HORIZON LINE — ALWAYS LOCATE THE HEAD ON THE HORIZON.

HL

DRAW THE HEAD FIRST THEN THE TORSO & LEGS

FOR CROWDS JUST ADD HEADS & SHOULDERS

FIGURES IN THE FAR DISTANCE CAN BE SOLID BLACK

• THE BASIC FIGURE

OVAL FOR HEAD

CL

CENTER LINE

① BASE ② MALE ♂ ③ FEMALE ♀

Note: ALWAYS BEGIN YOUR FIGURE DRAWING WITH LIGHT LAYOUT LINES

ADD SLOPE TO SHOULDERS

④ ♂ ⑤ ♀

ROUGH OUT SHOES AS TRIANGLES THEN REFINE

HAND ⑥ FEET

⑦ DRESS UP THE FIGURES

• HEADS & FACES

CL — EYE — NOSE — MOUTH

FACIAL EXPRESSIONS & ACCESSORIES ADD CHARACTER

CL

FEMALE FACE IS SLIGHTLY HEART SHAPED

① THE HEAD ② HAIR ③ DETAILS

• MOTION

ADD SHADOWS

FORESHORTEN SHOES PLACE ONE ARM IN FRONT

CROSS LEGS TO SHOW FIGURES WALKING

• SITTING

STRATEGICALLY PLACED PEOPLE SITTING, DRINKING, RELAXING & READING CAN ENLIVEN YOUR COMPOSITION.

• FRAMING

USE FIGURES IN THE FOREGROUND TO DRAW THE VIEWER INTO THE PICTURE PLANE.

USE PLANTS TO COVER UP WHAT YOU DON'T WANT TO DRAW.!

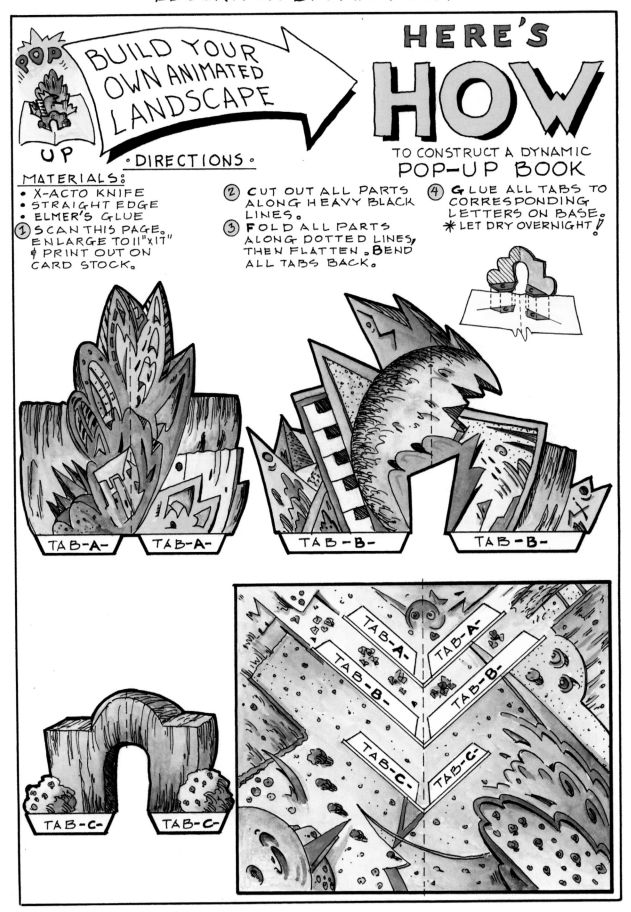

POP UP

BUILD YOUR OWN ANIMATED LANDSCAPE

HERE'S HOW

TO CONSTRUCT A DYNAMIC POP-UP BOOK

· DIRECTIONS ·

MATERIALS:
- X-ACTO KNIFE
- STRAIGHT EDGE
- ELMER'S GLUE
1. SCAN THIS PAGE. ENLARGE TO 11"x17" & PRINT OUT ON CARD STOCK.

2. CUT OUT ALL PARTS ALONG HEAVY BLACK LINES.
3. FOLD ALL PARTS ALONG DOTTED LINES, THEN FLATTEN. BEND ALL TABS BACK.

4. GLUE ALL TABS TO CORRESPONDING LETTERS ON BASE.
* LET DRY OVERNIGHT!

TAB-A- TAB-A-

TAB-B- TAB-B-

TAB-C- TAB-C-

TAB-A- TAB-A-
TAB-B-
TAB-B-
TAB-C-
TAB-C-

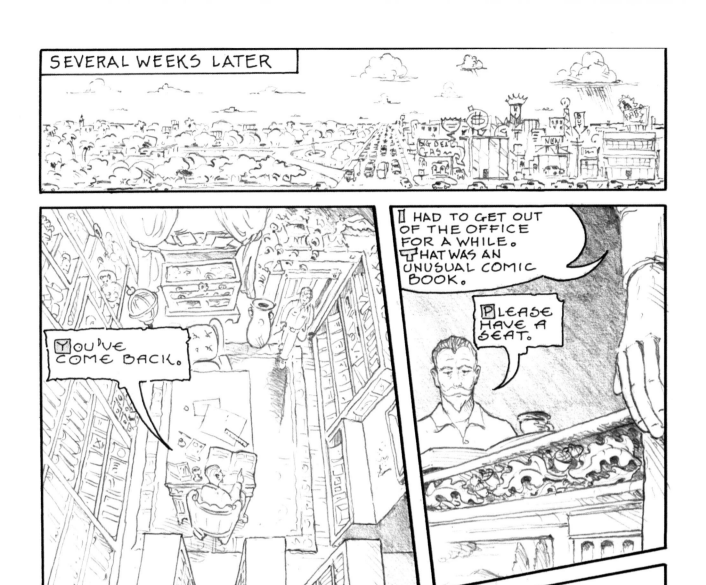

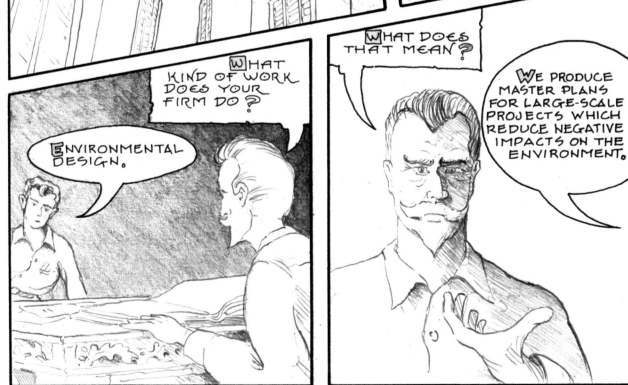

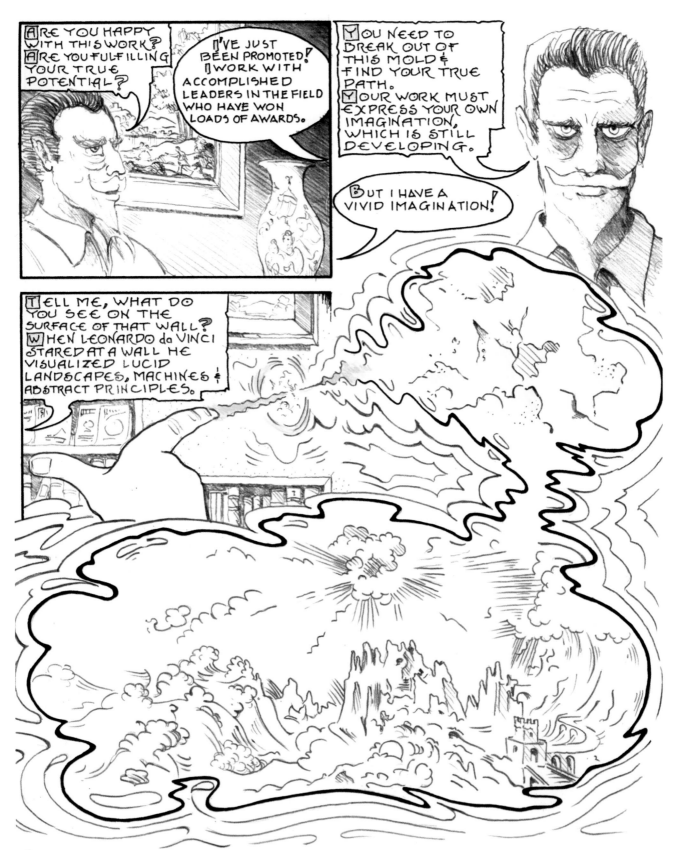

"WHEN YOU LOOK AT A WALL SPOTTED WITH STAINS, OR WITH A MIXTURE OF STONES, IF YOU HAVE TO DEVISE SOME SCENE, YOU MAY DISCOVER A RESEMBLANCE TO VARIOUS LANDSCAPES, BEAUTIFIED WITH MOUNTAINS, RIVERS, ROCKS, TREES, PLAINS, WIDE VALLEYS & HILLS IN VARIED ARRANGEMENTS..., WHICH YOU COULD REDUCE TO COMPLETE & DRAWN FORMS."

LEONARDO da VINCI

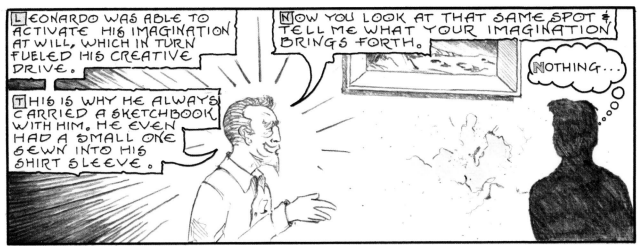

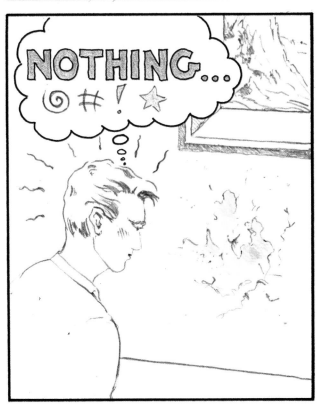

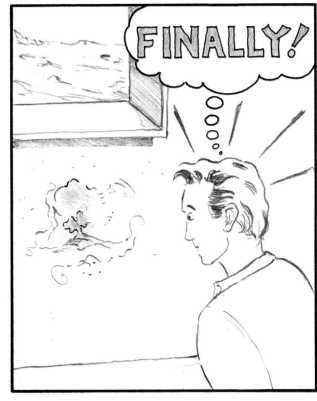

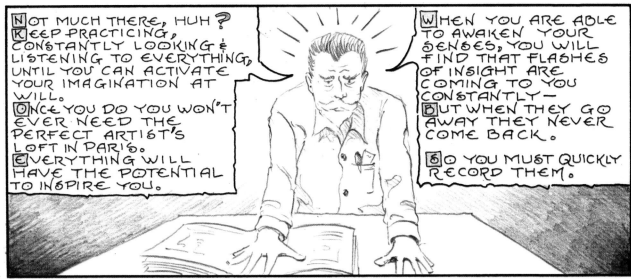

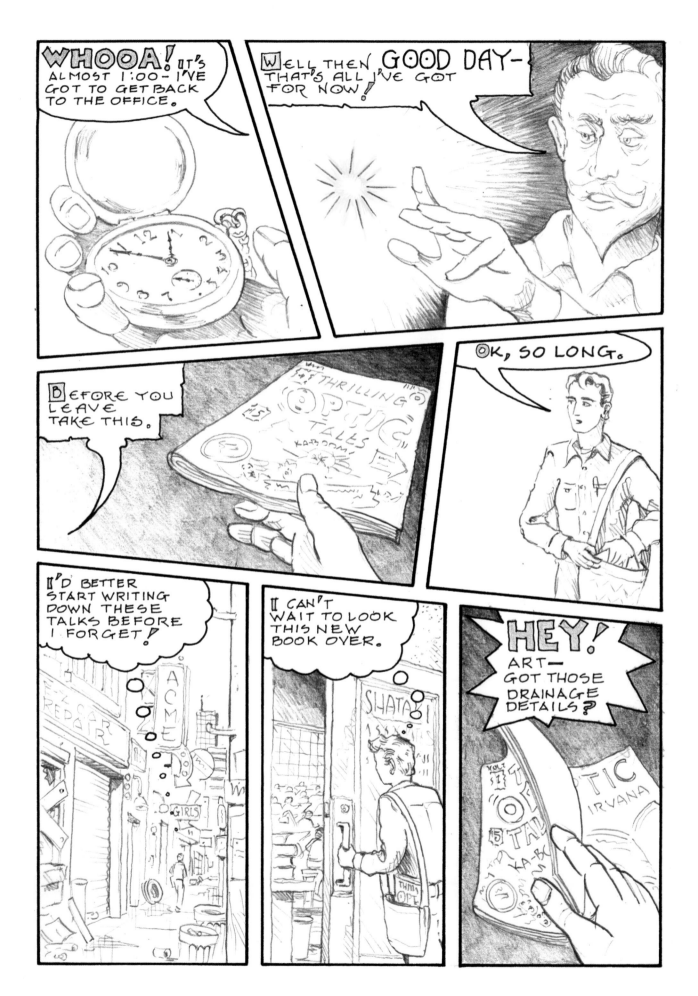

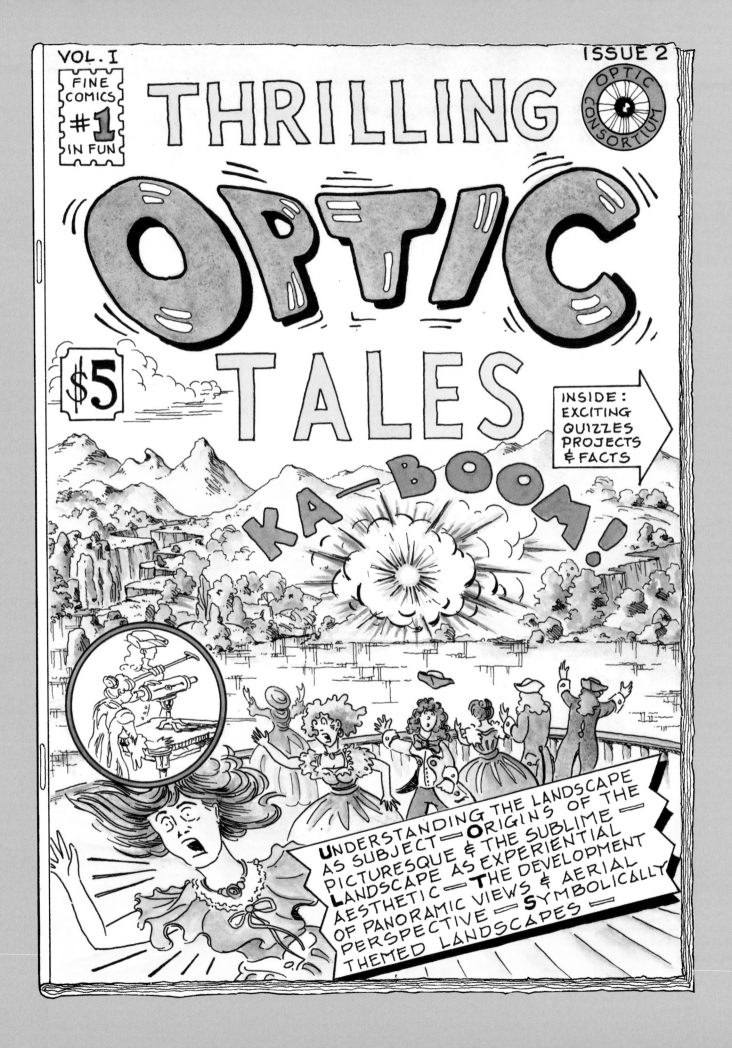

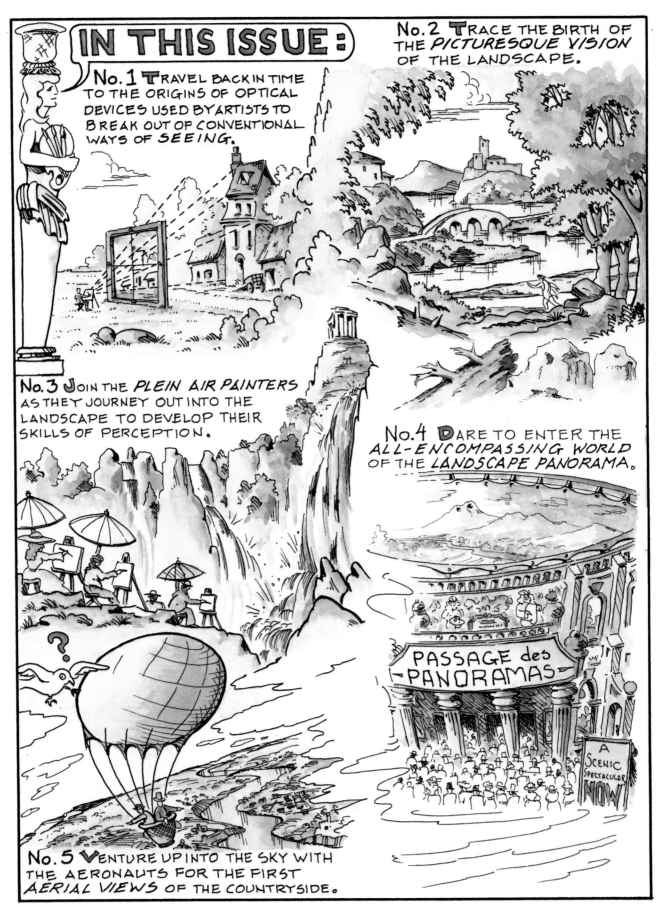

IN THIS ISSUE:

No. 1 TRAVEL BACK IN TIME TO THE ORIGINS OF OPTICAL DEVICES USED BY ARTISTS TO BREAK OUT OF CONVENTIONAL WAYS OF *SEEING*.

No. 2 TRACE THE BIRTH OF THE *PICTURESQUE VISION* OF THE LANDSCAPE.

No. 3 JOIN THE *PLEIN AIR PAINTERS* AS THEY JOURNEY OUT INTO THE LANDSCAPE TO DEVELOP THEIR SKILLS OF PERCEPTION.

No. 4 DARE TO ENTER THE ALL-ENCOMPASSING WORLD OF THE *LANDSCAPE PANORAMA*.

PASSAGE des PANORAMAS

A SCENIC SPECTACULAR NOW

No. 5 VENTURE UP INTO THE SKY WITH THE AERONAUTS FOR THE FIRST *AERIAL VIEWS* OF THE COUNTRYSIDE.

THRILLING OPTIC TALES, VOLUME I, ISSUE NUMBER 2. PUBLISHED BY THE UNIVERSITY OF VIRGINIA PRESS, CHARLOTTESVILLE, VIRGINIA, 22904/USA.

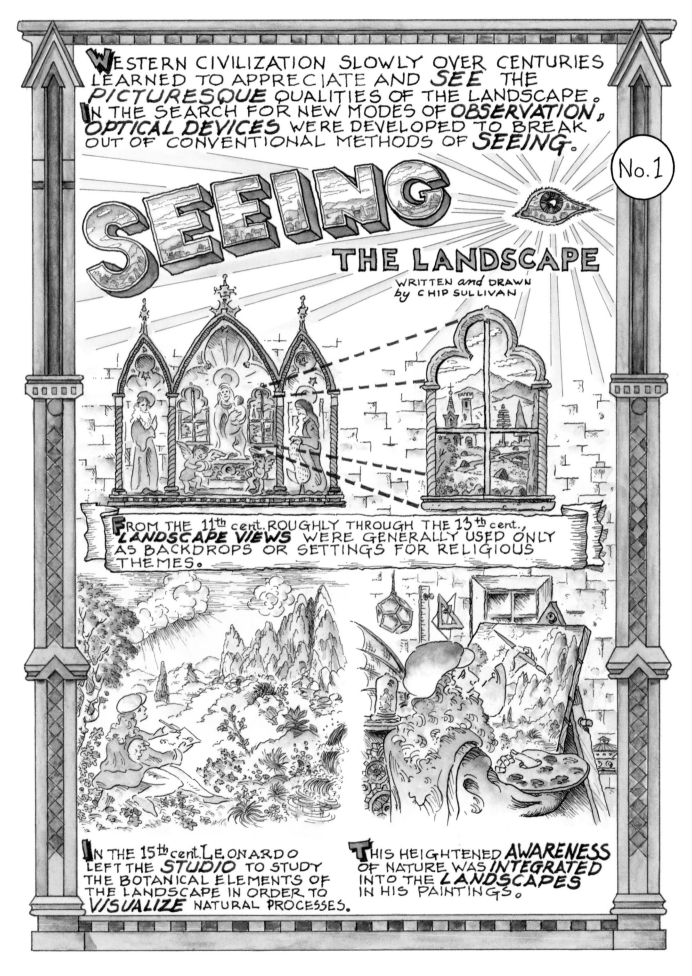

WESTERN CIVILIZATION SLOWLY OVER CENTURIES LEARNED TO APPRECIATE AND *SEE* THE *PICTURESQUE* QUALITIES OF THE LANDSCAPE. IN THE SEARCH FOR NEW MODES OF *OBSERVATION,* *OPTICAL DEVICES* WERE DEVELOPED TO BREAK OUT OF CONVENTIONAL METHODS OF *SEEING.*

SEEING

THE LANDSCAPE

WRITTEN *and* DRAWN *by* CHIP SULLIVAN

FROM THE 11th cent. ROUGHLY THROUGH THE 13th cent., *LANDSCAPE VIEWS* WERE GENERALLY USED ONLY AS BACKDROPS OR SETTINGS FOR RELIGIOUS THEMES.

IN THE 15th cent. LEONARDO LEFT THE *STUDIO* TO STUDY THE BOTANICAL ELEMENTS OF THE LANDSCAPE IN ORDER TO *VISUALIZE* NATURAL PROCESSES.

THIS HEIGHTENED *AWARENESS* OF NATURE WAS *INTEGRATED* INTO THE *LANDSCAPES* IN HIS PAINTINGS.

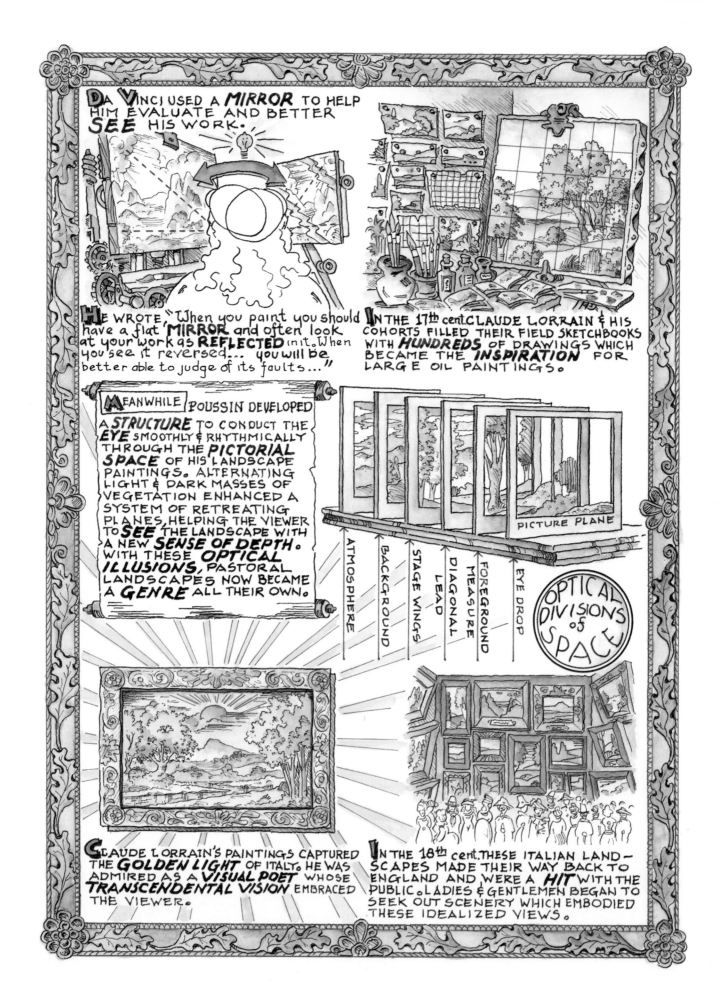

DA VINCI USED A **MIRROR** TO HELP HIM EVALUATE AND BETTER **SEE** HIS WORK.

HE WROTE, "When you paint you should have a flat **MIRROR** and often look at your work as **REFLECTED** in it. When you see it reversed... you will be better able to judge of its faults..."

IN THE 17th cent. CLAUDE LORRAIN & HIS COHORTS FILLED THEIR FIELD SKETCHBOOKS WITH **HUNDREDS** OF DRAWINGS WHICH BECAME THE **INSPIRATION** FOR LARGE OIL PAINTINGS.

MEANWHILE POUSSIN DEVELOPED A **STRUCTURE** TO CONDUCT THE **EYE** SMOOTHLY & RHYTHMICALLY THROUGH THE **PICTORIAL SPACE** OF HIS LANDSCAPE PAINTINGS. ALTERNATING LIGHT & DARK MASSES OF VEGETATION ENHANCED A SYSTEM OF RETREATING PLANES, HELPING THE VIEWER TO **SEE** THE LANDSCAPE WITH A NEW **SENSE OF DEPTH**. WITH THESE **OPTICAL ILLUSIONS**, PASTORAL LANDSCAPES NOW BECAME A **GENRE** ALL THEIR OWN.

PICTURE PLANE

ATMOSPHERE
BACKGROUND
STAGE WINGS
LEAD DIAGONAL
FOREGROUND MEASURE
EYE DROP

OPTICAL DIVISIONS OF SPACE

CLAUDE LORRAIN'S PAINTINGS CAPTURED THE **GOLDEN LIGHT** OF ITALY. HE WAS ADMIRED AS A **VISUAL POET** WHOSE **TRANSCENDENTAL VISION** EMBRACED THE VIEWER.

IN THE 18th cent. THESE ITALIAN LANDSCAPES MADE THEIR WAY BACK TO ENGLAND AND WERE A **HIT** WITH THE PUBLIC. LADIES & GENTLEMEN BEGAN TO SEEK OUT SCENERY WHICH EMBODIED THESE IDEALIZED VIEWS.

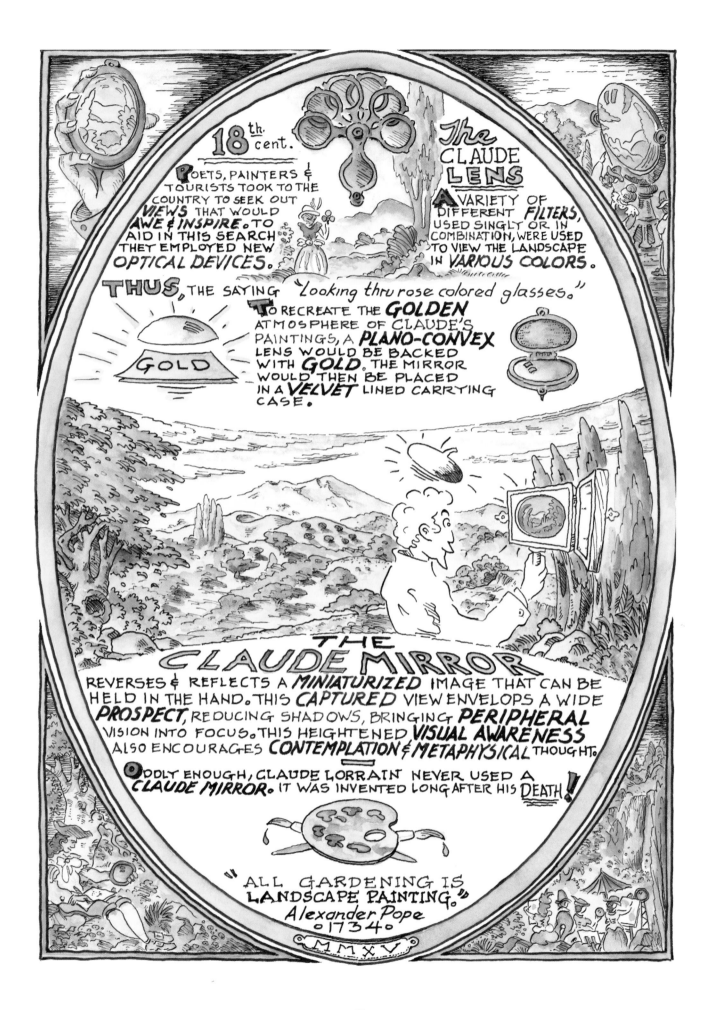

18th cent.

POETS, PAINTERS & TOURISTS TOOK TO THE COUNTRY TO SEEK OUT VIEWS THAT WOULD AWE & INSPIRE. TO AID IN THIS SEARCH THEY EMPLOYED NEW OPTICAL DEVICES.

The CLAUDE LENS

A VARIETY OF DIFFERENT FILTERS, USED SINGLY OR IN COMBINATION, WERE USED TO VIEW THE LANDSCAPE IN VARIOUS COLORS.

THUS, THE SAYING "Looking thru rose colored glasses."

TO RECREATE THE GOLDEN ATMOSPHERE OF CLAUDE'S PAINTINGS, A PLANO-CONVEX LENS WOULD BE BACKED WITH GOLD. THE MIRROR WOULD THEN BE PLACED IN A VELVET LINED CARRYING CASE.

GOLD

THE CLAUDE MIRROR

REVERSES & REFLECTS A MINIATURIZED IMAGE THAT CAN BE HELD IN THE HAND. THIS CAPTURED VIEW ENVELOPS A WIDE PROSPECT, REDUCING SHADOWS, BRINGING PERIPHERAL VISION INTO FOCUS. THIS HEIGHTENED VISUAL AWARENESS ALSO ENCOURAGES CONTEMPLATION & METAPHYSICAL THOUGHT.

ODDLY ENOUGH, CLAUDE LORRAIN NEVER USED A CLAUDE MIRROR. IT WAS INVENTED LONG AFTER HIS DEATH!

"ALL GARDENING IS LANDSCAPE PAINTING."
Alexander Pope
∘1734∘

MMXV

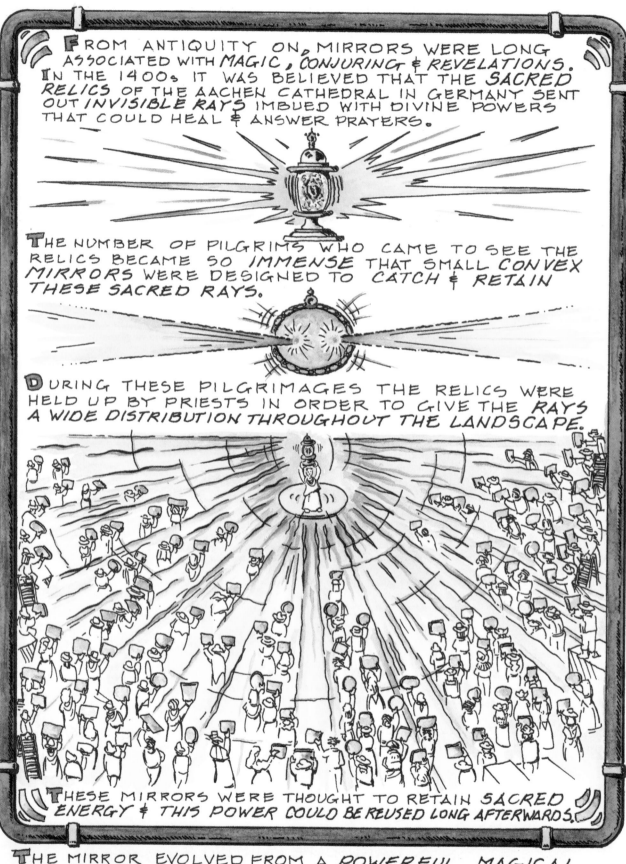

FROM ANTIQUITY ON, MIRRORS WERE LONG ASSOCIATED WITH *MAGIC, CONJURING & REVELATIONS.* IN THE 1400s IT WAS BELIEVED THAT THE *SACRED RELICS* OF THE AACHEN CATHEDRAL IN GERMANY SENT OUT *INVISIBLE RAYS* IMBUED WITH DIVINE POWERS THAT COULD HEAL & ANSWER PRAYERS.

THE NUMBER OF PILGRIMS WHO CAME TO SEE THE RELICS BECAME SO *IMMENSE* THAT SMALL *CONVEX MIRRORS* WERE DESIGNED TO *CATCH & RETAIN* THESE SACRED RAYS.

DURING THESE PILGRIMAGES THE RELICS WERE HELD UP BY PRIESTS IN ORDER TO GIVE THE *RAYS A WIDE DISTRIBUTION THROUGHOUT THE LANDSCAPE.*

THESE MIRRORS WERE THOUGHT TO RETAIN *SACRED ENERGY & THIS POWER COULD BE REUSED LONG AFTERWARDS.*

THE MIRROR EVOLVED FROM A *POWERFUL MAGICAL INSTRUMENT* INTO A TOOL FOR ARTISTS TO *SEE & COMPREHEND THE LANDSCAPE.* BY THE 1700s, GARDENS BEGAN TO BE LAID OUT BY LANDSCAPE PAINTERS TRAINED WITH THESE *MAGIC OPTICAL DEVICES.*

THE END

SCENIC RIDDLE

WHAT IS THE HIDDEN MESSAGE BEHIND NICOLAS POUSSIN'S "*THE ARCADIAN SHEPHERDS*," ONE OF THE MAJOR ICONS OF LANDSCAPE PAINTING? ITS MEANING HAS BEEN DEBATED CONTINUALLY SINCE ITS COMPLETION AROUND 1638.

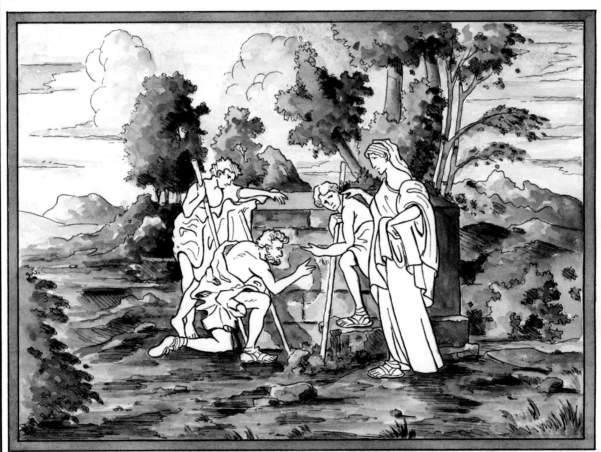

<u>HINT</u>: "Et in Arcadia Ego"

ANSWER: **H**ERE POUSSIN HAS RECREATED THE *MYTHICAL REALM of ARCADIA*— A TERRESTRIAL PARADISE WHERE INHABITANTS LIVED IN *BLISSFUL HARMONY WITH NATURE.* ⚰ THE 3 SHEPHERDS HAVE JUST DISCOVERED A LARGE TOMB WITH THE LATIN INSCRIPTION *Et in Arcadia Ego.* ⚰ THE LITERAL TRANSLATION READS "*Even in Arcadia am I,*" WHICH CAN ALSO BE INTERPRETED AS "*I, DEATH, EXIST IN ARCADIA AS WELL."* ⚰ THE FEMALE COMPANION (DESTINY) CALMLY COMFORTS ONE OF THE SHEPHERDS.

VISUAL QUIZ

Can You Find The 5 Faces of The Famous 18th cent. Landscape Artists?

EXCELLENT PRACTICE FOR REFINING YOUR OBSERVATION SKILLS

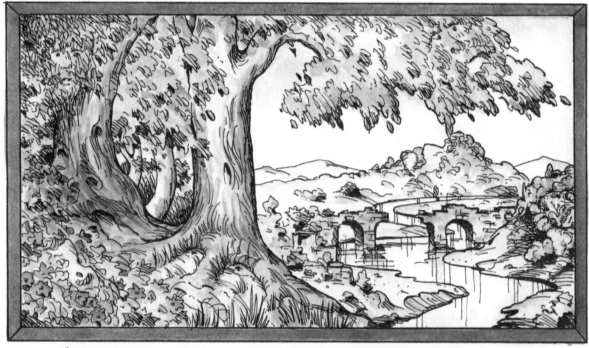

IT'S FUN TO LOOK FOR THE *HIDDEN PLEIN AIR PAINTERS* IN THE LANDSCAPE DRAWING ABOVE. ARE YOUR *EYES SHARP* ENOUGH TO FIND THEM? SOME OF THESE PAINTERS ARE LOOKING *STRAIGHT* AT YOU. SOME ARE UPSIDE DOWN—OTHERS ARE SIDE— WAYS—IT'S NOT AS EASY AS YOU MAY THINK—BUT DON'T *GIVE UP!*—KEEP LOOKING & YOU MAY FIND THEM ALL. WHEN YOU DO, CIRCLE THEM QUICKLY!

☆ *ANSWERS WILL BE IN THE NEXT ISSUE* ☆

HISTORY HAS SHOWN THAT THE *STUDY* OF LANDSCAPE CAN BE A FERTILE SOURCE OF *INSPIRATION.* THE ESTABLISHMENT & POPULARIZATION OF A PICTURESQUE STYLE IN THE LATE 1700'S BECAME A STANDARD BY WHICH NATURE WOULD BE JUDGED. WE ARE STILL RESPONDING TO THE *IDEALS* OF THE *PICTURESQUE* IN TV, CINEMA & THE WRITTEN WORD. ONCE THE *EYE* HAS BEEN TRAINED TO RECOGNIZE A PICTURESQUE COMPOSITION, MANY *VISUAL DELIGHTS* BECOME ACCESSIBLE & CAN LEAD THE *VIEWER* TO FIND...

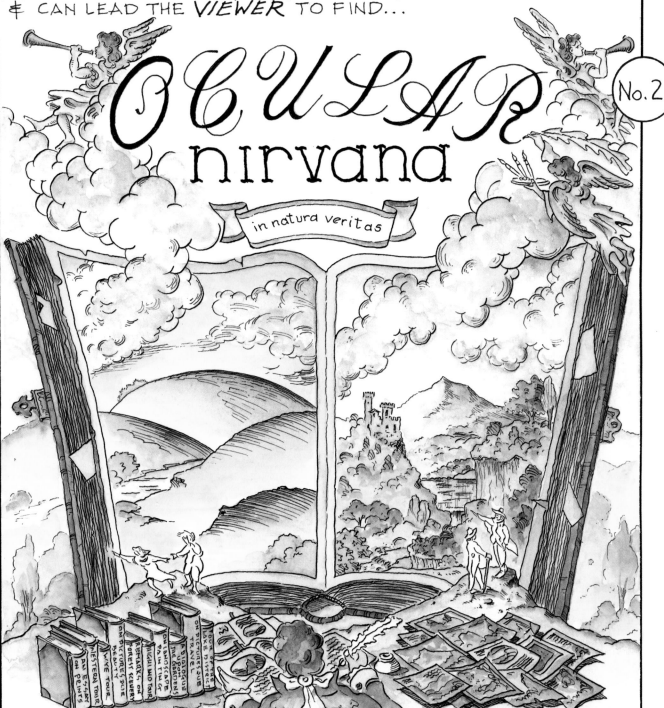

OCULAR
nirvana
in natura veritas

No. 2

WILLIAM **G**ILPIN (1724–1804) MORE THAN ANYONE ELSE HELPED TO ESTABLISH THE *PICTURESQUE VISION.* GILPIN'S REVOLUTIONARY THEORY EVOLVED FROM *DIRECT OBSERVATION* OF NATURE. HE PRODUCED OVER 6,000 *DRAWINGS* FROM HIS WALKING TOURS & EXCURSIONS INTO THE BRITISH LANDSCAPE. GILPIN PUBLISHED HIS DESCRIPTIONS OF THE LANDSCAPE IN *GUIDEBOOKS* THAT BECAME THE BASIS FOR THE "*PICTURESQUE TOUR.*"

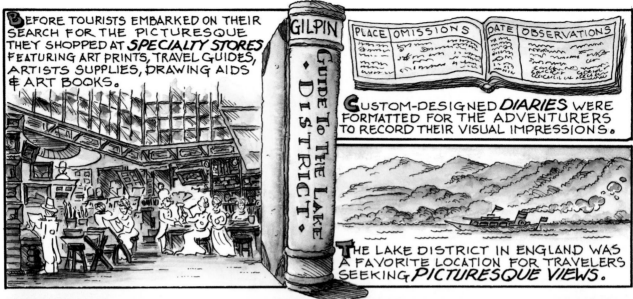

BEFORE TOURISTS EMBARKED ON THEIR SEARCH FOR THE PICTURESQUE THEY SHOPPED AT *SPECIALTY STORES* FEATURING ART PRINTS, TRAVEL GUIDES, ARTISTS SUPPLIES, DRAWING AIDS & ART BOOKS.

CUSTOM-DESIGNED *DIARIES* WERE FORMATTED FOR THE ADVENTURERS TO RECORD THEIR VISUAL IMPRESSIONS.

THE LAKE DISTRICT IN ENGLAND WAS A FAVORITE LOCATION FOR TRAVELERS SEEKING *PICTURESQUE VIEWS.*

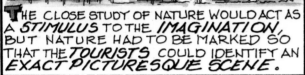

THE CLOSE STUDY OF NATURE WOULD ACT AS A *STIMULUS* TO THE *IMAGINATION,* BUT NATURE HAD TO BE MARKED SO THAT THE *TOURISTS* COULD IDENTIFY AN *EXACT PICTURESQUE SCENE.*

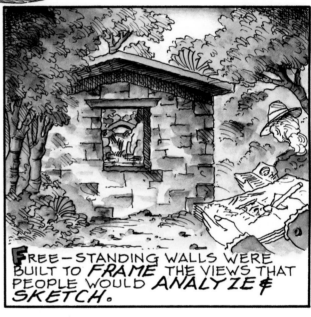

FREE-STANDING WALLS WERE BUILT TO *FRAME* THE VIEWS THAT PEOPLE WOULD *ANALYZE & SKETCH.*

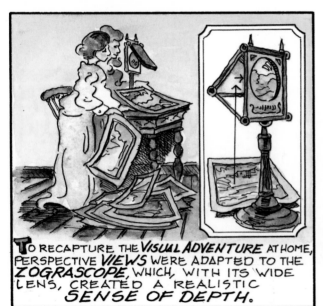

TO RECAPTURE THE *VISUAL ADVENTURE* AT HOME, PERSPECTIVE *VIEWS* WERE ADAPTED TO THE *ZOGRASCOPE,* WHICH, WITH ITS WIDE LENS, CREATED A REALISTIC *SENSE OF DEPTH.*

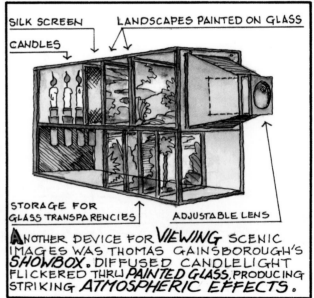

SILK SCREEN

LANDSCAPES PAINTED ON GLASS

CANDLES

STORAGE FOR GLASS TRANSPARENCIES

ADJUSTABLE LENS

ANOTHER DEVICE FOR *VIEWING* SCENIC IMAGES WAS THOMAS GAINSBOROUGH'S *SHOWBOX.* DIFFUSED CANDLELIGHT FLICKERED THRU *PAINTED GLASS,* PRODUCING STRIKING *ATMOSPHERIC EFFECTS.*

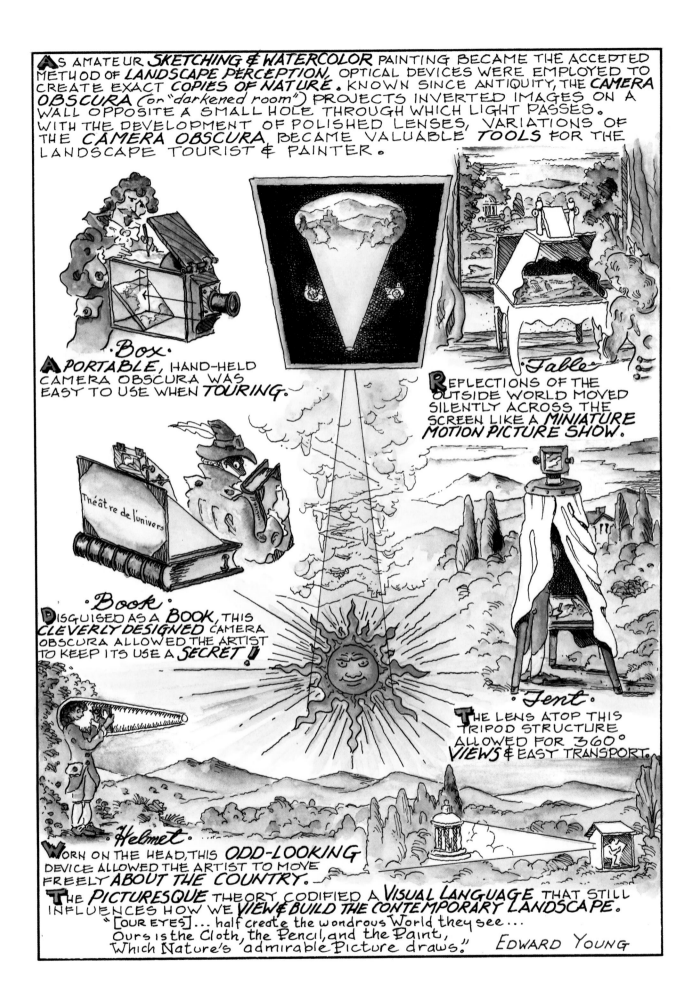

As amateur *SKETCHING & WATERCOLOR* painting became the accepted method of *LANDSCAPE PERCEPTION*, optical devices were employed to create exact *COPIES OF NATURE*. Known since antiquity, the *CAMERA OBSCURA* (or "darkened room") projects inverted images on a wall opposite a small hole through which light passes. With the development of polished lenses, variations of the *CAMERA OBSCURA* became valuable *TOOLS* for the landscape tourist & painter.

·Box·

A portable, hand-held camera obscura was easy to use when *TOURING*.

·Table·

Reflections of the outside world moved silently across the screen like a *MINIATURE MOTION PICTURE SHOW*.

Théâtre de l'univers

·Book·

Disguised as a *BOOK*, this *CLEVERLY DESIGNED* camera obscura allowed the artist to keep its use a *SECRET*!!

·Tent·

The lens atop this tripod structure allowed for 360° *VIEWS* & easy transport.

·Helmet·

Worn on the head, this *ODD-LOOKING* device allowed the artist to move freely *ABOUT THE COUNTRY*.

The *PICTURESQUE* theory codified a *VISUAL LANGUAGE* that still influences how we *VIEW & BUILD THE CONTEMPORARY LANDSCAPE*.

"[OUR EYES] ... half create the wondrous World they see ...
Ours is the Cloth, the Pencil, and the Paint,
Which Nature's admirable Picture draws." EDWARD YOUNG

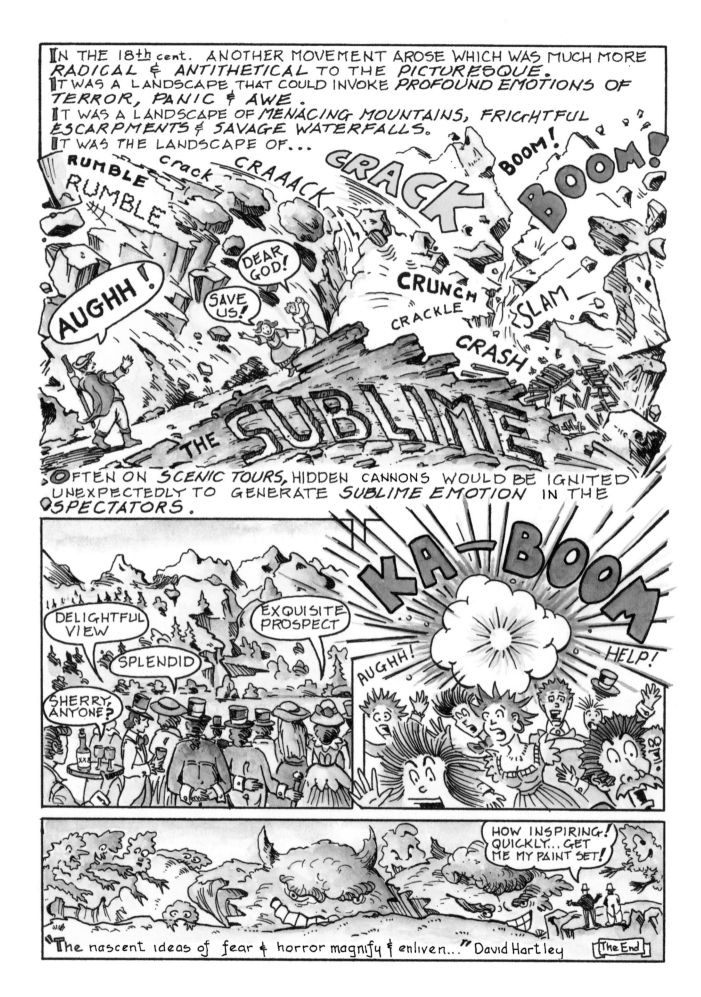

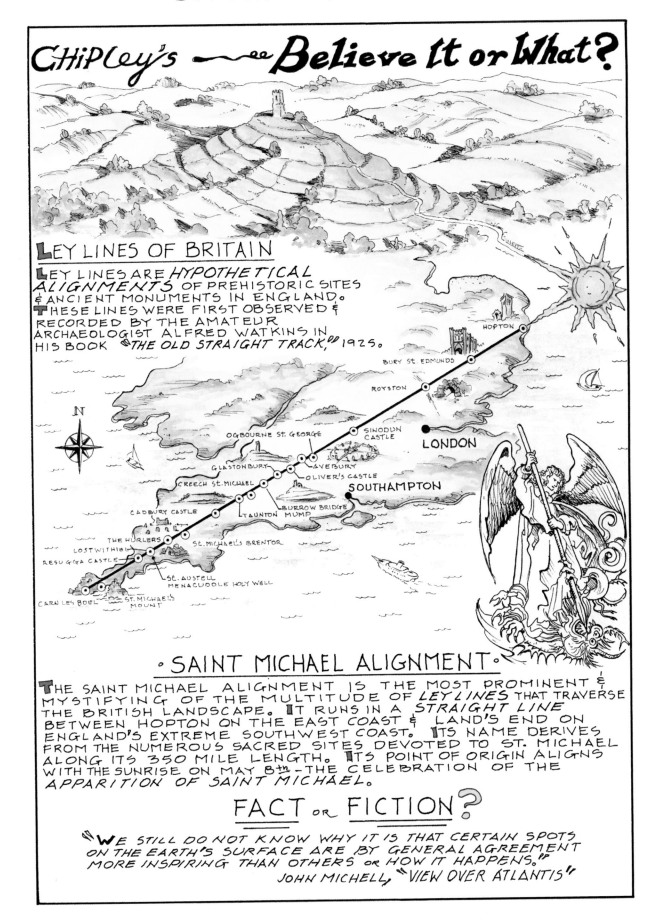

CHiPLey's —-- Believe It or What?

LEY LINES OF BRITAIN

LEY LINES ARE *HYPOTHETICAL ALIGNMENTS* OF PREHISTORIC SITES & ANCIENT MONUMENTS IN ENGLAND. THESE LINES WERE FIRST OBSERVED & RECORDED BY THE AMATEUR ARCHAEOLOGIST ALFRED WATKINS IN HIS BOOK *"THE OLD STRAIGHT TRACK,"* 1925.

• SAINT MICHAEL ALIGNMENT •

THE SAINT MICHAEL ALIGNMENT IS THE MOST PROMINENT & MYSTIFYING OF THE MULTITUDE OF *LEY LINES* THAT TRAVERSE THE BRITISH LANDSCAPE. IT RUNS IN A *STRAIGHT LINE* BETWEEN HOPTON ON THE EAST COAST & LAND'S END ON ENGLAND'S EXTREME SOUTHWEST COAST. ITS NAME DERIVES FROM THE NUMEROUS SACRED SITES DEVOTED TO ST. MICHAEL ALONG ITS 350 MILE LENGTH. ITS POINT OF ORIGIN ALIGNS WITH THE SUNRISE ON MAY 8th — THE CELEBRATION OF THE APPARITION OF SAINT MICHAEL.

FACT or FICTION?

"WE STILL DO NOT KNOW WHY IT IS THAT CERTAIN SPOTS ON THE EARTH'S SURFACE ARE BY GENERAL AGREEMENT MORE INSPIRING THAN OTHERS or HOW IT HAPPENS."
JOHN MICHELL, *"VIEW OVER ATLANTIS"*

BUILD YOUR OWN POUSSIN ACCORDIAN ◄o► DIORAMA ◄o►

THE MINIATURE *OPTICAL THEATER* IS A BENEFICIAL DEVICE TO HELP THE *LANDSCAPE ARTIST UNDERSTAND* THE *CLASSICAL LANDSCAPE COMPOSITION* AS DEVELOPED BY THE 17ᵗʰ CENT. LANDSCAPE PAINTER NICOLAS POUSSIN.

INSTRUCTIONS:

SCAN THIS PAGE & PRINT IT OUT ON AN 11"x17" SHEET OF CARD STOCK. CUT ALONG THICK BLACK LINES & CUT OUT ALL GRAY AREAS. GLUE TOGETHER AS SHOWN IN DIAGRAM Ⓐ

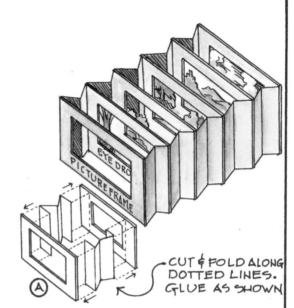

CUT & FOLD ALONG DOTTED LINES. GLUE AS SHOWN

FOLD ON DOTTED LINES

PICTURE FRAME

EYE DROP

① PICTURE FRAME DEFINES THE PICTORIAL FIELD

② EYE DROP PULLS THE EYE DOWN & INTO THE PICTURE FRAME

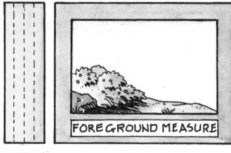

FOREGROUND MEASURE

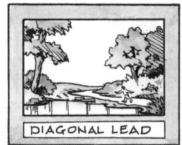

DIAGONAL LEAD

③ FOREGROUND MEASURE ACTS AS A GUIDE TO MEASURE THE SCALE OF THE PICTURE

④ DIAGONAL LEAD IS A RHYTHMICAL CURVING LINE LEADING THE EYE BACK

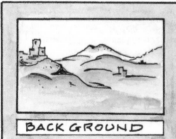

BACK GROUND

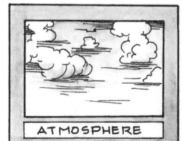

ATMOSPHERE

⑤ BACKGROUND IS A SERIES OF RECEDING PLANES TO CREATE DEPTH

⑥ ATMOSPHERE REVEALS DRAMATIC CLOUD FORMATIONS

"*Every scene seemed anticipated in some DREAM— it appeared as if some MAGICK LAND.*"

THOMAS JONES

BY THE 1820s *LANDSCAPE PAINTING* HAD BECOME A DISTINCT *GENRE*. THE PRACTICE OF *OUTDOOR* PAINTING BECAME POPULAR WITH THE *INTERNATIONAL* COMMUNITY OF ARTISTS WORKING IN CENTRAL ITALY. *ROME* BECAME THE PLACE TO GO TO *SEARCH* FOR THE EXPERIENCE OF *LIGHT & ATMOSPHERE*. ARTISTS PAINTED OUTDOORS TO TEST & SHARPEN THEIR SKILLS OF *PERCEPTION & EXECUTION*. BY PAINTING IN *OIL* DIRECTLY FROM NATURE, THESE PAINTERS BECAME KNOWN AS THE

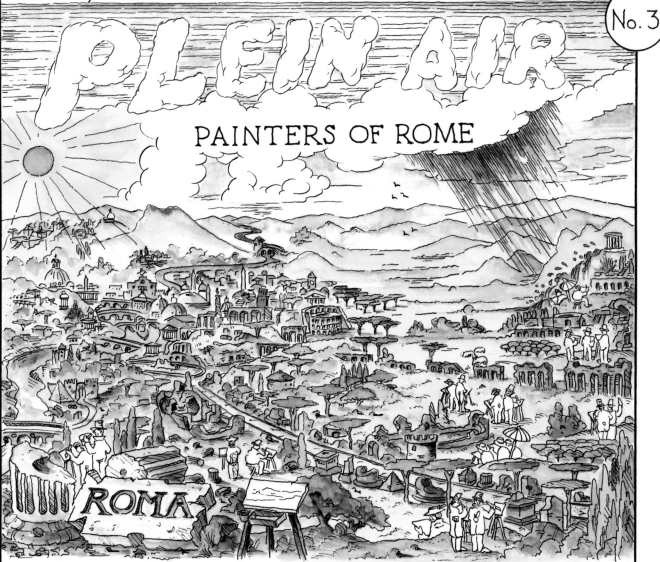

PLEIN AIR

No. 3

PAINTERS OF ROME

ROMA

"*NATURE IN ITALY INSPIRES THE IMAGINATION MORE THAN ANY- WHERE ELSE ... EVERYTHING IS THERE FOR THOUGHT, FOR IMAGINATION, FOR REVERIE. THE PUREST KIND OF SENSATION MINGLES WITH THE PLEASURES OF THE SOUL.*"

MADAME de STAËL

TRAVEL TO ITALY & ESPECIALLY TO *ROME* WAS CONSIDERED A *CRUCIAL EXPERIENCE* IN THE DEVELOPMENT OF THE *MIND* & THE REFINEMENT OF THE *SENSES*. ONE OF THE PRIMARY REASONS THE 19th-CENT. POET WOLFGANG Von GOETHE JOURNEYED TO ITALY WAS...

TO LEARN TO SEE !

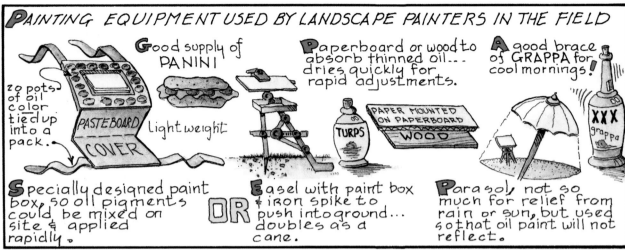

PAINTING EQUIPMENT USED BY LANDSCAPE PAINTERS IN THE FIELD

20 pots of oil color tied up into a pack.

Specially designed paint box, so oil pigments could be mixed on site & applied rapidly.

Good supply of PANINI — lightweight

PASTEBOARD COVER

OR

Easel with paint box & iron spike to push into ground... doubles as a cane.

Paperboard or wood to absorb thinned oil... dries quickly for rapid adjustments.

TURPS

PAPER MOUNTED ON PAPERBOARD — WOOD

A good brace of GRAPPA for cool mornings!

XXX grappa

Parasol, not so much for relief from rain or sun, but used so that oil paint will not reflect.

HOWEVER

Even more important than painting supplies, a **PISTOL** was necessary for protection against roving BANDITTI or the occasional poisonous snake.

GURRRR

IN HIS 1800 MANUAL, "ELEMENTS de PERSPECTIVE PRATIQUE," PIERRE de VALENCIENNES PRESCRIBED A METHODOLOGY FOR THE IMMEDIATE OBSERVATION OF NATURE. THESE SPONTANEOUSLY EXECUTED etudes (STUDIES) WOULD TEACH THE PAINTER HOW TO DEVELOP A VERSATILE & ELOQUENT PICTORIAL VOCABULARY.

① **T**o communicate the view, the IMPRESSION MUST BE DIRECTLY FELT.

② **S**peed is essential to capture the FLEETING EFFECTS OF LIGHT & ATMOSPHERE.

③ **S**pend no more than 2 HOURS several times a day & in CHANGING WEATHER CONDITIONS to capture specific effects of light.

④ **T**o capture rapidly changing effects of atmosphere, paint in the MORNING or EVENING NO MORE THAN ½ HOUR.

⑤ **I**N order for landscape artists to PLACE TRUTH in every portion of their work they should make studies of MOVING WATER.

⑥ **M**ake oil sketches of BEAUTIFUL TREES & THEIR DETAILS.

TO TRULY EXPERIENCE THE ROMAN CAMPAGNA IT WAS PARAMOUNT THAT LANDSCAPE ARTISTS SHOULD WALK & NOT RIDE IN CARRIAGES.

IN ORDER TO GRASP THE *ESSENCE OF THE VIEW* BEFORE THEM & TO REFINE THEIR *REFLEXES, THE PLEINAIR PAINTERS* WOULD TRY TO CAPTURE *EPHEMERAL SCENES* IN UNDER 30 MINUTES!

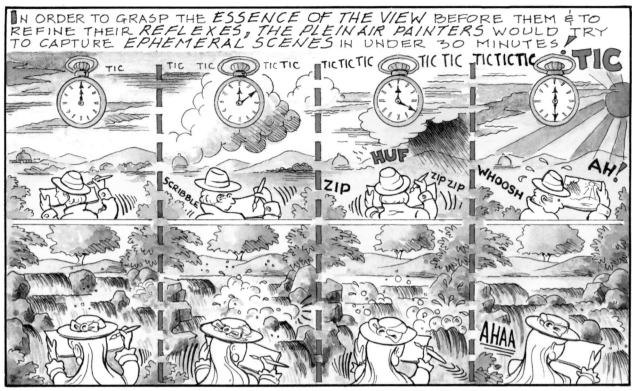

IN CONTRAST TO *BROAD PANORAMAS* PAINTERS WERE ENCOURAGED TO SEEK OUT *MINUTE DETAILS OF VISUAL DISTINCTION* & PRACTICE A FORM OF *ARTISTIC CALISTHENICS* BY PAINTING

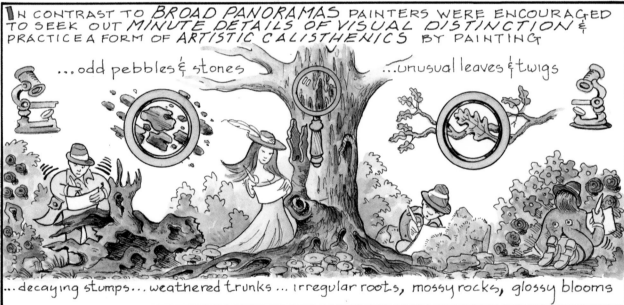

...odd pebbles & stones ...unusual leaves & twigs

...decaying stumps...weathered trunks...irregular roots, mossy rocks, glossy blooms

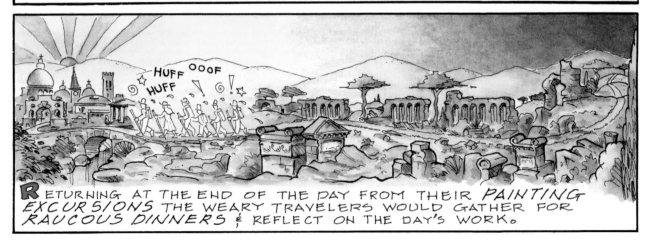

RETURNING AT THE END OF THE DAY FROM THEIR *PAINTING EXCURSIONS* THE WEARY TRAVELERS WOULD GATHER FOR *RAUCOUS DINNERS* & REFLECT ON THE DAY'S WORK.

DURING THE EARLY 1800s ARTISTS OFTEN GATHERED AT THE *SALON of ELIZABETH, duchess of DEVONSHIRE*, WHERE THEY WOULD *EXHIBIT & COMPARE* THEIR WORK IN LIVELY EXCHANGES. THE *SALON* ENVIRONMENT BECAME AN IMPORTANT ASPECT IN THE SOCIAL LIFE OF THE ROMAN ARTIST.

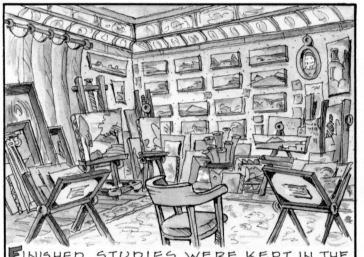

FINISHED STUDIES WERE KEPT IN THE STUDIO FOR *PRIVATE REFERENCE.* THEY WERE RARELY *SIGNED & NEVER SOLD!*

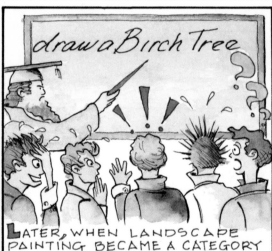

LATER, WHEN LANDSCAPE PAINTING BECAME A CATEGORY FOR THE *PRIX de ROME*, STUDENTS WERE EXPECTED to DRAW *SPECIFIC TREE SPECIES.*

BY THE EARLY 19th cent. *PLEIN AIR* LANDSCAPE PAINTING WAS A WIDESPREAD *PRACTICE* THAT ALMOST EVERY YOUNG ARTIST WAS EAGER TO *ENGAGE IN.* BUT MOST IMPORTANTLY IT HAD BECOME THE...

"*best manner to impress TRUTH on the MIND, because BODY & SOUL are as it were brought TOGETHER in it.*"
JOACHIM VON SANDRART

END

62

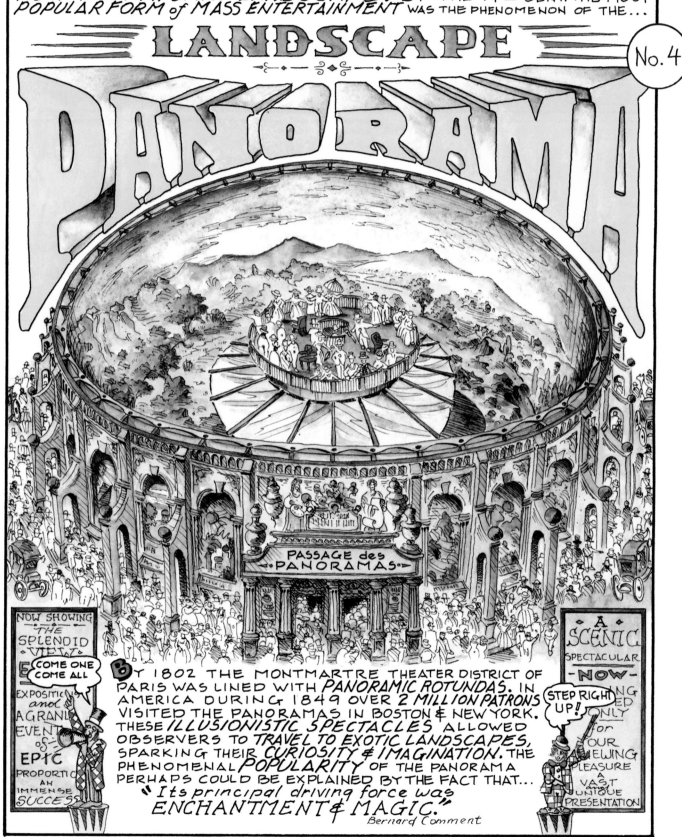

THE 360° REPRESENTATION OF THE LANDSCAPE HAS ITS ROOTS IN THE ITALIAN *"VEDUTE"* OF THE 18th CENT. ONE OF THE FIRST CIRCULAR PAINTINGS WAS PRODUCED BY LOUIS le MASSON IN 1779 FROM THE JANICULUM HILL IN ROME. THIS UNIQUE VISUAL FORM PLACED THE SPECTATOR IN THE *CENTER OF A CYLINDER* SO SHE WAS *COMPLETELY SURROUNDED* BY THE PAINTING AS IF IN A *NATURAL LANDSCAPE*. BY THE 19th CENT. THE MOST *POPULAR FORM of MASS ENTERTAINMENT* WAS THE PHENOMENON OF THE...

LANDSCAPE PANORAMA

No. 4

PASSAGE des PANORAMAS

NOW SHOWING *THE SPLENDID VIEW*

COME ONE COME ALL

EXPOSITION and A GRAND EVENT of EPIC PROPORTIONS AN IMMENSE SUCCESS

BY 1802 THE MONTMARTRE THEATER DISTRICT OF PARIS WAS LINED WITH *PANORAMIC ROTUNDAS*. IN AMERICA DURING 1849 OVER *2 MILLION PATRONS* VISITED THE PANORAMAS IN BOSTON & NEW YORK. THESE *ILLUSIONISTIC SPECTACLES* ALLOWED OBSERVERS TO *TRAVEL TO EXOTIC LANDSCAPES*, SPARKING THEIR *CURIOSITY & IMAGINATION*. THE PHENOMENAL *POPULARITY* OF THE PANORAMA PERHAPS COULD BE EXPLAINED BY THE FACT THAT...

"Its principal driving force was ENCHANTMENT & MAGIC." Bernard Comment

A SCENIC SPECTACULAR -NOW- BEING PRESENTED ONLY for YOUR VIEWING PLEASURE A VAST UNIQUE PRESENTATION

STEP RIGHT UP!

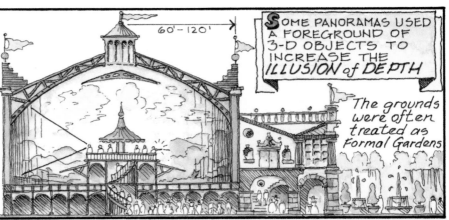

IN 1787 ROBERT BAKER TOOK OUT THE FIRST PATENT FOR A PANORAMA, ORIGINALLY CALLED "La Nature a Coup d' Oeil." THE SPECTATOR STEPPED INTO A DARKENED SEQUENCE OF SPACES THAT WERE CHOREOGRAPHED TO INCREASE THE *ANTICIPATION & DRAMA* OF BEING TRANSPORTED INTO ANOTHER *VISUAL DIMENSION*. ONCE ON THE OBSERVATION DECK THE VISITOR WAS IN THE CENTER OF A VAST *ENDLESS HORIZON*.

SOME PANORAMAS USED A FOREGROUND OF 3-D OBJECTS TO INCREASE THE *ILLUSION of DEPTH*

The grounds were often treated as Formal Gardens

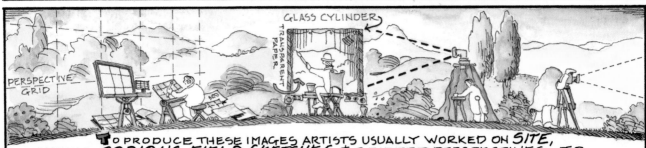

To PRODUCE THESE IMAGES ARTISTS USUALLY WORKED ON *SITE*, MAKING *COPIOUS FIELD SKETCHES* & GRIDDED PERSPECTIVES. TO INCREASE *ACCURACY*, A *CAMERA OBSCURA* WAS USED & LATER *PHOTOGRAPHY*. THE MOST UNIQUE DEVICE WAS A *GLASS CYLINDER* LINED WITH TRANSPARENT PAPER, ALLOWING THE ARTIST TO OUTLINE THE CORRECT PERSPECTIVE.

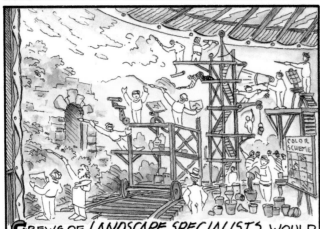

CREWS OF *LANDSCAPE SPECIALISTS* WOULD WORK ON *ROLLING TIERED PLATFORMS* WITH APPARATUS FOR ESTABLISHING PERSPECTIVE. A TEAM OF 2-5 ARTISTS COULD PRODUCE A PANORAMA IN 6-12 MONTHS.

JUST TAKE A *WHIFF* OF THAT SEA BREEZE!

THIS MOUNTAIN AIR IS SO *REFRESHING*!

To INCREASE THE *ILLUSION of NATURE*, AIR WAS FORCED THRU *FILTERS* OF ALGAE & KELP TO IMITATE *SEA BREEZES* & OVER ALPINE PLANTS TO PRODUCE *SENSATIONS* OF *MOUNTAIN AIR*. THIS ILLUSION WOULD NOT BE ATTEMPTED AGAIN UNTIL THE 1960s MOVIES WITH...

SMELL~O~VISION

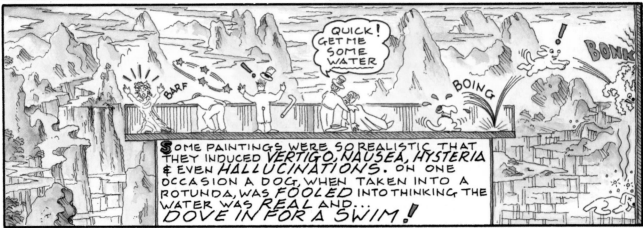

QUICK! GET ME SOME WATER

BARF

BOING

BONK

SOME PAINTINGS WERE SO REALISTIC THAT THEY INDUCED *VERTIGO, NAUSEA, HYSTERIA* & EVEN *HALLUCINATIONS*. ON ONE OCCASION A DOG, WHEN TAKEN INTO A ROTUNDA, WAS *FOOLED* INTO THINKING THE WATER WAS *REAL* AND... *DOVE IN FOR A SWIM!*

DURING THE ERA OF THE 360° PANORAMA, LARGE *SWEEPING VISTAS* OF THE AMERICAN LANDSCAPE BECAME POPULAR. ALBERT BIERSTADT RENDERED *MASSIVE PANORAMIC* LANDSCAPES OF THE AMERICAN WEST DURING THE 1860s & 1870s. SOME OF THESE IMAGES WERE AS LARGE AS 6'X10'. BY CONTRASTING SHARPLY DEFINED DETAIL WITH MASSIVE SCALE, THE VIEWER WAS *IMMERSED IN THE FORCES OF NATURE!*

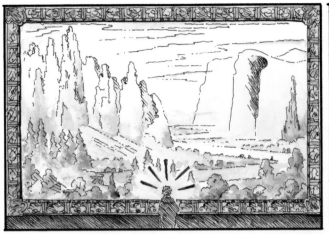

GOLLY!

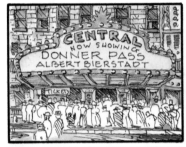

AHHH!

BIERSTADT'S PAINTINGS TOURED THE U.S., TRAVELING FROM TOWN TO TOWN. AUDIENCES LINED UP BY THE *THOUSANDS.* WITH THE CURTAIN DRAWN, A *LECTURE* WOULD BE DELIVERED ON THE SUBJECT, THEN *DRAMATICALLY* THE PAINTING WOULD BE *REVEALED!*

IN THE TWILIGHT YEARS OF THE PANORAMA SOME *ASTONISHING SPECIAL EFFECTS* WERE ACHIEVED AT FRANCE'S GREAT EXHIBITION OF 1900.

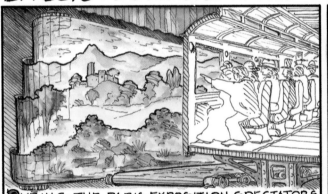

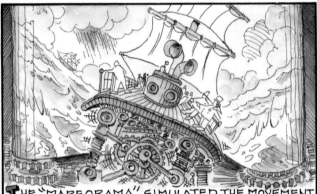

DURING THE PARIS EXPOSITION SPECTATORS GAZED AT A MOVING LANDSCAPE FROM STATIONARY TRAIN CAR WINDOWS. EACH OF THE 4 SUCCESSIVE LAYERS *MOVED AT DIFFERENT SPEEDS,* REPRODUCING THE EFFECT OF MOTION.

THE "MAREORAMA" SIMULATED THE MOVEMENT OF THE SEA THRU THE USE OF UNIVERSAL JOINTS TO PRODUCE THE *PITCH & ROLL* OF A SHIP. TWO *GIGANTIC* CANVASES WERE UNROLLED FROM BOW TO STERN, RECREATING A *TRANSATLANTIC VOYAGE.*

THE LANDSCAPE PANORAMAS ESTABLISHED A *PATTERN* FOR THE *MOVIE-GOING EXPERIENCE.* YET THE *BIRTH OF THE CINEMA* ESSENTIALLY *DOOMED* THE PANORAMA. UNFORTUNATELY THE *UNIQUE VISUAL ILLUSION* OF THE ALL-ENCOMPASSING VIEW WOULD BE LOST. WHEN COMPARING THE VISUAL QUALITY OF THE PANORAMA TO THE CINEMA, KAFKA WROTE, "*The images are more lifelike than in the cinema because, as in reality, they allow the GAZE to linger.*" IT WOULD NOT BE UNTIL THE 1950s THAT MOVIE PATRONS WOULD BE ABLE TO ENJOY THE *OPTICAL EFFECTS* OF THE PANORAMA THRU THE *WIDE-SCREEN PROCESS OF...*

CINERAMA

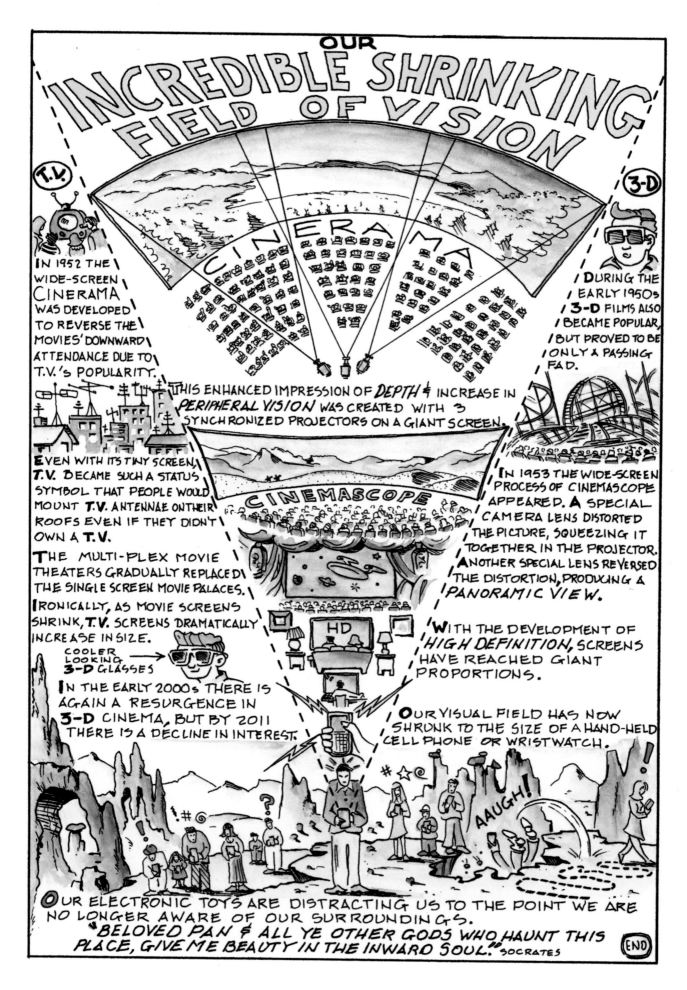

OUR INCREDIBLE SHRINKING FIELD OF VISION

T.V.

IN 1952 THE WIDE-SCREEN CINERAMA WAS DEVELOPED TO REVERSE THE MOVIES' DOWNWARD ATTENDANCE DUE TO T.V.'S POPULARITY.

EVEN WITH ITS TINY SCREEN, T.V. BECAME SUCH A STATUS SYMBOL THAT PEOPLE WOULD MOUNT T.V. ANTENNAE ON THEIR ROOFS EVEN IF THEY DIDN'T OWN A T.V.

THE MULTI-PLEX MOVIE THEATERS GRADUALLY REPLACED THE SINGLE SCREEN MOVIE PALACES.

IRONICALLY, AS MOVIE SCREENS SHRINK, T.V. SCREENS DRAMATICALLY INCREASE IN SIZE.

COOLER LOOKING 3-D GLASSES →

IN THE EARLY 2000s THERE IS AGAIN A RESURGENCE IN 3-D CINEMA, BUT BY 2011 THERE IS A DECLINE IN INTEREST.

3-D

DURING THE EARLY 1950s 3-D FILMS ALSO BECAME POPULAR, BUT PROVED TO BE ONLY A PASSING FAD.

THIS ENHANCED IMPRESSION OF *DEPTH* & INCREASE IN *PERIPHERAL VISION* WAS CREATED WITH 3 SYNCHRONIZED PROJECTORS ON A GIANT SCREEN.

IN 1953 THE WIDE-SCREEN PROCESS OF CINEMASCOPE APPEARED. A SPECIAL CAMERA LENS DISTORTED THE PICTURE, SQUEEZING IT TOGETHER IN THE PROJECTOR. ANOTHER SPECIAL LENS REVERSED THE DISTORTION, PRODUCING A *PANORAMIC VIEW.*

WITH THE DEVELOPMENT OF *HIGH DEFINITION*, SCREENS HAVE REACHED GIANT PROPORTIONS.

OUR VISUAL FIELD HAS NOW SHRUNK TO THE SIZE OF A HAND-HELD CELL PHONE OR WRISTWATCH.

AAUGH!

OUR ELECTRONIC TOYS ARE DISTRACTING US TO THE POINT WE ARE NO LONGER AWARE OF OUR SURROUNDINGS.
"BELOVED PAN & ALL YE OTHER GODS WHO HAUNT THIS PLACE, GIVE ME BEAUTY IN THE INWARD SOUL." SOCRATES

END

SINCE THEIR FIRST APPEARANCE, HOT AIR BALLOONS HAVE BEEN AN INTEGRAL FIXTURE IN OUR GARDENS, PARKS & OPEN SPACES. THE FIRST *AERIAL VIEWS OF THE LANDSCAPE* THOROUGHLY ALTERED OUR PERCEPTION OF THE EARTH'S SURFACE. JOIN US AS WE EMBARK ON AN ADVENTURE WITH THESE DARING *BALLOON AERONAUTS* AS THEY VENTURE THROUGH...

No. 5

LANDSCAPES FROM ALOFT

THE FIRST VIEWS OF THE *LANDSCAPE* FROM BALLOONS SEEMED LIKE *STRANGE ABERRATIONS*. *AERIAL PERSPECTIVE OPTICALLY FLATTENED* THE TOPOGRAPHIC FEATURES OF HILLS & VALLEYS. THESE SWEEPING *PANORAMAS* REVEALED THE *COMPLEX PATTERNS* OF FORESTS, FARMS, ROADS & WATERWAYS. BUILDINGS VIEWED *AXONOMETRICALLY* WERE TRANSFORMED INTO PLAN VIEWS. THE LANDSCAPE COULD NOW BE COMPREHENDED AS A *COMPLEX MATRIX*.

THE MONTGOLFIER BROTHERS INVENTED THE FIRST HOT AIR BALLOON IN FRANCE. ON SEPT. 19, 1783, THEY LAUNCHED THEIR *FIRST "MANNED" BALLOON.* IN THE WICKER BASKET RODE *A DUCK, A ROOSTER & A SHEEP,* SINCE THE AIR WAS THOUGHT TO BE UNBREATHABLE.

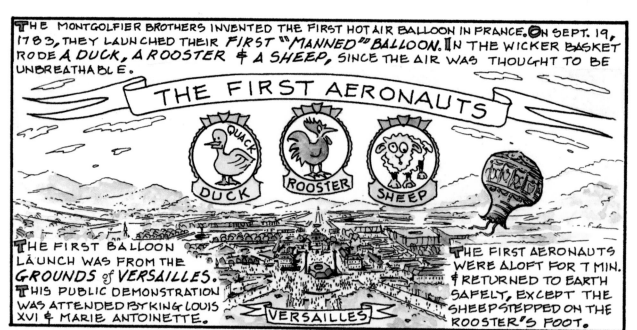

THE FIRST AERONAUTS

THE FIRST BALLOON LAUNCH WAS FROM THE *GROUNDS of VERSAILLES.* THIS PUBLIC DEMONSTRATION WAS ATTENDED BY KING LOUIS XVI & MARIE ANTOINETTE.

THE FIRST AERONAUTS WERE ALOFT FOR 7 MIN. & RETURNED TO EARTH SAFELY, EXCEPT THE SHEEP STEPPED ON THE ROOSTER'S FOOT.

VERSAILLES

THE FIRST HUMANS TO GO ALOFT IN A MONTGOLFIER BALLOON WERE PILÂTRE de ROZIER & MARQUIS d'ARLANDES. ON NOV. 21, 1783, A HALF MILLION SPECTATORS WATCHED THE LAUNCH FROM THE GARDENS *of the CHATEAU de la MUETTE.* THE BRIGHTLY PAINTED BALLOON FLEW 5 MILES ACROSS PARIS FOR 25 MIN. NOT LONG AFTER, ON DEC. 1, 1783, THE 1st MANNED HYDROGEN BALLOON WAS LAUNCHED IN THE TUILERIES GARDENS. Dr. CHARLES & MSSR. ROBERT STAYED ALOFT FOR TWO HOURS.

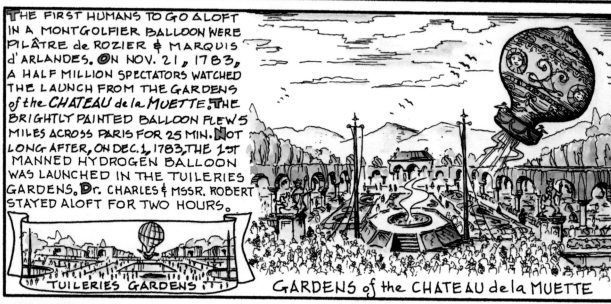

TUILERIES GARDENS

GARDENS of the CHATEAU de la MUETTE

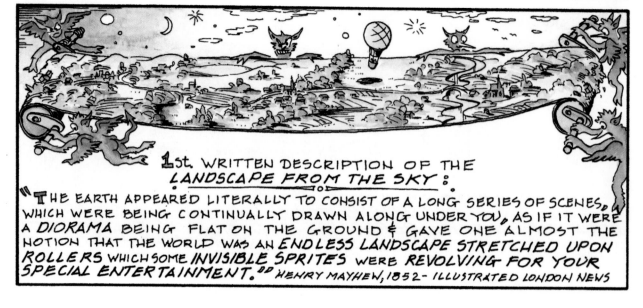

1st. WRITTEN DESCRIPTION OF THE *LANDSCAPE FROM THE SKY:*

"THE EARTH APPEARED LITERALLY TO CONSIST OF A LONG SERIES OF SCENES, WHICH WERE BEING CONTINUALLY DRAWN ALONG UNDER YOU, AS IF IT WERE A *DIORAMA* BEING FLAT ON THE GROUND & GAVE ONE ALMOST THE NOTION THAT THE WORLD WAS AN *ENDLESS LANDSCAPE STRETCHED UPON ROLLERS* WHICH SOME *INVISIBLE SPRITES* WERE *REVOLVING FOR YOUR SPECIAL ENTERTAINMENT."* HENRY MAYHEW, 1852 - ILLUSTRATED LONDON NEWS

THE FIRST AERIAL MAP WAS DRAWN FROM A BALLOON IN 1785 BY THOMAS BALDWIN. DRAWN AT AN ESTIMATED HEIGHT OF 4000-5000 FEET, THE FIRST MAPS OF THE EARTH WERE MADE FROM THE BALLOON BASKET. THE BRITISH ORDNANCE SURVEY—THE FIRST STATE MAPPING DIVISION IN THE WORLD—WAS PARTLY INSPIRED BY THE OVERVIEW GATHERED FROM THE VISTAS SEEN FROM BALLOONS.

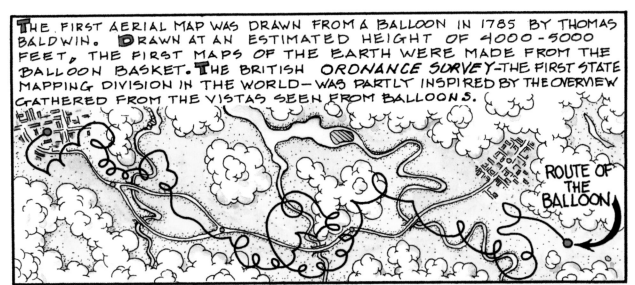

ROUTE OF THE BALLOON

NAPOLEON USED BALLOONS IN EGYPT FOR HIS ARTISTS & ENGINEERS TO DRAW TOPOGRAPHIC MAPS & SURVEYS FOR HIS VAST SCIENTIFIC WORK: *Description de l'Egypte.* THIS WAS THE FIRST THOROUGH ATTEMPT TO STUDY THE *ANTIQUITIES & GEOGRAPHY of EGYPT.*

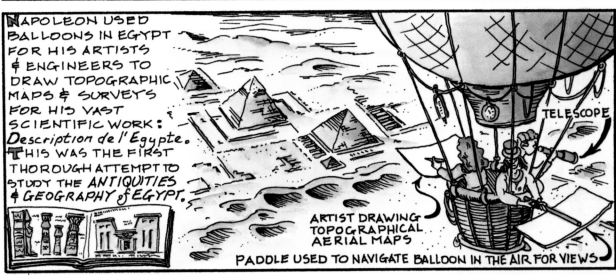

ARTIST DRAWING TOPOGRAPHICAL AERIAL MAPS

TELESCOPE

PADDLE USED TO NAVIGATE BALLOON IN THE AIR FOR VIEWS

BALLOONING ADDED A NEW AWARENESS OF THE FORMATION & TRANSFORMATION OF CLOUDS & THEIR ASTONISHING BEAUTY. THESE AERIAL OBSERVATIONS LED TO THE DEVELOPMENT OF METEOROLOGY.

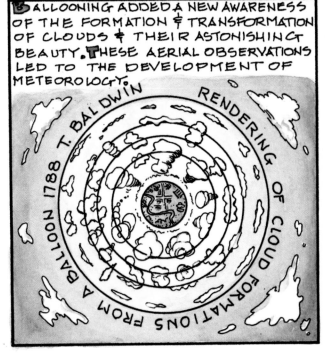

RENDERING OF CLOUD FORMATIONS FROM A BALLOON 1788 T. BALDWIN

FIRST AERIAL SEX

THE FIRST *AMOROUS ENCOUNTER* IN THE SKY ALLEGEDLY TOOK PLACE IN 1785 IN A BALLOON LAUNCHED FROM *ST. GEORGE'S FIELDS, LONDON.* ITS PASSENGERS WERE MR. GEORGE BIGGIN & MRS. LETITIA ANN SAGE.

THE ROMANCE OF *FLOATING ABOVE THE LANDSCAPE* IN LIGHTER THAN AIR CRAFT HAS NOT DISAPPEARED. FROM THE PIONEERING BALLOON LAUNCHES IN *GARDENS & PARKS* THIS PHENOMENON HAS CONTINUED INTO THE *LANDSCAPES OF THE 21ST CENTURY.* "*Of void & chaos, rising on high above the stars in awful majesty.*" HUMPHREY DAVY 1824

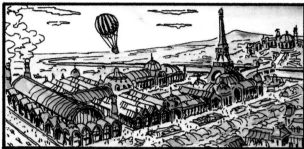 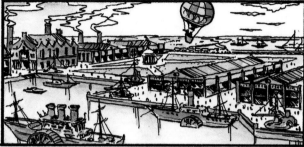

MANY RENDERINGS OF THE *INTERNATIONAL EXPOSITIONS* OF THE 19th CENT. FEATURED *BALLOONS FLYING OVERHEAD.* EVEN RENDERINGS OF *PROPOSED INDUSTRIAL PARKS* WOULD INCLUDE AN *AEROSTAT.* GENERATIONS OF *VICTORIAN BALLOONISTS* ASCENDED FROM THE *GARDENS OF THE CRYSTAL PALACE,* WITNESSED BY MASSIVE CROWDS IN A PARK SETTING.

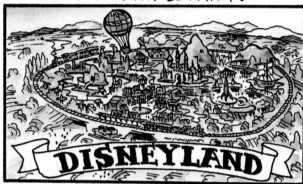 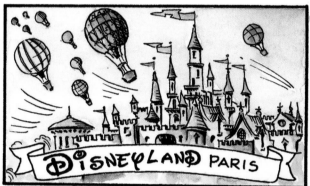

REALIZING THE ROMANCE & HISTORICAL SIGNIFICANCE OF *HOT AIR BALLOONS & PARKS* WALT DISNEY FEATURED A BALLOON AS A *CENTRAL FOCAL POINT* IN THE ORIGINAL RENDERINGS OF HIS *DISNEYLAND PARK.* YEARS LATER THE SKY WAS FILLED WITH *LIGHTER THAN AIR CRAFT* IN THE RENDERINGS OF *DISNEYLAND PARKS.*

CHANTILLY | PARC CITROEN | THE BIG APPLE | THE BIG ORANGE

IT'S NOT SUPRISING THAT HISTORICAL GARDENS SUCH AS Le NOTRE'S *CHANTILLY* & OLMSTED'S *CENTRAL PARK,* ALONG WITH THE *MOST INNOVATIVE PARKS* OF TODAY, CONTINUE TO BE THE SETTINGS FOR *SCHEDULED BALLOON LAUNCHES!*

"BALLOONING PRODUCED A *NEW & WHOLLY UNEXPECTED VISION OF THE EARTH.* THEY HAD IMAGINED THAT IT WOULD REVEAL THE *SECRETS OF THE HEAVENS ABOVE,* BUT IN FACT IT SHOWED THE *SECRETS OF THE WORLD BENEATH.*"
THE AGE OF WONDER, RICHARD HOLMES

THE END

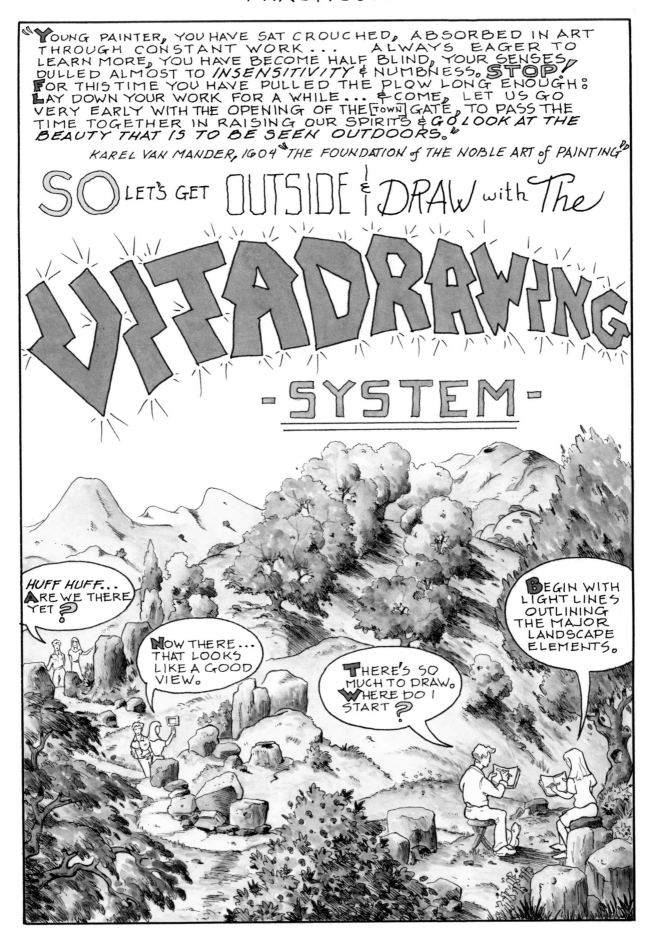

"THE PAINTER WHO IS INITIATED IN THE *DIVINE SECRETS* OF ART HEARS THE VOICE OF NATURE RECOUNTING ITS INFINITE MYSTERIES THROUGH TREES, PLANTS, FLOWERS, WATERS & MOUNTAINS."

E.T.A. HOFFMANN, 1816

- BASIC MATERIALS -

FOR YOUR SKETCHING ADVENTURE

YOU WILL ONLY NEED THE VERY BASIC SUPPLIES FOR FIELD SKETCHING.

⊙ SKETCHBOOKS

LANDSCAPE FORMAT

- SKETCHBOOKS SHOULD BE LANDSCAPE FORMAT & SMALL ENOUGH TO CARRY EASILY.
- MAKE SURE YOU HAVE RUBBER BANDS OR BINDER CLIPS TO HOLD YOUR PAGES DOWN IN THE WIND.

⊙ DRAWING TOOLS

YOU WILL NEED A SMALL BACKPACK FOR YOUR SUPPLIES. DON'T FORGET DRINKING WATER & SNACKS.

A SMALL PORTABLE CAMP STOOL OR AN ALL WEATHER PILLOW IS A NECESSITY.

GENERAL'S 314 DRAUGHTING

- THE GENERAL'S 314 PENCIL IS HANDY FOR LIGHT LAYOUT LINES OR TONE DRAWING.

PITT artist pen

- THE FABER-CASTELL PITT artist pen WITH EITHER S or F POINTS IS IDEAL FOR FIELD SKETCHING. THE RESPONSIVE POINTS ALLOW FOR VARYING LINE WEIGHTS.

MICRON

PIGMA'S MICRON 01 & 02 POINTS ARE ALSO VERY GOOD SKETCHING PENS, ALTHOUGH THE POINTS ARE MUCH STIFFER THAN THE PITT artist pen.

VITA LINE SKETCHING EXERCISES

⊙ THE *REVOLVER*

LOOSEN UP WITH A WIDE VARIETY OF LOOPING LINES DRAWN AS A *CONTINUOUS GESTURE.*

⊙ ATMOSPHERIC LINE WEIGHTS

VERY BENEFICIAL FOR CREATING THE ILLUSION OF DEPTH & PERSPECTIVE

- USE **DOTS** TO GIVE THE IMPRESSION OF DISTANCE IN THE BACKGROUND
- LIGHTLY **DASHED** LINES ARE USEFUL FOR MID-GROUND ELEMENTS
- THE **GRADUATED** LINE CAN MAKE YOUR DRAWING COME ALIVE WITH A DAZZLING VARIETY OF LINE WIDTHS

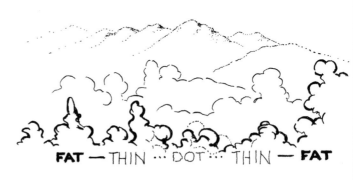

FAT — THIN ⋯ DOT ⋯ THIN — FAT

- THE *PARALLEL HATCH*

IDEAL FOR CREATING VOLUME QUICKLY

- THE **INSTA**-TREE

LOOP & SHADE WITH THE *PARALLEL HATCH*

LIGHT ⟶ DARK

OBSERVE SUN LOCATION
① LOOP

②③ *PARALLEL HATCH*
④ ADD SHADOWS ⑤ LEAVE LIGHT SPACES

COMPOSITION

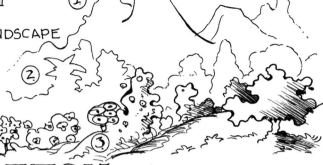

① EXAGGERATE DISTINCT LANDSCAPE FEATURES
② DEFINE WITH OUTLINES
③ CARTOONICATE WITH EXPRESSIVE LINE WORK.

THE FIELD SKETCH

① SELECT YOUR VIEW. VISUALIZE A FRAME ENCLOSING YOUR AREA OF FOCUS. DRAW THE PICTURE FRAME IN YOUR SKETCHBOOK.

② DRAW THE OUTLINE OF THE LANDSCAPE'S SILHOUETTE AGAINST THE SKY WITH VERY LIGHT LINES.

③ DRAW A FOREGROUND ELEMENT WHICH IS VERY CLOSE TO WHERE YOU ARE. NOW IMAGINE YOURSELF IN THE PICTURE FRAME.

VARY LINE WEIGHTS FROM **THIN** TO **THICK**

④ NOW BEGIN TO ADD IN THE MIDDLE GROUND - USING THE FOREGROUND & BACKGROUND SILHOUETTE TO NAVIGATE AS YOU LIGHTLY FILL IN THE DRAWING.

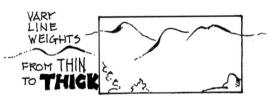

LIGHT ↑ DARK

ADD RIDGE LINE TOO!

⑤ BEGIN TO ADD IN LIGHT DETAILS, WORKING ACROSS THE PICTURE PLANE.

ONCE YOU COMPLETE THE COMPOSITION, DARKEN UP YOUR LINES.

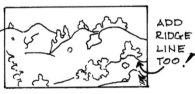

USE PARALLEL HATCH LINES FOR VOLUME

USE STIPPLES ALONG RIDGE LINES FOR ADDED DEPTH

FINALLY = add **Shadows**

VITADRAWING ON THE MOVE

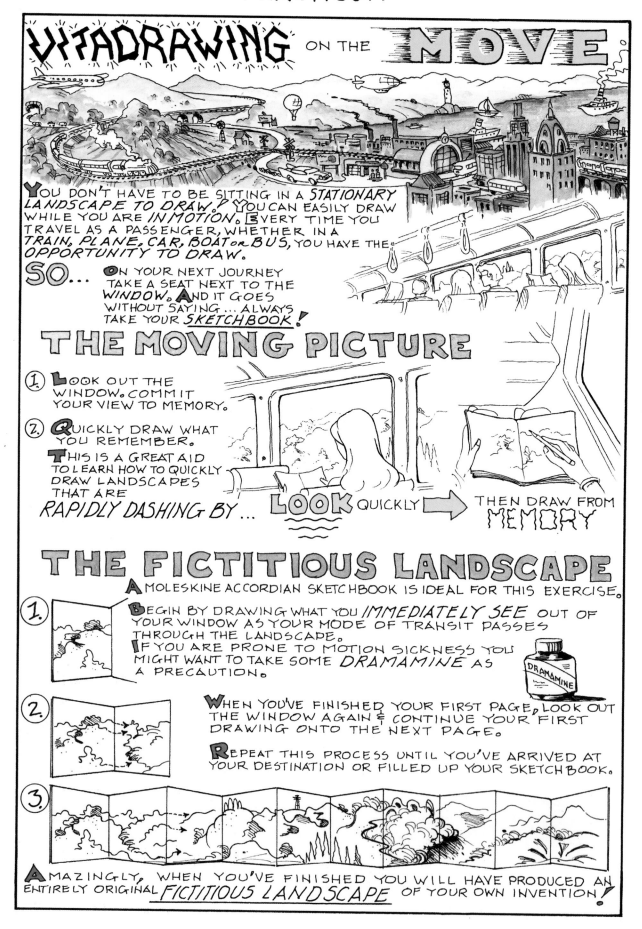

YOU DON'T HAVE TO BE SITTING IN A *STATIONARY LANDSCAPE TO DRAW.* YOU CAN EASILY DRAW WHILE YOU ARE *IN MOTION.* EVERY TIME YOU TRAVEL AS A PASSENGER, WHETHER IN A *TRAIN, PLANE, CAR, BOAT* or *BUS,* YOU HAVE THE *OPPORTUNITY TO DRAW.*

SO... ON YOUR NEXT JOURNEY TAKE A SEAT NEXT TO THE *WINDOW.* AND IT GOES WITHOUT SAYING... ALWAYS TAKE YOUR *SKETCHBOOK!*

THE MOVING PICTURE

1. LOOK OUT THE WINDOW. COMMIT YOUR VIEW TO MEMORY.

2. QUICKLY DRAW WHAT YOU REMEMBER.

 THIS IS A GREAT AID TO LEARN HOW TO QUICKLY DRAW LANDSCAPES THAT ARE

RAPIDLY DASHING BY... LOOK QUICKLY ➡ THEN DRAW FROM MEMORY

THE FICTITIOUS LANDSCAPE

A MOLESKINE ACCORDIAN SKETCHBOOK IS IDEAL FOR THIS EXERCISE.

1. BEGIN BY DRAWING WHAT YOU *IMMEDIATELY SEE* OUT OF YOUR WINDOW AS YOUR MODE OF TRANSIT PASSES THROUGH THE LANDSCAPE.
 IF YOU ARE PRONE TO MOTION SICKNESS YOU MIGHT WANT TO TAKE SOME *DRAMAMINE* AS A PRECAUTION.

2. WHEN YOU'VE FINISHED YOUR FIRST PAGE, LOOK OUT THE WINDOW AGAIN & CONTINUE YOUR FIRST DRAWING ONTO THE NEXT PAGE.

 REPEAT THIS PROCESS UNTIL YOU'VE ARRIVED AT YOUR DESTINATION OR FILLED UP YOUR SKETCHBOOK.

3.

AMAZINGLY, WHEN YOU'VE FINISHED YOU WILL HAVE PRODUCED AN ENTIRELY ORIGINAL *FICTITIOUS LANDSCAPE* OF YOUR OWN INVENTION!

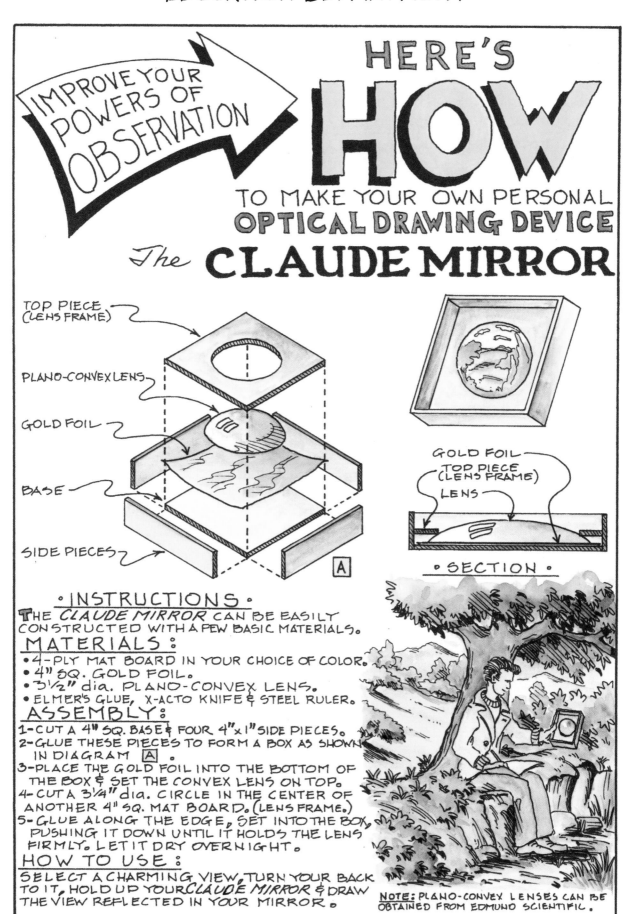

IMPROVE YOUR POWERS OF OBSERVATION

HERE'S **HOW**

TO MAKE YOUR OWN PERSONAL
OPTICAL DRAWING DEVICE

The **CLAUDE MIRROR**

TOP PIECE (LENS FRAME)

PLANO-CONVEX LENS

GOLD FOIL

BASE

SIDE PIECES

A

GOLD FOIL
TOP PIECE (LENS FRAME)
LENS

• SECTION •

• INSTRUCTIONS •

THE *CLAUDE MIRROR* CAN BE EASILY CONSTRUCTED WITH A FEW BASIC MATERIALS.

MATERIALS:
• 4-PLY MAT BOARD IN YOUR CHOICE OF COLOR.
• 4" SQ. GOLD FOIL.
• 3½" dia. PLANO-CONVEX LENS.
• ELMER'S GLUE, X-ACTO KNIFE & STEEL RULER.

ASSEMBLY:
1 - CUT A 4" SQ. BASE & FOUR 4" x 1" SIDE PIECES.
2 - GLUE THESE PIECES TO FORM A BOX AS SHOWN IN DIAGRAM A.
3 - PLACE THE GOLD FOIL INTO THE BOTTOM OF THE BOX & SET THE CONVEX LENS ON TOP.
4 - CUT A 3¼" dia. CIRCLE IN THE CENTER OF ANOTHER 4" SQ. MAT BOARD. (LENS FRAME.)
5 - GLUE ALONG THE EDGE, SET INTO THE BOX, PUSHING IT DOWN UNTIL IT HOLDS THE LENS FIRMLY. LET IT DRY OVERNIGHT.

HOW TO USE:
SELECT A CHARMING VIEW, TURN YOUR BACK TO IT, HOLD UP YOUR *CLAUDE MIRROR* & DRAW THE VIEW REFLECTED IN YOUR MIRROR.

NOTE: PLANO-CONVEX LENSES CAN BE OBTAINED FROM EDMUND SCIENTIFIC.

WHAT RENAISSANCE PAINTING INSPIRED THE *DESIGN* OF THIS 20th cent. *TUSCAN LANDSCAPE?*

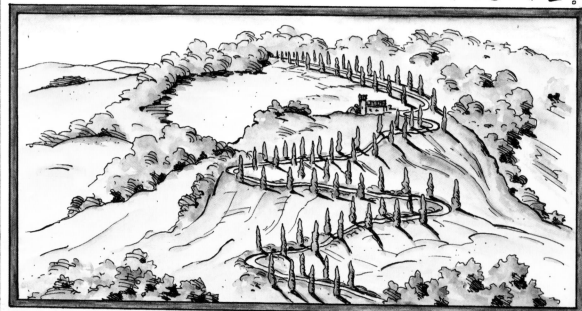

FIND OUT *and* LEARN MORE IN OUR **NEXT ISSUE**

77

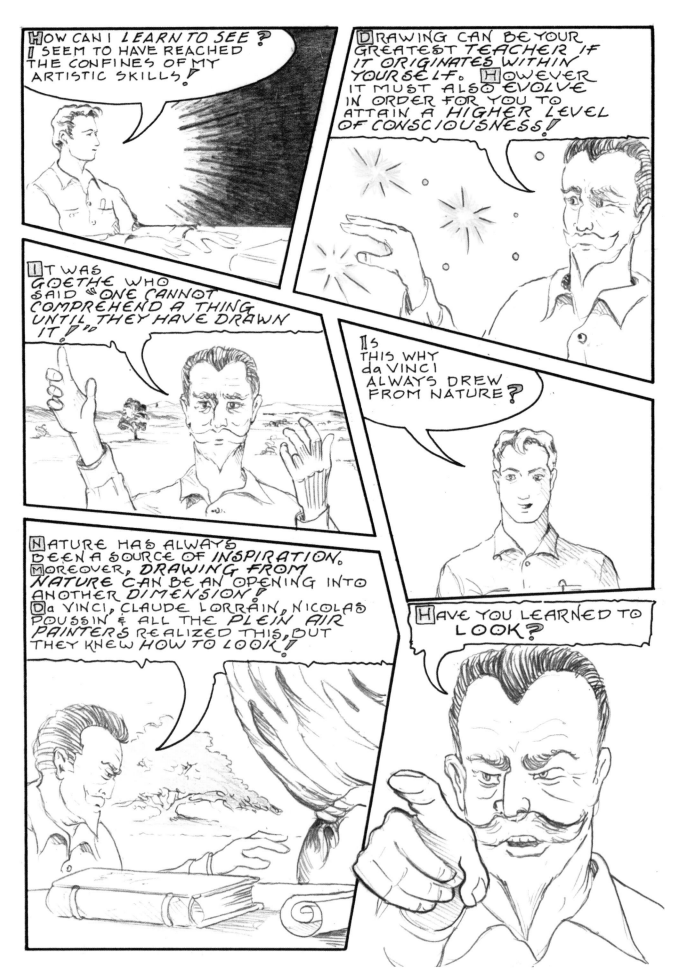

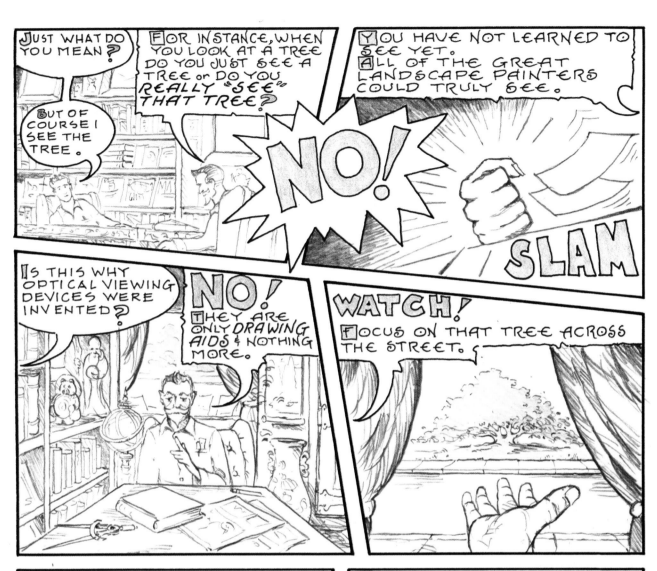

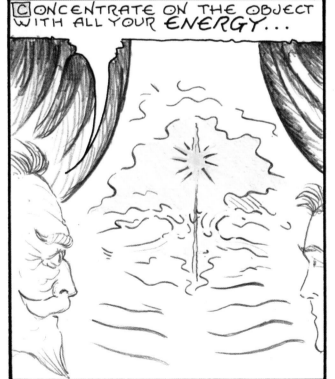

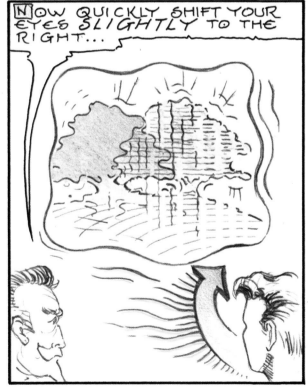

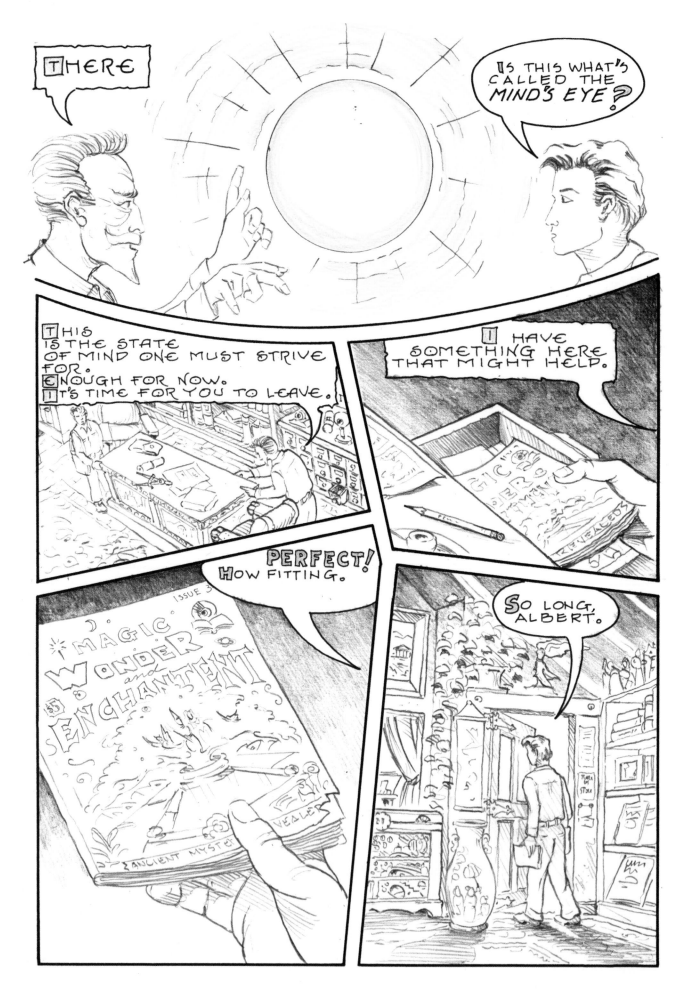

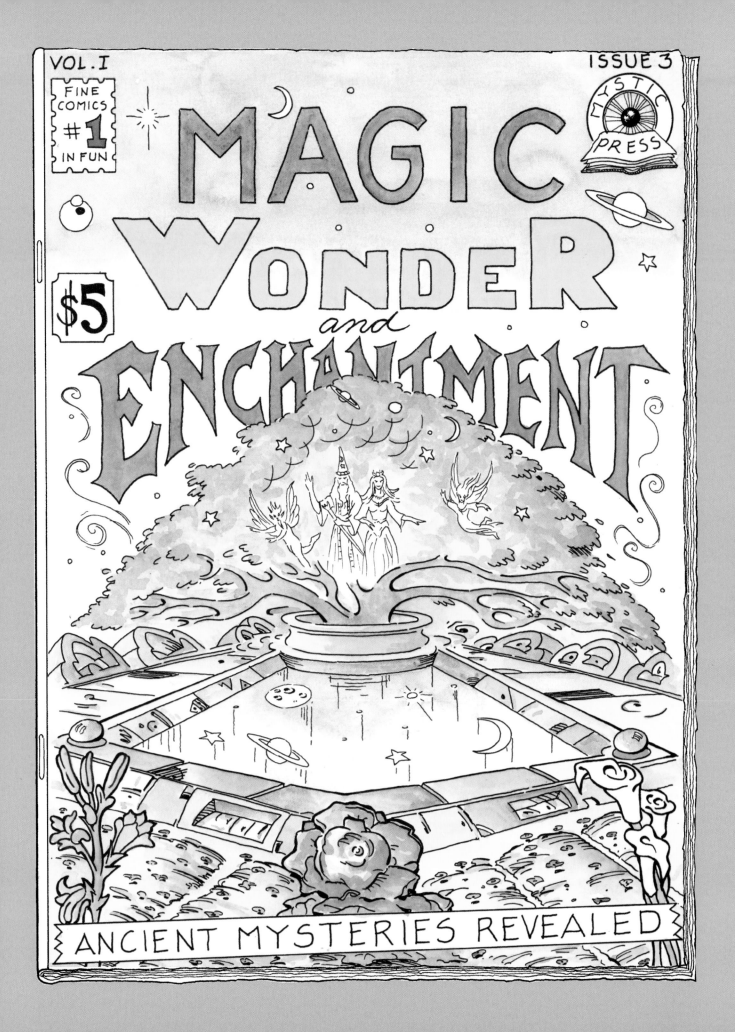

IN THIS ISSUE:

DISCOVER THE *LOST SECRETS* OF THE *ALCHEMIST'S GARDEN*.
No. 1

No. 2
FOLLOW OUR LANDSCAPE DETECTIVES APRIL & ROWAN IN THEIR *QUEST* TO FIND THE MEANING OF THE *METAPHYSICAL GARDEN*.

No. 4
LEARN HOW TO INCORPORATE THE POWER OF YOUR DREAMS IN THE CREATIVE PROCESS.
"I am not CONSCIOUS of myself anymore & IMAGES come to me as if in a DREAM."
VINCENT VAN GOGH

No. 3
UNCOVER THE *MYSTERIES* HIDDEN IN THE *ANCIENT FOREST OF FONTAINEBLEAU* THAT INSPIRED THE 19th cent. *PLEIN AIR PAINTERS*.

MAGIC, WONDER, AND ENCHANTMENT, VOLUME I, ISSUE NUMBER 3. PUBLISHED BY THE UNIVERSITY OF VIRGINIA PRESS, CHARLOTTESVILLE, VIRGINIA, 22904/USA.

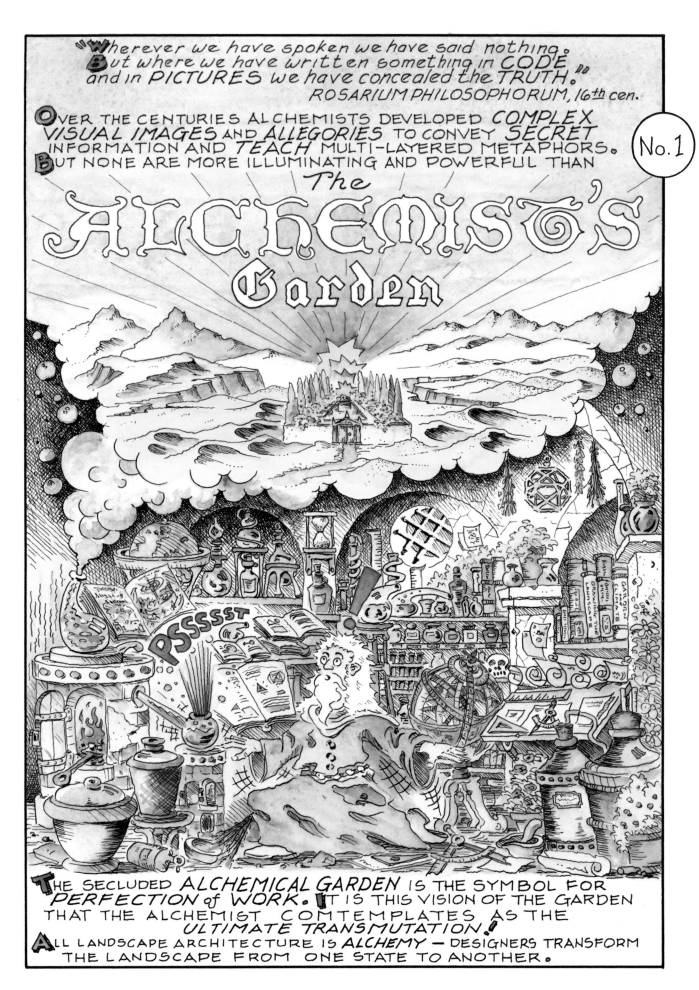

THE ALCHEMIST'S *JOURNEY TO KNOWLEDGE* IS REPRESENTED
BY THE *GARDEN LABYRINTH.* AS TRAVELERS NEGOTIATE
THEIR WAY THROUGH THIS TANGLED MAZE, IT IS VITAL THAT THEY
KEEP THEIR *FOCUS* ON THE *ULTIMATE DESTINATION.*
THOSE WHO WANDER FROM THE PATH LOSE THEIR
ORIENTATION AND FACE A *DANGEROUS FALL* !

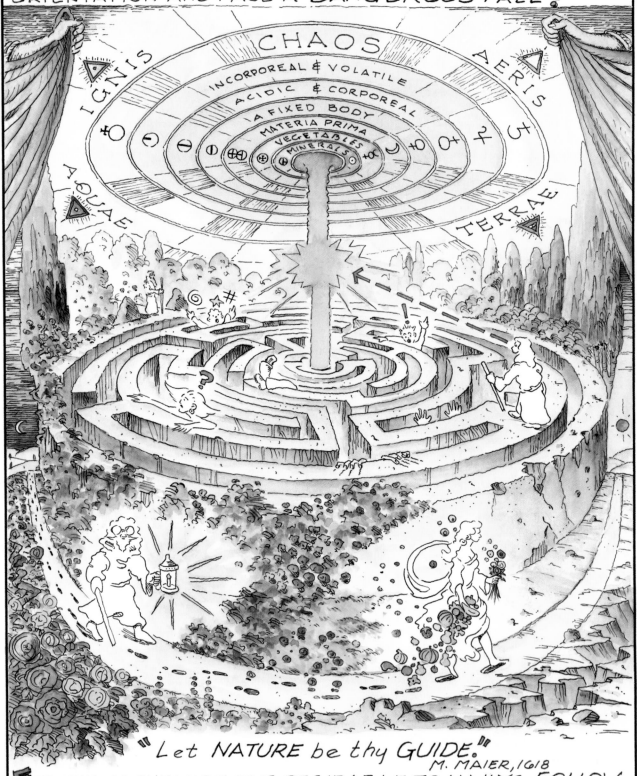

"Let NATURE be thy GUIDE."
M. MAIER, 1618

FOR THE ALCHEMIST IT IS DESIRABLE TO ALWAYS *FOLLOW*
IN THE *FOOTSTEPS OF NATURE.* REASON IS REPRESENTED
BY HIS WALKING STICK, EXPERIENCE BY THE SPECTACLES,
AND THE STUDY OF TEXTS BY THE LANTERN.

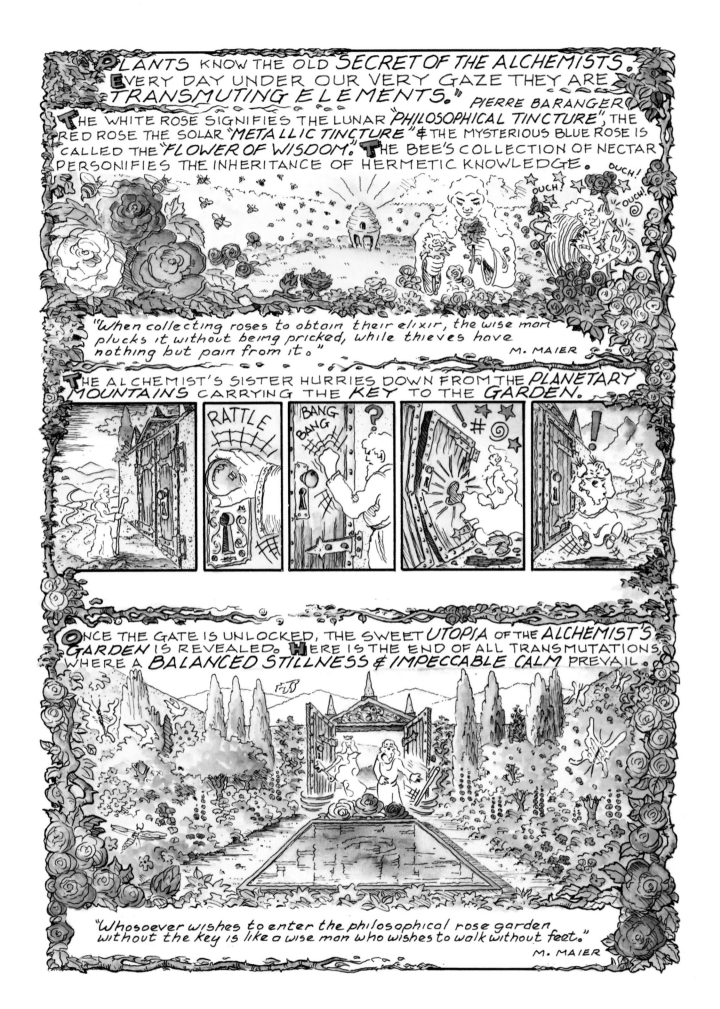

"PLANTS KNOW THE OLD SECRET OF THE ALCHEMISTS. EVERY DAY UNDER OUR VERY GAZE THEY ARE TRANSMUTING ELEMENTS." PIERRE BARANGER

THE WHITE ROSE SIGNIFIES THE LUNAR "PHILOSOPHICAL TINCTURE", THE RED ROSE THE SOLAR "METALLIC TINCTURE" & THE MYSTERIOUS BLUE ROSE IS CALLED THE "FLOWER OF WISDOM." THE BEE'S COLLECTION OF NECTAR PERSONIFIES THE INHERITANCE OF HERMETIC KNOWLEDGE.

OUCH! OUCH! OUCH!

"When collecting roses to obtain their elixir, the wise man plucks it without being pricked, while thieves have nothing but pain from it."
M. MAIER

THE ALCHEMIST'S SISTER HURRIES DOWN FROM THE PLANETARY MOUNTAINS CARRYING THE KEY TO THE GARDEN.

RATTLE

BANG BANG ?

@ *

! !

ONCE THE GATE IS UNLOCKED, THE SWEET UTOPIA OF THE ALCHEMIST'S GARDEN IS REVEALED. HERE IS THE END OF ALL TRANSMUTATIONS, WHERE A BALANCED STILLNESS & IMPECCABLE CALM PREVAIL.

"Whosoever wishes to enter the philosophical rose garden without the key is like a wise man who wishes to walk without feet."
M. MAIER

"IN ALCHEMY, THE LATIN WORD *LABOR* IS USED TO DESCRIBE THE PROCEDURES, METHODS & TECHNIQUES, — THE DAILY STRUGGLE WITH MATERIALS. ALSO IN LATIN, *ORA* MEANS *PRAYER*, & ALCHEMISTS NEVER TIRED OF POINTING OUT THAT *LABOR* & *ORA* SPELL *LABORATORY*. AS IN THE ARTIST'S STUDIO, SO IN THE ALCHEMIST'S LABORATORY: BOTH MINGLE *LABOR* and *ORA*." JAMES ELKINS

LIKEWISE A LANDSCAPE ARCHITECT'S STUDIO CREATES A SIMILAR *REFUGE* WHERE STRUGGLE & FAITH CO-EXIST. THUS AN EXCELLENT METAPHOR & MODE FOR THE PRACTICE OF LANDSCAPE ARCHITECTURE IS THE

ALCHEMIST'S LABORATORY

WORKING IN THE STUDIO MEANS LEAVING THE WORLD OF NORMALCY, RATIONALITY & ORDER OUTSIDE.

INSIDE, THE STUDIO IS ISOLATED, CHAOTIC & DISORDERLY.

OUTSIDE, THE WORLD IS SANE, ANTISEPTIC & COMFORTABLE.

INSIDE, IT IS A DAILY STRUGGLE OF OBSESSION, EXPLORATION & A DESPERATE SEARCH FOR CREATIVE SOLUTIONS.

TRUE ART CANNOT ARISE FROM COMPLACENCY, CONTENTMENT, NOR LUXURY, BUT FROM THE *FIRES OF THE CRUCIBLE.*

COMPREHENDING THE *ALCHEMICAL MYSTERIES OF METAMORPHOSIS* CAN BENEFIT THE LANDSCAPE ARCHITECT IN HIS OR HER STUDY OF ECOSYSTEMS. LIKE AN *ALCHEMICAL QUEST*, THE DESIGN PROCESS IS A *PATHWAY TO ILLUMINATION.*

"BY CALLING A THING TO MIND, ITS SPIRIT MANIFESTS ITSELF THROUGH [ONE'S] HAND & PALETTE." GUY OGILVY — *THE ALCHEMIST'S KITCHEN*

THE END

WANT TO KNOW THE ANSWER TO OUR LAST ISSUE'S *LANDSCAPE PUZZLE?* WELL, HERE IT IS!

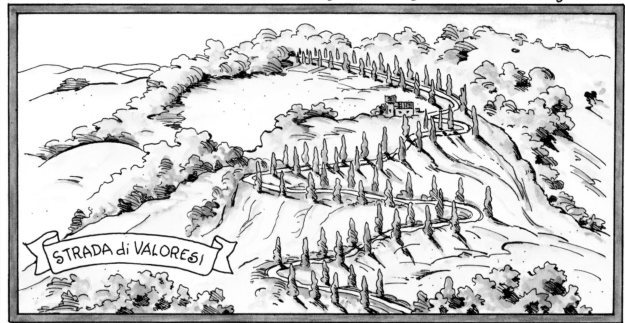

STRADA di VALORESI

Q: **WHAT** RENAISSANCE PAINTING INSPIRED THE DESIGN OF THIS 20th CENT. *TUSCAN LANDSCAPE,* THE "*STRADA di VALORESI*"?

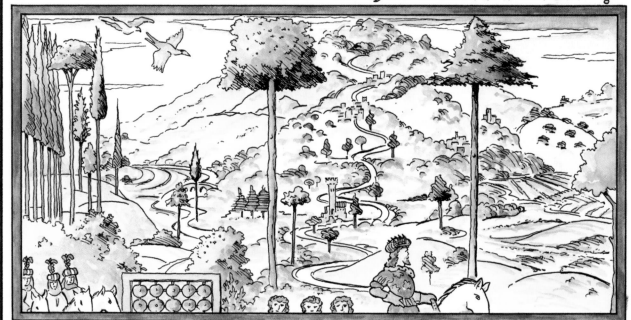

A: "*PROCESSION OF THE MAGI*" by BENOZZO GOZZOLI, 1459 CHAPEL OF THE MAGI, FLORENCE, PALAZZO MEDICI-RICCARDI. THIS LANDSCAPE PANORAMA IS PART OF A CONTINUOUS FRESCO CYCLE REPRESENTING THE "*PROCESSION OF THE MAGI*" WHILE PORTRAYING MANY MEMBERS OF THE MEDICI FAMILY & IMPORTANT DIGNITARIES WHO ARRIVED FOR THE *CONSUL OF FLORENCE* IN 1438-1439. THE MEDICI FAMILY FACILITATED THE RECONCILIATION BETWEEN THE CATHOLIC & BYZANTINE CHURCHES. LA FOCE, LOCATED IN THE *VAL d'ORCIA, TUSCANY,* WAS PURCHASED IN 1924 BY ANTONIO & IRIS ORIGO, WHO DEVOTED THEIR LIFE TO IMPROVING THE LANDSCAPE. THEY HIRED CECIL PINSENT TO DESIGN THE GARDENS. ANTONIO ORIGO LAID OUT THE NOW ICONIC & FAMOUS STRADA di VALORESI, INSPIRED BY GOZZOLI'S PAINTING.

VISUAL QUIZ

CAN YOU FIND YOUR WAY THROUGH THE *GARDEN LABYRINTH* ON YOUR *JOURNEY OF KNOWLEDGE* TO ARRIVE AT THE *ALCHEMIST'S ULTIMATE DESTINATION*?

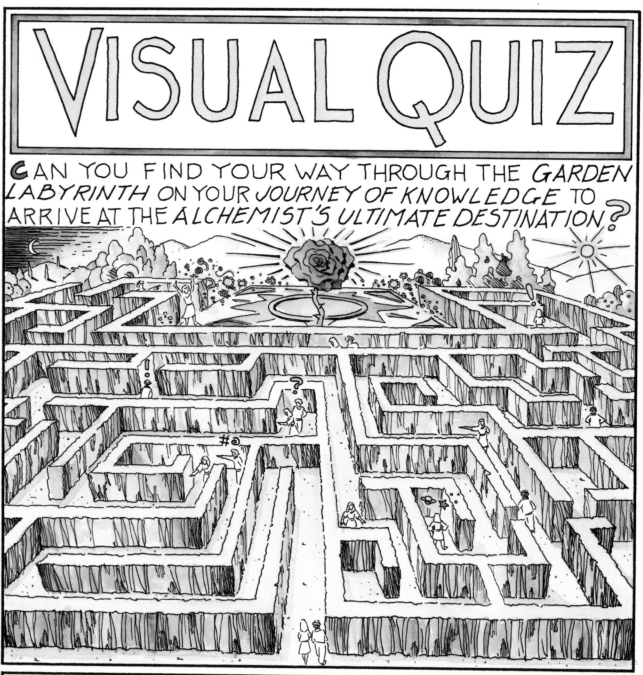

THE ANSWERS TO OUR LAST ISSUE'S VISUAL QUIZ:
"*FIND THE 5 FACES OF THE FAMOUS 17th CENT. LANDSCAPE PAINTERS*"

1. NICOLAS POUSSIN
2. CLAUDE LORRAIN
3. SALVATOR ROSA
4. IL DOMENICHINO
5. PIETRO da CORTONA
6. PAUL BRILL

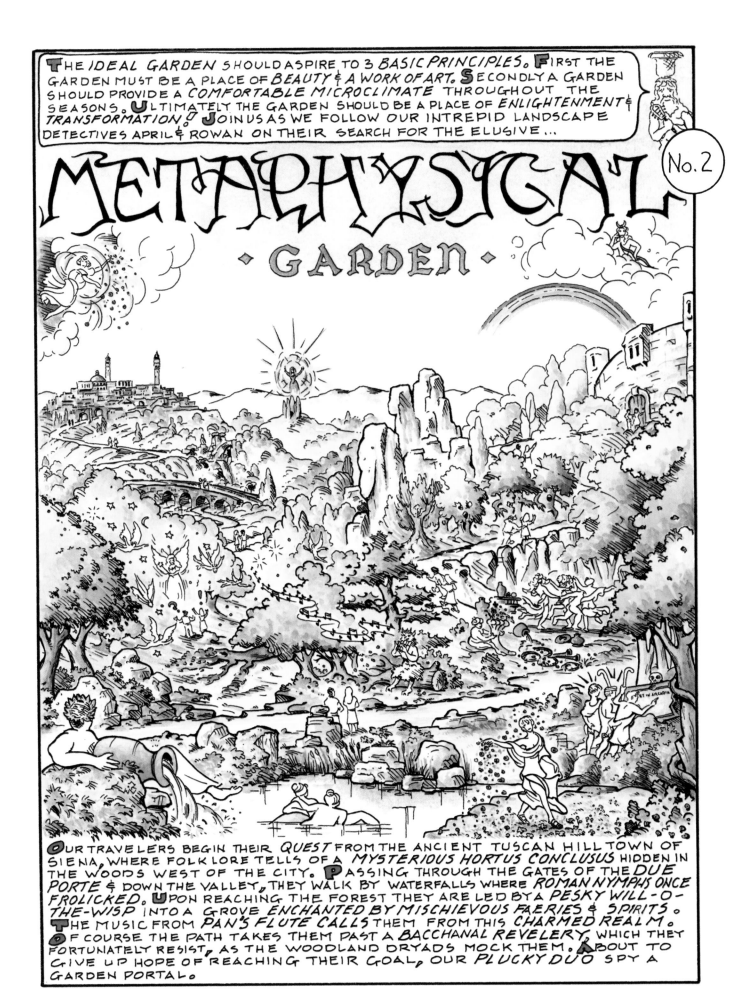

THE IDEAL GARDEN SHOULD ASPIRE TO 3 BASIC PRINCIPLES. FIRST THE GARDEN MUST BE A PLACE OF BEAUTY & A WORK OF ART. SECONDLY A GARDEN SHOULD PROVIDE A COMFORTABLE MICROCLIMATE THROUGHOUT THE SEASONS. ULTIMATELY THE GARDEN SHOULD BE A PLACE OF ENLIGHTENMENT & TRANSFORMATION. JOIN US AS WE FOLLOW OUR INTREPID LANDSCAPE DETECTIVES APRIL & ROWAN ON THEIR SEARCH FOR THE ELUSIVE...

METAPHYSICAL

· GARDEN ·

No. 2

OUR TRAVELERS BEGIN THEIR QUEST FROM THE ANCIENT TUSCAN HILL TOWN OF SIENA, WHERE FOLKLORE TELLS OF A MYSTERIOUS HORTUS CONCLUSUS HIDDEN IN THE WOODS WEST OF THE CITY. PASSING THROUGH THE GATES OF THE DUE PORTE & DOWN THE VALLEY, THEY WALK BY WATERFALLS WHERE ROMAN NYMPHS ONCE FROLICKED. UPON REACHING THE FOREST THEY ARE LED BY A PESKY WILL-O-THE-WISP INTO A GROVE ENCHANTED BY MISCHIEVOUS FAERIES & SPIRITS. THE MUSIC FROM PAN'S FLUTE CALLS THEM FROM THIS CHARMED REALM. OF COURSE THE PATH TAKES THEM PAST A BACCHANAL REVELERY, WHICH THEY FORTUNATELY RESIST, AS THE WOODLAND DRYADS MOCK THEM. ABOUT TO GIVE UP HOPE OF REACHING THEIR GOAL, OUR PLUCKY DUO SPY A GARDEN PORTAL.

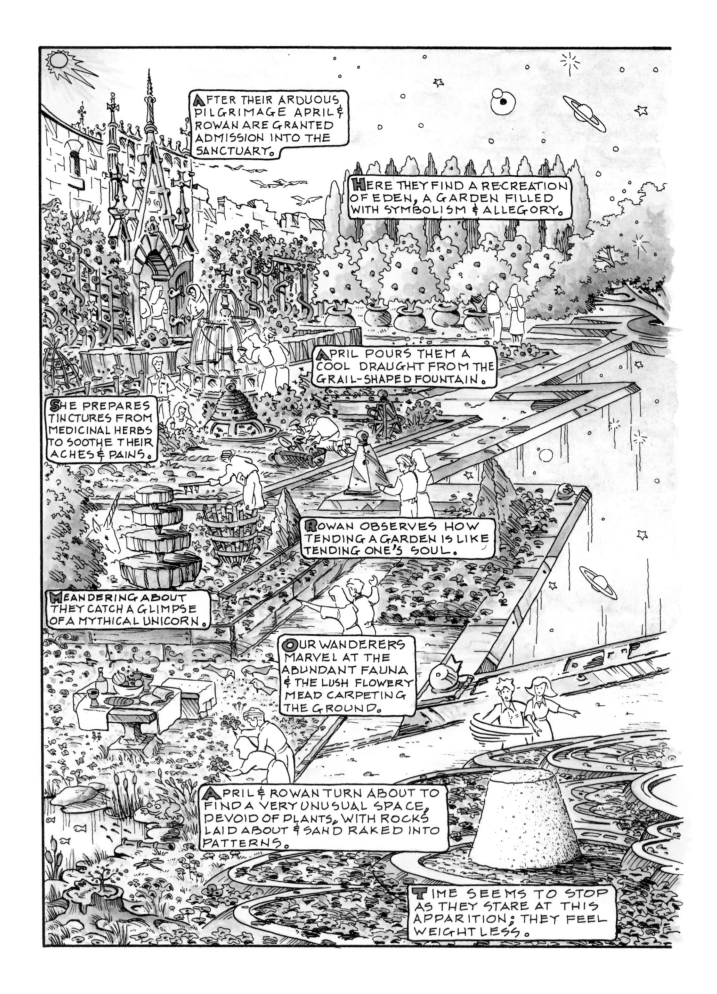

AFTER THEIR ARDUOUS PILGRIMAGE APRIL & ROWAN ARE GRANTED ADMISSION INTO THE SANCTUARY.

HERE THEY FIND A RECREATION OF EDEN, A GARDEN FILLED WITH SYMBOLISM & ALLEGORY.

APRIL POURS THEM A COOL DRAUGHT FROM THE GRAIL-SHAPED FOUNTAIN.

SHE PREPARES TINCTURES FROM MEDICINAL HERBS TO SOOTHE THEIR ACHES & PAINS.

ROWAN OBSERVES HOW TENDING A GARDEN IS LIKE TENDING ONE'S SOUL.

MEANDERING ABOUT THEY CATCH A GLIMPSE OF A MYTHICAL UNICORN.

OUR WANDERERS MARVEL AT THE ABUNDANT FAUNA & THE LUSH FLOWERY MEAD CARPETING THE GROUND.

APRIL & ROWAN TURN ABOUT TO FIND A VERY UNUSUAL SPACE, DEVOID OF PLANTS, WITH ROCKS LAID ABOUT & SAND RAKED INTO PATTERNS.

TIME SEEMS TO STOP AS THEY STARE AT THIS APPARITION; THEY FEEL WEIGHTLESS.

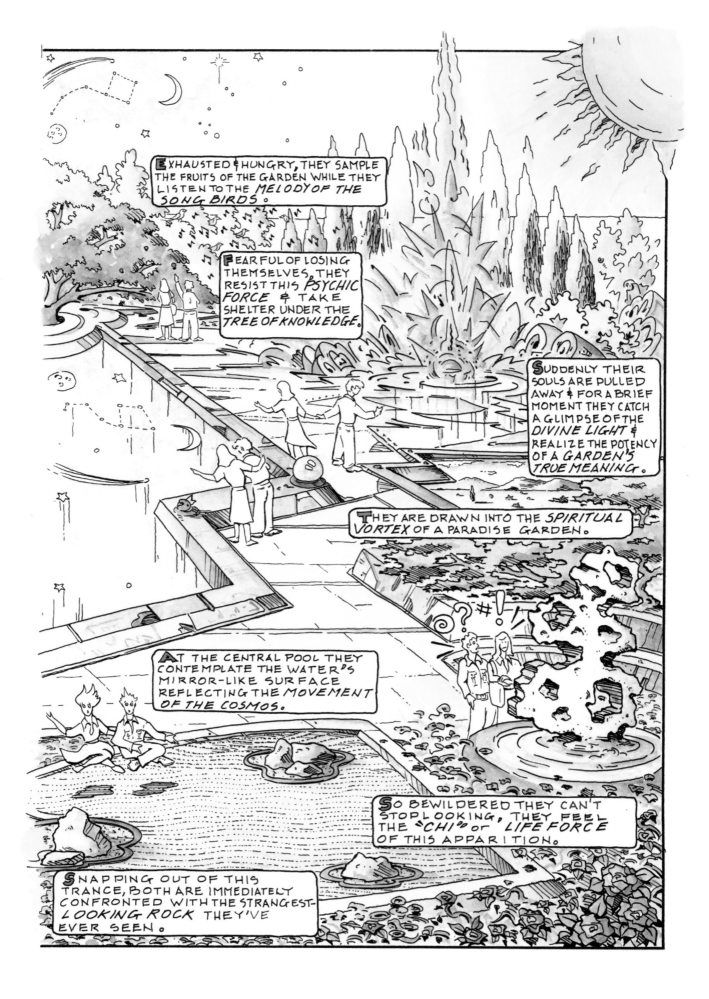

91

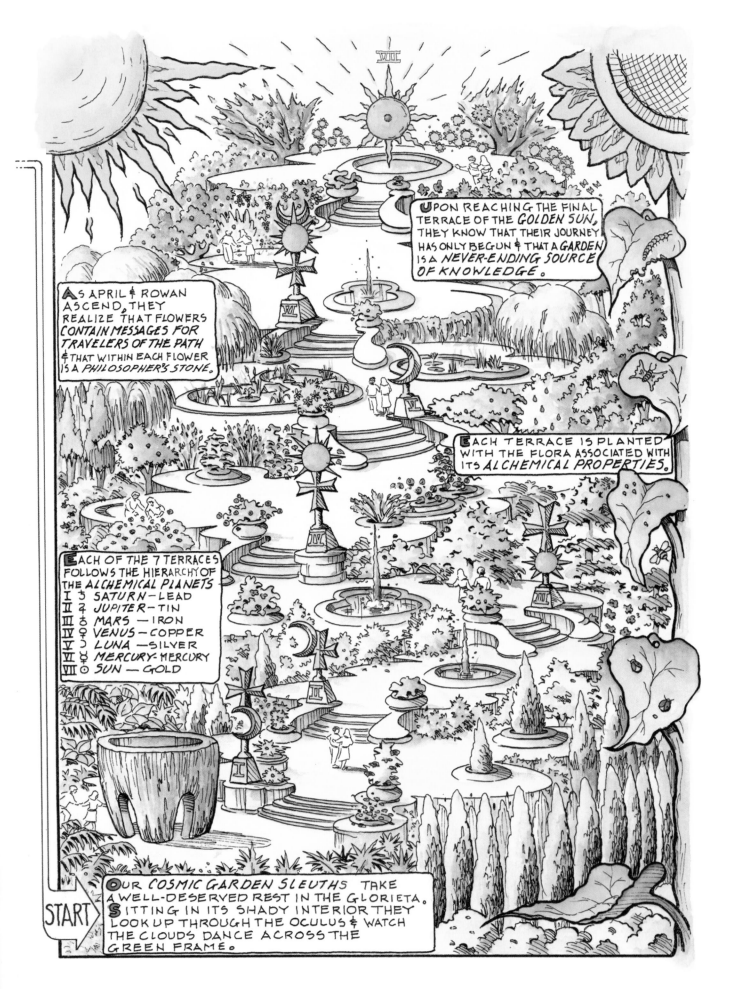

UPON REACHING THE FINAL TERRACE OF THE *GOLDEN SUN*, THEY KNOW THAT THEIR JOURNEY HAS ONLY BEGUN & THAT A *GARDEN* IS A *NEVER-ENDING SOURCE OF KNOWLEDGE*.

AS APRIL & ROWAN ASCEND, THEY REALIZE THAT FLOWERS *CONTAIN MESSAGES FOR TRAVELERS OF THE PATH* & THAT WITHIN EACH FLOWER IS A *PHILOSOPHER'S STONE*.

EACH TERRACE IS PLANTED WITH THE FLORA ASSOCIATED WITH ITS *ALCHEMICAL PROPERTIES*.

EACH OF THE 7 TERRACES FOLLOWS THE HIERARCHY OF THE *ALCHEMICAL PLANETS*
I ♄ *SATURN* — LEAD
II ♃ *JUPITER* — TIN
III ♂ *MARS* — IRON
IV ♀ *VENUS* — COPPER
V ☽ *LUNA* — SILVER
VI ☿ *MERCURY* — MERCURY
VII ☉ *SUN* — GOLD

OUR *COSMIC GARDEN SLEUTHS* TAKE A WELL-DESERVED REST IN THE GLORIETA. SITTING IN ITS SHADY INTERIOR THEY LOOK UP THROUGH THE OCULUS & WATCH THE CLOUDS DANCE ACROSS THE GREEN FRAME.

START

THE ROOTS OF THE FLOWER RUN DEEP. **W**HY DO WE MAKE OFFERINGS ON THE ALTARS OF OUR GODS? WHY DO WE GIVE FLOWERS TO OUR LOVED ONES? **T**HE METAPHORIC PROPERTIES OF THE FLOWER CAN BE SEEN AS A BLUEPRINT FOR CHANGE AND ENVIRONMENTAL CONSCIOUSNESS. **W**HAT IS THE TRUE MEANING OF THE FLOWER & **W**HY DO WE GIVE FLOWERS TO OUR LOVED & THE SYMBOLIC AND METAPHOR FOR THE SECRETS OF THE UNIVERSE. THE FLOWER CAN BE INTERPRETED AS A MINIATURE REPRESENTATION OF THE UNIVERSE.

WHAT IS THIS ?

...AS DESIGNERSAL IS TO ATTE... ...TO REINTEGRATE ...LOST CONCEPT... SPIRITUAL IN GA... ...IGN & COMBINE ...ELEMENTS OFTY WITH ...COLOGICAL ...ESS. **B**Y STUDYING THE MYSTICISM & SYMBOLISMTORIC GA... ...SCAPES WE CAN PRODUCE NEW WAYS TO ACHIEV... ...ETT... ...NCE BETWEEN HUMANS & NATURE.

OUR GREEN FUTURE LIES IN...

93

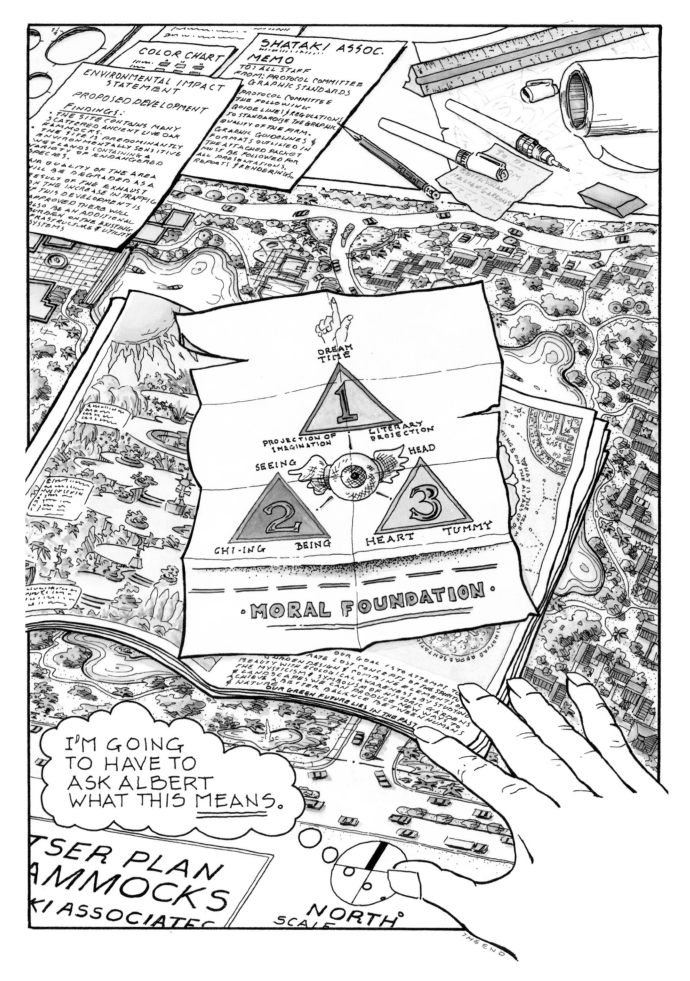

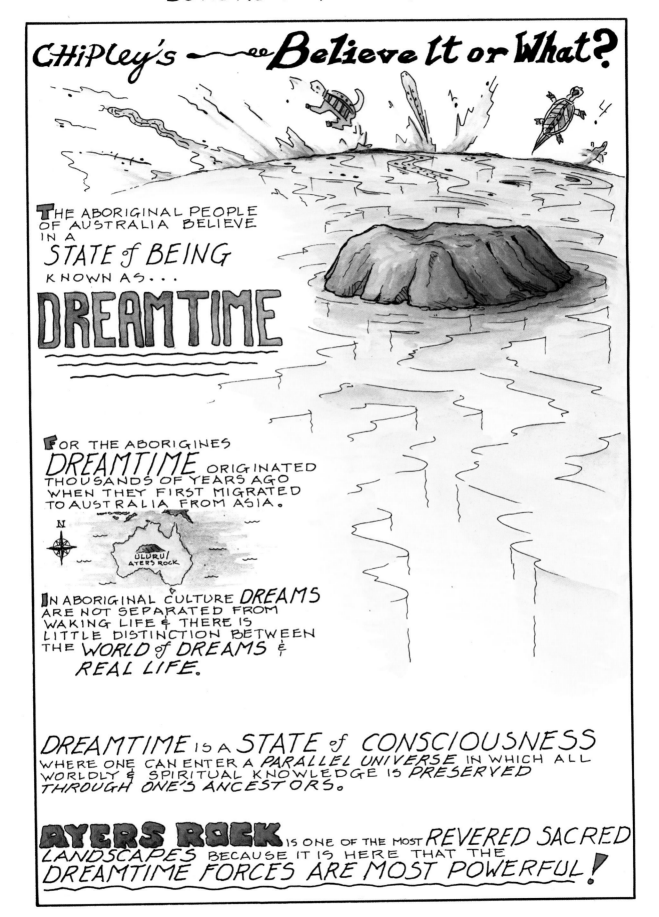

16th CENTURY INFORMATION RETRIEVAL DEVICE

HAVING TROUBLE KEEPING UP WITH ALL YOUR REFERENCES?

PERHAPS IT'S TIME TO REINTRODUCE THE **MULTI-BOOK READING WHEEL** — IT'S GREAT FOR VIEWING MULTIPLE IMAGES, & IS A CONVENIENT WAY TO CROSS-REFERENCE ABOUT A DOZEN BOOKS WITHOUT HAVING TO OPEN & CLOSE THEIR COVERS EACH TIME.

THIS MACHINE IS ESPECIALLY HANDY DURING THE *CREATIVE PROCESS*.

THE *BOOKWHEEL* WAS INVENTED IN THE 16th CENTURY BY THE ENGINEER AGOSTINO RAMELLI BUT WAS NOT BUILT UNTIL MUCH LATER.

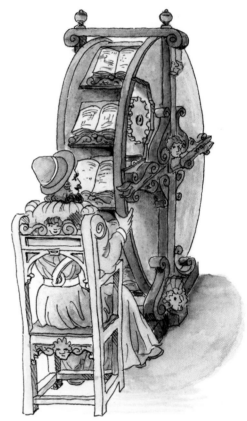

AGOSTINO RAMELLI
BOOK WHEEL, 16th cent.

THE ORIGINAL BOOK WHEEL HAS BEEN REFERRED TO AS THE *"KINDLE OF THE 16th CENTURY."* **T**HE ONE PICTURED ON THE LEFT WAS BUILT BY DANIEL LIBESKIND'S STUDENTS FOR THE 1986 *VENICE BIENNALE*. **H**OWEVER, IT WAS DESTROYED BY A TERRORIST BOMB IN A STORAGE FACILITY IN VENICE.

"I GUESS THERE ARE NEVER ENOUGH BOOKS, ... ONE OF THE FEW AUTHENTIC MAGICS OUR SPECIES HAS CREATED."
JOHN STEINBECK

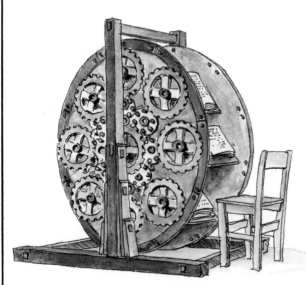

DANIEL LIBESKIND'S READING MACHINE 1986

THE TIME IS RIGHT FOR ITS REEMERGENCE!

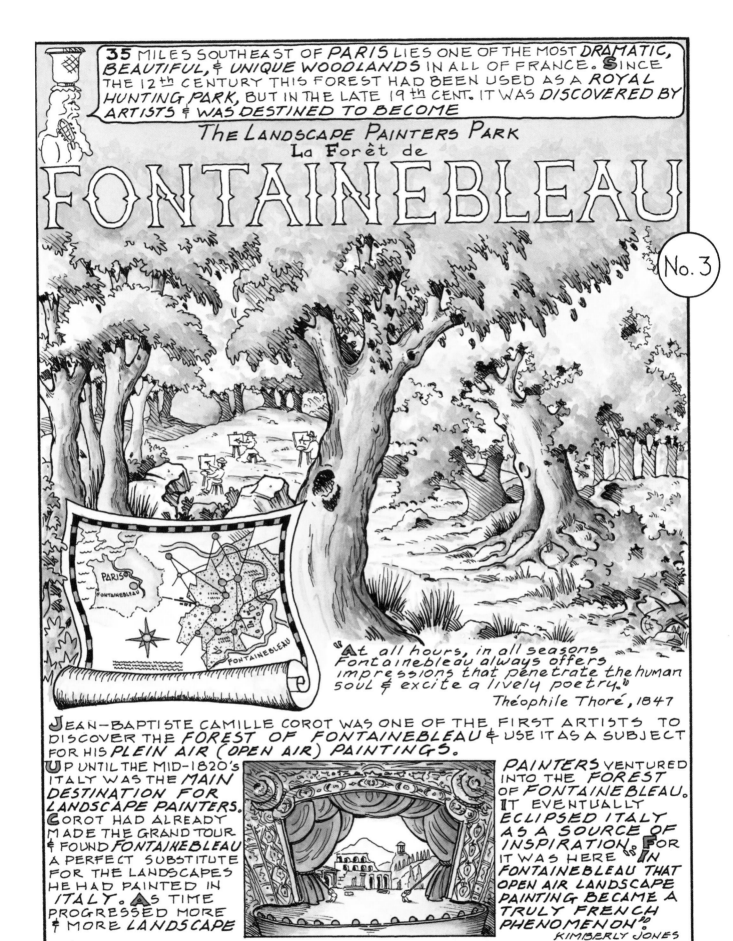

35 MILES SOUTHEAST OF *PARIS* LIES ONE OF THE MOST *DRAMATIC, BEAUTIFUL, & UNIQUE WOODLANDS* IN ALL OF FRANCE. SINCE THE 12th CENTURY THIS FOREST HAD BEEN USED AS A *ROYAL HUNTING PARK*, BUT IN THE LATE 19th CENT. IT WAS *DISCOVERED BY ARTISTS & WAS DESTINED TO BECOME*

The Landscape Painters Park
La Forêt de

FONTAINEBLEAU

No. 3

"At all hours, in all seasons Fontainebleau always offers impressions that penetrate the human soul & excite a lively poetry."
Théophile Thoré, 1847

JEAN-BAPTISTE CAMILLE COROT WAS ONE OF THE *FIRST ARTISTS* TO DISCOVER THE *FOREST OF FONTAINEBLEAU* & USE IT AS A SUBJECT FOR HIS *PLEIN AIR (OPEN AIR) PAINTINGS.*

UP UNTIL THE MID-1820's ITALY WAS THE *MAIN DESTINATION FOR LANDSCAPE PAINTERS.* COROT HAD ALREADY MADE THE GRAND TOUR & FOUND *FONTAINEBLEAU* A PERFECT SUBSTITUTE FOR THE LANDSCAPES HE HAD PAINTED IN *ITALY.* AS TIME PROGRESSED MORE & MORE *LANDSCAPE* *PAINTERS* VENTURED INTO THE *FOREST* OF *FONTAINEBLEAU.* IT EVENTUALLY *ECLIPSED ITALY* AS A SOURCE OF *INSPIRATION.* FOR IT WAS HERE IN *FONTAINEBLEAU* THAT OPEN AIR LANDSCAPE PAINTING BECAME A *TRULY FRENCH PHENOMENON."*
KIMBERLY JONES

THUS THE CURTAIN CLOSES ON ITALY AS A MECCA FOR THE PLEIN AIR PAINTERS.

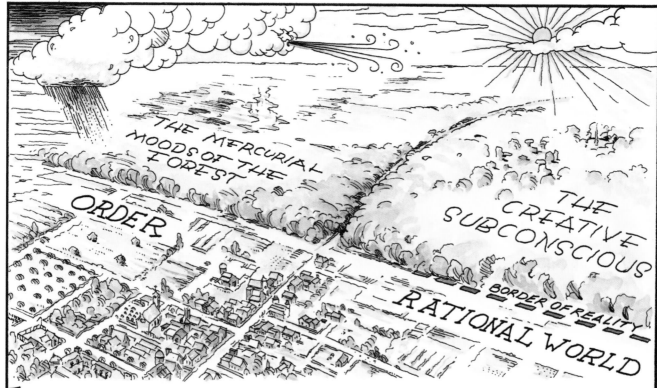

THE MERCURIAL MOODS OF THE FOREST

ORDER

THE CREATIVE SUBCONSCIOUS

BORDER OF REALITY

RATIONAL WORLD

FROM 1820 INTO THE EARLY 1870s THE FOREST OF FONTAINEBLEAU BECAME THE PRIMARY SETTING FOR ALMOST ALL OF THE FRENCH *PLEIN AIR PAINTERS*. THE FOREST, WITH ITS DRAMATIC VIEWS, GIGANTIC ANCIENT TREES & DIVERSE ECOSYSTEMS, PROVIDED AN *ENDLESS VARIETY OF POTENTIAL COMPOSITIONS* WAITING TO BE DISCOVERED. AROUND THE 1830s A *VIBRANT ARTISTS COMMUNITY* EMERGED ALONG THE WESTERN EDGE OF THE FOREST IN THE VILLAGE OF BARBIZON.

• BARBIZON •

It is here in Barbizon that one can plainly discern the division between the rational order of the town & the agricultural fields as they abut the edge of the *WILD, MYSTERIOUS FOREST*. From the security of their lodgings in Barbizon the artists made their pilgrimage into the forest to seek *KNOWLEDGE*, confront the *ELUSIVE MUSES* & find enlightenment through the act of painting.

IN BARBIZON THE "AUBERGE GANNE" BECAME THE MAIN COMMUNAL CENTER FOR ARTISTS PAINTING IN THE FOREST & OFFERED THEM INEXPENSIVE DORMITORY—STYLE ROOMS. DINNER WAS INCLUDED & THE ARTISTS RECEIVED A *PRE-PACKED LUNCH* IN A LINEN TOTE FOR THEIR *SOJOURNS INTO THE FOREST*. IN THE EVENING THE HOTEL WOULD BECOME A SALON OF SORTS WHERE AFTER A DAY OF PAINTING THE ARTISTS WOULD GATHER FOR AN EVENING OF EATING, DRINKING & LIVELY DISCUSSIONS.

THE *EXTREME VARIATIONS* IN TOPOGRAPHY & THE *BIZARRE ROCK FORMATIONS* CAPTIVATED & SPARKED THE *IMAGINATIONS* OF THE ARTISTS. MANY OF THE DISTINCTIVE BOULDERS HAVE THE APPEARANCE OF *STYLIZED ANIMALS OR HUMAN FORM.* IT WAS RUMORED THAT SOMETIMES THE PLEIN AIR ARTISTS COULD SENSE THE PRESENCE OF *DRUID PRIESTS* & *CELTS* WATCHING THEM PAINT FROM BEHIND THE ROCK OUTCROPPINGS. THESE SENSATIONS WERE HEIGHTENED BY THE RAPIDLY SHIFTING LIGHT, MYSTERIOUS SHADOWS & STRANGE GUSTS OF AIR.

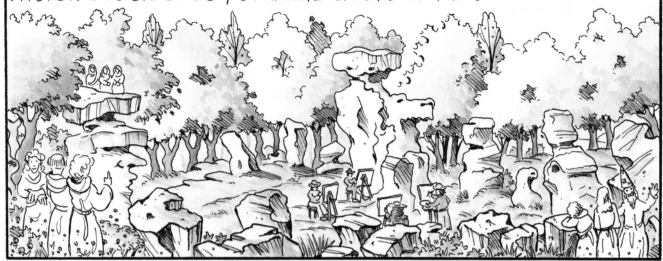

EXTRAORDINARY GEOLOGICAL SPECTACLES

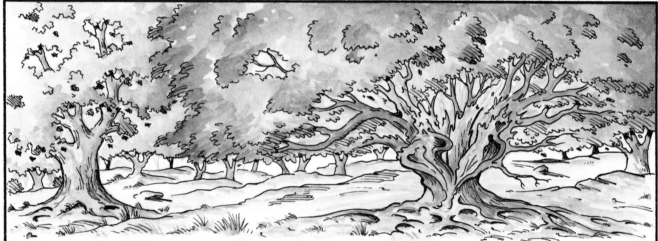

WITHIN THE OLD-GROWTH FOREST THE ARTIST COULD OBSERVE & PAINT NATURE IN ITS RAW & UNSPOILED STATE. THE *EERIE, ETERNAL SILENCE* OF THE WOODS COULD INDUCE A *STATE OF REVERENCE* & AWE WHERE PAINTING BECAME AN ACT OF *DEVOTION.* THE FOREST WAS BELIEVED TO BE A *LIVING ENTITY* & WAS A FAVORITE SUBJECT FOR THE PAINTERS. THE "*BODMER OAK*" DUBBED "*THE SACRED TREE*" BY ART CRITIC THEOPHILE THORÉ, BECAME THE STANDARD SUBJECT ON WHICH PAINTERS ESTABLISHED THEIR STATURE. ROUSSEAU'S PAINTINGS, IMBUED WITH A *SENSE OF THE METAPHYSICAL,* WERE A *MEDITATION ON NATURE* AS HE SOUGHT TO CAPTURE THE *SPIRIT OF THE EARTH.*

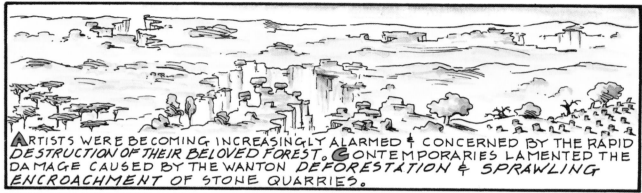

ARTISTS WERE BECOMING INCREASINGLY ALARMED & CONCERNED BY THE RAPID *DESTRUCTION OF THEIR BELOVED FOREST.* CONTEMPORARIES LAMENTED THE DAMAGE CAUSED BY THE WANTON *DEFORESTATION & SPRAWLING ENCROACHMENT* OF STONE QUARRIES.

UNCONTROLLED RAMPAGE OF STONE QUARRIES EPIDEMIC

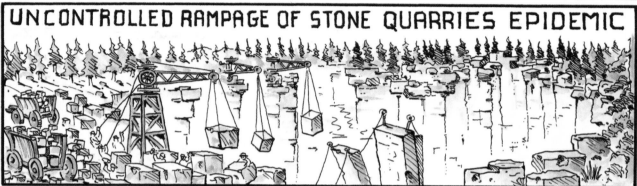

MASSIVE DESTRUCTION OF ANCIENT FOREST ESCALATING

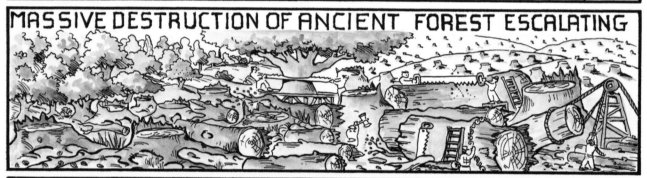

IN 1852 ROUSSEAU SUBMITTED A PETITION TO EMPEROR NAPOLEON III ON BEHALF OF ALL ARTISTS TO *PROTECT THE FOREST* FROM FURTHER *DEVASTATION,* CITING THE DESTRUCTION OF THE OLD TREES...
"*WHICH FOR THE ARTIST ARE THE SOURCE FROM WHICH THEY DERIVE THEIR INSPIRATION, THEIR JOY & THEIR FUTURE.*"

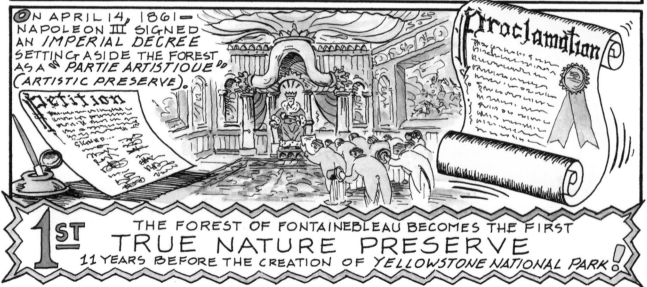

ON APRIL 14, 1861— NAPOLEON III SIGNED AN *IMPERIAL DECREE* SETTING ASIDE THE FOREST AS A "*PARTIE ARTISTIQUE*" (ARTISTIC PRESERVE).

Petition

Proclamation

1ST THE FOREST OF FONTAINEBLEAU BECOMES THE FIRST **TRUE NATURE PRESERVE** 11 YEARS BEFORE THE CREATION OF *YELLOWSTONE NATIONAL PARK* !

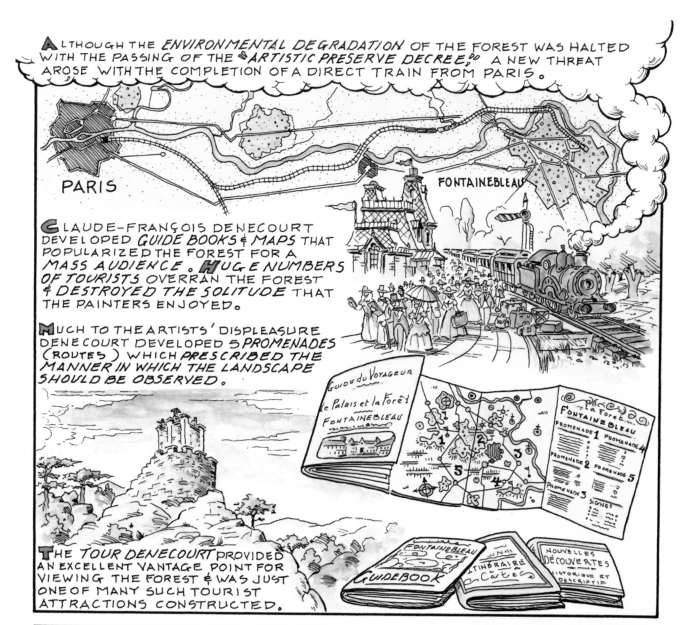

ALTHOUGH THE *ENVIRONMENTAL DEGRADATION* OF THE FOREST WAS HALTED WITH THE PASSING OF THE "*ARTISTIC PRESERVE DECREE*," A NEW THREAT AROSE WITH THE COMPLETION OF A DIRECT TRAIN FROM PARIS.

PARIS

FONTAINEBLEAU

CLAUDE-FRANÇOIS DENECOURT DEVELOPED *GUIDE BOOKS & MAPS* THAT POPULARIZED THE FOREST FOR A *MASS AUDIENCE*. HUGE NUMBERS OF TOURISTS OVERRAN THE FOREST & *DESTROYED THE SOLITUDE* THAT THE PAINTERS ENJOYED.

MUCH TO THE ARTISTS' DISPLEASURE DENECOURT DEVELOPED 5 *PROMENADES* (ROUTES) WHICH *PRESCRIBED THE MANNER IN WHICH THE LANDSCAPE SHOULD BE OBSERVED*.

THE *TOUR DENECOURT* PROVIDED AN EXCELLENT VANTAGE POINT FOR VIEWING THE FOREST & WAS JUST ONE OF MANY SUCH TOURIST ATTRACTIONS CONSTRUCTED.

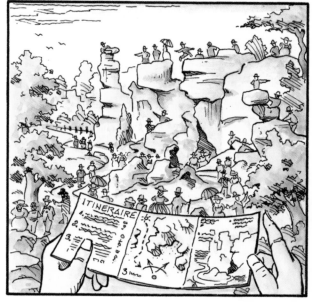

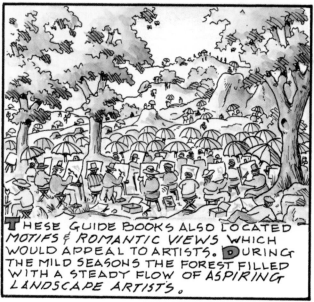

THESE GUIDE BOOKS ALSO LOCATED *MOTIFS & ROMANTIC VIEWS* WHICH WOULD APPEAL TO ARTISTS. DURING THE MILD SEASONS THE FOREST FILLED WITH A STEADY FLOW OF *ASPIRING LANDSCAPE ARTISTS*.

FOR ALMOST 40 YEARS FONTAINEBLEAU WAS A UNIQUE *EXPERIMENTAL OPEN-AIR LABORATORY* FOR LANDSCAPE PAINTERS. YET, AS DID THE ITALIAN LANDSCAPE, THE FOREST FADED AS AN ESSENTIAL PILGRIMAGE FOR PLEIN AIR PAINTERS. *MANY OF US HAVE PASSED ARCADIAN DAYS THERE & MOVED ON, BUT YET LEFT A PORTION OF OUR SOULS BEHIND US BURIED IN THE WOODS... THEY WILL RETURN TO WALK IN IT AT NIGHT IN THE FONDEST OF THEIR DREAMS.* ROBERT LOUIS STEVENSON 1896

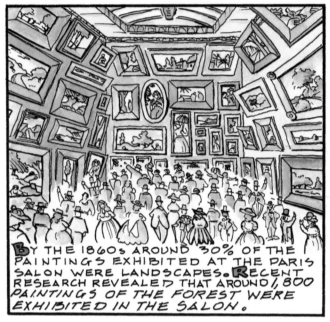

BY THE 1860s AROUND 30% OF THE PAINTINGS EXHIBITED AT THE PARIS SALON WERE LANDSCAPES. RECENT RESEARCH REVEALED THAT AROUND 1,800 PAINTINGS OF THE FOREST WERE EXHIBITED IN THE SALON.

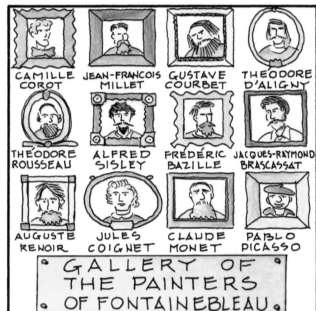

CAMILLE COROT — JEAN-FRANCOIS MILLET — GUSTAVE COURBET — THEODORE D'ALIGNY

THEODORE ROUSSEAU — ALFRED SISLEY — FRÉDÉRIC BAZILLE — JACQUES-RAYMOND BRASCASSAT

AUGUSTE RENOIR — JULES COIGNET — CLAUDE MONET — PABLO PICASSO

GALLERY OF THE PAINTERS OF FONTAINEBLEAU

JEAN-FRANCOIS MILLET "THE SHEPHERDESS" 1870-1874

MILLET SETTLED IN BARBIZON IN 1847 & MAINTAINED A STUDIO THERE THROUGHOUT HIS LIFETIME. HE WAS INSPIRED BY THE STRUGGLES OF THE LOCAL PEASANTS. THE POVERTY OF THEIR SITUATION WAS EXPRESSED IN HIS PAINTINGS & HAD A PROFOUND INFLUENCE ON VAN GOGH, WHO ADAPTED MILLET'S THEMES & EXPRESSIVE LINE WORK!

VINCENT VAN GOGH "THE SOWER" 1888

THE FOREST WOULD REMAIN A NECESSARY DESTINATION IN THE EDUCATION OF AN ARTIST FOR DECADES TO COME. SUCH PAINTERS AS PAUL CÉZANNE, GEORGES SEURAT, ODILON REDON, & EVEN PABLO PICASSO FOLLOWED IN THE HALLOWED FOOTSTEPS OF PREVIOUS PAINTERS OF THE FOREST. MANY OF THE YOUNG IMPRESSIONISTS HAD WORKED INTENSIVELY IN THE FOREST DURING THE MID-1860s & THEIR EXPERIMENTS THERE *FORMED THE FOUNDATIONS FOR THE REVOLUTION OF IMPRESSIONISM.* FOR HALF A CENTURY, THE FOREST OF FONTAINEBLEAU HAD BEEN THE PREMIER CENTER FOR ARTISTIC EXPERIMENTATION — THE CRUCIBLE IN WHICH THE *MODERN LANDSCAPE WAS FORGED."* KIMBERLY JONES

THE END

DREAMS HAVE PLAYED AN *INSTRUMENTAL ROLE* IN THE *ARTISTIC PROCESS* & INFLUENCED *LANDSCAPE DESIGN.* THIS IS EVIDENT IN THE ENIGMATIC *"HYPNEROTOMACHIA POLIPHILI,"* WRITTEN IN 1499. THE TEXT DESCRIBES POLIPHILO'S DREAM LANDSCAPES, WHICH ACCORDING TO GEORGINA MASSON *"Exercised profound influence on GARDEN DESIGN."* DREAMS HAVE THE POTENTIAL TO HELP US TAP INTO A WELLSPRING OF CREATIVITY. WE CAN BROADEN OUR RANGE OF INSPIRATION BY SEEKING DESIGN SOLUTIONS THROUGH...

No. 4

DREAMING the LANDSCAPE

THE BIBLIOTECA LAURENZIANA IN FLORENCE IS A *HAUNTING, SURREAL SPACE.* THIS ACHIEVEMENT IS EVEN MORE REMARKABLE WHEN WE REALIZE THAT THE *FLUID, ETHEREAL FORMS* OF THE STAIRCASE CAME TO MICHELANGELO IN A *DREAM!*

MICHELANGELO MODELED HIS IDEA IN CLAY AND PRESENTED HIS DRAWINGS TO POPE LEO & CARDINAL GIULIO de MEDICI. THE PROJECT WAS APPROVED & COMPLETED in 1559.

SURREALISM WAS PROBABLY THE FIRST ART MOVEMENT TO *EMBRACE DREAMING* AS A KEY SOURCE OF CONTENT FOR PAINTING. ANDRÉ BRETON WROTE IN AN EARLY MANIFESTO THAT SURREALISM WAS BASED ON "*THE SUPREME AUTHORITY OF THE DREAM.*" SALVADOR DALI WAS KNOWN TO FALL ASLEEP IN HIS STUDIO THEN <u>*JUMP UP*</u> *& IMMEDIATELY PAINT WHAT HE DREAMT.*

 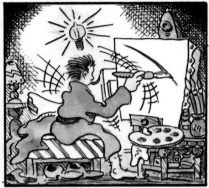

CAUTION! DON'T TRY THIS AT WORK!

MANY CONTEMPORARY LANDSCAPE ARCHITECTS & PLANNERS HAVE BEEN ABLE TO REGULATE THEIR *CREATIVE DREAMING* TO THE NIGHTTIME & TO USE THEIR *DREAMSCAPES* TO INSPIRE THEIR WORK.

MARCIA McNALLY HAD A DREAM WHERE SHE ENCOUNTERED AN OLD MAN WHO SHOWED HER A ROOM OF WALL-TO-WALL LICENSE PLATES. SHE SAW A WYOMING LICENSE PLATE WITH RED PAINTED BRONCOS. SHE TOLD RANDY HESTER HER DREAM, & HE STARTED COLLECTING WY. LICENSE PLATES. HE PAINTED THE FIGURES RED & CONSTRUCTED A *GARDEN WALL WITH THEM.*

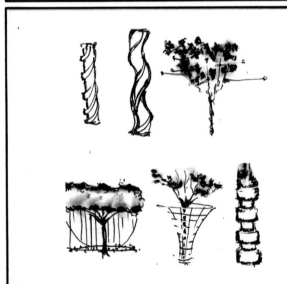

ROBERT HEWITT BEGAN STUDYING DREAM THEORY & DESIGN AS A GRADUATE STUDENT. ABOVE ARE HIS *DREAM DRAWINGS* OF TREE & TOPIARY FORMS THAT INFLUENCED HIS PROPOSED DESIGN OF A LIVING HIEROGLYPHIC WALL IN LUXOR, EGYPT.

CHERYL BARTON HAS KEPT A *DREAM JOURNAL* FOR OVER 20 YEARS. AT THE ONSET OF A PROJECT CHERYL OFTEN HAS A *REPEATING DREAM* OF FINDING HER WAY THROUGH A SERIES OF *ESCHER-LIKE SPACES.* THESE ENCLOSURES BECOME PROGRESSIVELY BIGGER AS SHE MAKES HER WAY UPWARDS ALONG TRICKY STAIRS. THE SMOOTHER HER *CREATIVE PROCESS* THE FASTER SHE ARRIVES AT THE SUMMIT & ITS PANORAMA.

DAVID MEYER OFTEN INCORPORATES ELEMENTS FROM HIS DREAMS INTO HIS *LANDSCAPE DESIGNS*. BELOW IS ONE OF DAVID'S *DREAM LANDSCAPES* THAT HAS INSPIRED HIS WORK.

HOW TO INTEGRATE YOUR DREAMS INTO THE
= DESIGN PROCESS =

THERE ARE MANY DIFFERENT TYPES OF DREAMS, BUT WITH PRACTICE & A FEW SIMPLE PROCEDURES *DREAMING* CAN BECOME A USEFUL *TOOL* FOR INSPIRING DESIGN.

(1) MAKE SURE YOU HAVE A *SKETCHBOOK* & *PEN* NEXT TO YOUR BED.

(2) BEFORE FALLING ASLEEP *FOCUS* ON THE DESIGN PROBLEM YOU ARE WORKING ON. SAY TO YOURSELF THAT YOU ARE GOING TO *REMEMBER* YOUR DREAM.

(3) WAKE UP IN YOUR DREAM & LOOK AT YOUR *HANDS*. PROJECT YOURSELF INTO THE *DREAM LANDSCAPE*.

(4) UPON WAKING — TRY & *REPLAY* YOUR DREAM A COUPLE OF TIMES BEFORE GETTING OUT OF BED.

(5) IMMEDIATELY DRAW A PLAN VIEW WHICH MAPS THE SPACES IN THE *SEQUENCES* THEY OCCURED. NEXT DRAW THE SIGNIFICANT DETAILS IN ELEVATION or PERSPECTIVE. DATE & TITLE YOUR DREAM.

REMEMBER— EVEN IF SOME IDEAS MIGHT SEEM IRRELEVANT, YOU ARE COLLECTING A *CATALOGUE of IDEAS* FOR FUTURE USE.

DURING A DREAM ANYTHING IS POSSIBLE

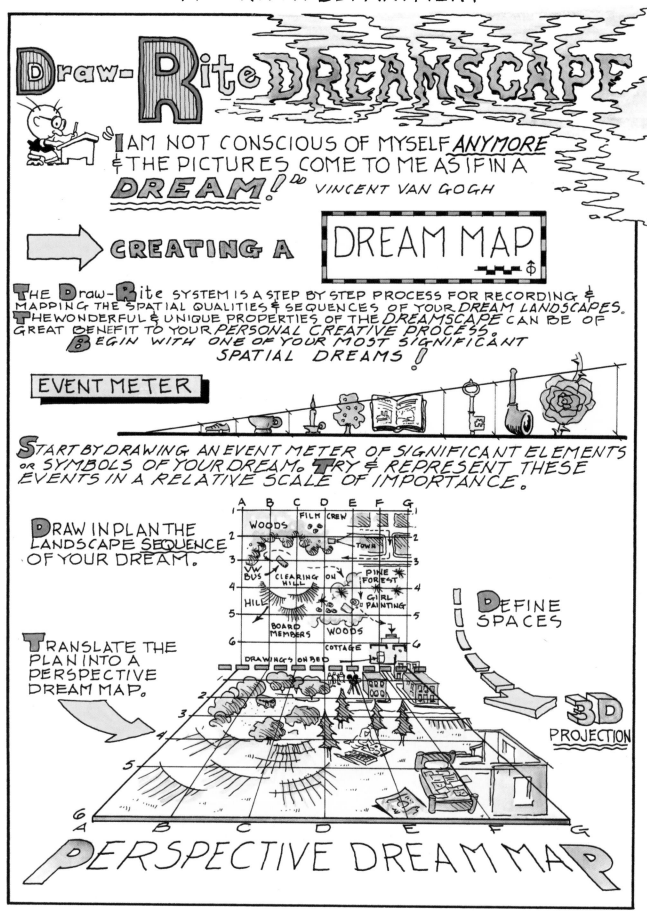

Draw-Rite DREAMSCAPE

"I AM NOT CONSCIOUS OF MYSELF *ANYMORE* & THE PICTURES COME TO ME AS IF IN A *DREAM!*" VINCENT VAN GOGH

CREATING A DREAM MAP

THE Draw-Rite SYSTEM IS A STEP BY STEP PROCESS FOR RECORDING & MAPPING THE SPATIAL QUALITIES & SEQUENCES OF YOUR *DREAM LANDSCAPES.* THE WONDERFUL & UNIQUE PROPERTIES OF THE *DREAMSCAPE* CAN BE OF GREAT BENEFIT TO YOUR *PERSONAL CREATIVE PROCESS.* BEGIN WITH ONE OF YOUR MOST SIGNIFICANT SPATIAL DREAMS!

EVENT METER

START BY DRAWING AN EVENT METER OF SIGNIFICANT ELEMENTS OR SYMBOLS OF YOUR DREAM. TRY & REPRESENT THESE EVENTS IN A RELATIVE SCALE OF IMPORTANCE.

DRAW IN PLAN THE LANDSCAPE SEQUENCE OF YOUR DREAM.

TRANSLATE THE PLAN INTO A PERSPECTIVE DREAM MAP.

DEFINE SPACES

3D PROJECTION

PERSPECTIVE DREAM MAP

106

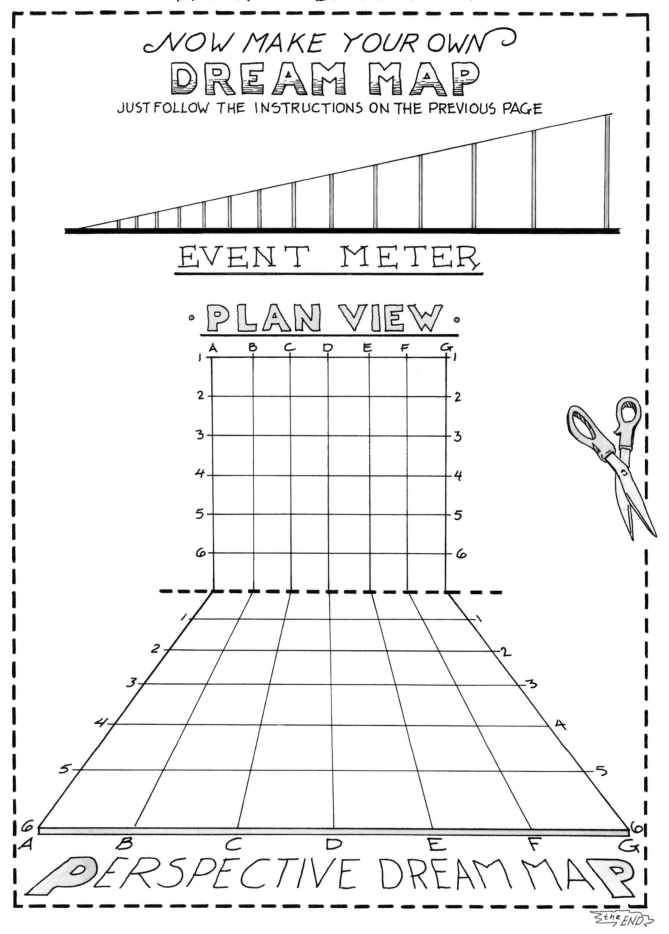

NOW MAKE YOUR OWN
DREAM MAP
JUST FOLLOW THE INSTRUCTIONS ON THE PREVIOUS PAGE

EVENT METER

· PLAN VIEW ·

PERSPECTIVE DREAM MAP

the END

IN 18th CENTURY ENGLAND *WATERCOLOR PAINTING* ACHIEVED THE STATUS OF *A MATURE PAINTING MEDIUM*. J.M.W. TURNER'S USE OF WATER COLOR ESTABLISHED HIM AS ONE OF THE *GREATEST LANDSCAPE PAINTERS OF ALL TIME*. TODAY, MASTERING THE BASICS OF WATERCOLOR PAINTING IS AN ESSENTIAL MEANS TO *CAPTURING RESPONSIVE IMPRESSIONS OF YOUR ENVIRONMENT*. THE FOLLOWING PAGES PRESENT A SERIES OF CONCISE EXERCISES & A HEARTY...

Welcome

TO

THE WONDERFUL WORLD

OF

WATERCOLOR

IT'S

SCIENTIFIC *and* ENTERTAINING!

IN ALCHEMY **WATER** (*SOLUTIO*) REPRESENTS THE RETURN TO THE *SUBCONSCIOUS*. THUS THROUGH THE ACT OF *WATERCOLOR PAINTING* WE CAN *UNLEASH THE INTUITIVE POWER OF THE SUBCONSCIOUS*.

– BASIC MATERIALS –

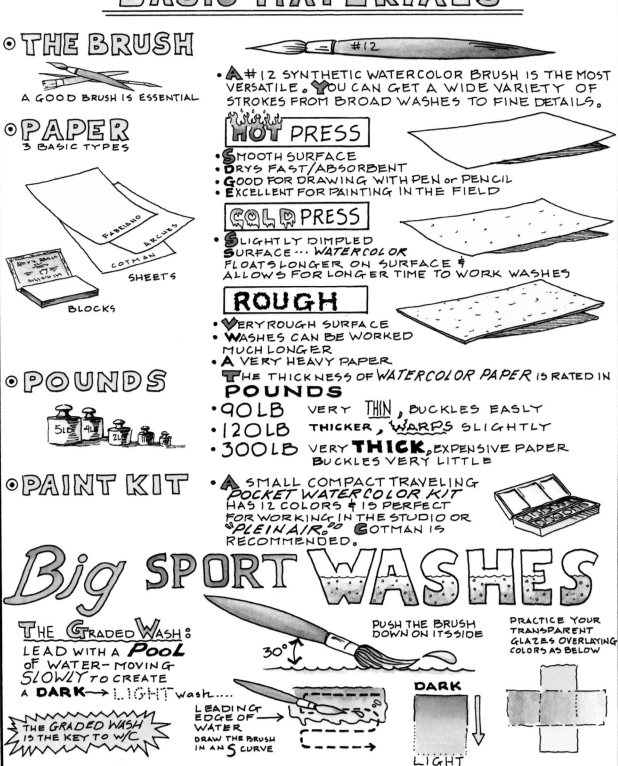

● THE BRUSH

A GOOD BRUSH IS ESSENTIAL

• A #12 SYNTHETIC WATERCOLOR BRUSH IS THE MOST VERSATILE. YOU CAN GET A WIDE VARIETY OF STROKES FROM BROAD WASHES TO FINE DETAILS.

● PAPER

3 BASIC TYPES

FABRIANO ARCHES COTMAN SHEETS

BLOCKS

HOT PRESS
• SMOOTH SURFACE
• DRYS FAST/ABSORBENT
• GOOD FOR DRAWING WITH PEN or PENCIL
• EXCELLENT FOR PAINTING IN THE FIELD

COLD PRESS
• SLIGHTLY DIMPLED SURFACE... WATERCOLOR FLOATS LONGER ON SURFACE & ALLOWS FOR LONGER TIME TO WORK WASHES

ROUGH
• VERY ROUGH SURFACE
• WASHES CAN BE WORKED MUCH LONGER
• A VERY HEAVY PAPER

● POUNDS

T THE THICKNESS OF *WATERCOLOR PAPER* IS RATED IN **POUNDS**
• 90 LB VERY THIN, BUCKLES EASLY
• 120 LB THICKER, WARPS SLIGHTLY
• 300 LB VERY **THICK**, EXPENSIVE PAPER BUCKLES VERY LITTLE

● PAINT KIT

• A SMALL COMPACT TRAVELING *POCKET WATERCOLOR KIT* HAS 12 COLORS & IS PERFECT FOR WORKING IN THE STUDIO OR "PLEIN AIR." COTMAN IS RECOMMENDED.

Big SPORT WASHES

THE Graded Wash:
LEAD WITH A **Pool** of WATER– MOVING *SLOWLY* TO CREATE A **DARK** → LIGHT wash....

THE *GRADED WASH* IS THE KEY TO W/C

30° PUSH THE BRUSH DOWN ON ITS SIDE

LEADING EDGE OF WATER
DRAW THE BRUSH IN AN S CURVE

DARK
LIGHT

PRACTICE YOUR TRANSPARENT GLAZES OVERLAYING COLORS AS BELOW

Granulated Wash:
FLOAT THE COLOR IN A POOL OF WATER —
THE PIGMENT SEPARATES FROM ITS BINDER & DROPS OUT & FALLS INTO THE PAPER DIMPLES, CREATING A SOFT... STIPPLED... GRANULATED WASH

BIG BUBBLE of WATER

GRANULATED WASH

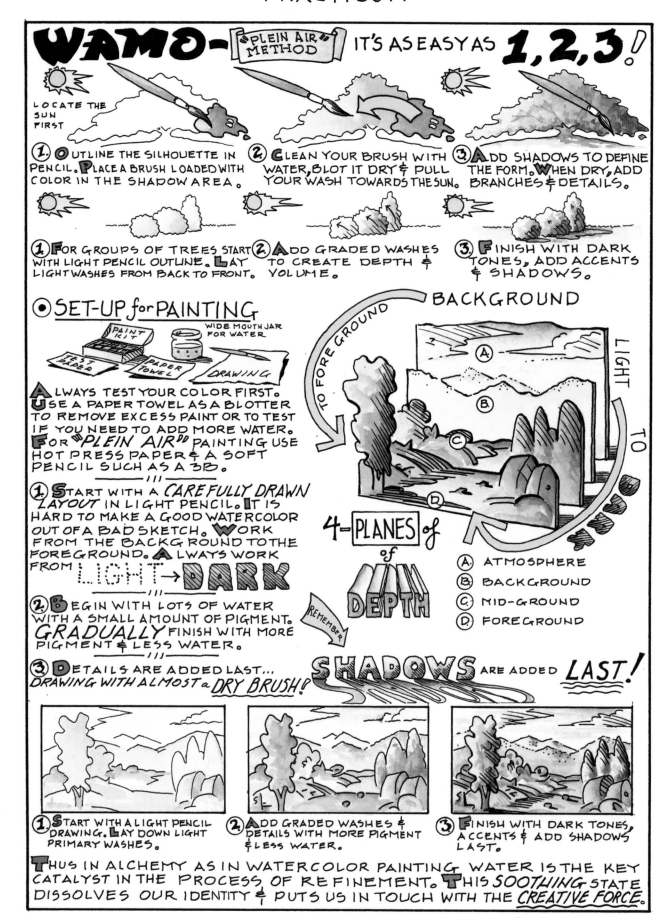

WAMO— "PLEIN AIR" METHOD — IT'S AS EASY AS 1, 2, 3!

LOCATE THE SUN FIRST

1. **O**UTLINE THE SILHOUETTE IN PENCIL. **P**LACE A BRUSH LOADED WITH COLOR IN THE SHADOW AREA.

2. **C**LEAN YOUR BRUSH WITH WATER, BLOT IT DRY & PULL YOUR WASH TOWARDS THE SUN.

3. **A**DD SHADOWS TO DEFINE THE FORM. WHEN DRY, ADD BRANCHES & DETAILS.

1. **F**OR GROUPS OF TREES START WITH LIGHT PENCIL OUTLINE. **L**AY LIGHT WASHES FROM BACK TO FRONT.

2. **A**DD GRADED WASHES TO CREATE DEPTH & VOLUME.

3. **F**INISH WITH DARK TONES, ADD ACCENTS & SHADOWS.

● SET-UP for PAINTING

PAINT KIT
WIDE MOUTH JAR FOR WATER
TEST PAPER
PAPER TOWEL
DRAWING

ALWAYS TEST YOUR COLOR FIRST. **U**SE A PAPER TOWEL AS A BLOTTER TO REMOVE EXCESS PAINT OR TO TEST IF YOU NEED TO ADD MORE WATER. **F**OR "PLEIN AIR" PAINTING USE HOT PRESS PAPER & A SOFT PENCIL SUCH AS A 3B.

1. **S**TART WITH A *CAREFULLY DRAWN LAYOUT* IN LIGHT PENCIL. IT IS HARD TO MAKE A GOOD WATERCOLOR OUT OF A BAD SKETCH. **W**ORK FROM THE BACKGROUND TO THE FOREGROUND. **A**LWAYS WORK FROM LIGHT → DARK

2. **B**EGIN WITH LOTS OF WATER WITH A SMALL AMOUNT OF PIGMENT. *GRADUALLY* FINISH WITH MORE PIGMENT & LESS WATER.

3. **D**ETAILS ARE ADDED LAST... *DRAWING WITH ALMOST a DRY BRUSH!*

BACKGROUND
TO FORE GROUND
LIGHT TO DARK

4 = PLANES of DEPTH

REMEMBER

(A) ATMOSPHERE
(B) BACKGROUND
(C) MID-GROUND
(D) FOREGROUND

SHADOWS ARE ADDED LAST!

1. **S**TART WITH A LIGHT PENCIL DRAWING. **L**AY DOWN LIGHT PRIMARY WASHES.

2. **A**DD GRADED WASHES & DETAILS WITH MORE PIGMENT & LESS WATER.

3. **F**INISH WITH DARK TONES, ACCENTS & ADD SHADOWS LAST.

THUS IN ALCHEMY AS IN WATERCOLOR PAINTING WATER IS THE KEY CATALYST IN THE PROCESS OF REFINEMENT. **T**HIS *SOOTHING* STATE DISSOLVES OUR IDENTITY & PUTS US IN TOUCH WITH THE *CREATIVE FORCE.*

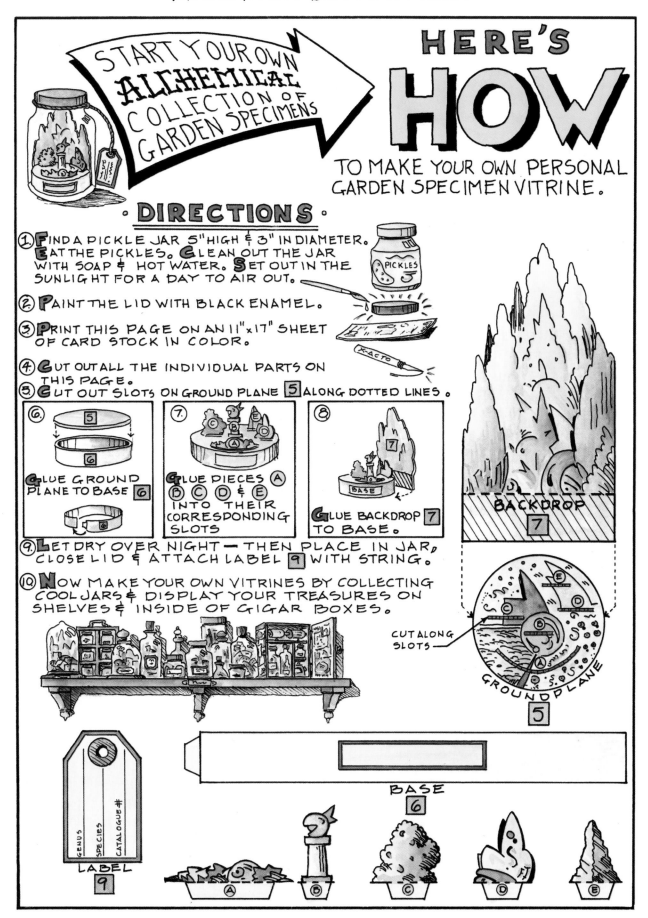

START YOUR OWN **ALCHEMICAL** COLLECTION OF GARDEN SPECIMENS

HERE'S **HOW**

TO MAKE YOUR OWN PERSONAL GARDEN SPECIMEN VITRINE.

· DIRECTIONS ·

①. FIND A PICKLE JAR 5" HIGH & 3" IN DIAMETER. EAT THE PICKLES. CLEAN OUT THE JAR WITH SOAP & HOT WATER. SET OUT IN THE SUNLIGHT FOR A DAY TO AIR OUT.

②. PAINT THE LID WITH BLACK ENAMEL.

③. PRINT THIS PAGE ON AN 11"x17" SHEET OF CARD STOCK IN COLOR.

④. CUT OUT ALL THE INDIVIDUAL PARTS ON THIS PAGE.

⑤. CUT OUT SLOTS ON GROUND PLANE 5 ALONG DOTTED LINES.

⑥. GLUE GROUND PLANE TO BASE 6

⑦. GLUE PIECES A B C D & E INTO THEIR CORRESPONDING SLOTS

⑧. GLUE BACKDROP 7 TO BASE.

⑨. LET DRY OVER NIGHT — THEN PLACE IN JAR, CLOSE LID & ATTACH LABEL 9 WITH STRING.

⑩. NOW MAKE YOUR OWN VITRINES BY COLLECTING COOL JARS & DISPLAY YOUR TREASURES ON SHELVES & INSIDE OF CIGAR BOXES.

PICKLES

BACKDROP 7

CUT ALONG SLOTS

GROUND PLANE 5

GENUS SPECIES CATALOGUE #

LABEL 9

BASE 6

A B C D E

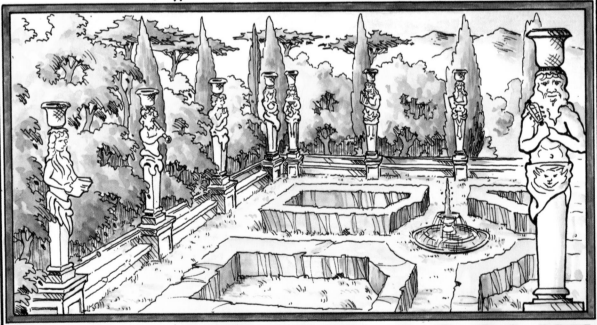

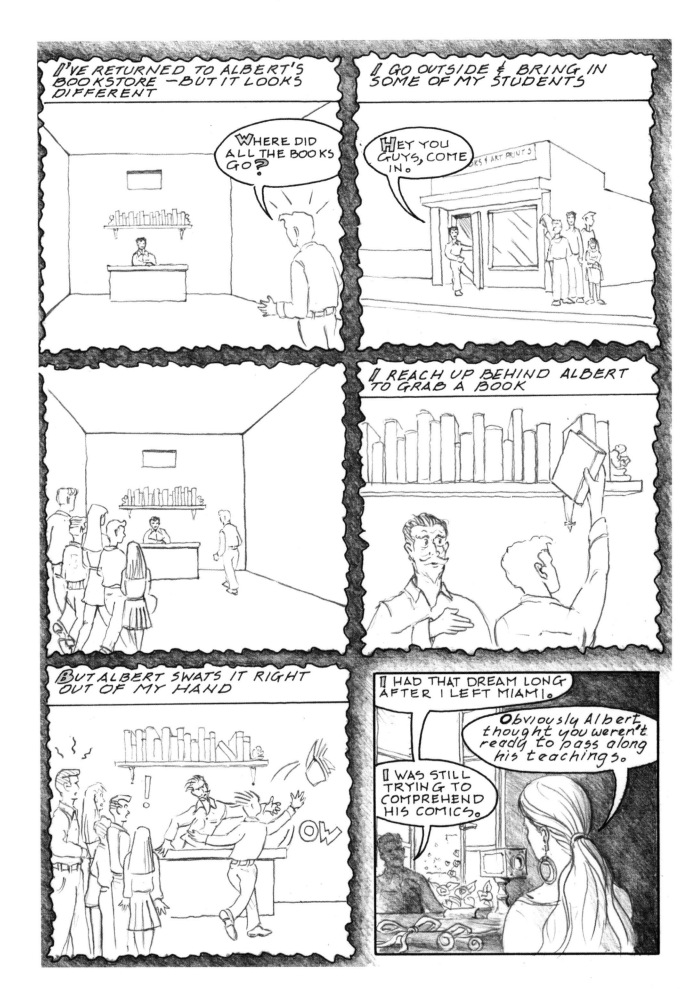

109



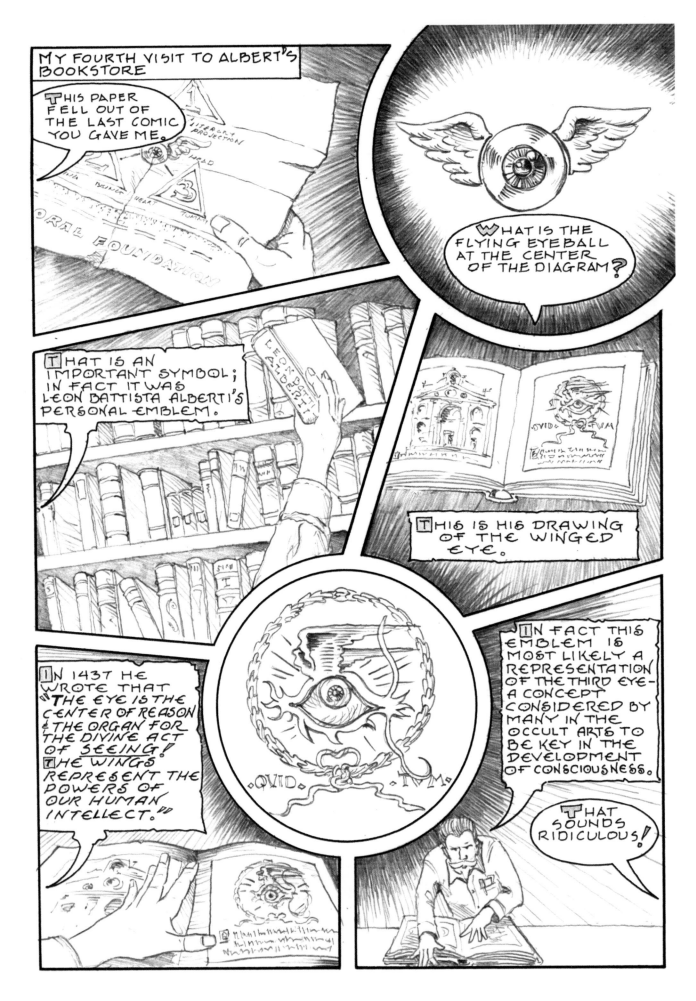

115

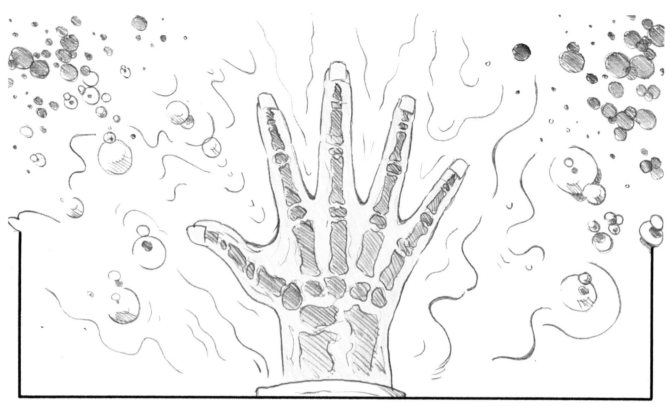

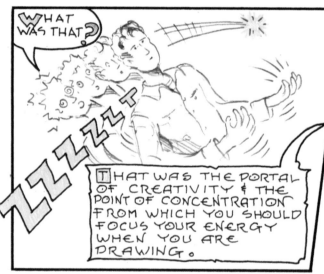

WHAT WAS THAT?

ZZZZZT

THAT WAS THE PORTAL OF CREATIVITY & THE POINT OF CONCENTRATION FROM WHICH YOU SHOULD FOCUS YOUR ENERGY WHEN YOU ARE DRAWING.

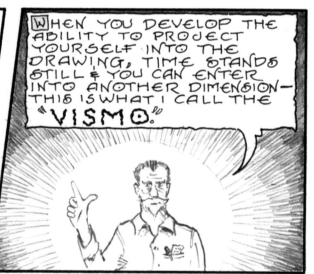

WHEN YOU DEVELOP THE ABILITY TO PROJECT YOURSELF INTO THE DRAWING, TIME STANDS STILL & YOU CAN ENTER INTO ANOTHER DIMENSION— THIS IS WHAT I CALL THE "VISMO."

DRAWING IS A FORM OF MEDITATION. THINK ABOUT WHAT IS HAPPENING WHEN THE WORK IS GOING WELL.

HERE IS ANOTHER BOOK FOR YOU TO READ, NOT JUST TO OCCUPY A SPACE ON YOUR SHELF.

A BOOK CAN HAVE A LIFE OF ITS OWN— WHAT WILL YOU GIVE TO THIS ONE?

VOLUME I ISSUE # 4

DEVICES and DESIRES

PINBALL MACHINES!

BACK AT THE OFFICE

ANOTHER MEMO... MORE CONDO RENDERINGS— TIGHTEN UP MY DRAWING STYLE — NO MORE WHIMSY — MORE REALISM — TONE DOWN MY COLOR PALETTE... THIS SUCKS! WHAT A BUNCH OF IDIOTS.

MEMO: TO HIM

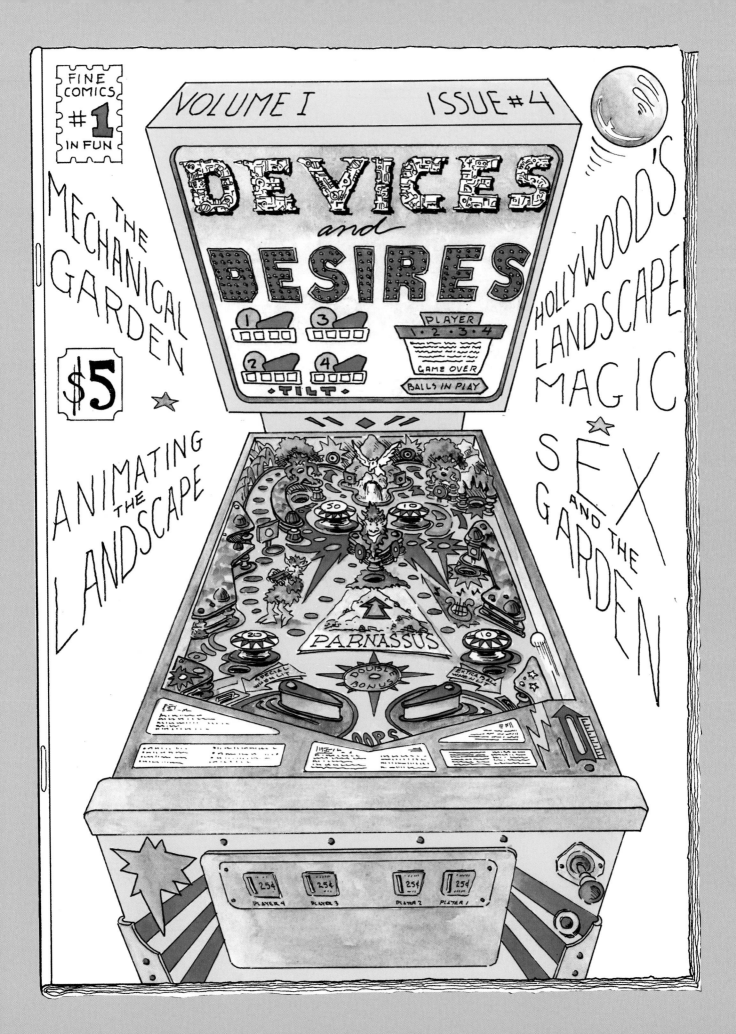

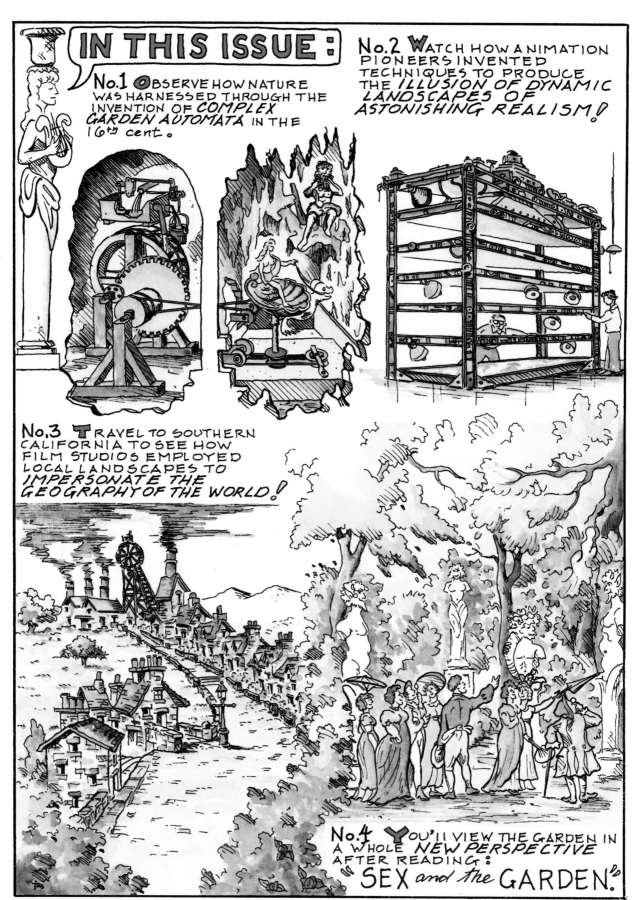

IN THIS ISSUE :

No.1 OBSERVE HOW NATURE WAS HARNESSED THROUGH THE INVENTION OF *COMPLEX GARDEN AUTOMATA* IN THE 16th cent.

No.2 WATCH HOW ANIMATION PIONEERS INVENTED TECHNIQUES TO PRODUCE THE *ILLUSION OF DYNAMIC LANDSCAPES OF ASTONISHING REALISM!*

No.3 TRAVEL TO SOUTHERN CALIFORNIA TO SEE HOW FILM STUDIOS EMPLOYED LOCAL LANDSCAPES TO *IMPERSONATE THE GEOGRAPHY OF THE WORLD!*

No.4 YOU'll VIEW THE GARDEN IN A WHOLE *NEW PERSPECTIVE* AFTER READING: "*SEX and the GARDEN.*"

DEVICES and DESIRES, VOLUME I, ISSUE NUMBER 4. PUBLISHED BY THE UNIVERSITY OF VIRGINIA PRESS, CHARLOTTESVILLE, VIRGINIA, 22904, USA.

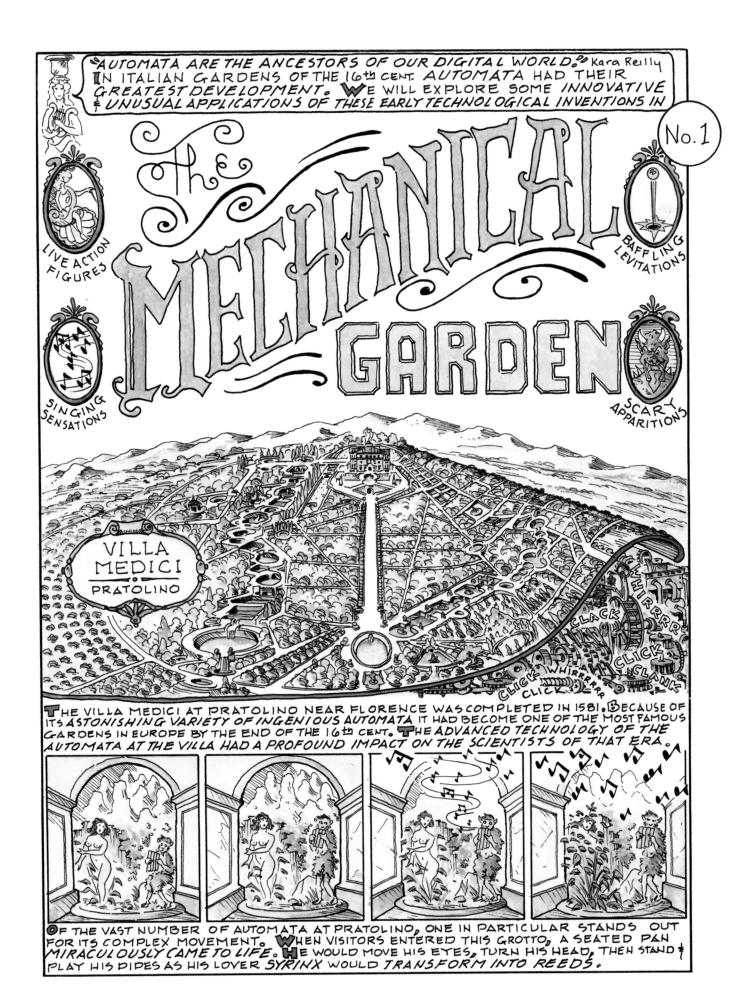

"AUTOMATA ARE THE ANCESTORS OF OUR DIGITAL WORLD." Kara Reilly

IN ITALIAN GARDENS OF THE 16th CENT. AUTOMATA HAD THEIR GREATEST DEVELOPMENT. WE WILL EXPLORE SOME *INNOVATIVE* & *UNUSUAL* APPLICATIONS OF THESE EARLY TECHNOLOGICAL INVENTIONS IN

No.1

THE MECHANICAL GARDEN

LIVE ACTION FIGURES

BAFFLING LEVITATIONS

SINGING SENSATIONS

SCARY APPARITIONS

VILLA MEDICI · PRATOLINO

THE VILLA MEDICI AT PRATOLINO NEAR FLORENCE WAS COMPLETED IN 1581. BECAUSE OF ITS ASTONISHING VARIETY OF INGENIOUS AUTOMATA IT HAD BECOME ONE OF THE MOST FAMOUS GARDENS IN EUROPE BY THE END OF THE 16th CENT. THE ADVANCED TECHNOLOGY OF THE AUTOMATA AT THE VILLA HAD A PROFOUND IMPACT ON THE SCIENTISTS OF THAT ERA.

OF THE VAST NUMBER OF AUTOMATA AT PRATOLINO, ONE IN PARTICULAR STANDS OUT FOR ITS COMPLEX MOVEMENT. WHEN VISITORS ENTERED THIS GROTTO, A SEATED PAN MIRACULOUSLY CAME TO LIFE. HE WOULD MOVE HIS EYES, TURN HIS HEAD, THEN STAND & PLAY HIS PIPES AS HIS LOVER *SYRINX* WOULD *TRANSFORM INTO REEDS.*

THE VILLA ALDOBRANDINI IN FRASCATI WAS BEGUN IN 1598 & COMPLETED IN 1603. ITS SPLENDID *AUTOMATA* ARE SITUATED IN THE *STANZA OF APOLLO.* LOCATED TO THE RIGHT OF THE CENTRAL NYMPHAEUM LIES THE ENTRY TO THE STANZA.

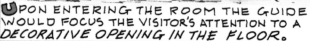

UPON ENTERING THE ROOM THE GUIDE WOULD FOCUS THE VISITOR'S ATTENTION TO A *DECORATIVE OPENING IN THE FLOOR.*

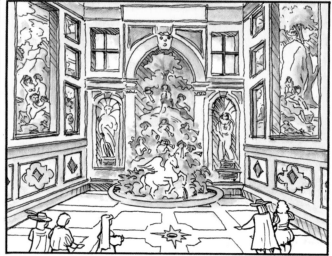

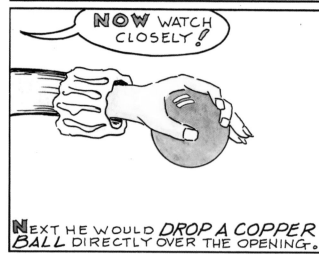

NOW WATCH CLOSELY!

NEXT HE WOULD *DROP A COPPER BALL* DIRECTLY OVER THE OPENING.

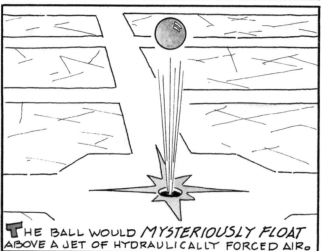

THE BALL WOULD *MYSTERIOUSLY FLOAT* ABOVE A JET OF HYDRAULICALLY FORCED AIR.

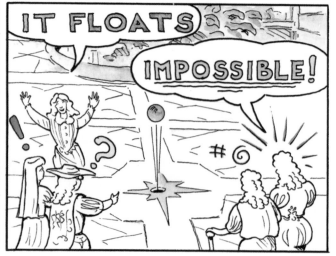

IT FLOATS

IMPOSSIBLE!

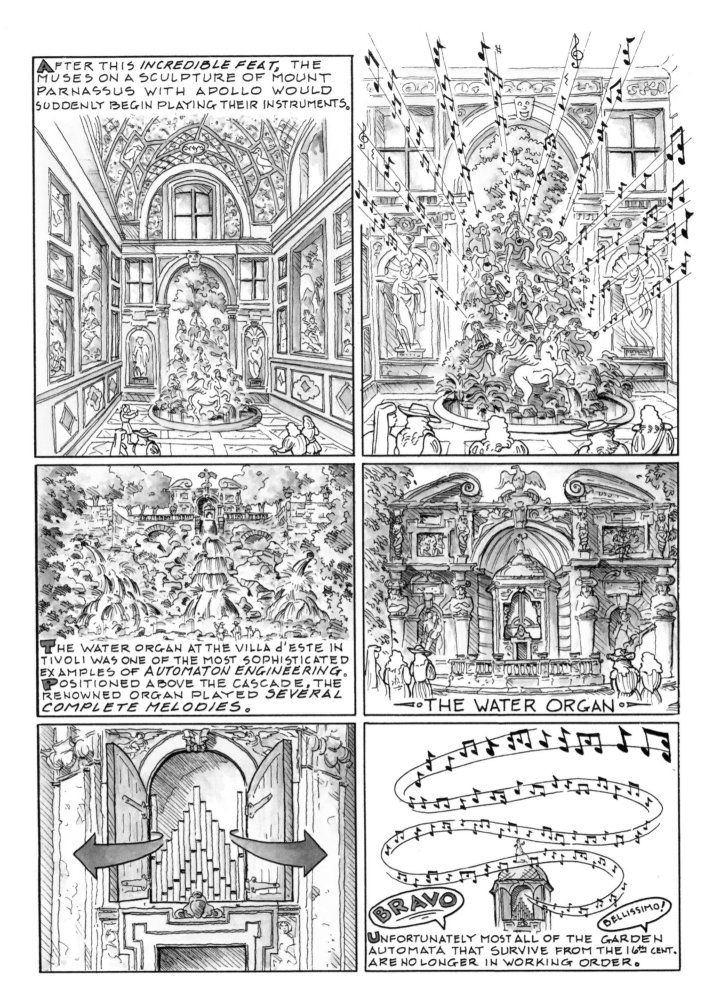

AFTER THIS *INCREDIBLE FEAT*, THE MUSES ON A SCULPTURE OF MOUNT PARNASSUS WITH APOLLO WOULD SUDDENLY BEGIN PLAYING THEIR INSTRUMENTS.

THE WATER ORGAN AT THE VILLA d'ESTE IN TIVOLI WAS ONE OF THE MOST SOPHISTICATED EXAMPLES OF *AUTOMATON ENGINEERING*. POSITIONED ABOVE THE CASCADE, THE RENOWNED ORGAN PLAYED *SEVERAL COMPLETE MELODIES*.

◄═ THE WATER ORGAN ═►

BRAVO

BELLISSIMO!

UNFORTUNATELY MOST ALL OF THE GARDEN AUTOMATA THAT SURVIVE FROM THE 16ᵗʰ CENT. ARE NO LONGER IN WORKING ORDER.

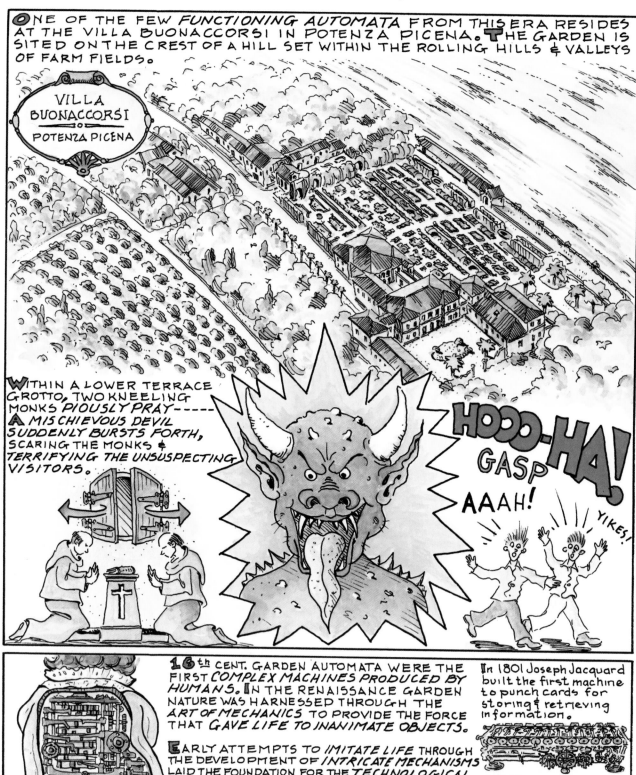

ONE OF THE FEW *FUNCTIONING AUTOMATA* FROM THIS ERA RESIDES AT THE VILLA BUONACCORSI IN POTENZA PICENA. THE GARDEN IS SITED ON THE CREST OF A HILL SET WITHIN THE ROLLING HILLS & VALLEYS OF FARM FIELDS.

VILLA BUONACCORSI
○
POTENZA PICENA

WITHIN A LOWER TERRACE GROTTO, TWO KNEELING MONKS *PIOUSLY PRAY*----- A MISCHIEVOUS DEVIL SUDDENLY BURSTS FORTH, SCARING THE MONKS & *TERRIFYING THE UNSUSPECTING VISITORS.*

HOOO-HA!
GASP
AAAH!
YIKES!

16th CENT. GARDEN AUTOMATA WERE THE FIRST *COMPLEX MACHINES PRODUCED BY HUMANS.* IN THE RENAISSANCE GARDEN NATURE WAS HARNESSED THROUGH THE *ART OF MECHANICS* TO PROVIDE THE FORCE THAT *GAVE LIFE TO INANIMATE OBJECTS.*

EARLY ATTEMPTS TO *IMITATE LIFE* THROUGH THE DEVELOPMENT OF *INTRICATE MECHANISMS* LAID THE FOUNDATION FOR THE *TECHNOLOGICAL REVOLUTION THAT FOLLOWED.* THESE MACHINES CAN BE VIEWED AS THE PRECURSORS TO THE *MODERN COMPUTER* WHERE THE DISK OF STEEL WEDGES IS LIKE A SOFTWARE PROGRAM & THE CAMS FUNCTION AS HARDWARE.

AUTOMATA HAVE MORPHED OVER THE CENTURIES INTO THE DIGITAL SCREEN OF CYBERSPACE. 𝒫𝒟 *KARA REILLY*

"THE WRITER"
AUTOMATA BUILT IN THE 1770s BY Pierre Jaquet-droz.

In 1801 Joseph Jacquard built the first machine to punch cards for storing & retrieving information.

2015
Turn right at the light in 200 feet.

end

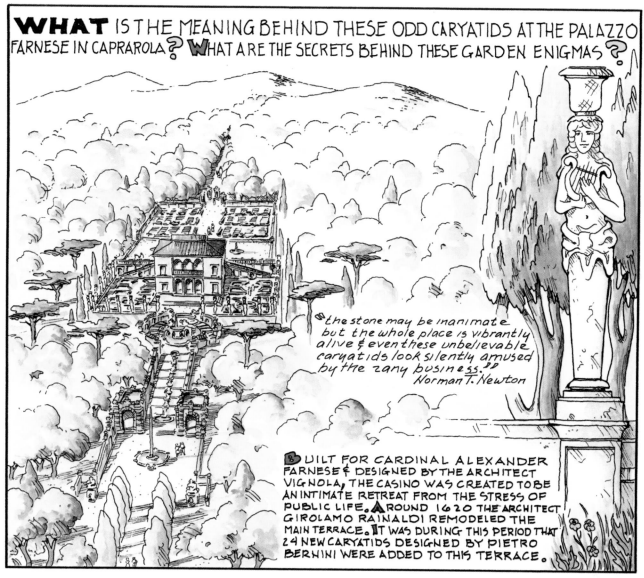

WHAT IS THE MEANING BEHIND THESE ODD CARYATIDS AT THE PALAZZO FARNESE IN CAPRAROLA? **W**HAT ARE THE SECRETS BEHIND THESE GARDEN ENIGMAS?

"the stone may be inanimate but the whole place is vibrantly alive & even these unbelievable caryatids look silently amused by the zany business."
Norman T. Newton

BUILT FOR CARDINAL ALEXANDER FARNESE & DESIGNED BY THE ARCHITECT VIGNOLA, THE CASINO WAS CREATED TO BE AN INTIMATE RETREAT FROM THE STRESS OF PUBLIC LIFE. **A**ROUND 1620 THE ARCHITECT GIROLAMO RAINALDI REMODELED THE MAIN TERRACE. **I**T WAS DURING THIS PERIOD THAT 24 NEW CARYATIDS DESIGNED BY PIETRO BERNINI WERE ADDED TO THIS TERRACE.

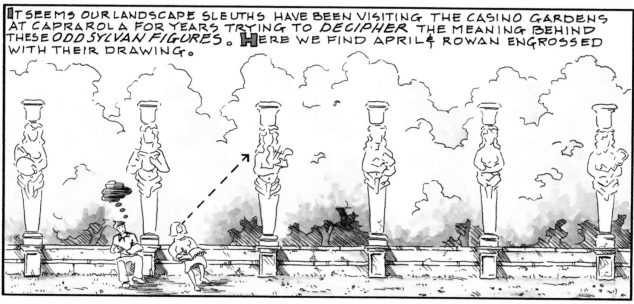

IT SEEMS OUR LANDSCAPE SLEUTHS HAVE BEEN VISITING THE CASINO GARDENS AT CAPRAROLA FOR YEARS TRYING TO *DECIPHER* THE MEANING BEHIND THESE *ODD SYLVAN FIGURES*. **H**ERE WE FIND APRIL & ROWAN ENGROSSED WITH THEIR DRAWING.

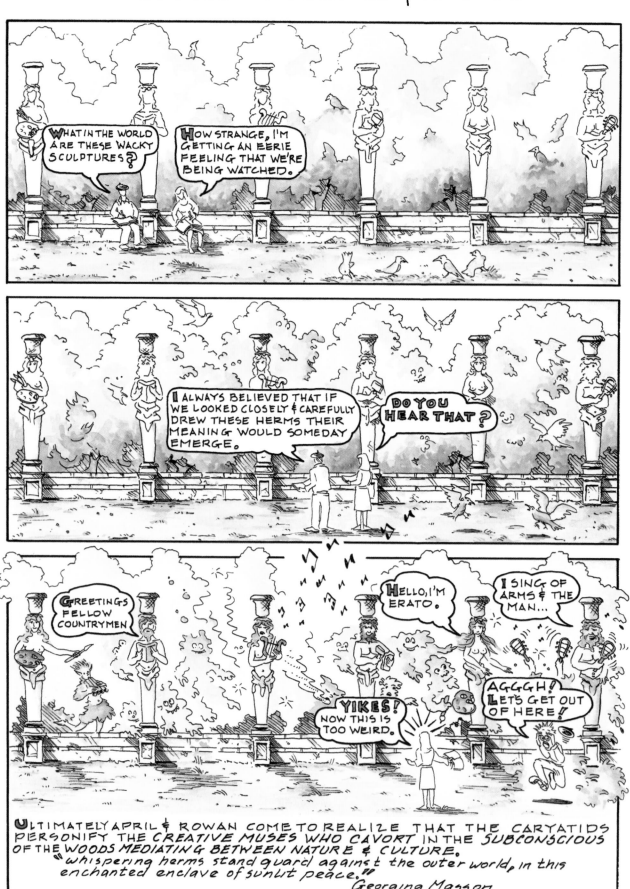

BONUS RIDDLE!

SCENIC RIDDLE

CAN YOU **GUESS** WHAT IS *REALLY GOING ON* IN THE BOSCO OF THIS 18th cent. PAINTING BY JEAN-ANTOINE WATTEAU?

HINT: OOH-LA-LA

ANSWER: WELL, IT APPEARS THAT THIS WOODLAND SETTING HAS ENCOURAGED A FEW AMOROUS ACTIVITIES. ① ON THE LEFT A GENTLEMAN BECKONS A LADY TO A MORE PRIVATE LOCATION. ② A RELATIONSHIP DEEPENS AS A GUITARIST SERENADES HIS BELLE. ③ THE MAN LEANING ON THE URN FLIRTS WITH THE SEATED WOMAN. ④ THE 2 CENTRAL FIGURES HAVE COUPLED. ⑤ THE WOMAN ON THE FAR RIGHT IS MYSTERIOUSLY DISAPPEARING INTO THE WOODS. ⑥ THE CHILDREN INNOCENTLY PLAY, OBLIVIOUS TO THESE ETERNAL MATING RITUALS.

VISUAL QUIZ

WHAT ARE THESE CRAZY BOMBASTIC FORMS **?**
WHERE IN THE WORLD IS THIS STRANGE
CONTEMPORARY GARDEN **?**

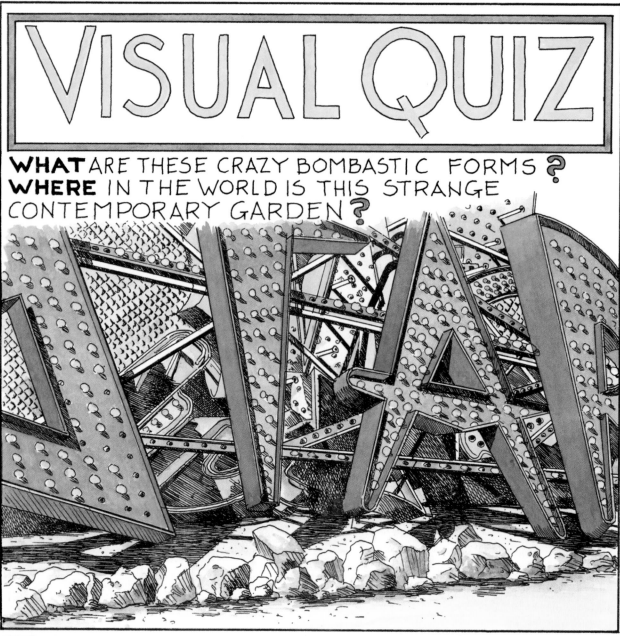

THE ANSWER TO OUR LAST ISSUE'S VISUAL QUIZ: "FIND YOUR WAY THROUGH THE GARDEN LABYRINTH TO THE ALCHEMIST'S ULTIMATE DESTINATION."

WHAT DID YOU LEARN ON YOUR JOURNEY OF KNOWLEDGE **?**

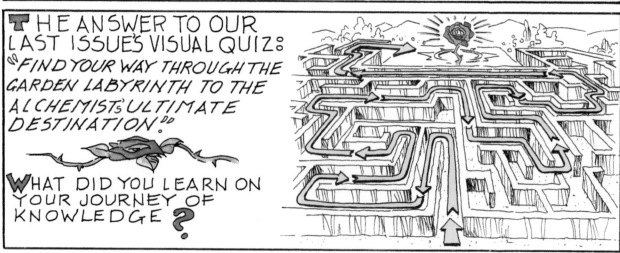

AS ANIMATION BECOMES A MORE COMMON REPRESENTATIONAL TOOL FOR LANDSCAPE ARCHITECTS, IT'S IMPORTANT TO STUDY THE *LESSONS & TECHNIQUES* OF ANIMATION PIONEERS. THESE MASTERS REALIZED EARLY IN THE DEVELOPMENT OF THE ART FORM THAT *DYNAMIC LANDSCAPES ENHANCED* THEIR STORYTELLING. THE ABILITY OF ANIMATION TO *TRANSCEND* THE LAWS OF *PHYSICS, BIOLOGY & LOGIC* ALLOW IT TO BE A *UNIQUE FORM OF SPATIAL REPRESENTATION.*

ANIMATING THE LANDSCAPE

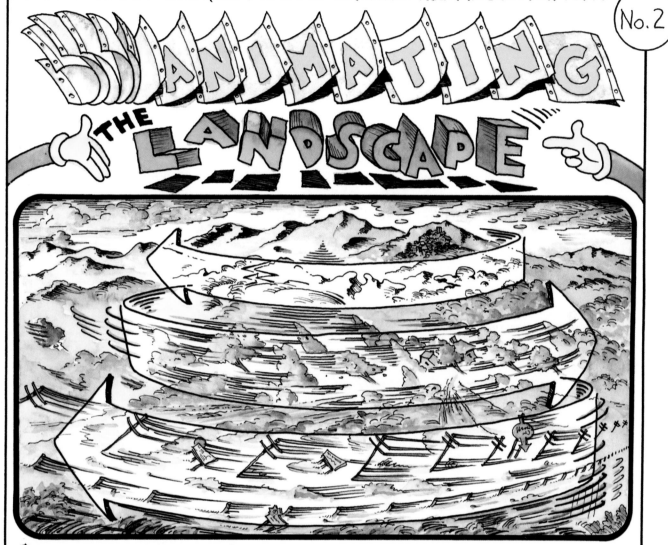

THE LANDSCAPE IS *ALIVE*. WHEN WE MOVE THROUGH IT, THE DIFFERENT PLANES OF *FOREGROUND, MID-GROUND & BACKGROUND* SHIFT AT DIFFERENT *SPEEDS & DIRECTIONS.* THE FOREGROUND WILL *SPEED* PAST, THE MID-GROUND WILL SHIFT IN THE *OPPOSITE*-DIRECTION & THE BACKGROUND WILL APPEAR *STATIONARY.*

THIS EFFECT CAN ALSO HOLD TRUE IN URBAN SPACES. THE PIAZZA DELLA SIGNORIA IN FLORENCE IS A UNIQUELY *ANIMATED URBAN PLACE.* AS ONE MOVES ACROSS THE PLAZA THE SCULPTURES APPEAR TO MOVE APART & COMPRESS TOGETHER AGAIN.

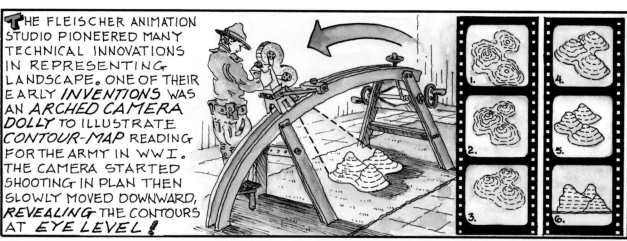

THE FLEISCHER ANIMATION STUDIO PIONEERED MANY TECHNICAL INNOVATIONS IN REPRESENTING LANDSCAPE. ONE OF THEIR EARLY *INVENTIONS* WAS AN *ARCHED CAMERA DOLLY* TO ILLUSTRATE *CONTOUR-MAP* READING FOR THE ARMY IN WWI. THE CAMERA STARTED SHOOTING IN PLAN THEN SLOWLY MOVED DOWNWARD, *REVEALING* THE CONTOURS AT *EYE LEVEL!*

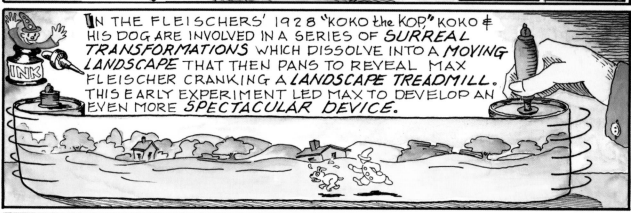

IN THE FLEISCHERS' 1928 "KOKO the KOP," KOKO & HIS DOG ARE INVOLVED IN A SERIES OF *SURREAL TRANSFORMATIONS* WHICH DISSOLVE INTO A *MOVING LANDSCAPE* THAT THEN PANS TO REVEAL MAX FLEISCHER CRANKING A *LANDSCAPE TREADMILL*. THIS EARLY EXPERIMENT LED MAX TO DEVELOP AN EVEN MORE *SPECTACULAR DEVICE.*

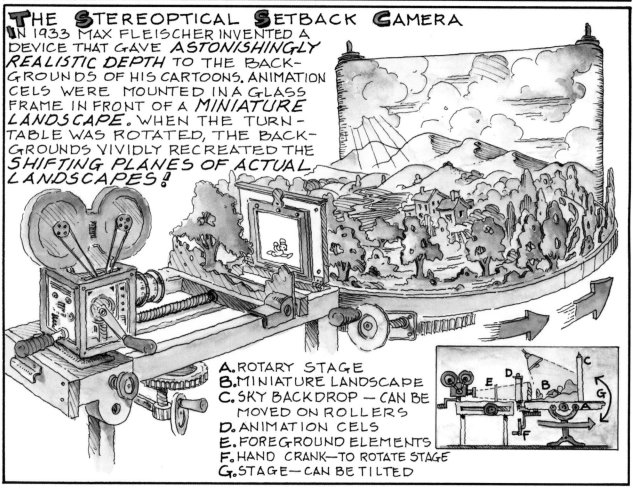

THE STEREOPTICAL SETBACK CAMERA

IN 1933 MAX FLEISCHER INVENTED A DEVICE THAT GAVE *ASTONISHINGLY REALISTIC DEPTH* TO THE BACKGROUNDS OF HIS CARTOONS. ANIMATION CELS WERE MOUNTED IN A GLASS FRAME IN FRONT OF A *MINIATURE LANDSCAPE*. WHEN THE TURNTABLE WAS ROTATED, THE BACKGROUNDS VIVIDLY RECREATED THE *SHIFTING PLANES OF ACTUAL LANDSCAPES!*

A. ROTARY STAGE
B. MINIATURE LANDSCAPE
C. SKY BACKDROP — CAN BE MOVED ON ROLLERS
D. ANIMATION CELS
E. FOREGROUND ELEMENTS
F. HAND CRANK—TO ROTATE STAGE
G. STAGE—CAN BE TILTED

DISNEY LATER DEVELOPED A *MULTI-PLANE CAMERA* WHICH COULD PRODUCE A REALISTIC ILLUSION OF *SPATIAL DEPTH* BY SHOOTING THROUGH A SERIES OF *ANIMATION PLANES.* EACH PLANE COULD MOVE AT DIFFERENT *PROGRESSIVE RATES of SPEED & DIRECTION.* ADDITIONALLY, TRAVELING SHOTS COULD FOLLOW AN ANIMATED CHARACTER THROUGH THE LANDSCAPE.

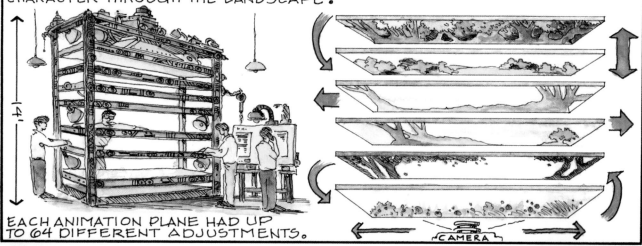

EACH ANIMATION PLANE HAD UP TO 64 DIFFERENT ADJUSTMENTS.

CAMERA

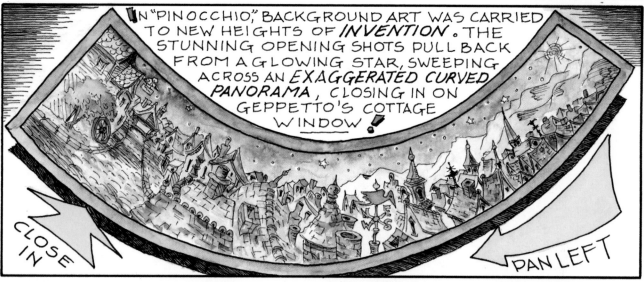

IN "PINOCCHIO," BACKGROUND ART WAS CARRIED TO NEW HEIGHTS OF *INVENTION.* THE STUNNING OPENING SHOTS PULL BACK FROM A GLOWING STAR, SWEEPING ACROSS AN *EXAGGERATED CURVED PANORAMA*, CLOSING IN ON GEPPETTO'S COTTAGE WINDOW !

CLOSE IN

PAN LEFT

THE CONTEMPORARY MASTER OF ANIMATION, HAYAO MIYAZAKI, USES ANIMATION TO VIBRANTLY EMPHASIZE THE *VITALITY & DYNAMISM* OF NATURE. MIYAZAKI'S ANIMATION IS FILLED WITH *REMARKABLE LANDSCAPE SEQUENCES* OF ANCIENT FORESTS, RUSTLING FOLIAGE, VERDANT FIELDS, SHIFTING SHADOWS, BILLOWING CLOUDS & LIGHT-REFRACTING WATER. TO ACHIEVE THESE BREATH-TAKING LANDSCAPES, UP TO 40 LAYERS OF BACKGROUND OVERLAYS ARE USED. MIYAZAKI'S WORK EXPLORES THE *SPECTACULAR POTENTIAL* OF ANIMATION TO INSPIRE *A SENSE OF WONDER ABOUT THE NATURAL WORLD.*

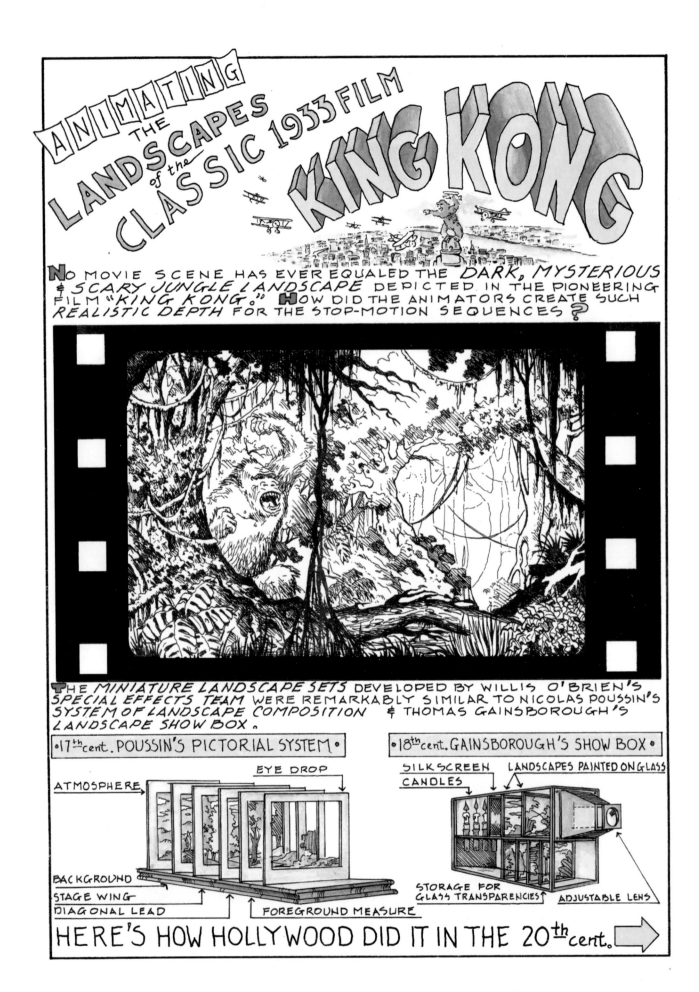

ANIMATING THE LANDSCAPES of the CLASSIC 1933 FILM KING KONG

NO MOVIE SCENE HAS EVER EQUALED THE *DARK, MYSTERIOUS* & *SCARY JUNGLE LANDSCAPE* DEPICTED IN THE PIONEERING FILM "KING KONG." HOW DID THE ANIMATORS CREATE SUCH *REALISTIC DEPTH* FOR THE STOP-MOTION SEQUENCES?

THE *MINIATURE LANDSCAPE SETS* DEVELOPED BY WILLIS O'BRIEN'S SPECIAL EFFECTS TEAM WERE REMARKABLY SIMILAR TO NICOLAS POUSSIN'S SYSTEM OF LANDSCAPE COMPOSITION & THOMAS GAINSBOROUGH'S LANDSCAPE SHOW BOX.

• 17th cent. POUSSIN'S PICTORIAL SYSTEM •

ATMOSPHERE
EYE DROP
BACKGROUND
STAGE WING
DIAGONAL LEAD
FOREGROUND MEASURE

• 18th cent. GAINSBOROUGH'S SHOW BOX •

SILKSCREEN
CANDLES
LANDSCAPES PAINTED ON GLASS
STORAGE FOR GLASS TRANSPARENCIES
ADJUSTABLE LENS

HERE'S HOW HOLLYWOOD DID IT IN THE 20th cent.

STOP-MOTION LANDSCAPE STAGE

1933 KING KONG

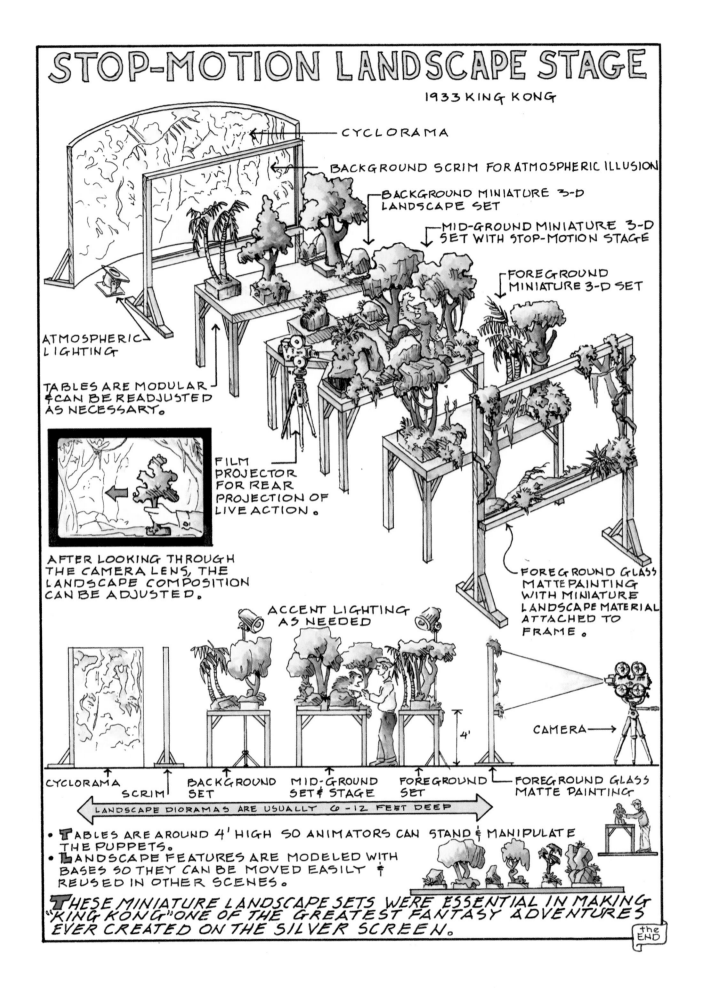

CYCLORAMA

BACKGROUND SCRIM FOR ATMOSPHERIC ILLUSION

BACKGROUND MINIATURE 3-D LANDSCAPE SET

MID-GROUND MINIATURE 3-D SET WITH STOP-MOTION STAGE

FOREGROUND MINIATURE 3-D SET

ATMOSPHERIC LIGHTING

TABLES ARE MODULAR & CAN BE READJUSTED AS NECESSARY.

FILM PROJECTOR FOR REAR PROJECTION OF LIVE ACTION.

AFTER LOOKING THROUGH THE CAMERA LENS, THE LANDSCAPE COMPOSITION CAN BE ADJUSTED.

FOREGROUND GLASS MATTE PAINTING WITH MINIATURE LANDSCAPE MATERIAL ATTACHED TO FRAME.

ACCENT LIGHTING AS NEEDED

4'

CAMERA →

CYCLORAMA SCRIM BACKGROUND SET MID-GROUND SET & STAGE FOREGROUND SET FOREGROUND GLASS MATTE PAINTING

LANDSCAPE DIORAMAS ARE USUALLY 6-12 FEET DEEP

- TABLES ARE AROUND 4' HIGH SO ANIMATORS CAN STAND & MANIPULATE THE PUPPETS.
- LANDSCAPE FEATURES ARE MODELED WITH BASES SO THEY CAN BE MOVED EASILY & REUSED IN OTHER SCENES.

THESE MINIATURE LANDSCAPE SETS WERE ESSENTIAL IN MAKING "KING KONG" ONE OF THE GREATEST FANTASY ADVENTURES EVER CREATED ON THE SILVER SCREEN.

the END

CHiPLeY's — Believe It or What?

THE MARIE ANTOINETTE TYMPANON PLAYER

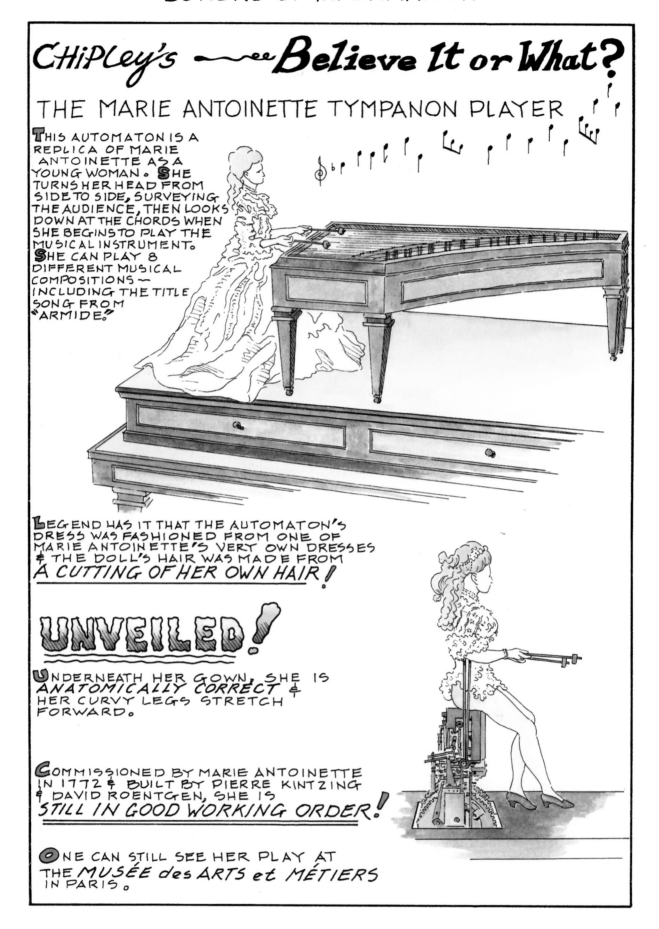

THIS AUTOMATON IS A REPLICA OF MARIE ANTOINETTE AS A YOUNG WOMAN. SHE TURNS HER HEAD FROM SIDE TO SIDE, SURVEYING THE AUDIENCE, THEN LOOKS DOWN AT THE CHORDS WHEN SHE BEGINS TO PLAY THE MUSICAL INSTRUMENT. SHE CAN PLAY 8 DIFFERENT MUSICAL COMPOSITIONS — INCLUDING THE TITLE SONG FROM "ARMIDE."

LEGEND HAS IT THAT THE AUTOMATON'S DRESS WAS FASHIONED FROM ONE OF MARIE ANTOINETTE'S VERY OWN DRESSES & THE DOLL'S HAIR WAS MADE FROM *A CUTTING OF HER OWN HAIR!*

UNVEILED!

UNDERNEATH HER GOWN, SHE IS *ANATOMICALLY CORRECT* & HER CURVY LEGS STRETCH FORWARD.

COMMISSIONED BY MARIE ANTOINETTE IN 1772 & BUILT BY PIERRE KINTZING & DAVID ROENTGEN, SHE IS *STILL IN GOOD WORKING ORDER!*

ONE CAN STILL SEE HER PLAY AT THE *MUSÉE des ARTS et MÉTIERS* IN PARIS.

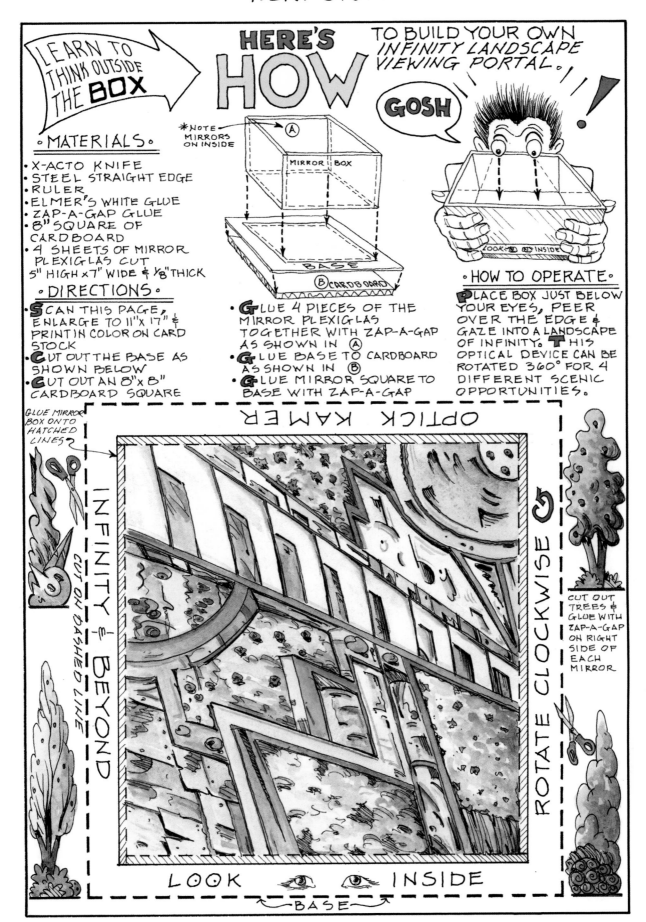

LEARN TO THINK OUTSIDE THE **BOX**

HERE'S **HOW** TO BUILD YOUR OWN INFINITY LANDSCAPE VIEWING PORTAL !!!

GOSH

*NOTE MIRRORS ON INSIDE

Ⓐ MIRROR BOX

BASE
Ⓑ CARDBOARD

LOOK INSIDE

• MATERIALS •

• X-ACTO KNIFE
• STEEL STRAIGHT EDGE
• RULER
• ELMER'S WHITE GLUE
• ZAP-A-GAP GLUE
• 8" SQUARE OF CARDBOARD
• 4 SHEETS OF MIRROR PLEXIGLAS CUT 5" HIGH x 7" WIDE & 1/8" THICK

• DIRECTIONS •

• **S**CAN THIS PAGE, ENLARGE TO 11"x 17" & PRINT IN COLOR ON CARD STOCK
• **C**UT OUT THE BASE AS SHOWN BELOW
• **C**UT OUT AN 8"x 8" CARDBOARD SQUARE

• **G**LUE 4 PIECES OF THE MIRROR PLEXIGLAS TOGETHER WITH ZAP-A-GAP AS SHOWN IN Ⓐ
• **G**LUE BASE TO CARDBOARD AS SHOWN IN Ⓑ
• **G**LUE MIRROR SQUARE TO BASE WITH ZAP-A-GAP

• HOW TO OPERATE •

PLACE BOX JUST BELOW YOUR EYES, PEER OVER THE EDGE & GAZE INTO A LANDSCAPE OF INFINITY. **T**HIS OPTICAL DEVICE CAN BE ROTATED 360° FOR 4 DIFFERENT SCENIC OPPORTUNITIES.

GLUE MIRROR BOX ONTO HATCHED LINES

OPTICK KAMER

INFINITY & BEYOND
CUT ON DASHED LINE

ROTATE CLOCKWISE ↻

CUT OUT TREES & GLUE WITH ZAP-A-GAP ON RIGHT SIDE OF EACH MIRROR

LOOK INSIDE

BASE

133

THE HISTORY OF FILM HAS ITS ROOTS IN *MAGIC*. THE FIRST MOVIE HOUSES WERE IN FACT CONVERTED MAGIC THEATERS. THE FATHER OF FRENCH CINEMA, GEORGE MÉLIÈS, WAS A POPULAR MASTER MAGICIAN WHO CLEVERLY COMBINED FILM WITH THE SAME *OPTICAL PRINCIPLES USED IN MAGIC*. HIS CINEMATIC ILLUSIONS BECAME A FORM OF *SCENIC CONJURING* & THE FOUNDATION FOR...

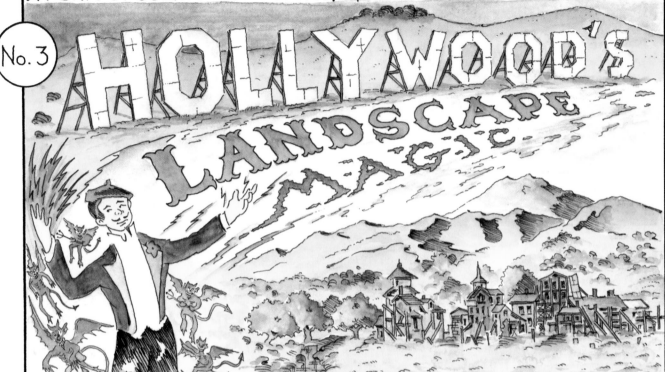

No. 3

HOLLYWOOD'S LANDSCAPE MAGIC

AS CINEMATOGRAPHY EVOLVED FROM THE ART OF TRICKERY, IT WAS ONLY NATURAL THAT A FILM'S LANDSCAPE SETTING SHOULD ALSO DECEIVE AUDIENCES. THIS WAS ESPECIALLY TRUE IN SOUTHERN CALIFORNIA, WHERE FILM STUDIOS EMPLOYED THE LOCAL LANDSCAPE TO *IMPERSONATE THE GEOGRAPHY OF THE WORLD*. PARAMOUNT RANCH IN THE SANTA MONICA MOUNTAINS SERVED AS THE SETTING FOR 100s OF FILMS. THE *CHIMERIC* QUALITY OF THE LANDSCAPE ENABLED IT TO BE *TRANSFORMED* INTO ANY PLACE IN TIME!

☆ STONE AGE ☆
FLINT STONES, VIVA ROCK VEGAS, 2000

☆ 13th cent. CHINA ☆
THE ADVENTURES OF MARCO POLO, 1938

☆ MISSOURI ☆
THE ADVENTURES OF TOM SAWYER, 1938

☆ SAN FRANCISCO ☆
WELLS FARGO, 1937

☆ THE WILD WEST ☆
DR. QUINN, MEDICINE WOMAN, T.V. SERIES, 1993-98

☆ THE SOUTH SEAS ☆
EBB TIDE, 1937

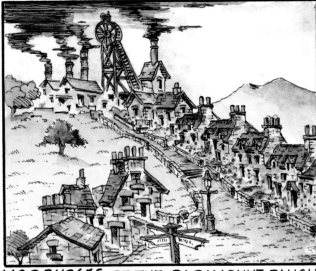

ONE OF THE MORE REMARKABLE *METAMORPHOSES* OF THE PARAMOUNT RANCH WAS FOR THE 1941 FILM "HOW GREEN WAS MY VALLEY." HERE A NATIVE CALIFORNIA HILLSIDE POSED AS A WELSH MINING TOWN. THIS SET DESIGN *EXAGGERATED THE DIMINISHING PERSPECTIVE* OF THE STEEP TOPOGRAPHY TO PRODUCE THE *SENSATION OF DISTANCE.*

10,000 DAFFODILS!

LANDSCAPE ARCHITECT FLORENCE YOCH (1890-1972) NOT ONLY HAD A SUCCESSFUL PRACTICE IN So Cal, SHE ALSO CREATED LANDSCAPE SETS FOR MANY CLASSIC HOLLYWOOD FILMS. IN "HOW GREEN WAS MY VALLEY" YOCH DESIGNED A *FINELY TUNED SEQUENCE* WHERE 10,000 DAFFODILS BLOOMED AT THE SAME TIME IN THE ARID SANTA MONICA MOUNTAINS!

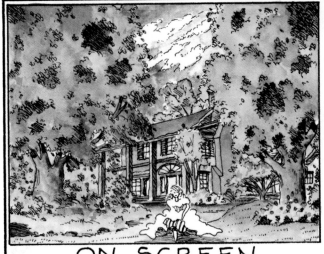

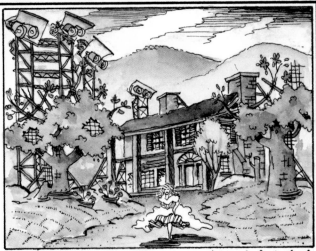

ON SCREEN REALITY

DAVID SELZNICK COMMISSIONED FLORENCE YOCH TO DESIGN THE SET FOR TARA IN "GONE WITH THE WIND." SELZNICK ENVISIONED TARA AS A LOST EDEN. YOCH CREATED A SET THAT IMITATED THE LANDSCAPE OF A SOUTHERN PLANTATION & MIMICKED THE ATMOSPHERE OF THE CIVIL WAR ERA. HOWEVER THE *LUSH* ESTATE THAT THE MOVIEGOER SEES ON SCREEN IS NOT WHAT EXISTS IN *REALITY...*

WHERE ARE THE **TREES** ?

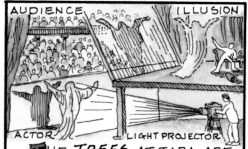

...THE *TREES* AT TARA ARE PAINTED ON A SHEET OF GLASS MOUNTED IN FRONT OF THE CAMERA! EARLY FILM MAKERS QUICKLY REALIZED THAT THE *VISUAL TRICKERY* OF THE VICTORIAN MAGIC THEATER COULD BE ADAPTED TO CINEMATOGRAPHY.

☆ MATTE SHOTS ☆

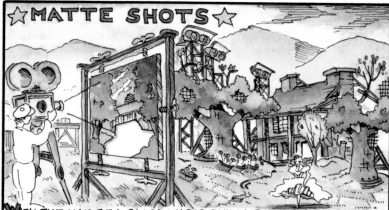

WITH THE USE OF A GLASS MATTE ONLY A PORTION OF THE SET HAS TO BE CONSTRUCTED. THE MATTE IS *INDECIPHERABLE* TO THE AUDIENCE IF SHOWN FOR LESS THAN 3 SEC. AFTER THAT THE *ILLUSION* CAN BE DISCERNED.

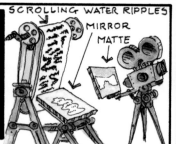

TERRACED RICE FARMS WERE CREATED WITH A MATTE FOR "THIRTY SECONDS OVER TOKYO" (1944). THE EFFECT OF RIPPLING WATER WAS ACHIEVED WITH A MIRROR & A REVOLVING SCROLL.

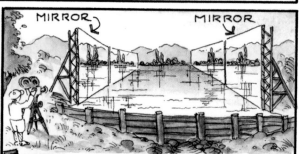

TO CREATE THE ILLUSION OF A GREAT EXPANSE OF WATER AT PARAMOUNT RANCH, LARGE MIRRORS WERE PLACED OPPOSITE EACH OTHER OVER A DAMMED STREAM.

☆ STUNT TREES & SHRUBS ☆

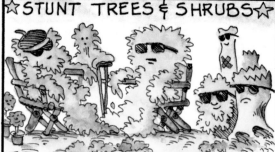

FAKE BREAK-AWAY *STUNT TREES & SHRUBS* ARE USED DURING A MOVIE WHEN LARGE MOVING OBJECTS or ARNOLD SCHWARZENEGGER CRASH THROUGH TREES or SHRUBS.

STUNT TREES CAN BE SEEN IN *ACTION* IN THE 2004 "STARSKY & HUTCH." STARSKY'S CAR *BLASTS* THROUGH THE WOODS DURING THE BIG CHASE SCENE. BUT NO *LIVING PLANTS WERE HARMED IN THIS PRODUCTION!*

Haunted Garden Set Pine Trunks Acacia Trunks Palm Trunks Dead Trees Jungle Set

— *LANDSCAPE YOUR OWN MOVIE SET!!* —

SINCE 1937 *JACKSON SHRUBS* HAS SUPPLIED THE T.V. & MOTION PICTURE INDUSTRY WITH BOTH LIVE & ARTIFICIAL PLANT RENTALS. YOU CAN RENT ALMOST ANY CONCEIVABLE TYPE OF PLANT FORM, FROM FALL LEAVES, SILK FLOWERS, WINTER FORESTS, JUNGLE SETS, BURNED WOODLAND, SWAMPS, STUMPS & EVEN COMPLETE JAPANESE GARDENS! HOWEVER THE REAL ART IS IN CONVINCING THE AUDIENCE THAT *"THEY ARE WATCHING A GENUINE WONDER."* JIM STEINMEYER

HOLLYWOOD'S BACKLOT URBANISM

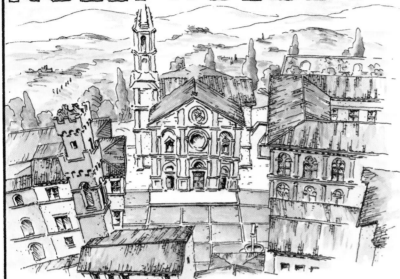

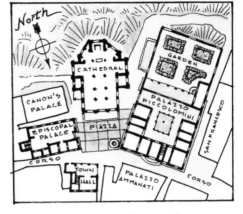

· TOWN PLAN ·
= PIENZA =
ARCH. BERNARDO ROSSELLINO
1450

THE RENAISSANCE TOWN PLAN FOR PIENZA, ITALY, IS A MASTERPIECE OF *THEATRICAL SET DESIGN.* BERNARDO ROSSELLINO RENOVATED POPE PIUS II'S NATIVE VILLAGE OF CORSIGNANO IN 1450, WHICH THE POPE RENAMED IN HONOR OF HIMSELF. THE PLAN RADIATES OUTWARD FROM THE CENTRAL PIAZZA; EACH NARROW STREET SLIGHTLY CURVES TO CREATE THE *ILLUSION OF DEPTH,* MAKING THE TOWN APPEAR LARGER. STRATEGICALLY PLACED OFF CENTER, THE DECORATIVE WELLHEAD *DYNAMICALLY ACTIVATES THE SPACE.*

UNIVERSAL'S FRANKENSTEIN VILLAGE

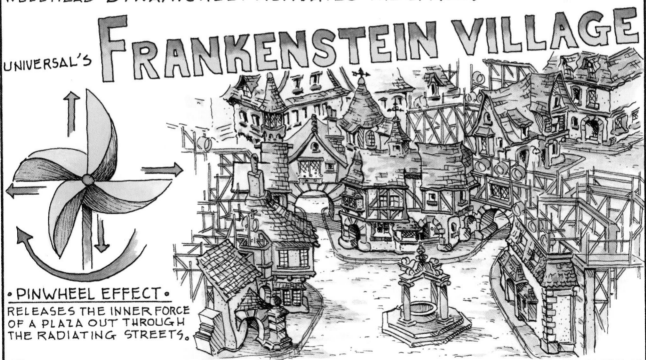

· PINWHEEL EFFECT ·
RELEASES THE INNER FORCE OF A PLAZA OUT THROUGH THE RADIATING STREETS.

UNIVERSAL'S BACKLOT EUROPEAN VILLAGE EXEMPLIFIES MANY OF THE *ELEMENTS OF PIENZA'S REFINED URBAN PLAN.* ABOVE WE SEE THE SET DRESSED FOR ONE OF THE GREATEST HORROR FILMS OF ALL TIME — THE 1935 "BRIDE OF FRANKENSTEIN." THE HUMAN-SCALED CENTRAL PLAZA IS FRAMED WITH A *COHESIVE ARCHITECTURAL STYLE UNIFYING THE SPACE.* THE OFFSET FOUNTAIN ACTS AS A FOCAL POINT IN THE PLAZA. THE ARTICULATED FACADES & VARYING ROOFLINES MAXIMIZE THE POTENTIAL FOR DIVERSE SCENE SHOTS. THE RADIATING ROADS & ARCHES PRODUCE AN *ILLUSION OF DEPTH WITHIN A DENSE URBAN SETTING.*

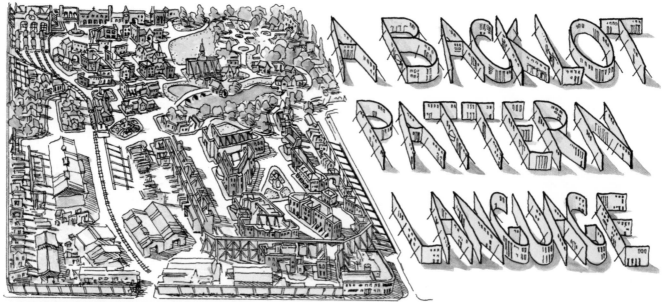

A BACKLOT PATTERN LANGUAGE

1 — THE PORTAL OF DRAMA
THE ARCH CREATES A STRONG SENSE OF ENTRY & FRAMES A DRAMATIC TRANSITION FROM ONE SPACE TO ANOTHER.

2 — INDENTIFIABLE NEIGHBORHOODS
WALLS DEFINE PUBLIC & PRIVATE SPACES & ESTABLISH NEIGHBORHOOD BOUNDARIES. THE MODULATION OF FACADES PRODUCES AN INTIMATE PEDESTRIAN SCALE.

3 — MOSAIC OF FACADES
URBAN SPACES SHOULD BE WHIMSICAL & FUN, NOT STERILE & PRETENTIOUS. CONNECTED IRREGULAR FACADES WITH PITCHED ROOFS SET THE STAGE FOR CAPTIVATING SCENARIOS.

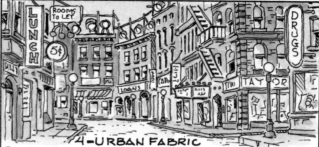

4 — URBAN FABRIC
CITY STREETS DEFINED BY 4-6 STORY BROWNSTONES CREATE AN IDEAL STAGE FOR URBAN LIFE. A BACKDROP OF STREET-LEVEL SHOPS PROVIDES A SETTING FOR LIVELY PEDESTRIAN THEATER.

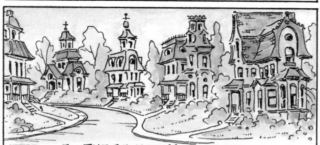

5 — THE SENSUOUS CURVE
GENTLY CURVED ROADS IMPLY AN ELEGANCE OF MOVEMENT. EXAGGERATED BUILDING HEIGHTS & NARROW WIDTHS PRODUCE AN ILLUSION OF GRANDEUR & SPACIOUSNESS.

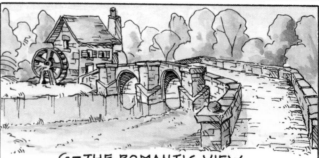

6 — THE ROMANTIC VIEW
A LANDSCAPE COMPOSITION OF TREES, LAWN, RIVER & A BRIDGE CAN INDUCE THE MOOD OF AN ARCADIAN EDEN.

the END

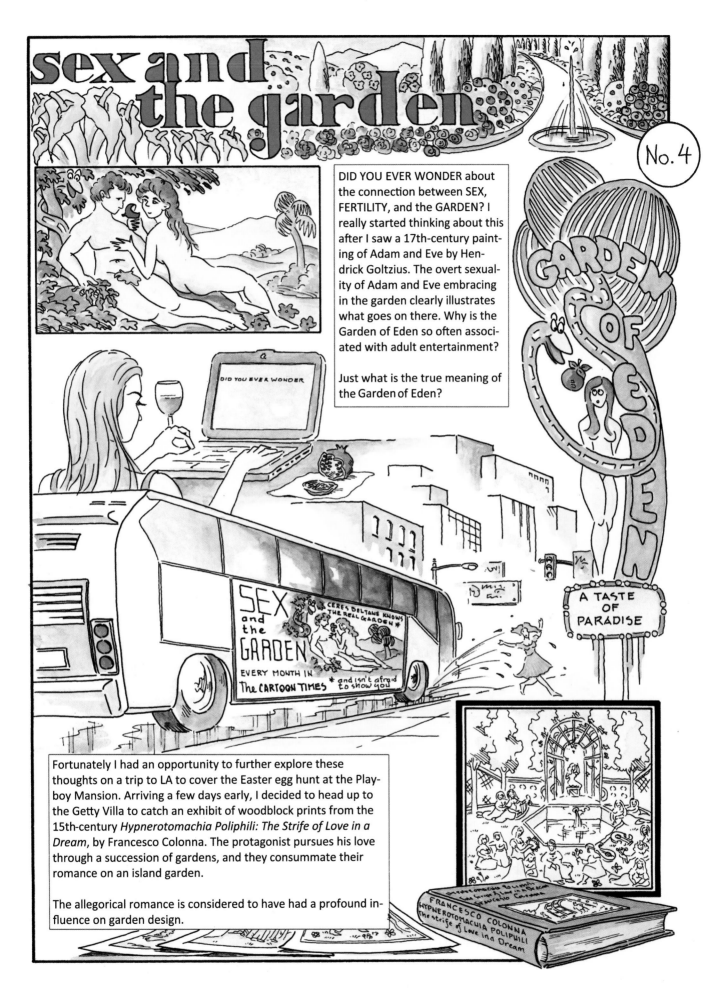

sex and the garden

GARDEN OF EDEN

DID YOU EVER WONDER about the connection between SEX, FERTILITY, and the GARDEN? I really started thinking about this after I saw a 17th-century painting of Adam and Eve by Hendrick Goltzius. The overt sexuality of Adam and Eve embracing in the garden clearly illustrates what goes on there. Why is the Garden of Eden so often associated with adult entertainment?

Just what is the true meaning of the Garden of Eden?

DID YOU EVER WONDER

A TASTE OF PARADISE

SEX and the GARDEN EVERY MONTH IN The CARTOON TIMES *and isn't afraid to show you*

CERES DELTANE KNOWS THE REAL GARDEN

Fortunately I had an opportunity to further explore these thoughts on a trip to LA to cover the Easter egg hunt at the Playboy Mansion. Arriving a few days early, I decided to head up to the Getty Villa to catch an exhibit of woodblock prints from the 15th-century *Hypnerotomachia Poliphili: The Strife of Love in a Dream*, by Francesco Colonna. The protagonist pursues his love through a succession of gardens, and they consummate their romance on an island garden.

The allegorical romance is considered to have had a profound influence on garden design.

FRANCESCO COLONNA HYPNEROTOMACHIA POLIPHILI The strife of Love in a Dream

After poring over these emblematic illustrations, I wolfed down a quick lunch and wandered out to the garden to see the Greek and Roman sculptures. Jet lag finally caught up with me and I had to sit down.

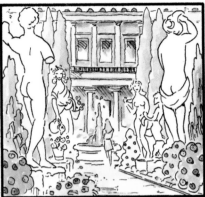

WOW...that was some nap! WHAT IS GOING ON HERE? Now I understand what these erotic garden sculptures are about!

I need a CATALOGUE to identify the special attributes of all these garden idols.

FAMOUS SEX STARS of GARDEN MYTHOLOGY

☆ ISIS ☆

ANCIENT EGYPTIAN GODDESS, WORSHIPPED AS THE IDEAL MOTHER & PATRONESS OF NATURE & MUSIC.

☆ PRIAPUS ☆
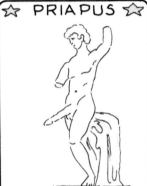
RUSTIC FERTILITY GOD, PROTECTOR OF FRUIT, PLANTS & GARDENS. STATUES WERE COMMON IN GREEK & ROMAN GARDENS.

☆ FLORA ☆
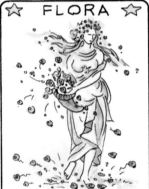
IN ROMAN MYTHOLOGY FLORA WAS THE GODDESS OF FLOWERS & THE SEASON OF SPRING. FLORA WAS ALSO A FERTILITY GODDESS.

☆ PAN ☆
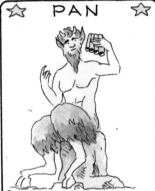
GREEK GOD OF THE WIND, SHEPHERDS & FLOCKS & NATURE. WANDERING THE HILLS OF ARCADIA CHASING NYMPHS.

☆ DAPHNE ☆

GREEK NYMPH ASSOCIATED WITH WELLS, STREAMS, BROOKS, FOUNTAINS & OTHER BODIES OF WATER.

☆ DIONYSUS ☆

GREEK GOD OF THE GRAPE HARVEST & VINE, & OF RITUAL MADNESS & ECSTASY. KNOWN AS BACCHUS BY THE ROMANS.

☆ APHRODITE ☆

THE GREEK GOD OF LOVE, BEAUTY, PLEASURE & PROCREATION. TO ROMANS SHE WAS KNOWN AS VENUS.

☆ DIANA EFESINA ☆

CLASSICAL PERSONIFICATION OF NATURE AS THE MANY BREASTED DIANA OF EPHESUS.

How provocative to hold an Easter egg hunt for charity at the Playboy Mansion, a temple of Hedonism. How did BUNNIES become associated with EASTER in the first place?

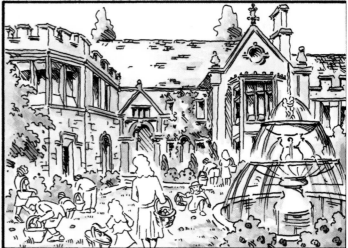

It seems that bunnies in pagan mythology symbolized SPRING and new life, and were the sacred animal of the Goddess Eostre, the deity of spring and fertility. Eggs, too, were an ancient symbol of fertility.

In Renaissance gardens, this symbol of fertility manifested itself in a unique way as the RABBIT ISLAND. This conceit still exists at Villa Dona dalle Rose. One male and one female rabbit would be placed on the island and rapidly reproduce. Once the island reached full capacity, the rabbits would be harvested and the process started over again. These rabbit islands or *leporariums* date back to Roman times.

RABBIT ISLAND — VILLA DONA dalle ROSE, ITALY

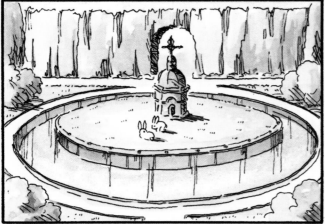

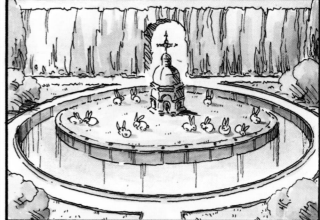

After everyone left the Easter egg hunt, I strolled over to the famous garden grotto. Boy, did I get an eyeful; the place reeked of phero-mones. I had entered a damp, dark cave where all inhibitions dissolved, sensuous pleasures abounded, and human gods and goddesses were worshipped.

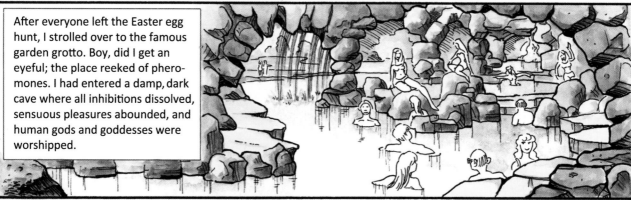

Caves and grottos have been part of mythology and religion since pre-history. Early nature spirits like water nymphs were believed to dwell there. Ancient Greeks and Persians understood the cave as the source of life and the divine wellspring. Domestic grottos proliferated in the homes and gardens of the patrician class during the Roman Republic. Elaborately decorated grottos were popular additions to Italian Renaissance gardens of the 15th and 16th centuries.

When I returned to New York City, I couldn't wait to get together with my friends for a night out. Amanda brought a new art book of erotic flower portraits she was reviewing. We were shocked at just how explicitly sexual flowers can be; if I didn't know better I would have thought I was looking at pornography.

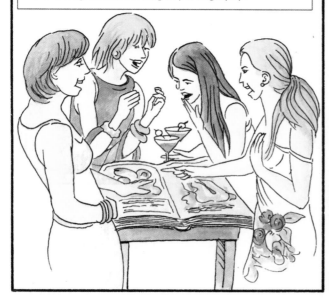

The great taxonomist Carl Linneaus theorized that plants have sexual organs and reproduced on a "marriage bed." He developed his whole system of taxonomy based on sexual classification.

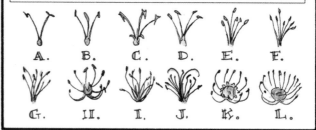

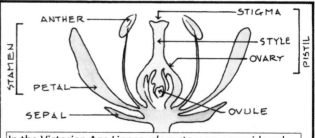

In the Victorian Age Linneaus's system was considered so sexually provocative that it was improper for ladies to view his work.

Amanda mentioned that the hottest new thing in the city was the adult-only maypole celebration held at the Botanic Garden. She said this was totally the best way to meet guys, and that we should all go. It's true that maypole celebrations have pagan roots and functioned as spring fertility and mating rituals.

Our evening turned into a frenzied night of dancing, with couples wandering off into the woods. Amanda circled the date on her calendar for next year.

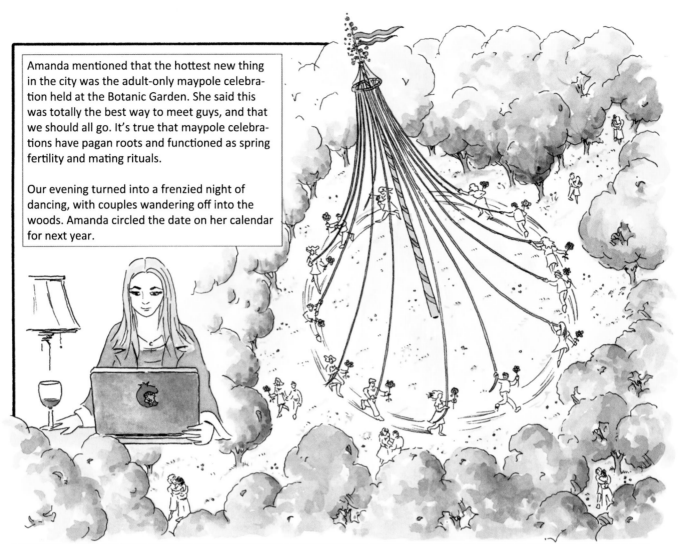

Later that week I was assigned to cover an environmental art installation by an emerging landscape artist. Get this -- it was titled the "Garden of Eden." When I got downtown I found a hotel room completely filled with plastic flowers and plants, and occupied by a totally nude man and woman. We know what they will be up to later!

Is this what represents our society's version of the Garden of Eden? I can only wonder.

THE END

143

A PEN FILLED WITH INK IS ONE OF THE WORLD'S OLDEST TOOLS FOR WRITING & DRAWING. VIRTUALLY NO OTHER MEDIUM CAN PRODUCE *IMMEDIATE EXPRESSIVE & ENERGY-FILLED LINE WORK.* THE *FLEXIBLE & REACTIVE* NIB OF THE INK PEN IS *UNPARALLELED* AS A DRAWING INSTRUMENT.

JOIN US AS WE EXPLORE
THE
Ancient Art
of
PEN and INK
IT'S

NITRO

POWERFUL SH*T

"PEN DRAWINGS, IN THEIR SIMPLE BLACK AGAINST WHITE, HAVE A CRISPNESS & DIRECTNESS THAT ARE APPEALING; THEY ARE *FULL OF LIFE & LIGHT.* MANY OF THEM ARE ONLY SUGGESTIVE, LEAVING MUCH TO THE *IMAGINATION,* & WE TAKE PLEASURE IN THIS." ARTHUR GUPTILL

- BASIC MATERIALS -

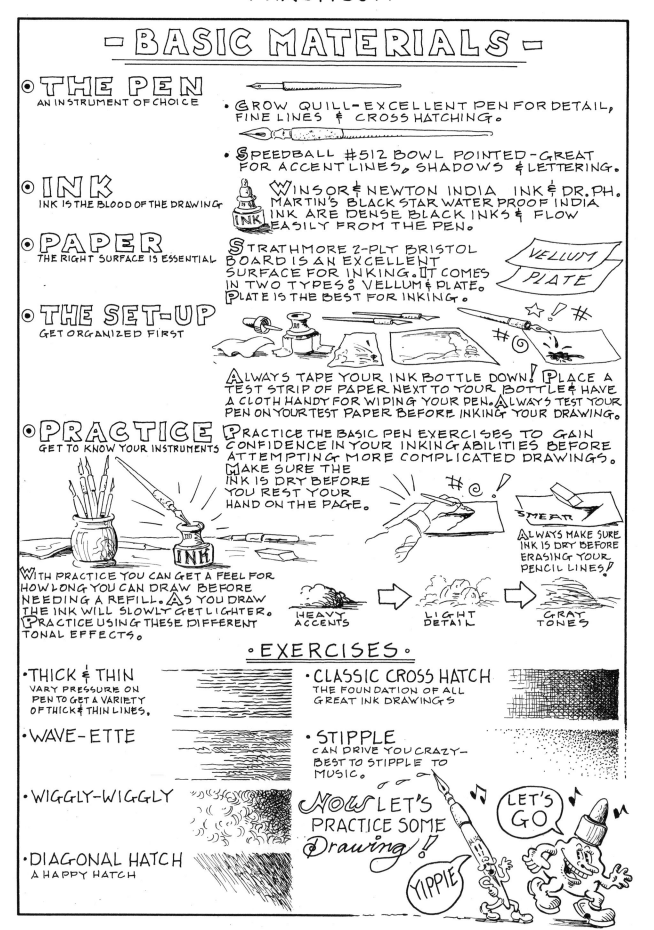

⊙ THE PEN
AN INSTRUMENT OF CHOICE

- CROW QUILL - EXCELLENT PEN FOR DETAIL, FINE LINES & CROSS HATCHING.

- SPEEDBALL #512 BOWL POINTED - GREAT FOR ACCENT LINES, SHADOWS & LETTERING.

⊙ INK
INK IS THE BLOOD OF THE DRAWING

WINSOR & NEWTON INDIA INK & DR. PH. MARTIN'S BLACK STAR WATER PROOF INDIA INK ARE DENSE BLACK INKS & FLOW EASILY FROM THE PEN.

⊙ PAPER
THE RIGHT SURFACE IS ESSENTIAL

STRATHMORE 2-PLY BRISTOL BOARD IS AN EXCELLENT SURFACE FOR INKING. IT COMES IN TWO TYPES: VELLUM & PLATE. PLATE IS THE BEST FOR INKING.

⊙ THE SET-UP
GET ORGANIZED FIRST

ALWAYS TAPE YOUR INK BOTTLE DOWN! PLACE A TEST STRIP OF PAPER NEXT TO YOUR BOTTLE & HAVE A CLOTH HANDY FOR WIPING YOUR PEN. ALWAYS TEST YOUR PEN ON YOUR TEST PAPER BEFORE INKING YOUR DRAWING.

⊙ PRACTICE
GET TO KNOW YOUR INSTRUMENTS

PRACTICE THE BASIC PEN EXERCISES TO GAIN CONFIDENCE IN YOUR INKING ABILITIES BEFORE ATTEMPTING MORE COMPLICATED DRAWINGS. MAKE SURE THE INK IS DRY BEFORE YOU REST YOUR HAND ON THE PAGE.

SMEAR

ALWAYS MAKE SURE INK IS DRY BEFORE ERASING YOUR PENCIL LINES!

WITH PRACTICE YOU CAN GET A FEEL FOR HOW LONG YOU CAN DRAW BEFORE NEEDING A REFILL. AS YOU DRAW THE INK WILL SLOWLY GET LIGHTER. PRACTICE USING THESE DIFFERENT TONAL EFFECTS.

HEAVY ACCENTS → LIGHT DETAIL → GRAY TONES

° EXERCISES °

- **THICK & THIN**
 VARY PRESSURE ON PEN TO GET A VARIETY OF THICK & THIN LINES.

- **WAVE-ETTE**

- **WIGGLY-WIGGLY**

- **DIAGONAL HATCH**
 A HAPPY HATCH

- **CLASSIC CROSS HATCH**
 THE FOUNDATION OF ALL GREAT INK DRAWINGS

- **STIPPLE**
 CAN DRIVE YOU CRAZY - BEST TO STIPPLE TO MUSIC.

Now LET'S PRACTICE SOME *Drawing*!

YIPPIE LET'S GO

INK-O-RAMA

BELOW IS AN EASY TO FOLLOW, STEP-BY-STEP PROCESS FOR YOU TO CONCEIVE & INK OUT YOUR VERY OWN--- *GONZO GARDEN*

① LAY IT OUT
USE A GENERAL'S 314 PENCIL TO LAY OUT YOUR CONCEPTUAL IDEA WITH LIGHT LINES.

② ROUGH IT OUT
OUTLINE YOUR SHAPES WITH A CROW QUILL PEN. DEVELOP YOUR DESIGN BY RESPONDING TO THE FORMS AS THEY TAKE SHAPE.

③ GET SMALL
REFINE YOUR DRAWING BY ADDING DETAIL & HATCHES WITH A #512 PEN POINT. AS YOUR DRAWING BECOMES 3-DIMENSIONAL YOU BECOME ONE WITH IT, & ARE NOW...

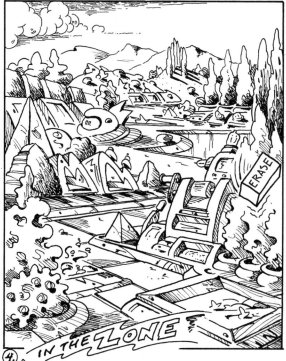

④ *IN THE ZONE!*
ADD SHADOWS UNTIL THE DRAWING BECOMES REAL & *TIME STOPS.* ERASE THE PENCIL LINES. *SIT BACK & ENJOY!*

INK TEXTURES

Dip the eraser of a #2 Ticonderoga pencil in ink or a stamp pad & stamp it on your paper for special effects.

Use a Q-tip dipped in ink to fill in large areas of black. Can also be used as dry brush.

After dipping your brush in ink, blot it on a paper towel & use it to create feathery gray tones.

Use white-out pens to produce white highlights & also make corrections.

An X-Acto blade or single-edge razor blade can be used to scrape inked areas for rain-like effects or highlights.

SPLATTER

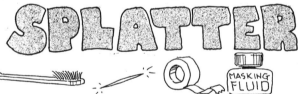

With the splatter technique you can achieve some very cool effects quite quickly. Mask off the area you don't want to be sprayed using tape or masking fluid. Dip a toothbrush into black ink, hold the brush about 5" away from the area to be splattered & carefully stroke the bristles toward you with a toothpick, until you achieve the desired effect.

The same effect can be applied to dark areas using Dr. Ph. Martin's bleed proof white.

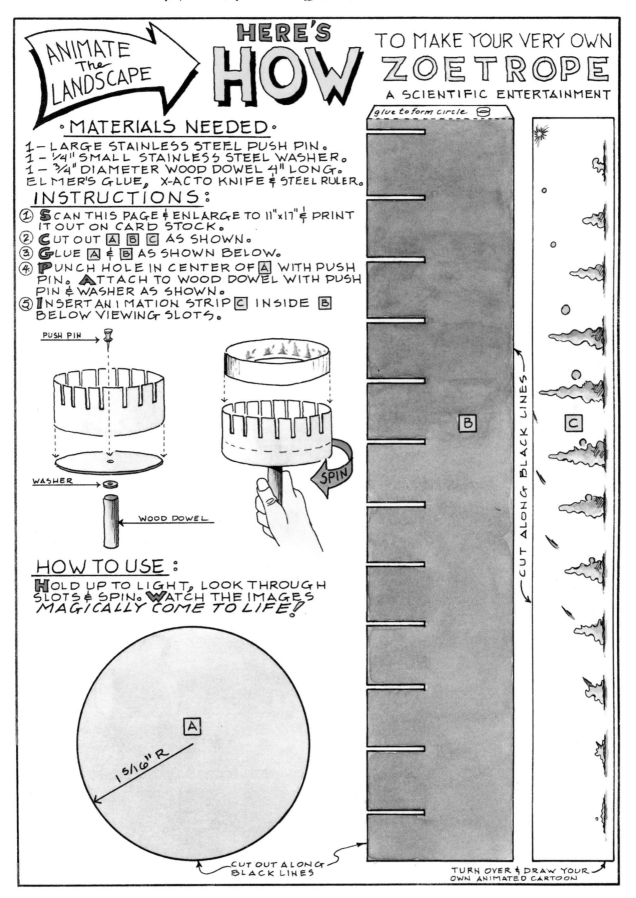

ANIMATE The LANDSCAPE

HERE'S HOW TO MAKE YOUR VERY OWN ZOETROPE
A SCIENTIFIC ENTERTAINMENT

·MATERIALS NEEDED·
1- LARGE STAINLESS STEEL PUSH PIN.
1- 1/4" SMALL STAINLESS STEEL WASHER.
1- 3/4" DIAMETER WOOD DOWEL 4" LONG.
ELMER'S GLUE, X-ACTO KNIFE & STEEL RULER.

INSTRUCTIONS:
1. SCAN THIS PAGE & ENLARGE TO 11"x17" & PRINT IT OUT ON CARD STOCK.
2. CUT OUT A B C AS SHOWN.
3. GLUE A & B AS SHOWN BELOW.
4. PUNCH HOLE IN CENTER OF A WITH PUSH PIN. ATTACH TO WOOD DOWEL WITH PUSH PIN & WASHER AS SHOWN.
5. INSERT ANIMATION STRIP C INSIDE B BELOW VIEWING SLOTS.

PUSH PIN

WASHER

WOOD DOWEL

SPIN

HOW TO USE:
HOLD UP TO LIGHT, LOOK THROUGH SLOTS & SPIN. WATCH THE IMAGES MAGICALLY COME TO LIFE!

A
1 5/16" R

CUT OUT ALONG BLACK LINES

glue to form circle

B

CUT ALONG BLACK LINES

C

TURN OVER & DRAW YOUR OWN ANIMATED CARTOON

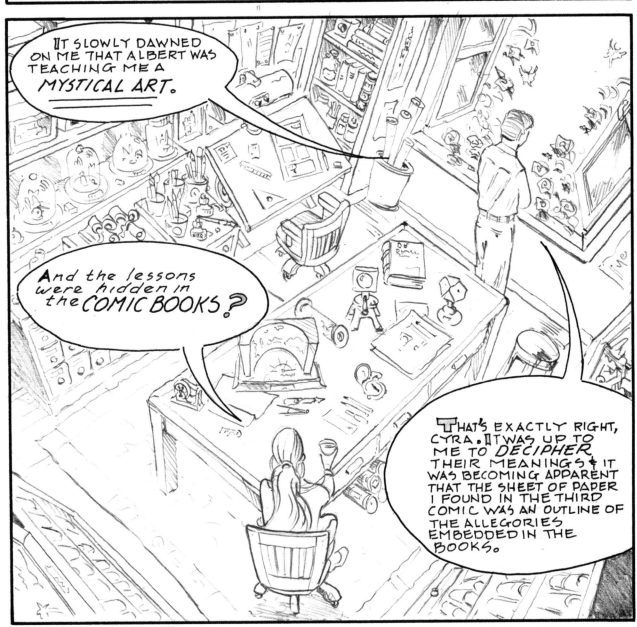

I STILL HAD NO IDEA WHO ALBERT WAS.

YOUR CREATIVE WORK MUST BE BUILT ON A *MORAL FOUNDATION.*

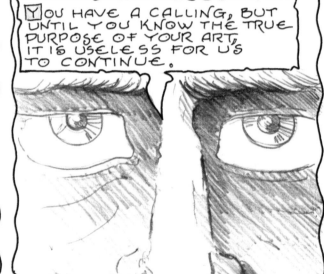

YOU HAVE A CALLING, BUT UNTIL YOU KNOW THE TRUE PURPOSE OF YOUR ART, IT IS USELESS FOR US TO CONTINUE.

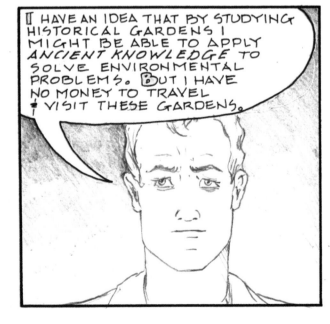

I HAVE AN IDEA THAT BY STUDYING HISTORICAL GARDENS I MIGHT BE ABLE TO APPLY *ANCIENT KNOWLEDGE* TO SOLVE ENVIRONMENTAL PROBLEMS. BUT I HAVE NO MONEY TO TRAVEL + VISIT THESE GARDENS.

YOU FOOL. THE SOLUTIONS YOU SEEK ARE RIGHT IN FRONT OF YOU.

THAT'S IMPOSSIBLE! NOT IN THIS SHALLOW & MATERIALISTIC CITY.

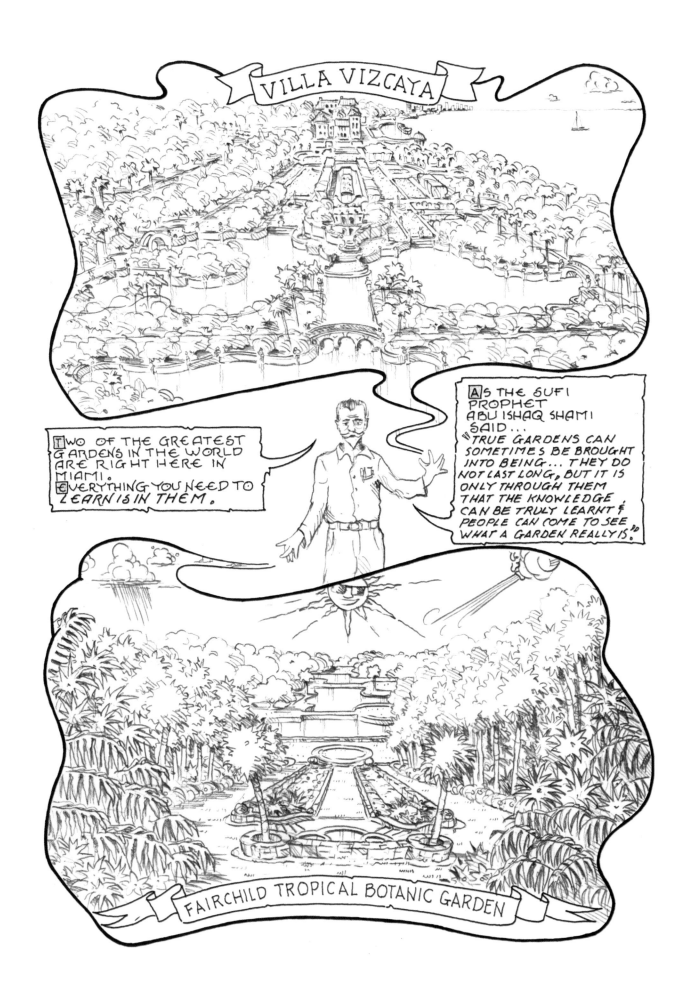

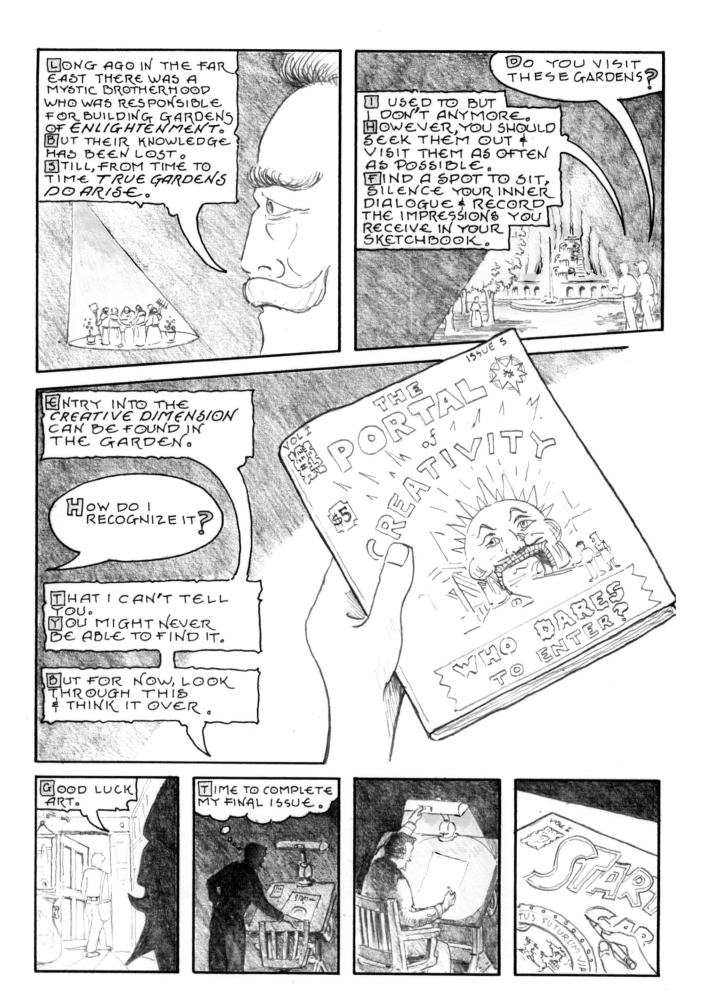

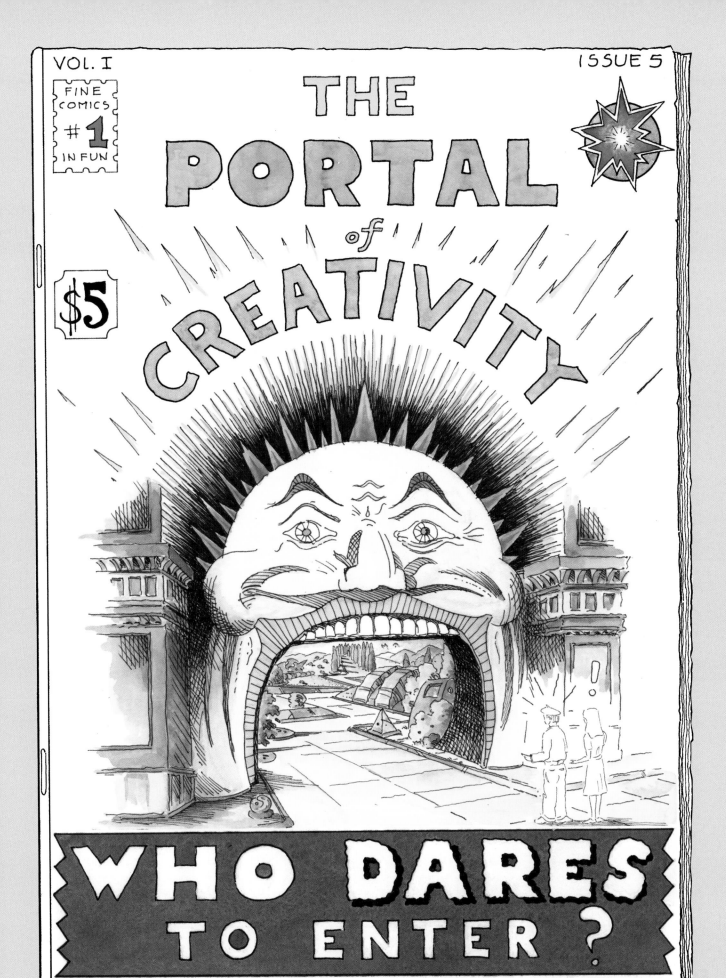

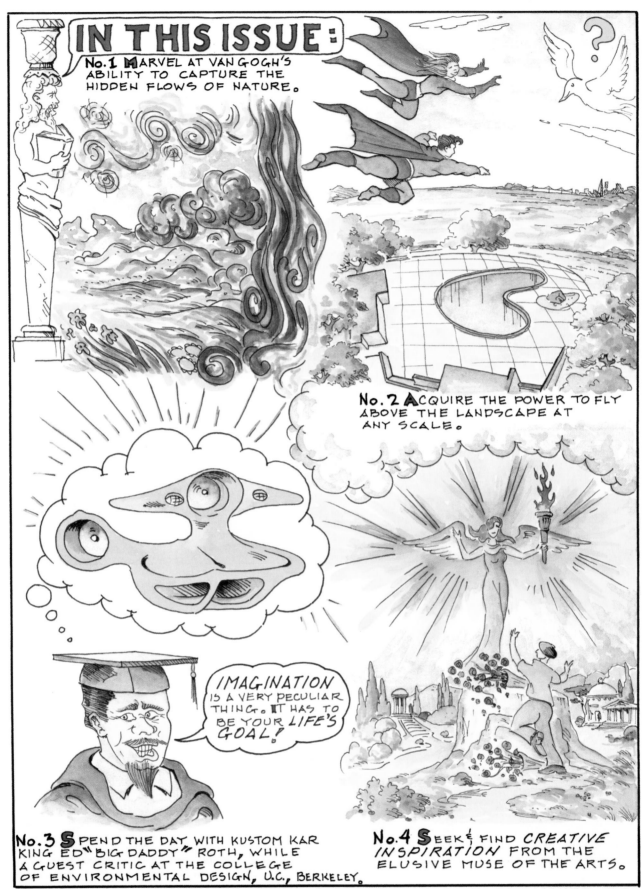

"IT IS THE PAINTER'S DUTY TO BE ENTIRELY ABSORBED BY NATURE."
VINCENT VAN GOGH

AS A CHILD VAN GOGH DEVELOPED A STRONG AFFINITY WITH NATURE & ALWAYS ADMIRED LANDSCAPE PAINTINGS. VAN GOGH ULTIMATELY BECAME ONE OF THE MOST *EXPRESSIVE & INNOVATIVE LANDSCAPE PAINTERS* THE WORLD HAS EVER KNOWN, *ILLUMINATING AN ECSTATIC VISION OF HIS ENVIRONMENT.* THUS AROUSED BY THE *FORCES OF NATURE,* VAN GOGH'S PAINTINGS REVEAL HIS...

LUST
FOR
Landscape

No. 1

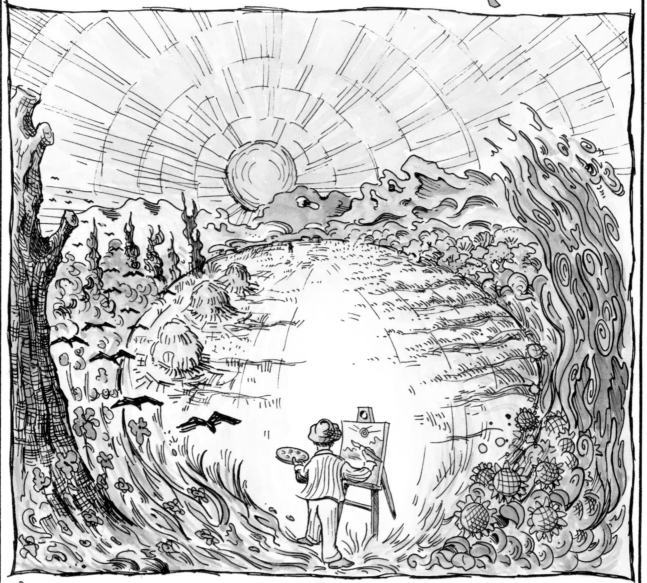

"SOMETIMES I LONG TO MAKE A LANDSCAPE, JUST AS I CRAVE A LONG WALK TO REFRESH MYSELF, & IN ALL NATURE I SEE EXPRESSION & SOUL." VINCENT VAN GOGH

AT FIRST GLANCE THE DRAWINGS OF VINCENT VAN GOGH SEEM LIKE TYPICAL LANDSCAPES, BUT IN REALITY HE IS MAKING A STRONG *STATEMENT ABOUT THE ENVIRONMENT!*

THIS DRAWING SHOWS THE *TRADITIONAL DUTCH FARMLANDS* VANISHING UNDER NEW MODES OF TRANSPORTATION & AGRICULTURAL TECHNIQUES.

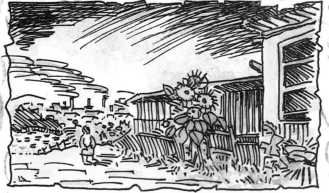

HERE VAN GOGH ILLUSTRATES THE *DESPOILING* OF THE FRENCH COUNTRYSIDE BY INDUSTRIAL SPRAWL.

IN MONTMARTRE, THE RAPID URBANIZATION CONTRASTS WITH THE RUSTIC GARDENS IN THE FOREGROUND.

"I see that nature has told me something, has spoken to me, and I have put it down in shorthand." VINCENT VAN GOGH

WHEN VAN GOGH FIRST VENTURED TO MONTMAJOUR IN JULY OF 1888 THE *MISTRAL WAS SO FEROCIOUS* HE COULD HARDLY *STAND UP*. HE PAINTED THIS WINDSWEPT OAK FIGHTING TO MAINTAIN ITS HOLD ON THE HILLSIDE IN THE VIOLENT WINDS AS AN ALLEGORY FOR HIS OWN *STRUGGLE* AGAINST THE ELEMENTS OF MONTMAJOUR.

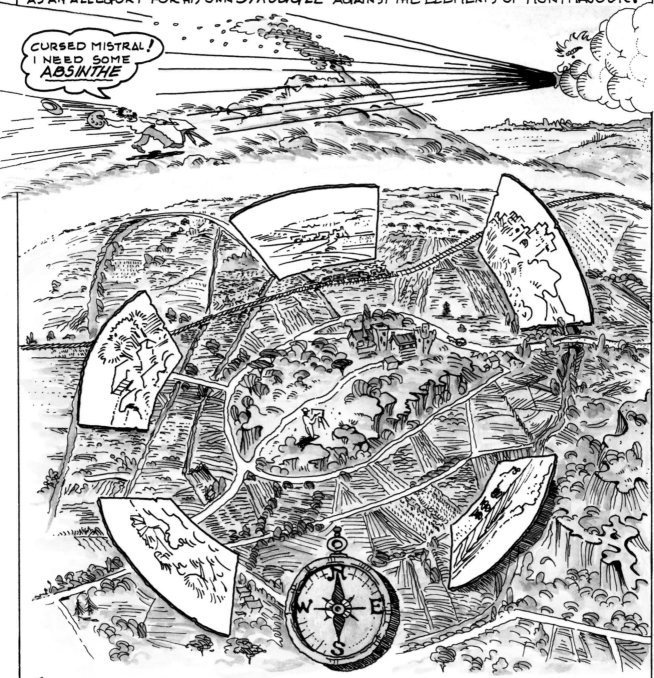

FOR VAN GOGH THE EXPANSIVE VISTAS FROM MONTMAJOUR *SYMBOLIZED NATURE'S CYCLE OF LIFE AND THE ETERNITY OF TIME*. DURING ONE WEEK IN JULY OF 1888 HE PAINTED FIVE SWEEPING PANORAMIC VIEWS. VAN GOGH'S INTENTION WAS TO PRODUCE A *SYSTEMATIC NARRATIVE* OF LA GRAU IN AN APPROXIMATE RELATIONSHIP WITH THE *MAIN POINTS OF THE COMPASS*.

360° PANORAMA AT MONTMAJOUR THAT VAN GOGH PLANNED TO PAINT BUT NEVER FINISHED.

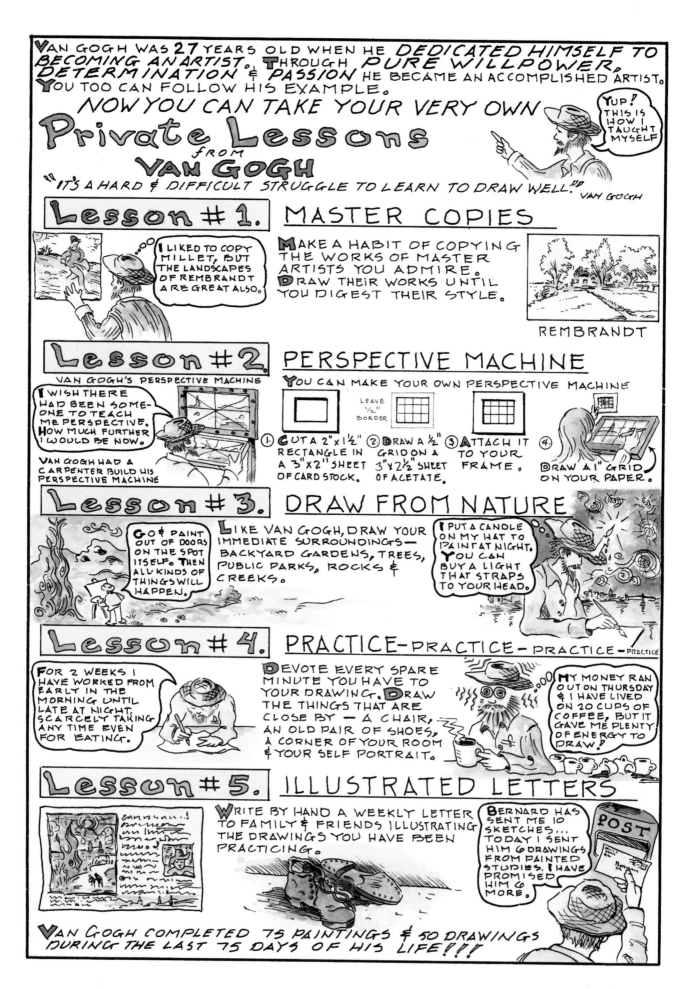

VAN GOGH WAS **27** YEARS OLD WHEN HE *DEDICATED HIMSELF TO BECOMING AN ARTIST.* THROUGH *PURE WILLPOWER, DETERMINATION & PASSION* HE BECAME AN ACCOMPLISHED ARTIST. YOU TOO CAN FOLLOW HIS EXAMPLE.

NOW YOU CAN TAKE YOUR VERY OWN

Private Lessons
FROM
VAN GOGH

"IT'S A HARD & DIFFICULT STRUGGLE TO LEARN TO DRAW WELL." VAN GOGH

YUP! THIS IS HOW I TAUGHT MYSELF

Lesson #1. MASTER COPIES

I LIKED TO COPY MILLET, BUT THE LANDSCAPES OF REMBRANDT ARE GREAT ALSO.

MAKE A HABIT OF COPYING THE WORKS OF MASTER ARTISTS YOU ADMIRE. DRAW THEIR WORKS UNTIL YOU DIGEST THEIR STYLE.

REMBRANDT

Lesson #2. PERSPECTIVE MACHINE

VAN GOGH'S PERSPECTIVE MACHINE

I WISH THERE HAD BEEN SOME-ONE TO TEACH ME PERSPECTIVE. HOW MUCH FURTHER I WOULD BE NOW.

VAN GOGH HAD A CARPENTER BUILD HIS PERSPECTIVE MACHINE

YOU CAN MAKE YOUR OWN PERSPECTIVE MACHINE

LEAVE 1/2" BORDER

① CUT A 2"x1½" RECTANGLE IN A 3"x2" SHEET OF CARD STOCK.

② DRAW A ½" GRID ON A 3"x2½" SHEET OF ACETATE.

③ ATTACH IT TO YOUR FRAME.

④ DRAW A 1" GRID ON YOUR PAPER.

Lesson #3. DRAW FROM NATURE

GO & PAINT OUT OF DOORS ON THE SPOT ITSELF. THEN ALL KINDS OF THINGS WILL HAPPEN.

LIKE VAN GOGH, DRAW YOUR IMMEDIATE SURROUNDINGS— BACKYARD GARDENS, TREES, PUBLIC PARKS, ROCKS & CREEKS.

I PUT A CANDLE ON MY HAT TO PAINT AT NIGHT. YOU CAN BUY A LIGHT THAT STRAPS TO YOUR HEAD.

Lesson #4. PRACTICE-PRACTICE-PRACTICE-PRACTICE

FOR 2 WEEKS I HAVE WORKED FROM EARLY IN THE MORNING UNTIL LATE AT NIGHT, SCARCELY TAKING ANY TIME EVEN FOR EATING.

DEVOTE EVERY SPARE MINUTE YOU HAVE TO YOUR DRAWING. DRAW THE THINGS THAT ARE CLOSE BY — A CHAIR, AN OLD PAIR OF SHOES, A CORNER OF YOUR ROOM & YOUR SELF PORTRAIT.

MY MONEY RAN OUT ON THURSDAY & I HAVE LIVED ON 20 CUPS OF COFFEE, BUT IT GAVE ME PLENTY OF ENERGY TO DRAW!

Lesson #5. ILLUSTRATED LETTERS

WRITE BY HAND A WEEKLY LETTER TO FAMILY & FRIENDS ILLUSTRATING THE DRAWINGS YOU HAVE BEEN PRACTICING.

BERNARD HAS SENT ME 10 SKETCHES... TODAY I SENT HIM 6 DRAWINGS FROM PAINTED STUDIES. I HAVE PROMISED HIM 6 MORE.

POST

VAN GOGH COMPLETED 75 PAINTINGS & 50 DRAWINGS DURING THE LAST 75 DAYS OF HIS LIFE!!!

SCENIC RIDDLE

CONNECT THE DOTS & SEE IF YOU CAN RECOGNIZE THIS FAMOUS GIANT EARTH SCULPTURE.

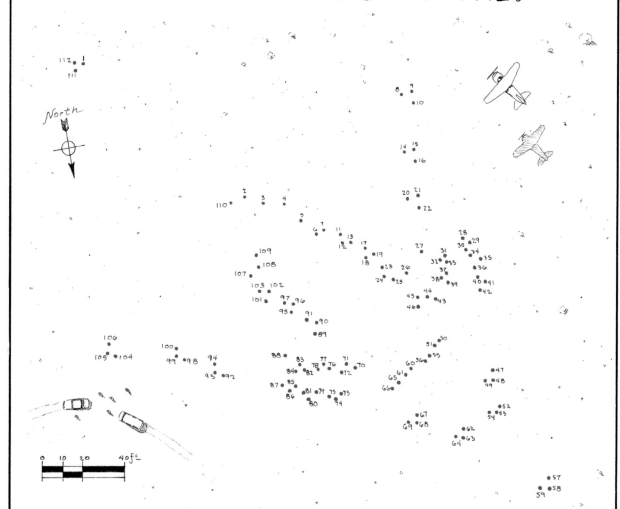

HINT: "COLIBRI"

ANSWER:

THIS *ENORMOUS GROUND DRAWING* IS KNOWN AS THE *HUMMINGBIRD* (*COLIBRI* IN SPANISH) & IS LOCATED IN THE NAZCA DESERT OF SOUTHERN PERU. IT IS JUST ONE OF HUNDREDS OF COLOSSAL STYLIZED FIGURES & *GEOMETRICAL DESIGNS* BELIEVED TO HAVE BEEN CREATED BETWEEN 400-650AD. NO ONE KNOWS EXACTLY HOW THEY WERE MADE OR THEIR EXACT PURPOSE. THE NAZCA LINES ARE ONE OF THE *GREAT LANDSCAPE MYSTERIES OF ALL TIME*!

VISUAL QUIZ

DRAW YOUR VISION OF WHAT LIES BEYOND THE

PORTAL of CREATIVITY

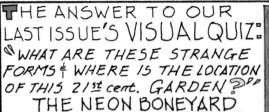

THE ANSWER TO OUR LAST ISSUE'S VISUAL QUIZ:
"WHAT ARE THESE STRANGE FORMS & WHERE IS THE LOCATION OF THIS 21st cent. GARDEN?"
THE NEON BONEYARD
LAS VEGAS, NEVADA
THIS UNUSUAL *STEEL & NEON GARDEN* PRESERVES SOME OF THE MOST FAMOUS SIGNS OF THE LAS VEGAS STRIP. THE 2-ACRE MUSEUM WAS FOUNDED IN 1996 & IS OPEN TO THE PUBLIC. VISIT TODAY!

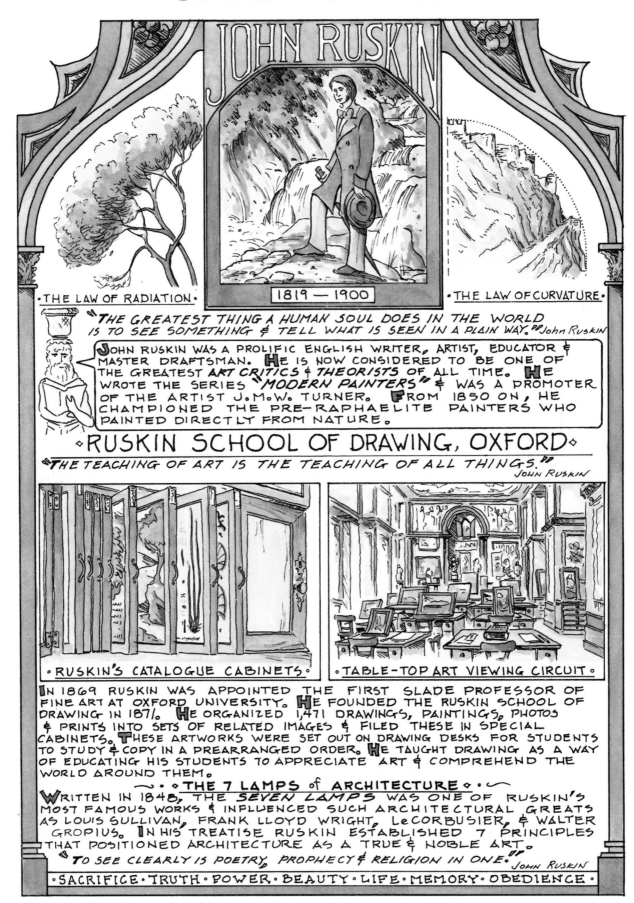

JOHN RUSKIN

1819 — 1900

·THE LAW OF RADIATION·

·THE LAW OF CURVATURE·

"THE GREATEST THING A HUMAN SOUL DOES IN THE WORLD IS TO SEE SOMETHING & TELL WHAT IS SEEN IN A PLAIN WAY." *John Ruskin*

JOHN RUSKIN WAS A PROLIFIC ENGLISH WRITER, ARTIST, EDUCATOR & MASTER DRAFTSMAN. HE IS NOW CONSIDERED TO BE ONE OF THE GREATEST *ART CRITICS* & *THEORISTS* OF ALL TIME. HE WROTE THE SERIES *"MODERN PAINTERS"* & WAS A PROMOTER OF THE ARTIST J.M.W. TURNER. FROM 1850 ON, HE CHAMPIONED THE PRE-RAPHAELITE PAINTERS WHO PAINTED DIRECTLY FROM NATURE.

◇RUSKIN SCHOOL OF DRAWING, OXFORD◇

"THE TEACHING OF ART IS THE TEACHING OF ALL THINGS."
JOHN RUSKIN

·RUSKIN'S CATALOGUE CABINETS·

·TABLE-TOP ART VIEWING CIRCUIT·

IN 1869 RUSKIN WAS APPOINTED THE FIRST SLADE PROFESSOR OF FINE ART AT OXFORD UNIVERSITY. HE FOUNDED THE RUSKIN SCHOOL OF DRAWING IN 1871. HE ORGANIZED 1,471 DRAWINGS, PAINTINGS, PHOTOS & PRINTS INTO SETS OF RELATED IMAGES & FILED THESE IN SPECIAL CABINETS. THESE ARTWORKS WERE SET OUT ON DRAWING DESKS FOR STUDENTS TO STUDY & COPY IN A PREARRANGED ORDER. HE TAUGHT DRAWING AS A WAY OF EDUCATING HIS STUDENTS TO APPRECIATE ART & COMPREHEND THE WORLD AROUND THEM.

~·◦ THE 7 LAMPS of ARCHITECTURE ◦·~

WRITTEN IN 1848, THE *SEVEN LAMPS* WAS ONE OF RUSKIN'S MOST FAMOUS WORKS & INFLUENCED SUCH ARCHITECTURAL GREATS AS LOUIS SULLIVAN, FRANK LLOYD WRIGHT, LeCORBUSIER, & WALTER GROPIUS. IN HIS TREATISE RUSKIN ESTABLISHED 7 PRINCIPLES THAT POSITIONED ARCHITECTURE AS A TRUE & NOBLE ART.

"TO SEE CLEARLY IS POETRY, PROPHECY & RELIGION IN ONE." *JOHN RUSKIN*

·SACRIFICE·TRUTH·POWER·BEAUTY·LIFE·MEMORY·OBEDIENCE·

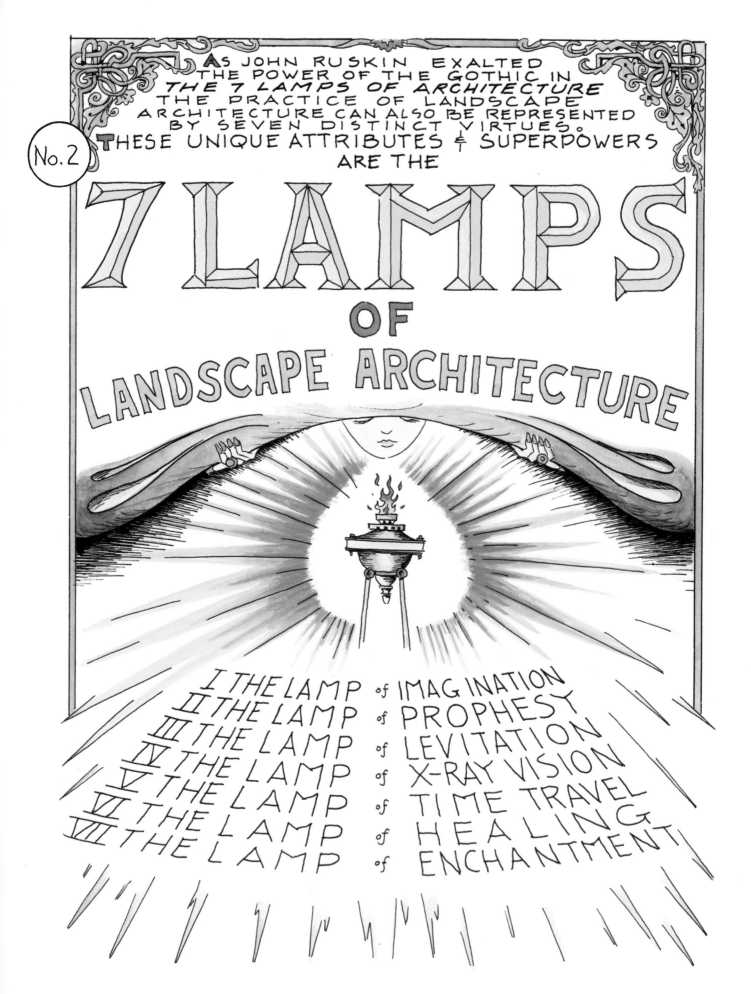

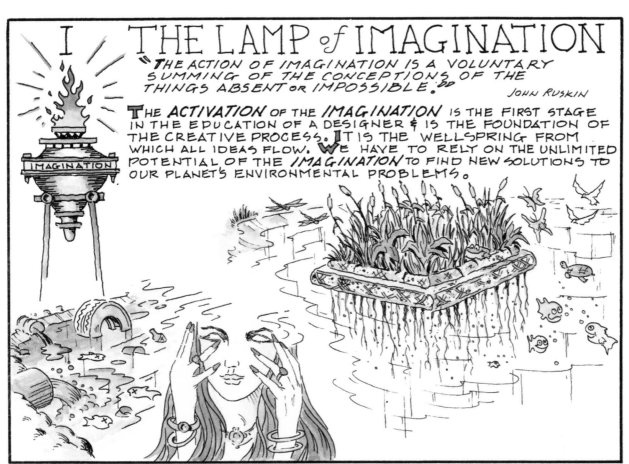

I THE LAMP of IMAGINATION

"THE ACTION OF IMAGINATION IS A VOLUNTARY SUMMING OF THE CONCEPTIONS OF THE THINGS ABSENT OR IMPOSSIBLE."

JOHN RUSKIN

THE ACTIVATION OF THE IMAGINATION IS THE FIRST STAGE IN THE EDUCATION OF A DESIGNER & IS THE FOUNDATION OF THE CREATIVE PROCESS. IT IS THE WELLSPRING FROM WHICH ALL IDEAS FLOW. WE HAVE TO RELY ON THE UNLIMITED POTENTIAL OF THE IMAGINATION TO FIND NEW SOLUTIONS TO OUR PLANET'S ENVIRONMENTAL PROBLEMS.

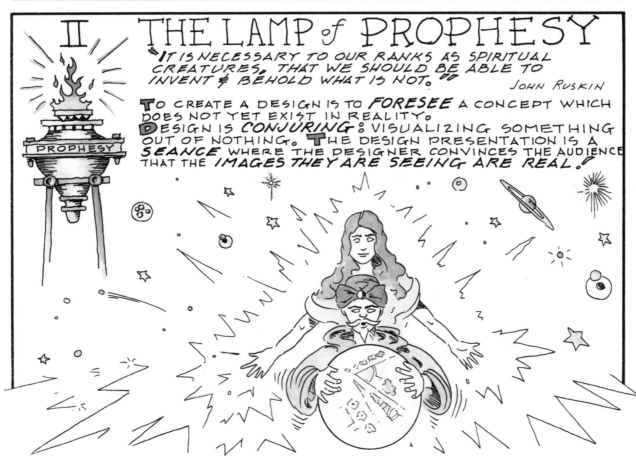

II THE LAMP of PROPHESY

"IT IS NECESSARY TO OUR RANKS AS SPIRITUAL CREATURES, THAT WE SHOULD BE ABLE TO INVENT & BEHOLD WHAT IS NOT."

JOHN RUSKIN

TO CREATE A DESIGN IS TO FORESEE A CONCEPT WHICH DOES NOT YET EXIST IN REALITY. DESIGN IS CONJURING: VISUALIZING SOMETHING OUT OF NOTHING. THE DESIGN PRESENTATION IS A SEANCE WHERE THE DESIGNER CONVINCES THE AUDIENCE THAT THE IMAGES THEY ARE SEEING ARE REAL!

III THE LAMP of LEVITATION

"ONE OF THE MOST MARKED DISTINCTIONS BETWEEN ONE ARTIST & ANOTHER, IN THE POINT OF SKILL, WILL BE FOUND IN THEIR RELATIVE DELICACY OF PERCEPTION..."

JOHN RUSKIN

PERHAPS THE MOST *AMAZING POWER* THE LANDSCAPE ARCHITECT POSSESSES IS THE ABILITY TO *LEVITATE* & *FLY* ABOVE THE LANDSCAPE.

LEARNING TO VISUALIZE SITE PLANS AT A VARIETY OF SCALES GIVES THE DESIGNER ONE OF THE MOST MIRACULOUS ATTRIBUTES OF THE SUPER-HERO... *FLIGHT!*

THUS THE LANDSCAPE ARCHITECT CAN EXAMINE AT WILL HER SITE PLANS FROM ANY AERIAL VIEWPOINT *IMAGINABLE*.

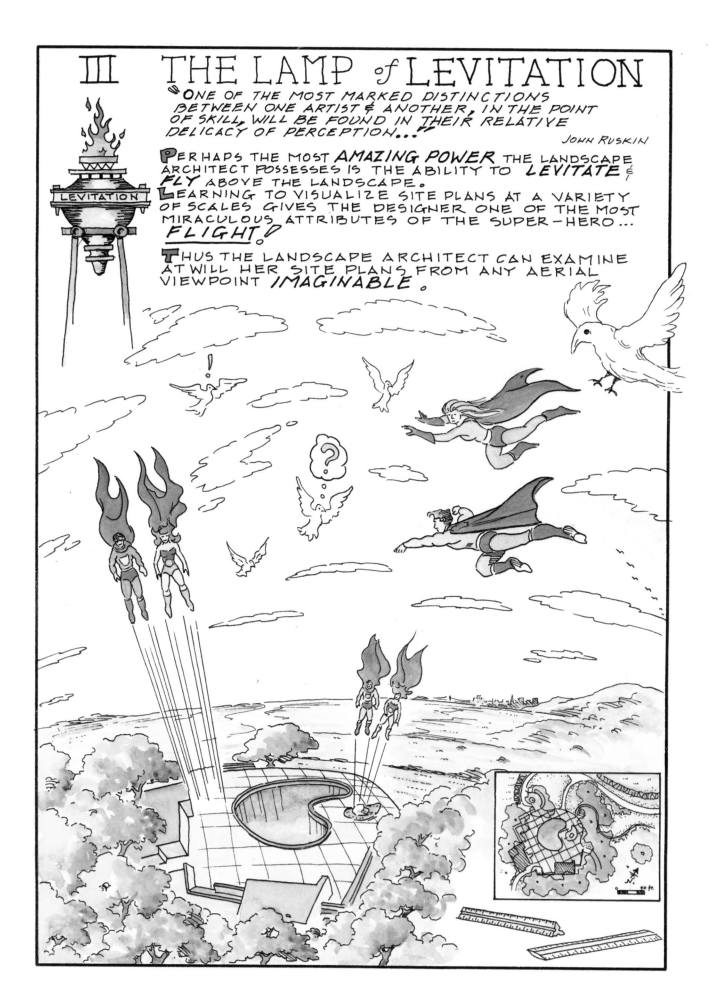

THE LAMP of X-RAY VISION

"A POWER FAITHFUL MORE THAN THOUGHTFUL, WHICH CONCEIVED & FELT MORE THAN CREATED." JOHN RUSKIN

IN ORDER TO UNDERSTAND & PRODUCE CONSTRUCTION DOCUMENTS ONE HAS TO DEVELOP THE ABILITY TO ACTUALLY *SEE THROUGH SOLID MATTER.* WHEN ONE ACQUIRES A KNOWLEDGE OF CONSTRUCTION & TOPOGRAPHY, HE or SHE WILL BEGIN TO POSSESS THE POWER OF *X-RAY VISION!* THIS TALENT ALLOWS ONE TO SEE HIDDEN INFRASTRUCTURE & INVISIBLE CYCLES OF NATURE.

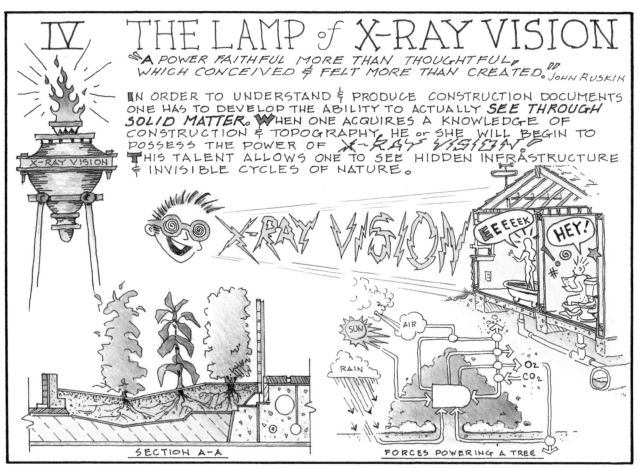

SECTION A-A

FORCES POWERING A TREE

THE LAMP of TIME TRAVEL

"AND THUS IN THE PROCESS OF TIME... IT MIGHT COME TO PASS, THAT A NEW STYLE SHOULD ARISE." JOHN RUSKIN

THE LANDSCAPE ARCHITECT ALSO ACQUIRES THE DELIGHTFUL POWER TO *JOURNEY THROUGH TIME!* WHEN A DESIGNER EMBARKS ON THE PROCESS OF SITE ANALYSIS, HE or SHE CAN TRAVEL BACK THROUGH EONS OF TIME, OR MOVE FORWARD & BEYOND INTO THE FUTURE. ONCE ABOARD THIS *PERSONAL TIME MACHINE,* THE LANDSCAPE ARCHITECT CAN OBSERVE MASSIVE CHANGES IN GEOLOGY, MIGRATION, CLIMATE & VEGETATION.

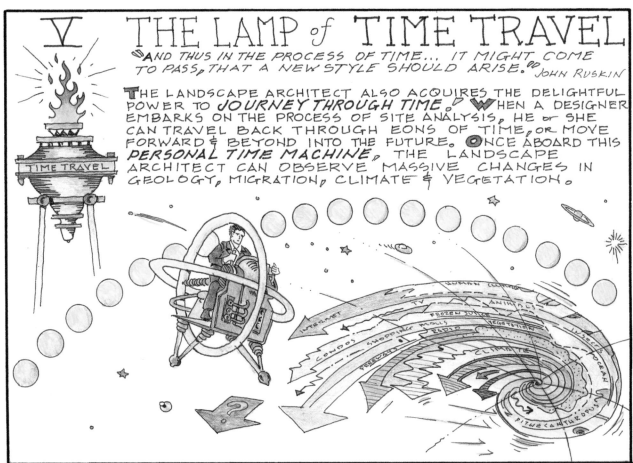

VI THE LAMP of HEALING

"GOD HAS LENT US THE EARTH FOR OUR LIFE; IT IS A GREAT ENTAIL. IT BELONGS AS MUCH TO THOSE WHO COME AFTER US."
JOHN RUSKIN

ONE OF THE MOST IMPORTANT POWERS THE LANDSCAPE ARCHITECT POSSESSES IS THE CAPABILITY TO HEAL & CURE POISONED, POLLUTED LANDSCAPES. THROUGH THE PROCESS OF BIOREMEDIATION, REGENERATION & METAMORPHOSIS, THE DESIGNER CREATES HEALTHY ECOSYSTEMS TO REPLACE SICK & DESTROYED ONES. AS A RESULT THE LANDSCAPE ARCHITECT ACHIEVES THE RANK OF HEALER & STEWARD.

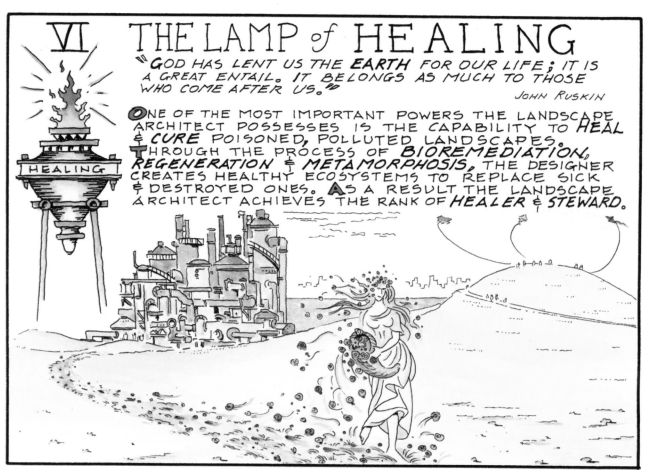

VII THE LAMP of ENCHANTMENT

"THE ESSENTIAL CHARACTERS OF BEAUTY DEPEND ON THE EXPRESSION OF VITAL ENERGY IN ORGANIC THINGS."
JOHN RUSKIN

IN THE FINAL STAGES OF A LANDSCAPE ARCHITECT'S EDUCATION HE or SHE GAINS ACCESS TO THE WORLD OF ENCHANTMENT. WHEN ALL 7 LAMPS HAVE BEEN GATHERED INTO ONE UNIFIED SHINING LIGHT OF ENCHANTMENT, THE LANDSCAPE ARTIST WILL HAVE AT HIS or HER COMMAND THE SUPERPOWERS NECESSARY TO MITIGATE THE COURSE OF HUMANITY'S WANTON DESTRUCTION OF THE ENVIRONMENT.

"THE SEARCH STILL REMAINS WITH US, EVEN WHEN WE HAVE WILLFULLY LEFT THE FOUNTAINS OF IT." *JOHN RUSKIN*

THE END

CHiPley's ⸺ oo *Believe It or What?*

JOHN RUSKIN

BEST and BIGGEST

IN THE EARLY 20th CENTURY TOBACCO COMPANIES OFTEN USED THE NAMES OF WRITERS & CRITICS AS BRAND NAMES FOR THEIR CIGARS. THE CIGAR COMPANIES PROMOTED THE IDEA THAT TOBACCO WAS A *MUSE for CREATIVITY.*

THE "JOHN RUSKIN" WAS THE LEWIS CIGAR COMPANY'S MAIN BRAND; IN ONE WEEK 500,000 JOHN RUSKIN CIGARS WERE SOLD IN NEW YORK CITY ALONE!

THEY ARE MILD

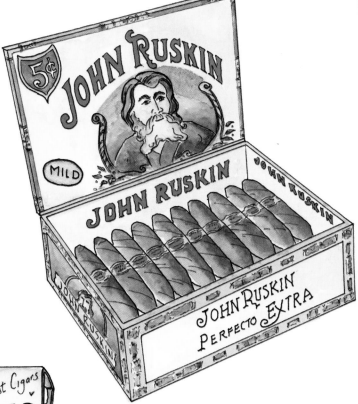

THE RUSKIN BRAND EVEN HAD ITS OWN MATCHES TO ADVERTIZE THEIR CIGAR.

IRONICALLY RUSKIN WAS ALMOST ENTIRELY ALONE AMONG 19th CENTURY WRITERS WHO OPPOSED THE USE OF TOBACCO.

HE BELIEVED THAT TOBACCO CORRUPTED THE MORALS OF YOUTH! YET THE CIGAR BEARING HIS NAME WAS ONE OF THE MOST POPULAR CIGARS EVER SOLD!

HOW NUTS IS THAT ?

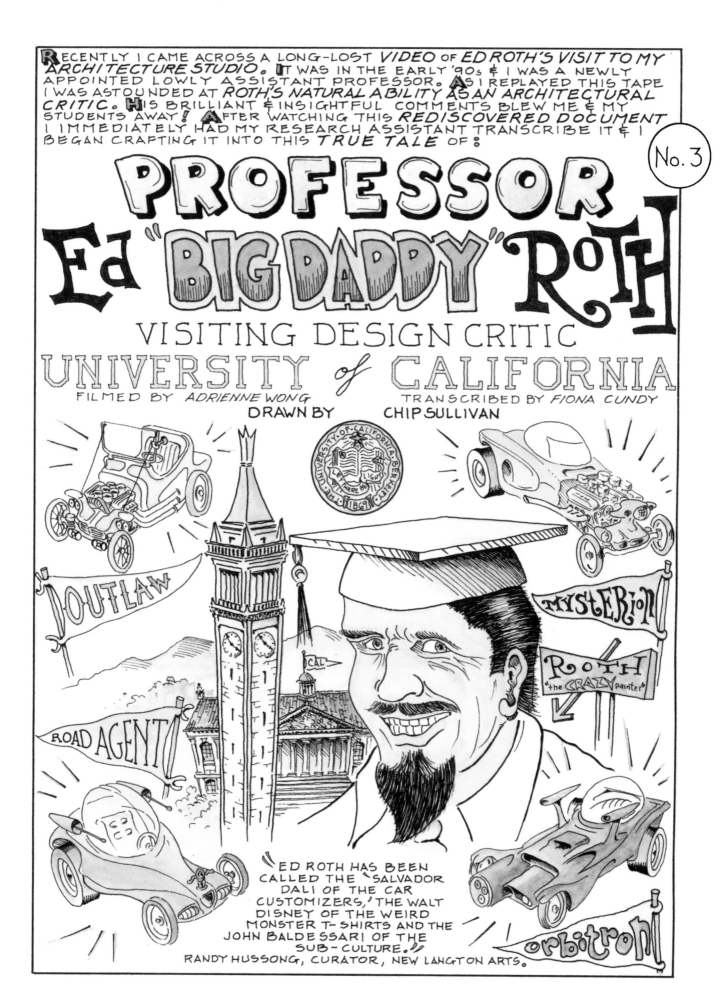

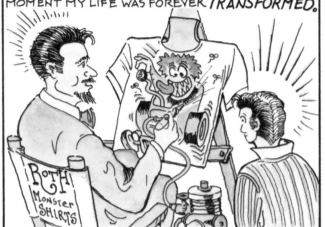

WHEN I WAS 15 YEARS OLD MY FATHER TOOK ME TO THE AUTORAMA CAR SHOW IN WASHINGTON, D.C., WHERE I FIRST SAW ROTH AIRBRUSHING *WEIRDO T-SHIRTS*. I STOOD TRANSFIXED WATCHING HIM CHURN OUT ONE *WILD IMAGE* AFTER ANOTHER. FROM THAT MOMENT MY LIFE WAS FOREVER *TRANSFORMED*.

ROTH
Monster
SHIRTS

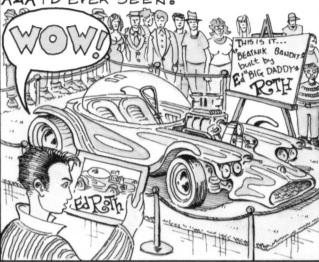

ROTH EVEN GAVE ME AN AUTOGRAPHED PHOTO OF HIS NEWEST *KAL KUSTOM KAR*, THE *BEATNIK BANDIT*, THE *COOLEST KAR* I'D EVER SEEN.

WOW!

THIS IS IT... "BEATNIK BANDIT" built by Ed "BIG DADDY" ROTH

Ed Roth

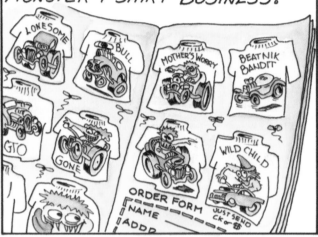

ROTH INSPIRED ME TO BECOME AN *OFFBEAT ARTIST*. HIS *MONSTER T-SHIRT CATALOGUES* BECAME MY *ART SCHOOL*. I DEVELOPED MY *DRAWING SKILLS* COPYING HIS DESIGNS & EVEN STARTED MY OWN *MONSTER T-SHIRT BUSINESS*.

LONESOME
BULL
MOTHER'S WORRY
BEATNIK BANDIT
GTO
GONE
WILD CHILD
ORDER FORM
NAME
ADDR
JUST SEND CK or $

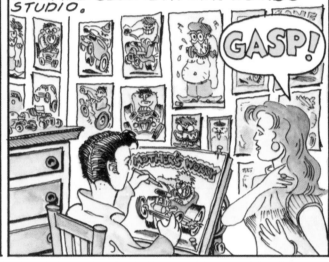

MY FIRST MASTER COPY WAS ROTH'S *"MOTHER'S WORRY"* & MY MOTHER DID WORRY AFTER LOOKING INTO MY ROOM, WHICH HAD BECOME MY OWN *WEIRDO STUDIO*.

GASP!

MOTHER'S WORRY

YEARS LATER...

AFTER BEING HIRED AS AN *ASSISTANT PROFESSOR* AT U.C.'s *COLLEGE OF ENVIRONMENTAL DESIGN* I WAS ASSIGNED TO TEACH A SITE PLANNING COURSE FOR ARCHITECTS & LANDSCAPE ARCHITECTURE STUDENTS. I IMMEDIATELY DEVELOPED A *STUDIO PROJECT* FOR THE DESIGN OF A SACRE COMPLEX FOR A ROTH ART CENTER. THE PROGRAM DIRECTED THE STUDENTS TO DESIGN A SITE PLAN THAT INCLUDED:

1. ROTH HOME & ART STUDIO
2. WEIRDO GALLERY & ART STUDIO
3. CAFE-SALON
4. KUSTOM KAR EXHIBITION HALL
5. CAR PINSTRIPING & PAINTING SHOP
6. LIVE/WORK STUDIOS WITH CAR FABRICATION WORKSHOPS

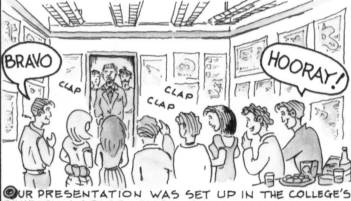

TAKING A WILD CHANCE, WE CALLED ROTH & INVITED HIM TO BE ON THE PROJECT'S *DESIGN JURY*. TO OUR DELIGHT *HE AGREED TO COME*. I MET HIM THE MORNING OF THE REVIEW IN THE PARKING LOT BEHIND WURSTER HALL, WHERE HE HAD SLEPT IN HIS HONDA THAT NIGHT.

BRAVO

CLAP

CLAP
CLAP

HOORAY!

OUR PRESENTATION WAS SET UP IN THE COLLEGE'S EXHIBITION SPACE, WHERE ROTH ENTERED TO A *HERO'S WELCOME!*

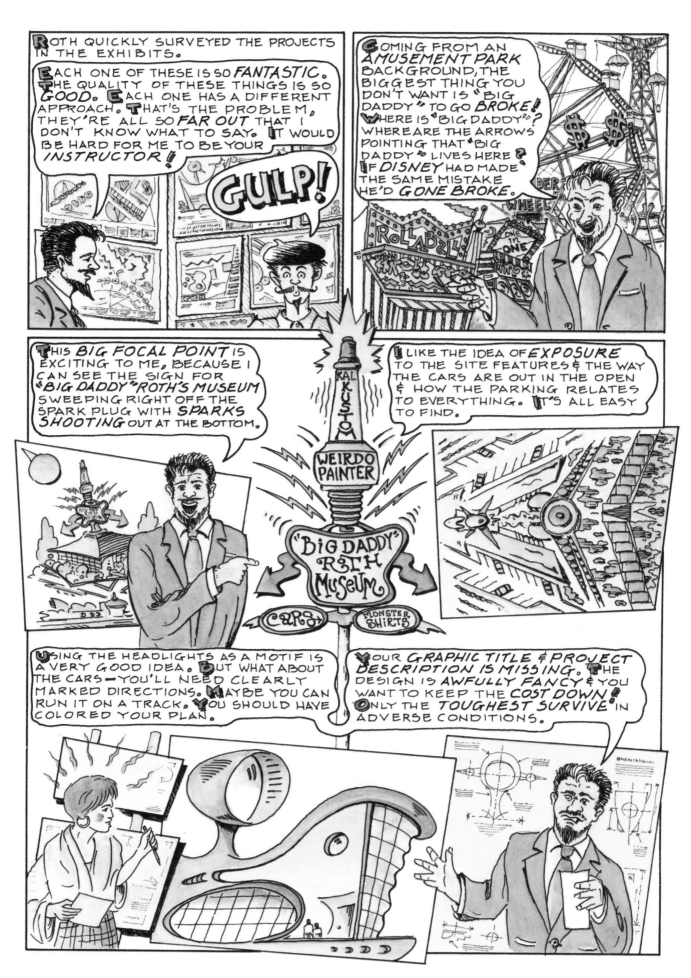

ROTH QUICKLY SURVEYED THE PROJECTS IN THE EXHIBITS.

EACH ONE OF THESE IS SO *FANTASTIC*. THE QUALITY OF THESE THINGS IS SO *GOOD*. EACH ONE HAS A DIFFERENT APPROACH. THAT'S THE PROBLEM, THEY'RE ALL SO *FAR OUT* THAT I DON'T KNOW WHAT TO SAY. IT WOULD BE HARD FOR ME TO BE YOUR *INSTRUCTOR!*

GULP!

COMING FROM AN *AMUSEMENT PARK* BACKGROUND, THE BIGGEST THING YOU DON'T WANT IS "BIG DADDY" TO GO *BROKE!* WHERE IS "BIG DADDY"? WHERE ARE THE ARROWS POINTING THAT "BIG DADDY" LIVES HERE? IF *DISNEY* HAD MADE THE SAME MISTAKE HE'D *GONE BROKE*.

THIS *BIG FOCAL POINT* IS EXCITING TO ME, BECAUSE I CAN SEE THE SIGN FOR *"BIG DADDY" ROTH'S MUSEUM* SWEEPING RIGHT OFF THE SPARK PLUG WITH *SPARKS SHOOTING* OUT AT THE BOTTOM.

I LIKE THE IDEA OF *EXPOSURE* TO THE SITE FEATURES & THE WAY THE CARS ARE OUT IN THE OPEN & HOW THE PARKING RELATES TO EVERYTHING. IT'S ALL EASY TO FIND.

USING THE HEADLIGHTS AS A MOTIF IS A VERY GOOD IDEA. BUT WHAT ABOUT THE CARS—YOU'LL NEED CLEARLY MARKED DIRECTIONS. MAYBE YOU CAN RUN IT ON A TRACK. YOU SHOULD HAVE COLORED YOUR PLAN.

YOUR *GRAPHIC TITLE* & *PROJECT DESCRIPTION IS MISSING*. THE DESIGN IS *AWFULLY FANCY* & YOU WANT TO KEEP THE *COST DOWN.* ONLY THE *TOUGHEST SURVIVE* IN ADVERSE CONDITIONS.

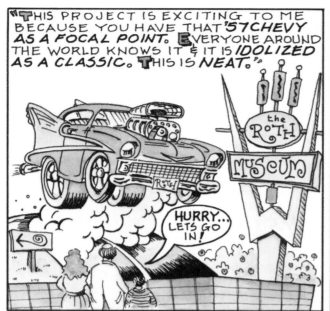

"THIS PROJECT IS EXCITING TO ME BECAUSE YOU HAVE THAT '57 CHEVY AS A FOCAL POINT. EVERYONE AROUND THE WORLD KNOWS IT & IT IS IDOLIZED AS A CLASSIC. THIS IS NEAT."

HURRY... LETS GO IN!

the ROTH MUSEUM

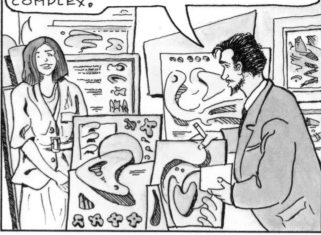

HAVING EVERYTHING UNDER ONE ROOF IS INTRIGUING & I LIKE THE STUFF ON TOP. YOUR ROOF SYSTEM CAN COVER THE CUSTOM CARS CHEAPLY. YOU HAVE A CONTINUOUS LOOK TO THE ARCHITECTURAL COMPLEX.

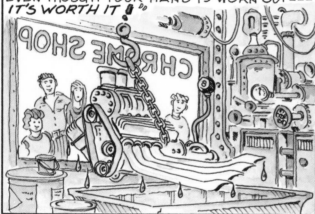

"CREATING LIVE / WORK IN THE SAME PLACE IS A GREAT IDEA & YOU'VE OPENED THEM UP SO SPECTATORS CAN WATCH THE WORK GOING ON INSIDE THE CUSTOM CAR GARAGES, SHOWING THEM JUST WHAT A CHROME SHOP IS & WHAT'S GOING ON IN THERE. TERRIFIC COLORING, EVEN THOUGH YOUR HAND IS WORN OUT--- IT'S WORTH IT !"

CHROME SHOP

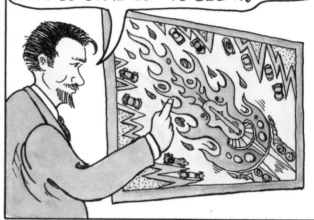

THE HOT ROD FLAMES IN THIS PROJECT WILL REALLY SPARK INTEREST IN MY WORK, ESPECIALLY WHEN IT IS ADVERTISED IN NEW YORK - THEY'RE GOING TO REMEMBER THAT. IF IT'S IN A BOOK THEY'LL NEVER FORGET IT & THEY'LL COME OUT TO SEE IT.

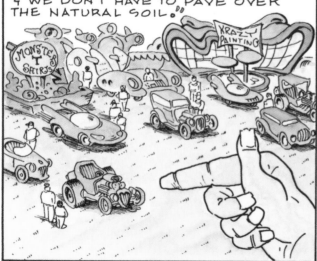

"USING GRASS AS A TEMPORARY PARKING LOT IS A PRETTY GOOD IDEA. WE DO THAT OFTEN AT OUR CAR SHOWS & WE DON'T HAVE TO PAVE OVER THE NATURAL SOIL."

MONSTER T SHIRTS

KRAZY PAINTING

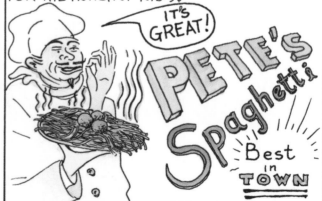

"I LIKE THE OPENNESS OF THIS ONE, PEOPLE TEND TO GATHER IN GROUPS WHEN THEY GO TO THIS TYPE OF AN ATTRACTION & YOU'VE GOT PLENTY OF ROOM FOR THAT TO HAPPEN HERE. YOU HAVE THE CONCESSIONS & CUSTOM CAR DISPLAYS SITED PERFECTLY BUT YOU'LL NEED SOMETHING LIKE PETE'S SPAGHETTI FOR THE HUNGRY KIDS."

IT'S GREAT!

PETE'S Spaghetti
Best in TOWN

A VERY UNIQUE *ECOLOGICAL* THING HERE IS TO RECYCLE TIRES INTO AN ACTUAL DISPLAY. I LIKE THE IDEA THAT YOU'VE DESIGNED A PLACE THAT IS *ACCESSIBLE TO THE HANDICAPPED.* MAKING PARKING SPACES A *DIFFERENT COLOR* — NOW THAT'S A *GREAT IDEA* — HMMM!

I ALWAYS LIKED THESE *'50s DESIGN STYLES,* BECAUSE THEY ARE SIMILAR TO THE LOS ANGELES *DRIVE-IN ATMOSPHERE* WITH THE KIND OF *JUNK* TO GIVE YOU THAT *'50s* FEELING & WITH JUST ENOUGH PALM TREES TO GIVE THE PLAN A FORMAL LOOK. THIS VIEW FROM MY PRIVATE LIVING SPACE WILL DEFINITELY GIVE ME *INSPIRATION.*

WE SADLY REALIZED THAT OUR DAY WITH ROTH WAS WINDING DOWN AS HE FINISHED UP WITH SOME *PHILOSOPHICAL MUSINGS.*

FOR THE CLIENT PUTTING UP THE MONEY FOR YOUR PROJECT, GIVE THEM SOMETHING THAT'S *FAR OUT!* DON'T GIVE THEM SOMETHING NORMAL.

IMAGINATION IS A VERY PECULIAR THING TO DEVELOP & THAT HAS TO BE YOUR *LIFE'S GOAL.* TO DEVELOP *IMAGINATION* SO THAT YOU CANNOT STOP SOMETHING THAT'S *NOT NORMAL,* BUT SO *FAR OUT!* IT CAN'T JUST BE YOUR FIRST IDEA, BUT MAYBE THE *15th IDEA* AFTER PLAYING WITH YOUR PENCIL. *SKETCHING IDEAS & COMING UP WITH SOMETHING.*

YOU DON'T *USE YOUR FIRST IDEA.* LIKE WHEN I BUILD MY CARS, I ALWAYS SAY TO MYSELF *HAS THIS BEEN DONE BEFORE?* IF IT'S BEEN DONE BEFORE YOU DON'T DO IT! IF YOU START WITH SOMETHING THAT COMES OUT OF YOUR MIND OR SOMETHING YOU ADMIRE — TAKE OFF FROM THAT & *CHANGE IT AROUND* — CHANGE IT AROUND! YOU KNOW EVERY CAR HAS 4 WHEELS, SO THAT'S IN YOUR *IMAGINATION* — JUST THINK OF SOMETHING *CRAZY & IT WILL HAPPEN!* DON'T PUT YOURSELF IN THAT CLASS OF PEOPLE THAT *ARE SATISFIED WITH NORMAL THINGS!*

PEOPLE THAT DON'T EVEN KNOW ME CAME TO JUST SEE ME AT CAR SHOWS LOOKING FOR *INSPIRATION!*

I'M THE SYMBOL OF IT ALL

THERE'S NOTHING QUITE AS SATISFYING AS A NIGHT SPENT IN YOUR CAR. COME *GENTLEMEN* I'LL SHOW YOU MY *HUMBLE ABODE.*

AND HE WAS GONE . . .

THE LIVING END

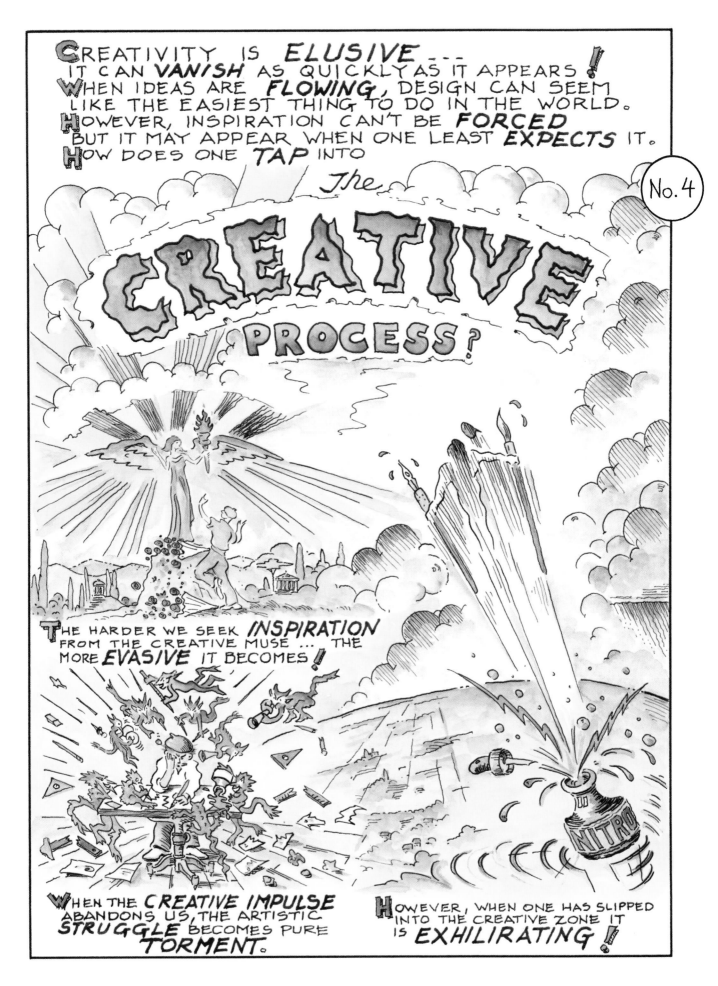

CREATIVITY IS *ELUSIVE*---
IT CAN *VANISH* AS QUICKLY AS IT APPEARS!
WHEN IDEAS ARE *FLOWING*, DESIGN CAN SEEM
LIKE THE EASIEST THING TO DO IN THE WORLD.
HOWEVER, INSPIRATION CAN'T BE *FORCED*
BUT IT MAY APPEAR WHEN ONE LEAST *EXPECTS* IT.
HOW DOES ONE *TAP* INTO

The **CREATIVE** PROCESS?

No. 4

THE HARDER WE SEEK *INSPIRATION*
FROM THE CREATIVE MUSE ... THE
MORE *EVASIVE* IT BECOMES!

WHEN THE *CREATIVE IMPULSE*
ABANDONS US, THE ARTISTIC
STRUGGLE BECOMES PURE
TORMENT.

HOWEVER, WHEN ONE HAS SLIPPED
INTO THE CREATIVE ZONE IT
IS *EXHILIRATING*!

177

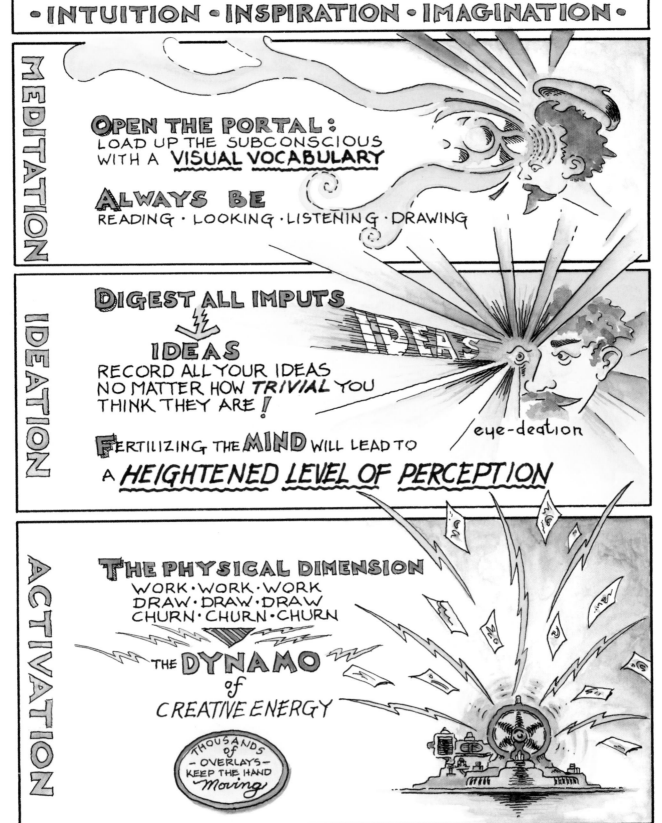

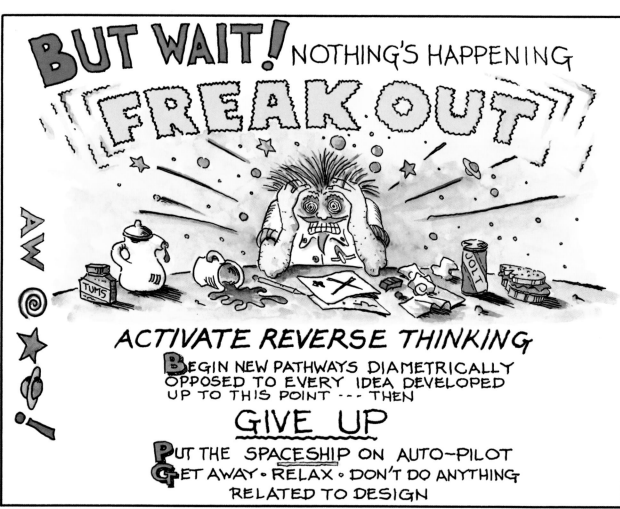

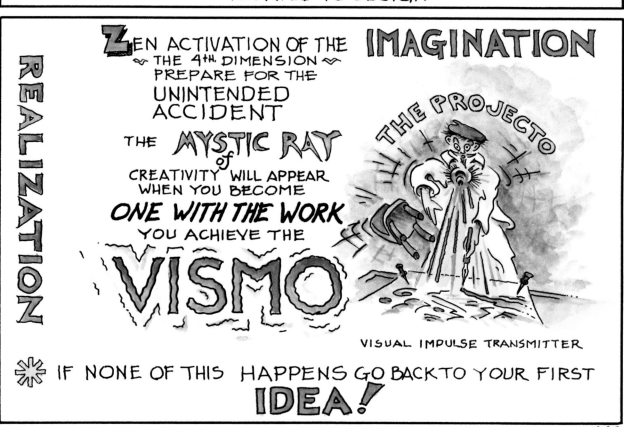

THE PROCESS FOR **CREATIVE PRODUCTION** DURING THE RENAISSANCE IN ITALY RESEMBLES THE DESIGN METHODOLOGY STILL TAUGHT IN ACADEMIA & PRACTICED IN THE PROFESSION TODAY. FOR YOUR ENJOYMENT & EDIFICATION WE HAVE ASSEMBLED FROM MANY HISTORICAL SOURCES, THE . . .

WHAMMO-ITALIANO

RENAISSANCE DESIGN PROCESS

① SCHIZZI - *SKETCHES IN THE FORM OF A STAIN*

ONE BEGINS WITH *ROUGH COMPOSITIONAL IDEAS* TO FIND THE MANNER OF THE POSES or DESIGN. SKETCHES ARE RAPIDLY POURED FORTH ONTO THE PAPER *dal furor dello artifice* — "*in a fury of artistic inspiration.*" THESE DRAWINGS ARE CALLED *primi pensieri* or "*first thoughts.*"

↪ INITIAL SKETCHES FOR A GARDEN & VILLA BY LEONARDO DA VINCI.

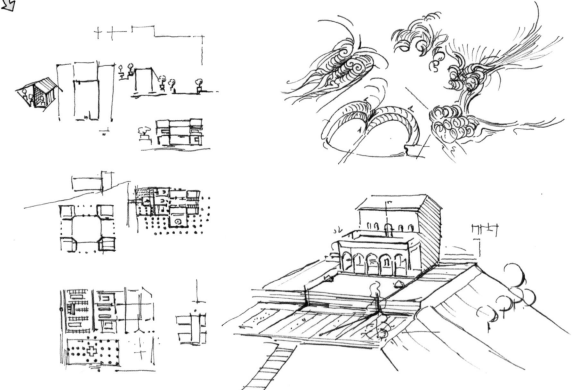

" THE ARTIST THEN HAS IT FIRST IN HIS MIND & THEN IN HIS HANDS ... SO THAT HE MIGHT CREATE PROPORTIONAL HARMONY IN A SINGLE GLANCE."

LEONARDO DA VINCI

② DISEGNI - *DRAWINGS* or *DESIGNS*

STAGE 2 IS THE PRODUCTION OF A *VARIETY* OF MORE DETAILED TYPES OF DRAWINGS *done with all the diligence possible.*
THIS STEP INCLUDES *modelli or "quartered drawings"* DONE TO SCALE TO COMMUNICATE THE DESIGN INTENT TO THE *PATRON.*

LEONARDO DA VINCI: *DESIGNS & PLANS FOR A CHURCH.*

TINTORETTO: *STUDY FOR THE BATTLE OF ZARA.*

③ CARTONE - *CARTOON*

THE FINAL SELECTION OF THE DESIGN IS NOW MADE ACCORDING TO *giudizio dell'occhio* — *"the judgment of the eye."*
IN THE CASE OF FRESCO THE DESIGN IS ENLARGED TO FULL SCALE & TRANSFERRED TO THE SURFACE TO BE PAINTED.
IN THE CASE OF A GARDEN OR BUILDING, MEASURED DRAWINGS ARE FINALIZED.
TODAY THE LAST STAGE OF THE DESIGN PROCESS IS THE PRODUCTION OF WORKING DRAWINGS & CONSTRUCTION DETAILS.

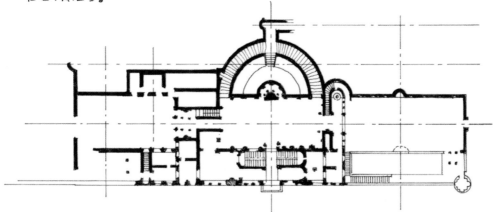

RAPHAEL: *PLAN FOR THE VILLA MADAMA, ROME.*

"THE PAINTER'S MIND MUST OF NECESSITY ENTER INTO NATURE'S MIND IN ORDER TO ACT AS AN INTERPRETER BETWEEN NATURE & ART."
LEONARDO DA VINCI

TRICKS & TIPS

FOR TODAY'S *LADS & LASSIES* WHO WANT TO PURSUE THEIR OWN *CREATIVE FORCE* WHILE BEING EMPLOYED FULL TIME.

TIP — THE JOURNAL

ALWAYS KEEP A JOURNAL BY YOUR SIDE IN WHICH YOU CAN DRAW & WRITE DAILY. RECORD YOUR THOUGHTS, IDEAS & DREAMS. THE JOURNAL WILL EVENTUALLY BECOME YOUR PERSONAL *ENCYCLOPEDIA OF INSPIRATION* FOR FUTURE PROJECTS.

TRICK — THE LAB NOTEBOOK

GET YOURSELF SEVERAL OF THE CLASSIC MARBLE-COVERED LAB BOOKS CONTAINING NO MORE THAN 100 PAGES. FILL THEM WITH IMAGES & WORK YOU FIND INTERESTING. REFER TO THESE WHEN RESEARCHING PROJECTS; YOU WILL *SERENDIPITOUSLY* STUMBLE UPON IDEAS THAT WILL *SPARK EVEN MORE!*

TIP — FIND YOUR CREATIVE CYCLE

THE CREATIVE CYCLE IS LIKE A BIORHYTHM; IT *EBBS & FLOWS* THROUGH THE DAY.

MIDNIGHT 4 6 8 NOON 4 6 MIDNIGHT
POP ... SPARK

IT'S IMPORTANT TO FIND A 3-4 hr. BLOCK OF TIME THAT WORKS BEST FOR YOU. MOST WRITERS WORK ONLY 3-4 hrs. PER DAY.

MIDNIGHT 4 6 8 NOON 4 8 MIDNIGHT
THE JOB $

SOME ARTISTS PREFER TO GET UP AT 4AM & WORK FOR 3-4 HOURS BEFORE GOING TO THE OFFICE. THEY RESERVE THEIR FRESHLY *AWAKENED STATE* TO CONCENTRATE ON THEIR OWN WORK & THUS BE SLEEPY & TIRED ON THE JOB. SOME ARTISTS PREFER TO COME HOME, TAKE A NAP, WAKE UP, MAKE A POT OF COFFEE & WORK TILL 2:00 or 3:00 IN THE MORNING.

FIND YOUR CREATIVE TIME.

TRICK — THE ROUTINE

ONCE YOU DETERMINE YOUR CREATIVE CYCLE ESTABLISH A *SET ROUTINE.* MAKE IT A PRIORITY, A *SACROSANCT* TIME WHICH CANNOT BE INTERFERED WITH AT ANY COST.

TO ACCOMPLISH SOMETHING CREATIVE YOU HAVE TO *SACRIFICE* & *BE DRIVEN.*

NEVER BREAK YOUR ROUTINE

THE COOLEST THING EVER

YOUR CREATIVE ROUTINE GIVES YOU THE *FREEDOM* TO WORK ON WHATEVER YOU DESIRE. IT'S ENTIRELY UP TO YOU!

MAKE SURE IT'S THE *COOLEST THING YOU'VE EVER DONE.* YOUR CREATIVE PURSUIT SHOULD BECOME *YOUR PASSION,* SOMETHING YOU CAN'T WAIT TO GET BACK TO DOING.

GOALS & REWARDS

A GOOD METHOD TO TRICK YOURSELF TO GETTING BACK TO WORK IS TO TELL YOURSELF YOU ARE JUST GOING TO SIT AT YOUR WORK TABLE FOR A BRIEF TIME & WRITE OR DRAW A FEW LINES.

BEFORE YOU KNOW IT, HOURS WILL HAVE PASSED & YOU WILL BE AMAZED AT HOW MUCH YOU HAVE ACCOMPLISHED.

ALWAYS SET A GOAL TO WORK TOWARDS & PROMISE YOURSELF A REWARD WHEN YOU REACH THAT GOAL!

ONE PAGE A DAY

WRITE OR DRAW JUST **1** PAGE A DAY! **T**HINK ABOUT IT ...

AT THE END OF A YEAR YOU WILL HAVE AMASSED 365 *PAGES!* **T**HAT IS AN INCREDIBLE ACCOMPLISHMENT.

NEVER QUIT!

TO ACCOMPLISH ANYTHING IN LIFE IT TAKES...

=DETERMINATION=MOTIVATON= =DEDICATION=

BUT YOU ALSO NEED TO LEARN HOW TO TAKE *REJECTION.*

WHEN YOU'VE BEEN KNOCKED DOWN YOU NEED TO *GET BACK UP* & *GET BACK TO WORK.*

THIS IS WHAT SEPARATES THOSE WHO SUCCEED FROM THOSE WHO DON'T.

YOU WILL SUFFER DISAPPOINTMENT =

ALWAYS BELIEVE IN YOURSELF!

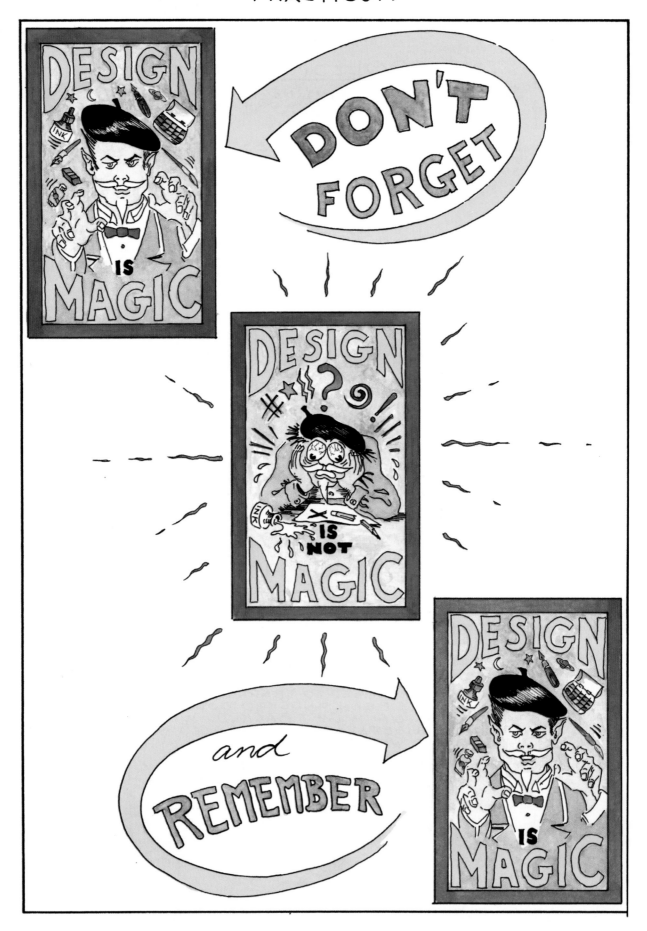

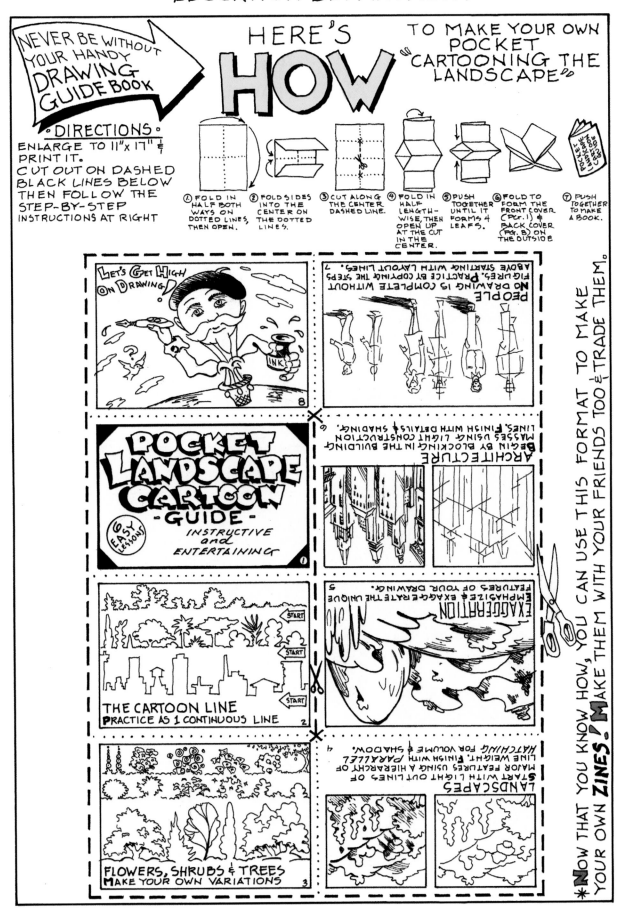

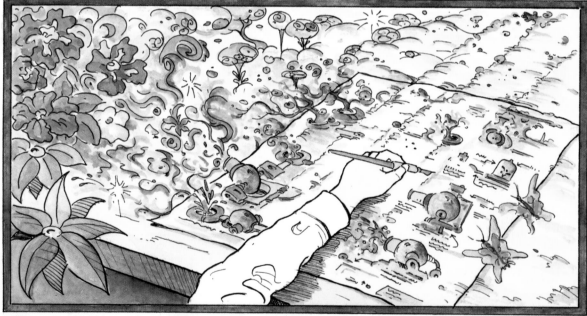

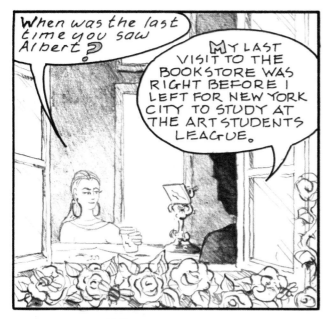

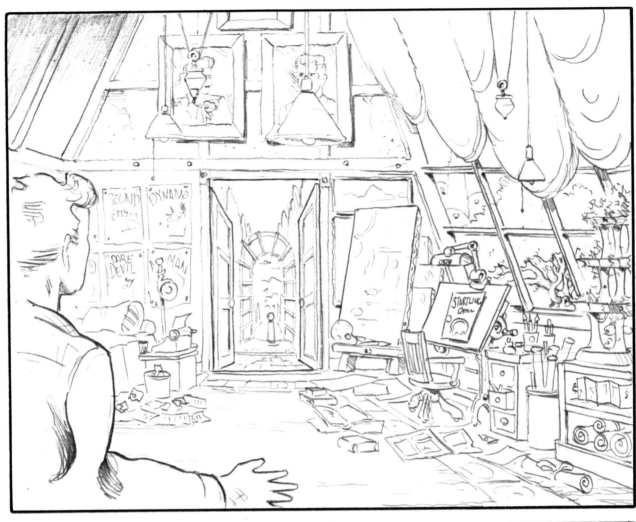

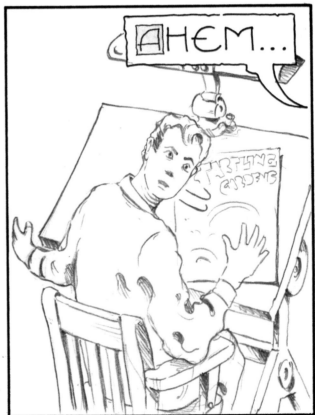

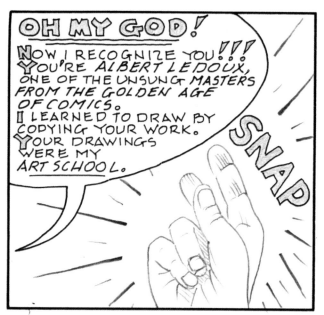

OH MY GOD! NOW I RECOGNIZE YOU!!! YOU'RE ALBERT LEDOUX, ONE OF THE UNSUNG MASTERS FROM THE GOLDEN AGE OF COMICS. I LEARNED TO DRAW BY COPYING YOUR WORK. YOUR DRAWINGS WERE MY ART SCHOOL.

SNAP

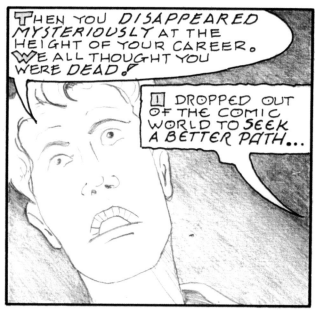

THEN YOU DISAPPEARED MYSTERIOUSLY AT THE HEIGHT OF YOUR CAREER. WE ALL THOUGHT YOU WERE DEAD!

I DROPPED OUT OF THE COMIC WORLD TO SEEK A BETTER PATH...

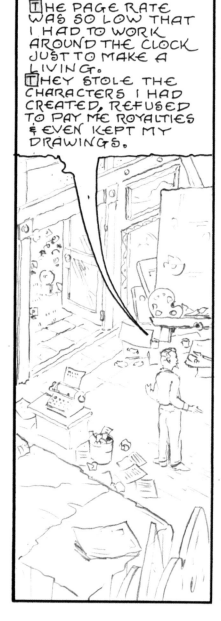

THE PAGE RATE WAS SO LOW THAT I HAD TO WORK AROUND THE CLOCK JUST TO MAKE A LIVING. THEY STOLE THE CHARACTERS I HAD CREATED, REFUSED TO PAY ME ROYALTIES & EVEN KEPT MY DRAWINGS.

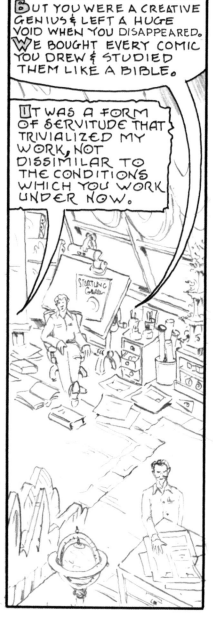

BUT YOU WERE A CREATIVE GENIUS & LEFT A HUGE VOID WHEN YOU DISAPPEARED. WE BOUGHT EVERY COMIC YOU DREW & STUDIED THEM LIKE A BIBLE.

IT WAS A FORM OF SERVITUDE THAT TRIVIALIZED MY WORK, NOT DISSIMILAR TO THE CONDITIONS WHICH YOU WORK UNDER NOW.

I NEVER REALIZED THAT. MY BOSS TOLD ME THAT MY RESEARCH OUTSIDE OF THE OFFICE WAS CIRCUMSPECT. I AM EXPECTED TO WORK EVENINGS & WEEKENDS WITH NO OVERTIME PAY. I'VE BEEN RIDICULED CONSTANTLY FOR LEAVING THE OFFICE AT 6:30 & EVEN PENALIZED FOR PURSUING MY OWN WORK.

ABOVE ALL YOU MUST THINK OF YOURSELF AS AN INVENTOR! NO ONE IN YOUR OFFICE IS GOING TO COME UP TO YOU & HAND YOU A POETIC VISION THAT WILL BECOME YOUR CALLING. YOU HAVE TO FIND IT YOURSELF.

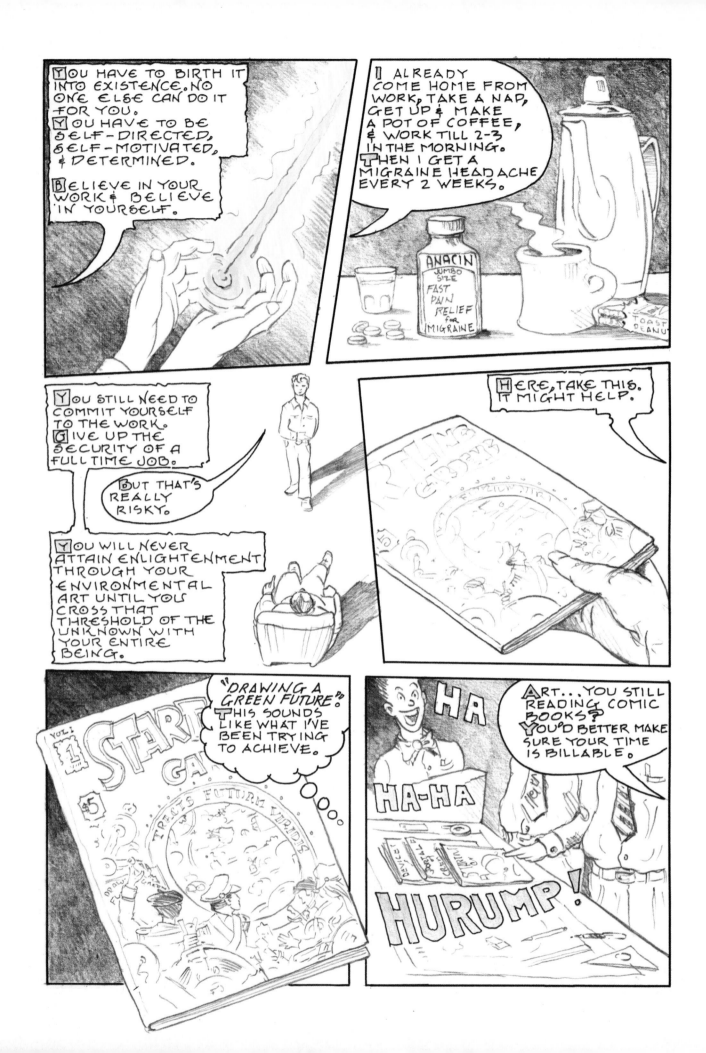

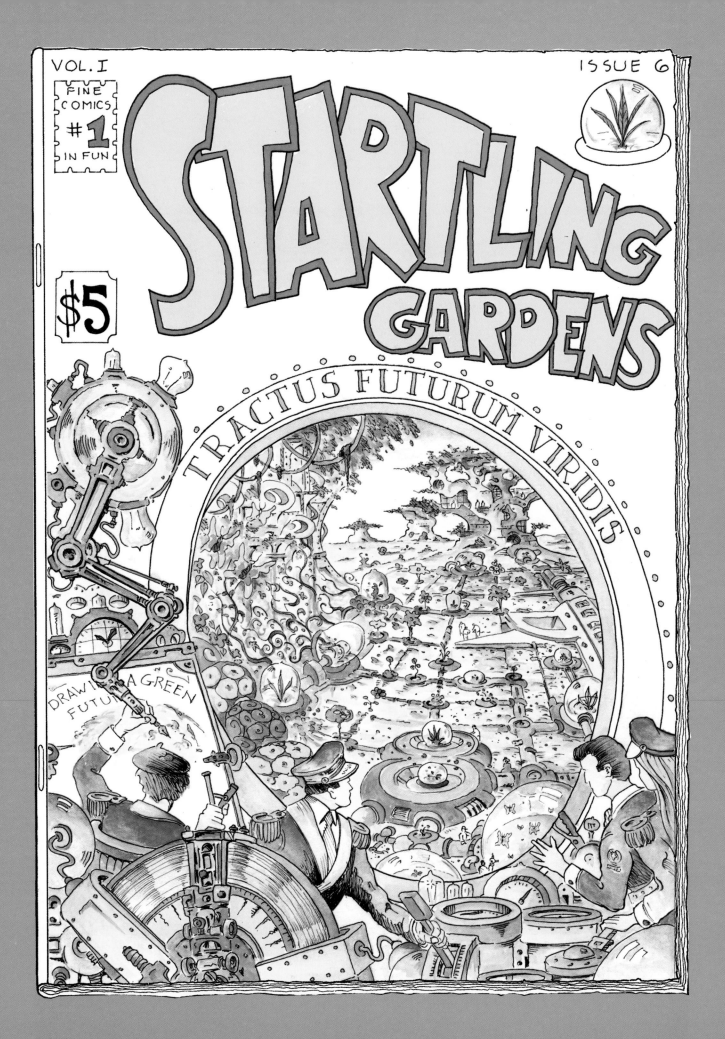

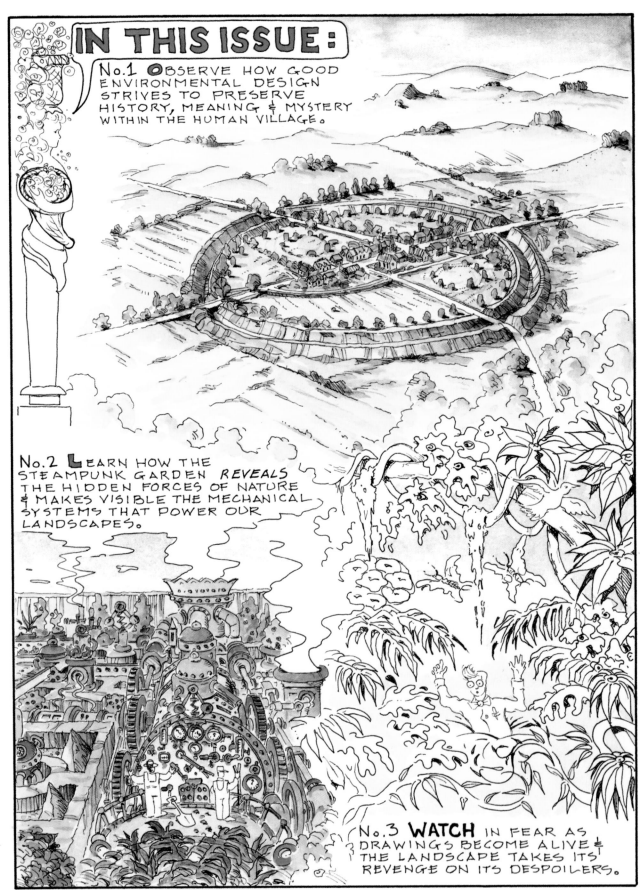

STARTLING GARDENS, VOLUME I, ISSUE NUMBER 6. PUBLISHED BY THE UNIVERSITY OF VIRGINIA PRESS, CHARLOTTESVILLE, VIRGINIA, 22904, USA.

OUR WORLD

OUR WORLD IS A WORLD OF *POTENTIAL,* IN WHICH THE GARDEN OASIS IS A POWERFUL SYMBOL OF THE *HEALING & RESTORATIVE* POWERS OF THE LANDSCAPE. IN A WORLD OF *MASSIVE ECOLOGICAL DESTRUCTION* THE GARDEN IS A *POTENTIAL POWER* THAT CAN REVERSE THE ENVIROMMENTAL DEGRADATION THAT IS ENGULFING THE WORLD.

BY ALBERT LEDOUX
WITH CREATIVE REVIEW by "*KITTY*" SULLIVAN

No.1

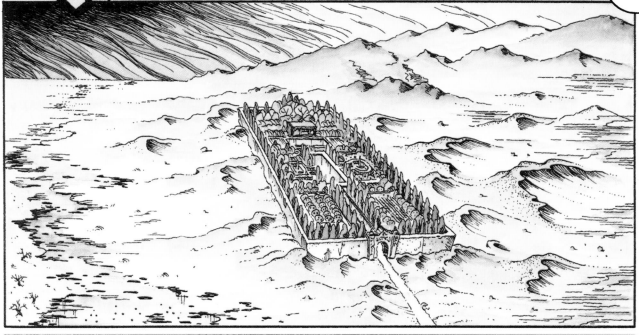

THE CURRENT LANDSCAPE IS FILLED WITH *POISONOUS, NOXIOUS, TOXIC WASTE SITES & WASTELANDS* LITTERED WITH LINGERING DEATH & HAUNTED VISTAS.

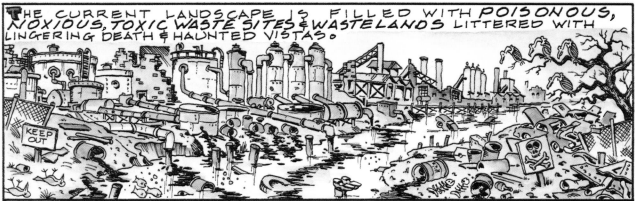

BUT IN *OUR WORLD* THESE WASTELANDS CAN BE RESTORED THROUGH *BIOREMEDIATION* INTO GREENWAYS, PARKS & WETLANDS.

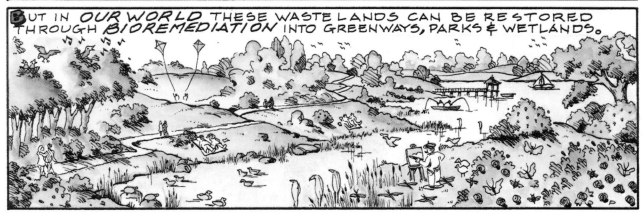

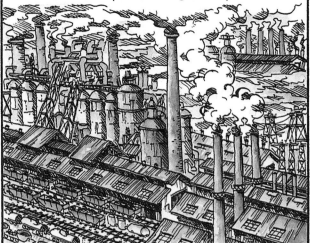

THE CURRENT ATMOSPHERE IS FILLED WITH *SMOKE* and *POLLUTION* — DESTROYING LUNGS, SEARING EYES, BURNING THROATS — DEVASTATING OUR HEALTH & WELL-BEING.

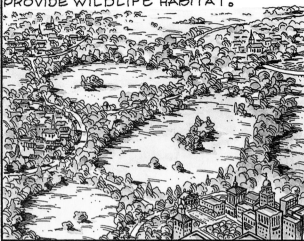

IN *OUR WORLD* WE CAN COUNTERACT THESE VAPOROUS, POISONOUS AIRS BY PLANTING *VAST GREENBELTS* OF OXYGEN-PRODUCING TREES WHICH PURIFY THE AIR, REDUCE HEAT DOMES & PROVIDE WILDLIFE HABITAT.

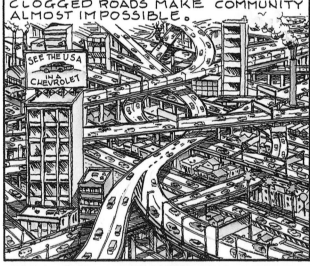

THE UTTER *WASTEFULNESS* OF EXISTING NETWORKS OF HIGHWAYS *STRANGLE* THE LANDSCAPE. CLOGGED ROADS MAKE COMMUNITY ALMOST IMPOSSIBLE.

SEE THE USA IN A CHEVROLET

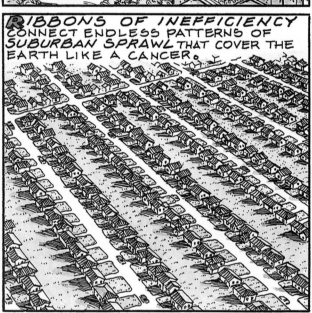

RIBBONS OF INEFFICIENCY CONNECT ENDLESS PATTERNS OF *SUBURBAN SPRAWL* THAT COVER THE EARTH LIKE A CANCER.

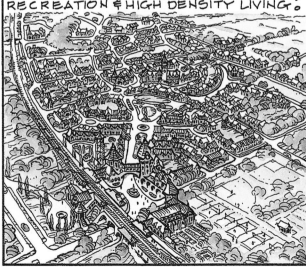

HOWEVER, IN *OUR WORLD* WE CAN SEE EFFICIENT *TRANSIT COMMUNITIES* WITH PEDESTRIAN-SCALED SHOPPING, RECREATION & HIGH DENSITY LIVING.

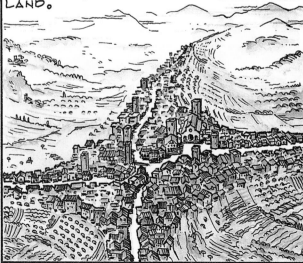

AND *TIMELESS CITIES* SENSITIVELY SITED WITH THE NATURAL TOPOGRAPHY THAT PRESERVE PRIME AGRICULTURAL LAND.

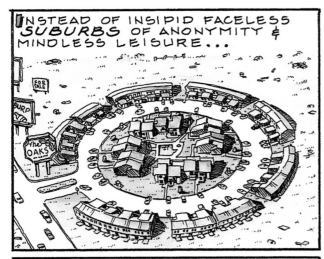

INSTEAD OF INSIPID FACELESS *SUBURBS* OF ANONYMITY & MINDLESS LEISURE...

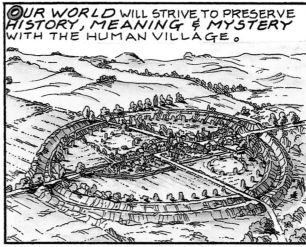

OUR WORLD WILL STRIVE TO PRESERVE *HISTORY, MEANING & MYSTERY* WITH THE HUMAN VILLAGE.

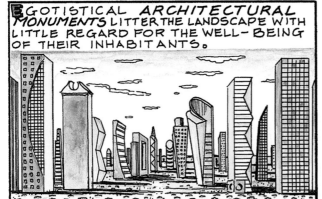

EGOTISTICAL *ARCHITECTURAL MONUMENTS* LITTER THE LANDSCAPE WITH LITTLE REGARD FOR THE WELL-BEING OF THEIR INHABITANTS.

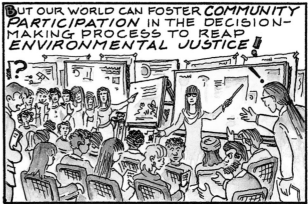

BUT OUR WORLD CAN FOSTER *COMMUNITY PARTICIPATION* IN THE DECISION-MAKING PROCESS TO REAP *ENVIRONMENTAL JUSTICE!*

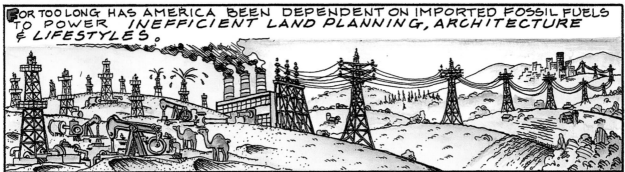

FOR TOO LONG HAS AMERICA BEEN DEPENDENT ON IMPORTED FOSSIL FUELS TO POWER *INEFFICIENT LAND PLANNING, ARCHITECTURE & LIFESTYLES.*

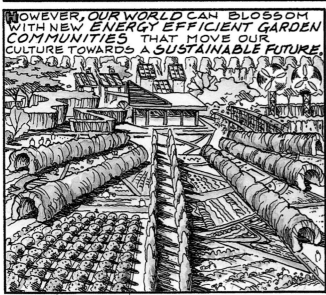

HOWEVER, *OUR WORLD* CAN BLOSSOM WITH NEW *ENERGY EFFICIENT GARDEN COMMUNITIES* THAT MOVE OUR CULTURE TOWARDS A *SUSTAINABLE FUTURE.*

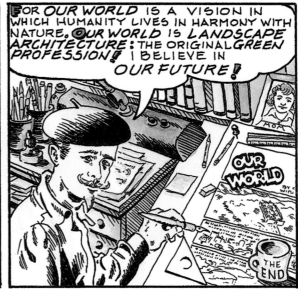

FOR *OUR WORLD* IS A VISION IN WHICH HUMANITY LIVES IN HARMONY WITH NATURE. *OUR WORLD* IS *LANDSCAPE ARCHITECTURE:* THE ORIGINAL *GREEN PROFESSION!* I BELIEVE IN *OUR FUTURE!*

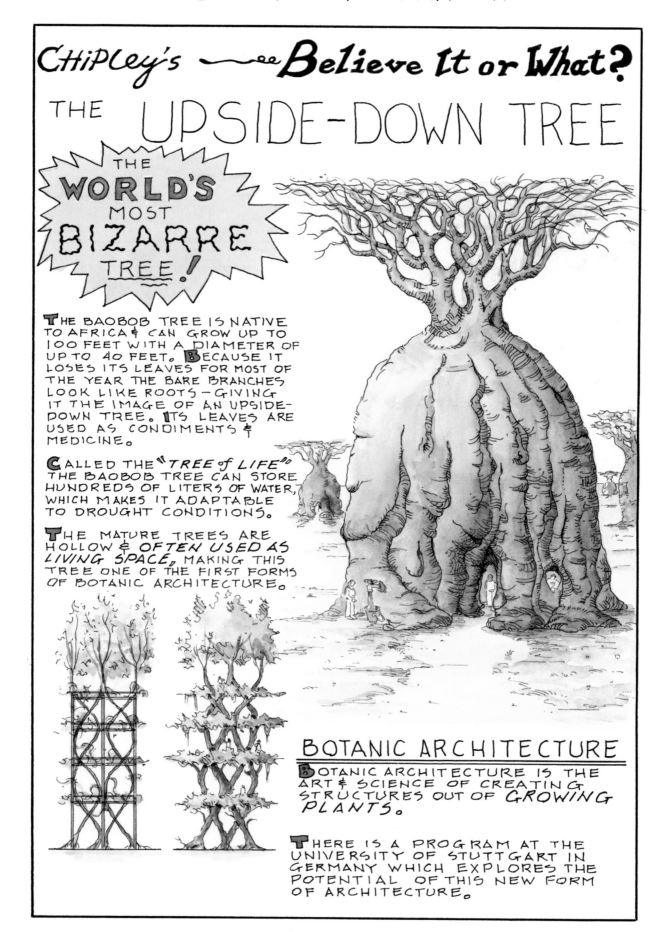

CHIPLEY'S ~ Believe It or What?

THE UPSIDE-DOWN TREE

THE WORLD'S MOST BIZARRE TREE!

THE BAOBOB TREE IS NATIVE TO AFRICA & CAN GROW UP TO 100 FEET WITH A DIAMETER OF UP TO 40 FEET. BECAUSE IT LOSES ITS LEAVES FOR MOST OF THE YEAR THE BARE BRANCHES LOOK LIKE ROOTS — GIVING IT THE IMAGE OF AN UPSIDE-DOWN TREE. ITS LEAVES ARE USED AS CONDIMENTS & MEDICINE.

CALLED THE "TREE of LIFE" THE BAOBOB TREE CAN STORE HUNDREDS OF LITERS OF WATER, WHICH MAKES IT ADAPTABLE TO DROUGHT CONDITIONS.

THE MATURE TREES ARE HOLLOW & OFTEN USED AS LIVING SPACE, MAKING THIS TREE ONE OF THE FIRST FORMS OF BOTANIC ARCHITECTURE.

BOTANIC ARCHITECTURE

BOTANIC ARCHITECTURE IS THE ART & SCIENCE OF CREATING STRUCTURES OUT OF GROWING PLANTS.

THERE IS A PROGRAM AT THE UNIVERSITY OF STUTTGART IN GERMANY WHICH EXPLORES THE POTENTIAL OF THIS NEW FORM OF ARCHITECTURE.

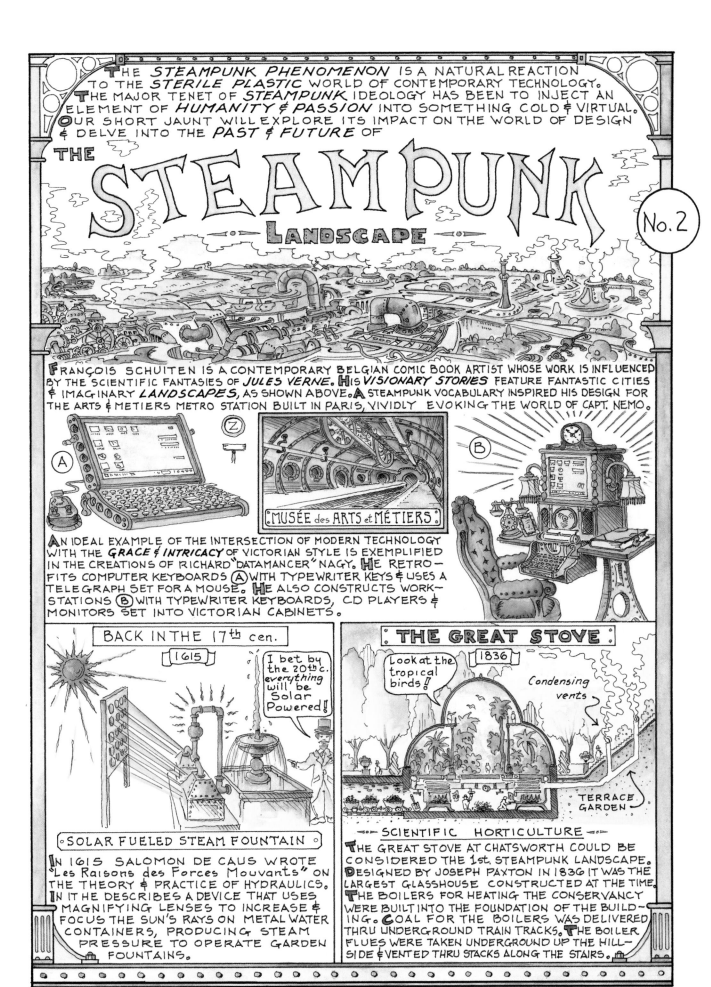

THE STEAMPUNK PHENOMENON IS A NATURAL REACTION TO THE STERILE PLASTIC WORLD OF CONTEMPORARY TECHNOLOGY. THE MAJOR TENET OF STEAMPUNK IDEOLOGY HAS BEEN TO INJECT AN ELEMENT OF HUMANITY & PASSION INTO SOMETHING COLD & VIRTUAL. OUR SHORT JAUNT WILL EXPLORE ITS IMPACT ON THE WORLD OF DESIGN & DELVE INTO THE PAST & FUTURE OF

THE STEAMPUNK LANDSCAPE

No. 2

FRANÇOIS SCHUITEN IS A CONTEMPORARY BELGIAN COMIC BOOK ARTIST WHOSE WORK IS INFLUENCED BY THE SCIENTIFIC FANTASIES OF JULES VERNE. HIS VISIONARY STORIES FEATURE FANTASTIC CITIES & IMAGINARY LANDSCAPES, AS SHOWN ABOVE. A STEAMPUNK VOCABULARY INSPIRED HIS DESIGN FOR THE ARTS & MÉTIERS METRO STATION BUILT IN PARIS, VIVIDLY EVOKING THE WORLD OF CAPT. NEMO.

Ⓐ Ⓩ Ⓩ

MUSÉE des ARTS et MÉTIERS

Ⓑ

AN IDEAL EXAMPLE OF THE INTERSECTION OF MODERN TECHNOLOGY WITH THE GRACE & INTRICACY OF VICTORIAN STYLE IS EXEMPLIFIED IN THE CREATIONS OF RICHARD "DATAMANCER" NAGY. HE RETRO‑FITS COMPUTER KEYBOARDS Ⓐ WITH TYPEWRITER KEYS & USES A TELEGRAPH SET FOR A MOUSE. HE ALSO CONSTRUCTS WORK‑STATIONS Ⓑ WITH TYPEWRITER KEYBOARDS, CD PLAYERS & MONITORS SET INTO VICTORIAN CABINETS.

BACK IN THE 17th cen.

1615

I bet by the 20th c. everything will be Solar Powered!

SOLAR FUELED STEAM FOUNTAIN

IN 1615 SALOMON DE CAUS WROTE "Les Raisons des Forces Mouvants" ON THE THEORY & PRACTICE OF HYDRAULICS. IN IT HE DESCRIBES A DEVICE THAT USES MAGNIFYING LENSES TO INCREASE & FOCUS THE SUN'S RAYS ON METAL WATER CONTAINERS, PRODUCING STEAM PRESSURE TO OPERATE GARDEN FOUNTAINS.

THE GREAT STOVE

Look at the tropical birds!

1836

Condensing vents

TERRACE GARDEN

SCIENTIFIC HORTICULTURE

THE GREAT STOVE AT CHATSWORTH COULD BE CONSIDERED THE 1st. STEAMPUNK LANDSCAPE. DESIGNED BY JOSEPH PAXTON IN 1836 IT WAS THE LARGEST GLASSHOUSE CONSTRUCTED AT THE TIME. THE BOILERS FOR HEATING THE CONSERVANCY WERE BUILT INTO THE FOUNDATION OF THE BUILD‑ING. COAL FOR THE BOILERS WAS DELIVERED THRU UNDERGROUND TRAIN TRACKS. THE BOILER FLUES WERE TAKEN UNDERGROUND UP THE HILL‑SIDE & VENTED THRU STACKS ALONG THE STAIRS.

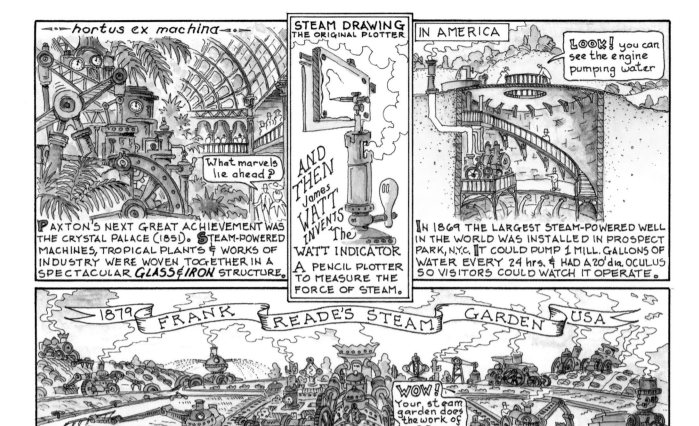

hortus ex machina

PAXTON'S NEXT GREAT ACHIEVEMENT WAS THE CRYSTAL PALACE (1851). STEAM-POWERED MACHINES, TROPICAL PLANTS & WORKS OF INDUSTRY WERE WOVEN TOGETHER IN A SPECTACULAR *GLASS & IRON* STRUCTURE.

STEAM DRAWING THE ORIGINAL PLOTTER — AND THEN James WATT INVENTS The WATT INDICATOR A PENCIL PLOTTER TO MEASURE THE FORCE OF STEAM.

IN AMERICA — IN 1869 THE LARGEST STEAM-POWERED WELL IN THE WORLD WAS INSTALLED IN PROSPECT PARK, N.Y.C. IT COULD PUMP 1 MILL. GALLONS OF WATER EVERY 24 HRS. & HAD A 20' dia. OCULUS SO VISITORS COULD WATCH IT OPERATE.

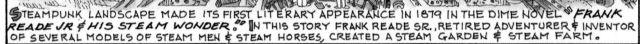

1879 FRANK READE'S STEAM GARDEN USA

STEAMPUNK LANDSCAPE MADE ITS FIRST LITERARY APPEARANCE IN 1879 IN THE DIME NOVEL "*FRANK READE JR & HIS STEAM WONDER.*" IN THIS STORY FRANK READE SR., RETIRED ADVENTURER & INVENTOR OF SEVERAL MODELS OF STEAM MEN & STEAM HORSES, CREATED A STEAM GARDEN & STEAM FARM.

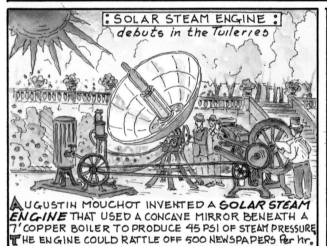

: SOLAR STEAM ENGINE : *debuts in the Tuileries*

AUGUSTIN MOUCHOT INVENTED A *SOLAR STEAM ENGINE* THAT USED A CONCAVE MIRROR BENEATH A 7' COPPER BOILER TO PRODUCE 45 PSI OF STEAM PRESSURE. THE ENGINE COULD RATTLE OFF 500 NEWSPAPERS per hr.

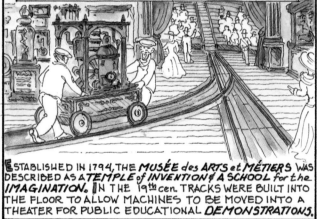

· THE TEMPLE of INVENTION ·

ESTABLISHED IN 1794, THE *MUSÉE des ARTS et MÉTIERS* WAS DESCRIBED AS A *TEMPLE of INVENTION & A SCHOOL for the IMAGINATION.* IN THE 19th cen. TRACKS WERE BUILT INTO THE FLOOR TO ALLOW MACHINES TO BE MOVED INTO A THEATER FOR PUBLIC EDUCATIONAL *DEMONSTRATIONS.*

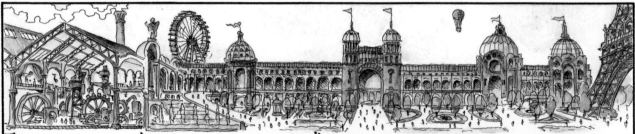

THE PLANNERS OF THE "*EXPOSITION UNIVERSELLE*" of 1900 SEAMLESSLY INTEGRATED URBAN DESIGN, PUBLIC OPEN SPACE & *STEAM TECHNOLOGY.* THE GALERIE des MACHINES WAS SET AMID GARDENS, LAWNS & FOUNTAINS, ON A CENTRAL AXIS OPPOSITE THE *EIFFEL TOWER.*

As the WONDERMENT of the MACHINE AGE began to wane, the POETRY OF MOVING GEARS, COGS, CYLINDERS & WHEELS gradually became CONCEALED. This process can be summed up in the above illustration which diagrams the EVOLUTION OF LOCOMOTIVE STREAMLINING in the 1930's & 40's. Today our world's mechanisms have mostly become MINISCULE, BURIED IN PLASTIC & SILICON. We can no longer see how things work. The INFRASTRUCTURE of landscape is hidden & cosmetically screened. Conversely, the work of scientist Howard Odum & the paintings of Charles Burchfield reveal insights into the HIDDEN FORCES OF NATURE. Odum DIAGRAMMED the flows of energy thru ecosystems & Burchfield expressed natural processes thru ABSTRACTION.

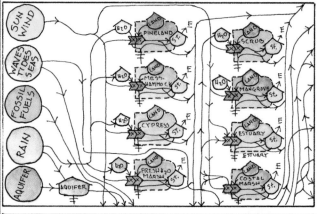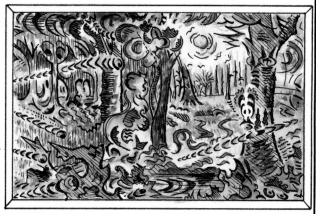

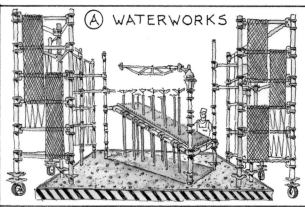

(A) WATERWORKS

(B) STEAM TEMPLE

This space is comfortable all year round.

Odum & Burchfield ILLUMINATED the landscape in the lab & studio; landscape architect GARY STRANG has developed a design methodology for "LANDSCAPE as INFRASTRUCTURE." Strang believes that the "masking of infrastructure is not only misleading but impractical" & proposes that "significant sources, paths & transition points of our collectively owned resources should be made legible in the landscape." The two art installations above illustrate this potential. (A) WATERWORKS presents landscape as a technological & natural construct, accentuating the infrastructure that supports it. (B) STEAM TEMPLE expresses the vast infrastructure of New York City, creating a microclimate that is modified with elements from underground.

the STEAM BOHEMIANS

The Berkeley "SHIPYARD" is an EXPERIMENTAL LABORATORY dedicated to developing ALTERNATIVE TECHNOLOGIES. For the past few years its members have been exploring the potential of organic gassifiers to produce fuel for motive power. The BYPRODUCTS are then RECYCLED thru a VERTICAL GARDEN in which its regeneration systems are EXPOSED & VISIBLE.

"The movement towards a SUSTAINABLE FUTURE must include the peeling away of intervening images between landscape FUNCTION & LANDSCAPE EXPERIENCE." ROBERT THAYER

~The End~

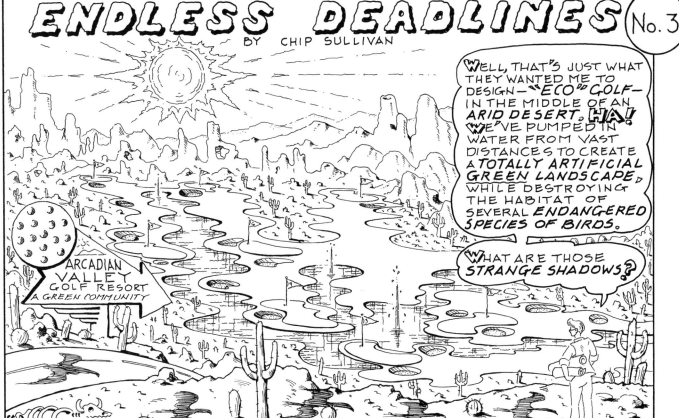

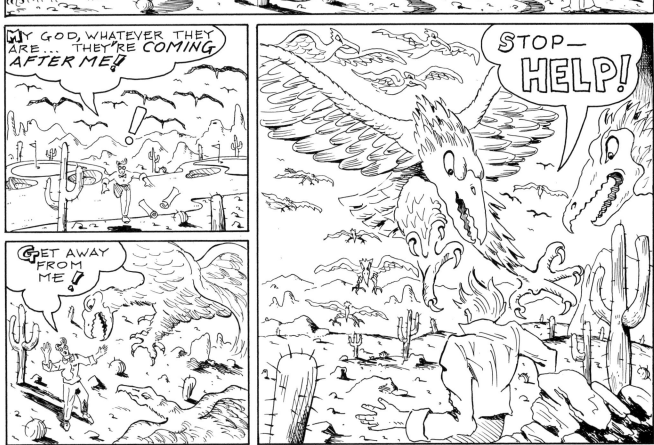

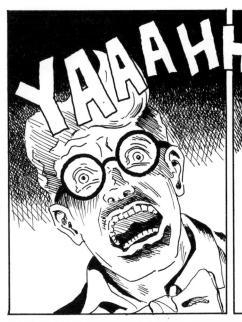

YAAAHHHH

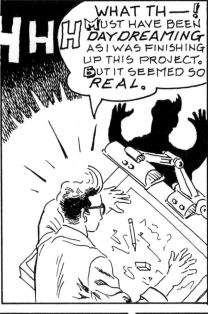

WHAT TH—! MUST HAVE BEEN DAYDREAMING AS I WAS FINISHING UP THIS PROJECT. BUT IT SEEMED SO REAL.

I'VE GOT TO GET HOLD OF MYSELF — THIS UNSCRUPULOUS EYE-WASH IS UNNERVING.

LATER AT THE INFAMOUS WATERING HOLE OF DEADBEATS, HIPSTERS & LANDSCAPE ARCHITECTS...

IT WAS EXACTLY AS I WAS DRAWING IT, ONLY I WAS IN THE SCENE & THESE STRANGE GIANT BIRDS WERE ATTACKING ME!

MAN... ADAM... YOU'VE GOT TO STOP TAKING ON SO MUCH WORK. YOU'RE HALLUCINATING.

I KNOW, BUT I COULD LOSE MY JOB IF I DON'T PUT IN THE OVERTIME.

WHAT? YOU CAN'T TAKE ON LESS WORK. YOU'RE THE BEST IN THE BUSINESS. YOUR RENDERINGS ALWAYS SELL OUR PROJECTS TO THE PUBLIC & THEY FLY THRU THE APPROVAL PROCESS.

YEAH BUT... OH ALL RIGHT. LET'S HAVE IT.

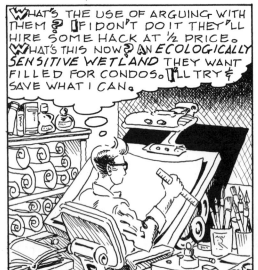

WHAT'S THE USE OF ARGUING WITH THEM? IF I DON'T DO IT THEY'LL HIRE SOME HACK AT ½ PRICE. WHAT'S THIS NOW? AN ECOLOGICALLY SENSITIVE WETLAND THEY WANT FILLED FOR CONDOS. I'LL TRY & SAVE WHAT I CAN.

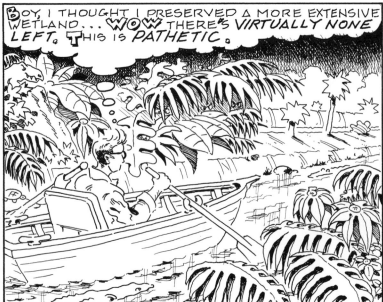

BOY, I THOUGHT I PRESERVED A MORE EXTENSIVE WETLAND... WOW THERE'S VIRTUALLY NONE LEFT. THIS IS PATHETIC.

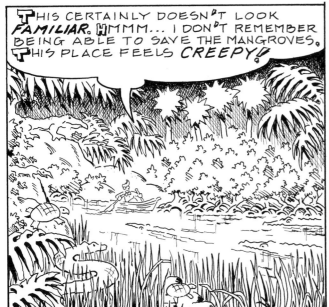

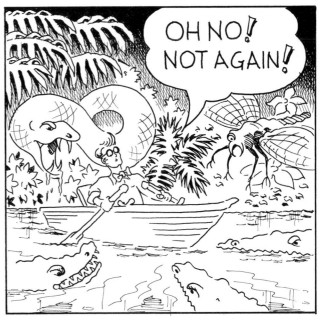

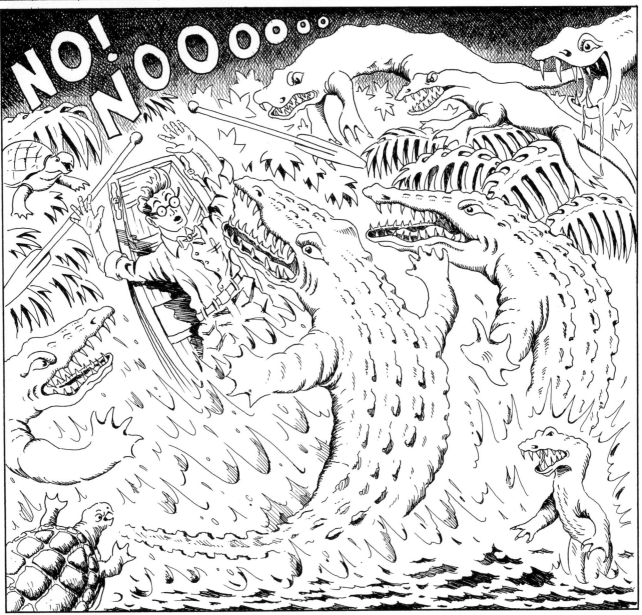

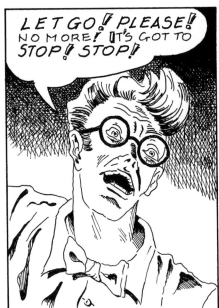

LET GO! PLEASE! NO MORE! IT'S GOT TO STOP! STOP!

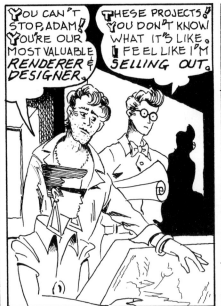

YOU CAN'T STOP, ADAM! YOU'RE OUR MOST VALUABLE RENDERER & DESIGNER.

THESE PROJECTS! YOU DON'T KNOW WHAT IT'S LIKE. I FEEL LIKE I'M SELLING OUT.

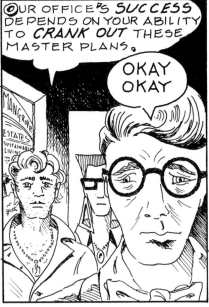

OUR OFFICE'S SUCCESS DEPENDS ON YOUR ABILITY TO CRANK OUT THESE MASTER PLANS.

OKAY OKAY

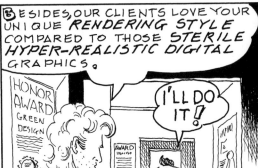

BESIDES, OUR CLIENTS LOVE YOUR UNIQUE RENDERING STYLE COMPARED TO THOSE STERILE HYPER-REALISTIC DIGITAL GRAPHICS.

I'LL DO IT!

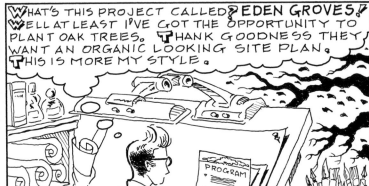

WHAT'S THIS PROJECT CALLED? EDEN GROVES! WELL AT LEAST I'VE GOT THE OPPORTUNITY TO PLANT OAK TREES. THANK GOODNESS THEY WANT AN ORGANIC LOOKING SITE PLAN. THIS IS MORE MY STYLE.

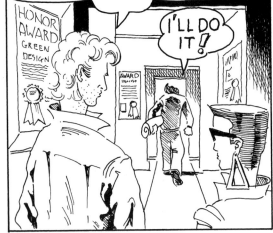

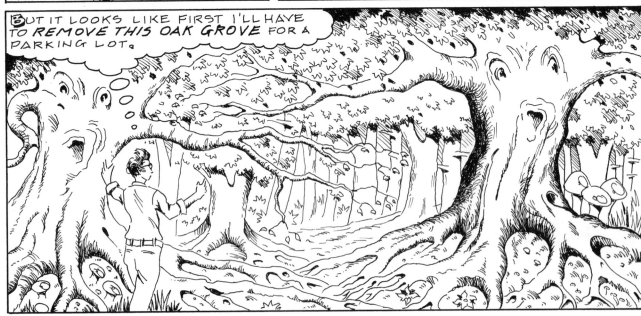

BUT IT LOOKS LIKE FIRST I'LL HAVE TO REMOVE THIS OAK GROVE FOR A PARKING LOT.

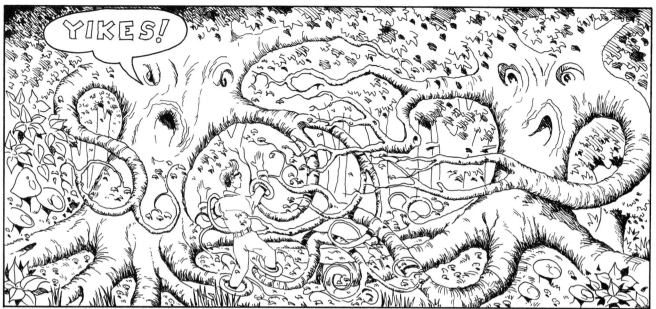

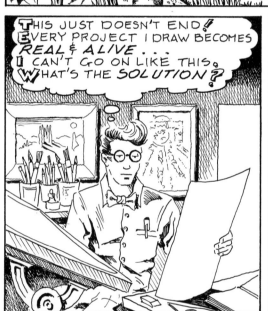

THIS JUST DOESN'T END! EVERY PROJECT I DRAW BECOMES REAL & ALIVE... I CAN'T GO ON LIKE THIS. WHAT'S THE SOLUTION?

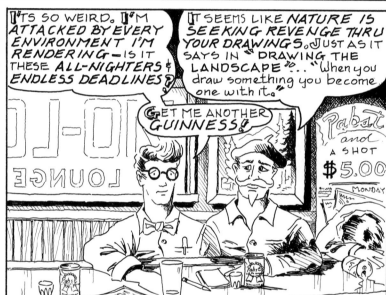

IT'S SO WEIRD. I'M ATTACKED BY EVERY ENVIRONMENT I'M RENDERING — IS IT THESE ALL-NIGHTERS & ENDLESS DEADLINES?

IT SEEMS LIKE NATURE IS SEEKING REVENGE THRU YOUR DRAWINGS. JUST AS IT SAYS IN "DRAWING THE LANDSCAPE"... "When you draw something you become one with it."

GET ME ANOTHER GUINNESS!

Pabst and A SHOT $5.00 MONDAY

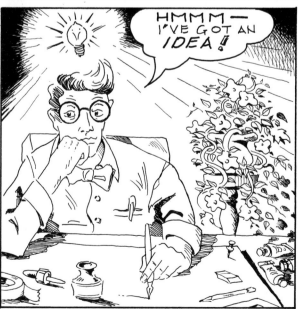

HMMM — I'VE GOT AN IDEA!

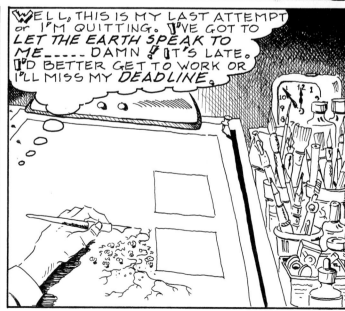

WELL, THIS IS MY LAST ATTEMPT or I'M QUITTING. I'VE GOT TO LET THE EARTH SPEAK TO ME..... DAMN! IT'S LATE. I'D BETTER GET TO WORK OR I'LL MISS MY DEADLINE.

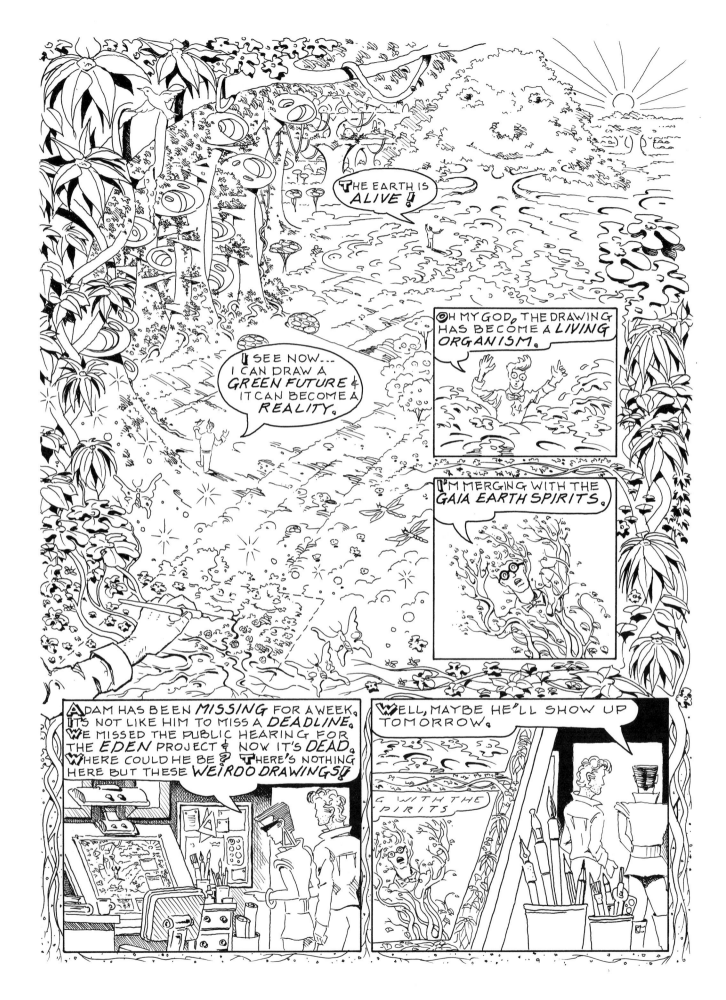

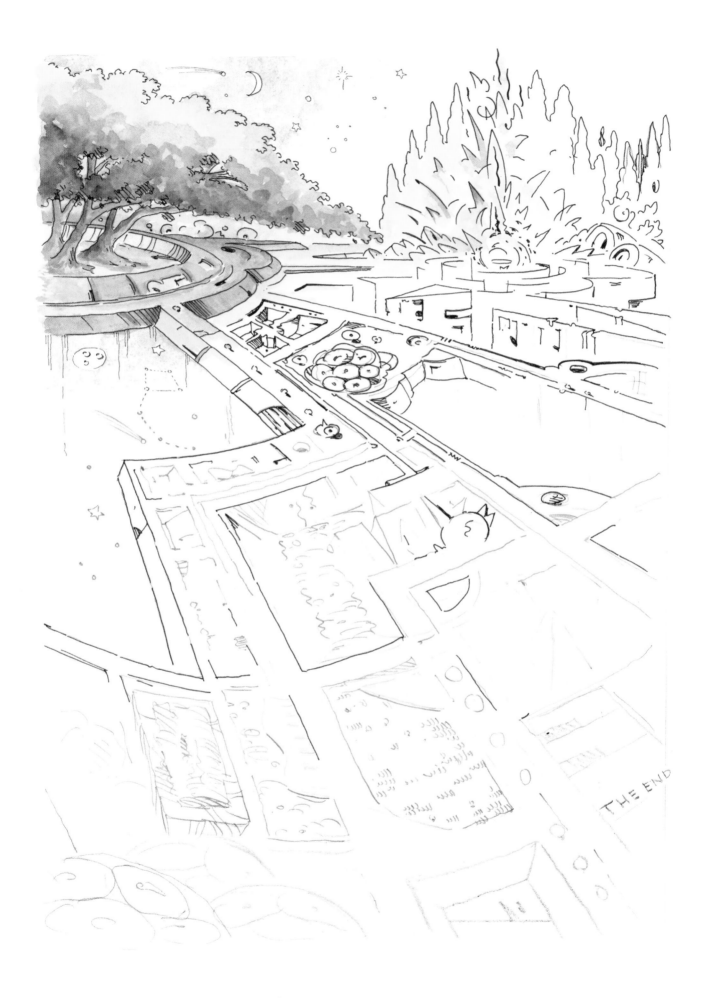

THE END

EPILOGUE

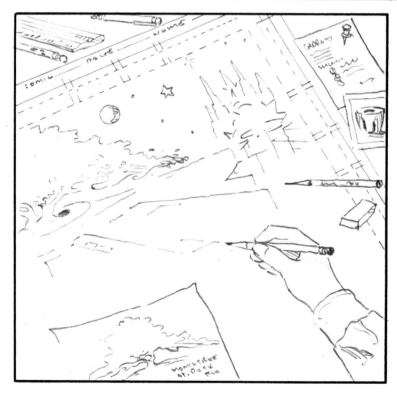

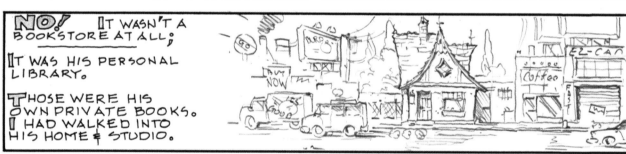

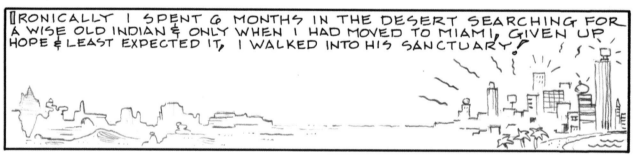

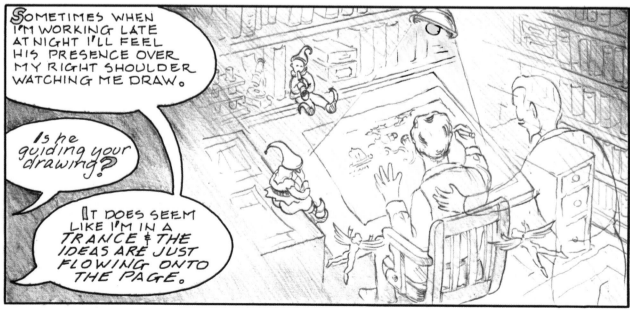

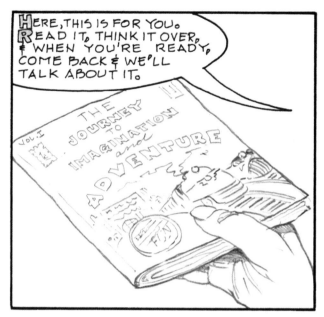

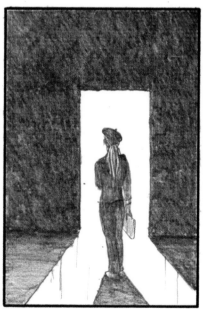

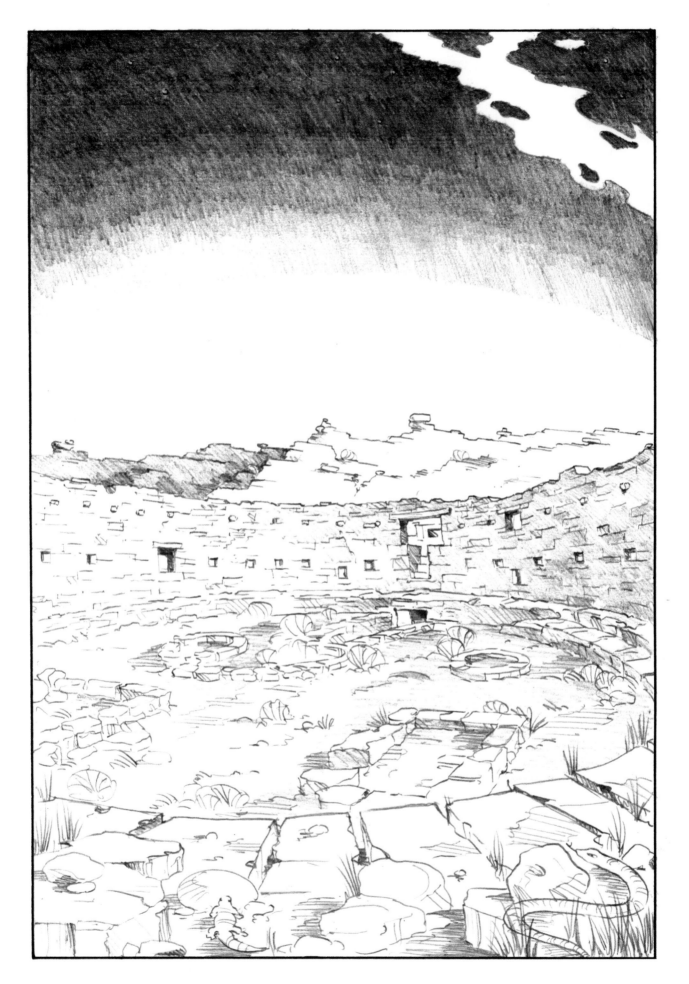

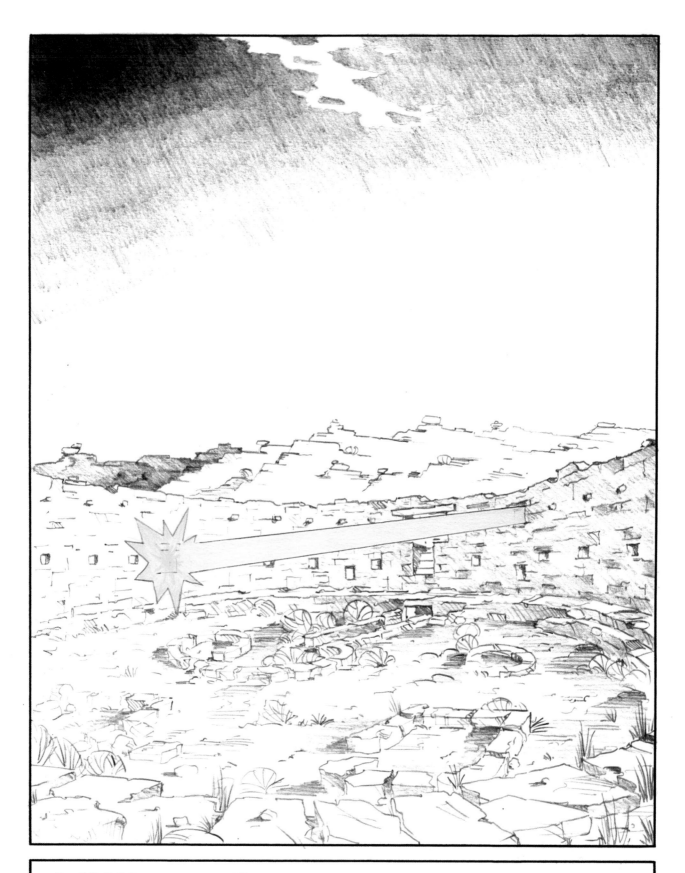

WHEN A TEACHER IS READY
A STUDENT APPEARS

THINK THE TRUTH
BE THE TRUTH
ACT THE TRUTH

FRANK JAMES 1932-97
landscape architect & mentor

BIBLIOGRAPHY

Adams, George, and Olive Whicher. *The Plant between Sun and Earth, and the Science of Physical and Ethereal Spaces*. London: Rudolf Steiner Press, 1980.

Alberti, Leon Battista. *On Painting*. London: Penguin Books, 1991.

Andrews, Malcolm. *Landscape and Western Art*. New York: Oxford University Press, 1999.

———. *The Search for the Picturesque*. Stanford, Calif.: Stanford University Press, 1989.

Argüelles, José and Miriam. *Mandala*. Boulder, Colo.: Shambhala Publications, 1972.

Bacon, Edmund N. *Design of Cities*. Harmondsworth, England: Penguin Books, 1967.

Bakhtiar, Laleh. *Sufi Expressions of the Mystic Quest*. New York: Avon Books, 1976.

Bambach, Carmen C., ed. *Leonardo Da Vinci: Master Draftsman*. New York: Metropolitan Museum of Art, 2003.

Botting, Douglas. *The Giant Airships: The Epic of Flight*. Alexandria, Va.: Time-Life Books, 1981.

Bulkeley, Kelly. *Transforming Dreams: Learning Spiritual Lessons from the Dreams You Never Forget*. New York: John Wiley & Sons, 2000.

Bull, Malcolm. *The Mirror of the Gods: How Renaissance Artists Rediscovered the Pagan Gods*. New York: Oxford University Press, 2005.

Carlin, John, Paul Karasik, and Brian Walker, eds. *Masters of American Comics*. New Haven, Conn.: Yale University Press, 2005.

Castaneda, Carlos. *The Teachings of Don Juan: A Yaqui Way of Knowledge*. Berkeley: University of California Press, 1968.

Cavallaro, Dani. *The Animé Art of Hayao Miyazaki*. Jefferson, N.C.: McFarland, 2006.

Chatwin, Bruce. *The Songlines*. New York: Penguin Books, 1987.

Colonna, Francesco. *Hypnerotomachia Poliphili: The Strife of Love in a Dream*. Trans. Joscelyn Godwin. New York: Thames & Hudson, 1999.

Comment, Bernard. *The Panorama*. London: Reaktion Books, 1999.

Conisbee, Philip, Sarah Faunce, and Jeremy Strick. *In the Light of Italy: Corot and Early Open-Air Painting*. Washington, D.C.: National Gallery of Art, 1996.

Donovan, Art. *The Art of Steampunk*. East Petersburg, Penn.: Fox Chapel Publishing, 2011.

Druick, Douglas W., and Peter Kort Zegers. *Van Gogh and Gauguin: The Studio of the South*. New York: Thames & Hudson, 2001.

Elkins, James. *What Painting Is*. New York: Routledge, 1999.

Evanier, Mark. *Kirby: King of Comics*. New York: Harry N. Abrams, 2008.

Ferguson, William M., and Arthur H. Rohn. *Anasazi Ruins of the Southwest in Color.* Albuquerque: University of New Mexico Press, 1987.

Ferriot, Dominique, Bruno Jacomy, and Louis André. *The Musée des Arts et Métiers.* Trans. France Bennett. Paris: Fondation Paribas, 1998.

Finch, Christopher. *The Art of Walt Disney.* Burbank, Calif.: Walt Disney Productions, 1975.

Fisher, Adrian, and Georg Gerster. *Labyrinth: Solving the Riddle of the Maze.* New York: Harmony Books, 1990.

Fleischer, Richard. *Out of the Inkwell: Max Fleischer and the Animation Revolution.* Lexington: University Press of Kentucky, 2005.

Folsom, Franklin. *America's Ancient Treasures.* New York: Rand McNally, 1971.

Frazer, James G. *The Golden Bough: The Roots of Religion and Folklore.* New York: Avenel, 1982.

Gibbons, Dave, Chip Kidd, and Mike Essl. *Watching the Watchmen.* London: Titan Books, 2008.

Guptill, Arthur L. *Color in Sketching and Rendering.* New York: Reinhold, 1935.

———. *Drawing with Pen and Ink, and a Word Concerning the Brush.* New York: Pencil Points Press, 1930.

———. *Rendering in Pencil.* New York: Watson Guptill Publications, 1977.

Hadingham, Evan. *Lines to the Mountain Gods: Nazca and the Mysteries of Peru.* Norman: University of Oklahoma Press, 1988.

Halter, Marc, and Brian B. Chin. *Histoire de la Ligne Maginot.* Florange, France: L'Imprimerie L'Huiller, 2011.

Hillier, Mary. *Automata and Mechanical Toys: An Illustrated History.* London: Jupiter Books, 1976.

Hollander, Ron. *All Aboard! The Story of Joshua Lionel Cowen and His Lionel Train Company.* New York: Workman Publishing, 1981.

Holmes, Richard. *The Age of Wonder: How the Romantic Generation Discovered the Beauty and Terror of Science.* New York: Pantheon Books, 2008.

Hunt, John Dixon. *Gardens and the Picturesque: Studies in the History of Landscape Architecture.* Cambridge, Mass.: MIT Press, 1992.

Ives, Colta, Susan Alyson Stein, Sjraar van Heugten, and Marije Vellekoop. *Vincent van Gogh: The Drawings.* New York: Metropolitan Museum of Art, 2005.

James, W. P. *The Locomotive Engineman's Manual: The Classic Locomotive Text from 1919.* Louisville, Kentucky: W. P. Publishing, 1919.

Jellicoe, Geoffrey and Susan, Patrick Goode, and Michael Lancaster. *The Oxford Companion to Gardens.* Oxford: Oxford University Press, 1986.

Jones, Kimberly. *In the Forest of Fontainebleau: Painters and Photographers from Corot to Monet.* New Haven, Conn.: Yale University Press, 2008.

Khayyám, Omar. *Rubáiyát of Omar Khayyám.* Trans. Edward FitzGerald. Garden City, N.Y.: Doubleday & Company Inc., 1952.

King, Ronald. *The Quest for Paradise: A History of the World's Gardens.* Weybridge, England: Whittet/Windward, 1979.

Lawlor, Robert. *Sacred Geometry: Philosophy and Practice.* London: Thames & Hudson, 1982.

Lazzaro, Claudia. *The Italian Renaissance Garden: From the Conventions of Planting, Design, and Ornament to the Grand Gardens of Sixteenth-Century Central Italy.* New Haven, Conn.: Yale University Press, 1990.

Leggatt, Charles, ed. *Constable: A Master Draughtsman.* Sudbury, England: Lavenham Press, 1994.

Leonardo da Vinci. *Leonardo on Painting*. Ed. and trans. Martin Kemp and Margaret Walker. London: Bath Press, Avon, 1988.

Leonardo da Vinci. *Selections from the Notebooks of Leonardo da Vinci*. Ed. Irma A. Richter. Oxford: Oxford University Press, 1952.

Lutz, Edwin George. *Animated Cartoons*. Bedford, Mass.: Applewood Books, 2014.

Macdougall, Elisabeth B., and Richard Ettinghausen, eds. *The Islamic Garden: Dumbarton Oaks Colloquium on the History of Landscape Architecture* IV. Washington, D.C.: Dumbarton Oaks, 1976.

Masson, Georgina. *Italian Gardens*. Woodbridge, England: Antique Collectors' Club, 1987.

Mendelowitz, Daniel M. A *Guide to Drawing*. New York: Holt, Rinehart and Winston, 1967.

Michell, John. *The Earth Spirit: Its Ways, Shrines, and Mysteries*. New York: Avon Books, 1975.

Mitchell, John. *The View over Atlantis*. New York: Ballantine Books, 1972.

Miyazaki, Hayao. *Starting Point: 1979–1996*. Trans. Beth Cary and Frederik L. Schodt. San Francisco: VIZ Media, 2009.

Murray, Peter. *The Architecture of the Italian Renaissance*. Rev. ed. New York: Schocken Books, 1963.

Neumann, Dietrich, ed. *Film Architecture: Set Designs from Metropolis to Blade Runner*. Munich: Prestel-Verlag, 1996.

Newton, Norman T. *Design on the Land: The Development of Landscape Architecture*. Cambridge, Mass.: Belknap Press, 1971.

Nitske, W. Robert. *The Zeppelin Story*. Cranbury, N.J.: A. S. Barnes, 1977.

Powers, William. *Hamlet's BlackBerry*. New York: HarperCollins, 2010.

Rand, Richard. *Claude Lorrain: The Painter as Draftsman—Drawings from the British Museum*. New Haven, Conn.: Yale University Press, 2006.

Raszkowski, Petra. *Pinball*. Trans. Phil Goddard. Cambridge: CLB Publishing, 1994.

Reilly, Kara. *Automata and Mimesis on the Stage of Theatre History*. New York: Palgrave Macmillan, 2011.

Reti, Ladislao, ed. *The Unknown Leonardo*. Maidenhead, England: McGraw-Hill, 1974.

Riopelle, Christopher, and Xavier Bray. A *Brush with Nature: The Gere Collection of Landscape Oil Sketches*. London: National Gallery Publications, 1999.

Roob, Alexander. *Alchemy and Mysticism: The Hermetic Cabinet*. Trans. Shaun Whiteside. Los Angeles: Taschen, 2005.

Rosenberg, Pierre, and Keith Christiansen, eds. *Poussin and Nature: Arcadian Visions*. New York: Metropolitan Museum of Art, 2008.

Roth, Ed. *Confessions of a Rat Fink: The Life and Times of Ed "Big Daddy" Roth*. Trans. Howie "Pyro" Kusten. New York: Pharos Books, 1992.

Ruskin, John. *The Elements of Drawing*. New York: Dover, 1971.

———. *The Seven Lamps of Architecture*. New York: Farrar, Straus and Giroux, 1986.

Sadi, Muslihu'd-Din. *The Rose Garden of Shekh Muslihu'd-Din Sadi of Shiraz*. Ed. Atish Kadah. Trans. Edward B. Eastwick. London: Octagon Press, 1979.

Schama, Simon. *Landscape and Memory*. Toronto: Vintage, 1995.

Sennett, Robert S. *Setting the Scene: The Great Hollywood Art Directors*. New York: Harry N. Abrams, 1994.

Shah, Idries. *The Sufis*. Garden City, N.Y.: Anchor Books, 1971.

Shlain, Leonard. *Art and Physics: Parallel Visions in Space, Time, and Light.* New York: Perennial, 1991.

Starger, Steve, and J. David Spurlock. *Wally's World: The Brilliant Life and Tragic Death of Wally Wood, The World's Second-Best Comic Book Artist.* Somerset, N.J.: Vanguard Productions, 2006.

Steiner, Rudolf. *A Road to Self-Knowledge and The Threshold of the Spiritual World.* London: Rudolf Steiner Press, 1975.

Stewart, Bhob, ed. *Against the Grain: Mad Artist Wallace Wood.* Raleigh, N.C.: Two-Morrows Publishing, 2003.

Stone, Irving, and Jean Stone. *Dear Theo: The Autobiography of Vincent Van Gogh.* Harmondsworth, England: Plume, 1995.

Sullivan, Chip. *Garden and Climate.* New York: McGraw-Hill, 2002.

Thacker, Christopher. *The History of Gardens.* Berkeley: University of California Press, 1979.

Topping, Brian. *The Engine Driver's Manual: How to Prepare, Fire, and Drive a Steam Locomotive.* Hersham, England: Ian Allan Publishing, 1998.

Vander Meer, Jeff, and S. J. Chambers. *The Steampunk Bible.* New York: Abrams, 2011.

Van der Ree, Paul, Gerrit Smienk, and Clemens Steenbergen. *Italian Villas and Gardens.* Amsterdam: Thoth, 1992.

Van Valkenburgh, Michael R. *Transforming the American Garden: 12 New Landscape Designs.* Cambridge, Mass.: Harvard University Graduate School of Design, 1986.

Vasari, Giorgio. *The Lives of the Artists.* Trans. Julia Conaway Bondanella and Peter Bondanella. New York: Oxford University Press, 1991.

Watts, Alan W. *Nature, Man, and Woman.* New York: Vintage Books, 1970.

Wharton, Edith. *Italian Villas and Their Gardens.* New York: Da Capo Press, 1976.

Wilber, Donald Newton. *Persian Gardens and Garden Pavilions.* Second ed. Washington, D.C.: Dumbarton Oaks, 1979.

Young, S. Mark, Steve Duin, and Mike Richardson. *Blast Off! Rockets, Robots, Ray Guns, and Rarities from the Golden Age of Space Toys!* Milwaukie, Ore.: Dark Horse Comics, 2001.

Zuffi, Stefano, and Francesca Castria Marchetti. *La pittura italiana: I maestri di ogni tempo e i loro capolavori.* Milan: Electa, 1997.

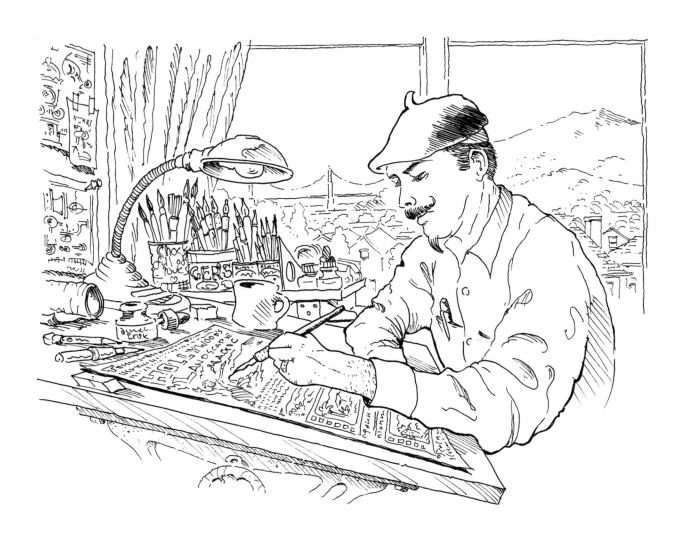

CHIP SULLIVAN is Professor of Landscape Architecture and
Environmental Planning at the University of California, Berkeley.
He is a winner of the Rome Prize and the author of the classic
Drawing the Landscape, now in its fourth edition.